CHASING
APHRODITE

CHASING APHRODITE

The Hunt for Looted Antiquities
at the World's Richest Museum

JASON FELCH
AND
RALPH FRAMMOLINO

HOUGHTON MIFFLIN HARCOURT
BOSTON • NEW YORK

For information about permission to reproduce selections from this book,
write to Permissions, Houghton Mifflin Harcourt Publishing Company,
215 Park Avenue South, New York, New York 10003.

www.hmhco.com

Library of Congress Cataloging-in-Publication Data
Felch, Jason.
Chasing Aphrodite: the hunt for looted antiquities at the world's
richest museum / Jason Felch and Ralph Frammolino.
p. cm.
ISBN 978-0-15-101501-6
1. Classical antiquities—Destruction and pillage. 2. Cultural property—
Repatriation—Italy. 3. Cultural property—Repatriation—California—Malibu.
4. J. Paul Getty Museum—Corrupt practices. I. Frammolino, Ralph. II. Title.
CC135.F46 2011
930—dc22 2010025835

Book design by Victoria Hartman

Printed in the United States of America

DOC 10 9 8 7

Photo credits appear on page 359.

For Nico

— J.F.

For Allyson and Anna

— R.F.

Contents

Prologue

IN RECENT YEARS, several of America's leading art museums have given up some of their finest pieces of classical art, handing over more than one hundred Greek, Roman, and Etruscan antiquities to the governments of Italy and Greece. The monetary value of the returned objects has been estimated at more than half a billion dollars. The aesthetic loss to the nation's art collections is immeasurable. Several of the objects have long been hailed as the defining masterpieces of their era. Yet for the most part, the museums gave up these ancient sculptures, vases, and frescoes under no legal obligation and with no promise of compensation. After decades of painstaking collecting, why would they be moved to such unheard-of generosity?

The returns followed an international scandal that exposed an ugly truth, something art insiders had long known but publicly denied. For decades, museums in America, Europe, and elsewhere had been buying recently looted objects from a criminal underworld of smugglers and fences, in violation of U.S. and foreign law.

The museum world's dirty little secret came to light amid revelations about pedophile priests in the Catholic Church and widespread steroid use in major league baseball. Like those scandals, the truth

about museums and looting—documented in blurry Polaroids and splashed across newspapers around the world—redefined some of America's most cherished institutions in the public mind. Museums have long been our civic temples, places to worship beauty and the diversity of the world's cultures. Now they are also recognized as multimillion-dollar showcases for stolen property.

The crime in question, trafficking in looted art, is hardly new. Indeed, it is probably the world's second-oldest profession. One of the earliest known legal documents is an Egyptian papyrus dating to 1100 B.C. that chronicles the trial of several men caught robbing the tombs of pharaohs. (The document resides not in Egypt, of course, but in London, after being "acquired" by the British Museum in the 1880s.) The Romans sacked Greece; Spain plundered the New World; Napoleon filled the Louvre with booty taken from across his empire. In the eighteenth century, caravans of British aristocrats on the grand tour blithely plucked what they wanted from ancient sites, sending home wagonloads of ancient art for their country estates.

This long parade of plunder has occasionally been interrupted by outcry and debate. In 70 B.C., a sharp-tongued Roman attorney named Cicero summoned all his oratorical skills to press a criminal case against the corrupt governor of Sicily, Gaius Verres, whose wholesale sacking of temples, private homes, and public monuments bordered on kleptomania.

"In all Sicily, in all that wealthy and ancient province . . . there was no silver vessel, no Corinthian or Delian plate, no jewel or pearl, nothing made of gold or ivory, no statue of marble or brass or ivory, no picture whether painted or embroidered, that he did not seek out, that he did not inspect, that, if he liked it, he did not take away," Cicero told the Roman Senate. Looting was "what Verres calls his passion; what his friends call his disease, his madness; what the Sicilians call his rapine."

In 1816, more than eighteen hundred years later, a similar condemnation echoed throughout the halls of the British Parliament af-

ter Thomas Bruce, Seventh Earl of Elgin, returned from Greece with shiploads of exquisitely carved friezes ripped from the Parthenon. The marbles represented the artistic zenith of ancient Greece and had survived for twenty-two centuries. Their removal represented the nadir of antiquities collecting. Even Britain's wealthy cognoscenti, men who had feasted on marble trophies from Greece and Rome for more than a century, recoiled at the magnitude of Lord Elgin's appetite. The most stinging rebuke flowed from the quill of Lord Byron, Elgin's contemporary and a great defender of Greek culture. In his poem "The Curse of Minerva," Byron gives voice to the goddess herself to denounce the intrepid collector:

> *I saw successive Tyrannies expire;*
> *'Scaped from the ravage of the Turk and Goth,*
> *Thy country sends a spoiler worse than both.*

Britain eventually bought the marbles from Elgin and installed them in the British Museum, the first of the so-called encyclopedic museums. It was soon joined by the Louvre, the National Museums in Berlin, and the Metropolitan Museum of Art in New York City. Throughout the eighteenth and nineteenth centuries, these reposito ries of human achievement accumulated some of the world's most celebrated works of art, many of which might otherwise have been lost. The museums pioneered new ways to protect and conserve them and spent millions building palatial galleries in which to display them. They saw themselves as products of the Enlightenment, brick-and-mortar extensions of Diderot's *Encyclopédie*. But they were also the products of colonialism, driven to collect by a sense of cultural superiority that justified the unchecked acquisition of relics from the far reaches of their empires.

In America, this attitude prevailed well into the post–World War II boom years, when prosperity gave rise to a new class of regional museums and nouveau riche art enthusiasts who adopted

the role of the enlightened collector. Many sought to make their mark in the niche of classical antiquities, which conveyed instant prestige and seemed to yield a never-ending supply of new master-pieces.

The sudden demand for antiquities fueled looting as never before, not just in Mediterranean countries but also across Latin America, the Middle East, and Asia. What had long been a small market in trinkets for tourists rapidly became a sophisticated global supply chain. Illegal excavations destroyed archaeological sites—and the historical record they contained—at a staggering pace.

The destruction coincided with the changing Zeitgeist of the 1960s. Archaeologically rich countries found a new appreciation for their antiquities, which offered a connection to a glorious past. These so-called source countries began dusting off long-forgotten laws that asserted state ownership of their cultural patrimony, including any undiscovered archaeological finds within their modern borders. The efforts came in fits and starts and were easily dismissed by collectors and museums. But they found a sympathetic following among archae-ologists, who saw firsthand the ravages of looting. Scholars began to trace the paths of looted objects from plundered gravesites to the shelves of local museums.

The crisis culminated in 1970 with a landmark international treaty for the protection of cultural property brokered by the United Na-tions Educational, Scientific, and Cultural Organization. The UNESCO Convention sought to stop the illicit flow of artifacts by weaving together a loose patchwork of national patrimony laws into a seamless net. The United States and more than one hundred other countries eventually signed the accord, agreeing to restrict the impor-tation of illicit objects. In doing so, they recognized that an antiquity's value lay not just in its intrinsic beauty but also in its archaeological context—where it was found and how it related to those surround-ings.

The treaty was hailed as a paradigm shift. The great collecting

museums in America and Europe publicly supported it, with Thomas Hoving, then director of the mighty Met, declaring, "The Age of Piracy is over."

But in truth, UNESCO changed very little. For the past forty years, museum officials have routinely violated the spirit, if not the letter, of the UNESCO treaty and foreign and domestic laws, buying ancient art they knew had been illegally excavated and spirited out of source countries.

Their actions amounted to a massive betrayal of museums' public mission. To educate the public and preserve the past, white-gloved curators did business with the most corrupt corners of the art world, cutting deals in Swiss bank vaults and smugglers' warehouses with the criminal underclass that controlled the market. They bought objects laundered through auction houses and private collections, accepting —and at times inventing—fake ownership histories that covered criminal origins with falsehoods that to this day obscure the historical record. In doing so, museums have fueled the destruction of far more knowledge than they have preserved, all while ostensibly deploring the havoc that looting wreaks on archaeological sites, our primary source of knowledge about our origins.

For the Age of Piracy to truly end, it took an international scandal of remarkable proportions. At the center of that scandal was the up-start J. Paul Getty Museum in Los Angeles. No institution struggled with the morality of buying looted antiquities more deeply than the Getty. And in the end, none paid a higher price.

Over four decades, the Getty chased many illicit masterpieces—a bronze athlete, a towering marble youth, a sculpture of savage griffins, a golden funerary wreath. One of those acquisitions—the museum's iconic seven-and-a-half-foot statue of Aphrodite, the Greek goddess of love—would become a totem for the beguiling beauty of ancient art.

The goddess held an allure so strong that a museum risked everything to own her; a nation rose up to demand her return; archaeolo-

gists, private investigators, and journalists scoured the globe for her origins; and a curator ruined herself trying to keep her.

This book is the story of that chase, an unprecedented inside account of how the world's richest museum was forced to confront its buried past and, in doing so, brought about an epochal change in the history of collecting art.

PART I

WINDFALLS
AND COVER-UPS

I

THE LOST BRONZE

I N T H E P R E D A W N L I G H T of a summer morning in 1964, the sixty-foot fishing trawler *Ferrucio Ferri* shoved off from the Italian seaport of Fano and motored south, making a steady eight knots along Italy's east coast. When the *Ferri* reached the peninsula of Ancona, Romeo Pirani, the boat's captain, set a course east-southeast, halfway between the dry sirocco wind that blew up from Africa and the cooler levanter that swept across the Adriatic from Yugoslavia.

The six-man crew dozed. The sea was glassy, but Pirani knew how temperamental the Adriatic could be at this time of year. Just a few weeks earlier, a sudden storm had blown across the sea, sinking three boats and killing four fishermen. Weather was not his only worry. The Second World War had left its mark on the sea and made his job all the more dangerous. Nets hauled up mines and bombs left behind decades before by retreating Nazi forces or their American pursuers. The arms of many men in Fano bore scars from the acid that oozed out of the rusting ordnance.

As the sun rose, blinding their eyes, Pirani and his crew sipped *moretta*, a hot mixture of rum, brandy, espresso, and anise, topped with a lemon rind and lots of sugar. The strong brew gave the men not just warmth but courage. By nightfall, the *Ferri* had reached its

destination, a spot in international waters roughly midway between Italy and Yugoslavia. The captain knew of a rocky outcropping that rose from the seabed where octopuses and schools of *merluza* and St. Peter's fish gathered for safety in the summer heat. Other boats ventured farther east, into the deep waters off the Yugoslav coast, where they risked arrest for poaching. But Pirani preferred this hidden shoal. Although fishing there meant occasionally snagging the nets on sharp rocks, the boat often returned to port full.

The crew cast its nets into the dark waters. They fished all night, sleeping in shifts.

Just after dawn, the nets got caught on something. Pirani gunned the engine and, with a jolt, the nets came free. As some of the men peered over the side, the crew hauled in its catch: a barnacle-encrusted object that resembled a man.

"*Cest un morto!*" cried one of the fishermen. A dead man!

As the sea gave up its secret, it quickly became apparent that the thing was too rigid and heavy to be a man. The crew dragged it to the bow of the boat. The life-size figure weighed about three hundred pounds, had black holes for eyes, and was frozen in a curious pose. Its right hand was raised to its head. Given the thickness of its encrustations, it looked as if it had been resting on the sea floor for centuries.

The men went about the immediate work of mending the torn nets. It was only later, when they stopped for a breakfast of roasted fish, that one of them grabbed a gaffe and pried off a patch of barnacles.

He let out a yelp. "*Cest de oro!*" he cried, pointing at the flash of brilliant yellow. Gold!

Pirani pushed through the huddle and looked at the exposed metal. Not gold, he declared, bronze. None of them had ever seen anything like it. It might be worth something. The *Ferri*'s men made a hasty decision. Rather than turn the figure over to local authorities, they would sell it and divvy up the profits.

As the *Ferri* motored back to Fano that afternoon, word came over

the radio that the town was afire with news of the discovery. The spark had come earlier, when the captain had mentioned it while chatting ship to shore with his wife. Crowds had gathered in the port for the *Ferri's* return. Pirani cut the engine and waited until nightfall. By the time the *Ferri* pulled into port, it was nearly 3 A.M. and the docks were deserted.

The crew brought the statue ashore on a handcart, hidden under a pile of nets, and took it to the house of Pirani's cousin, who owned the boat. After a few days, the statue began to smell of rotting fish. The cousin moved it to a covered garden patio and quietly invited several local antique dealers to have a look. They offered up to one million lire, but the crew wanted more.

With the statue's stench growing stronger by the day, the cousin fretted that someone would alert the police. He asked a friend with a Fiat 600 Mutipla to pick up the bronze statue and take it to a farm outside town, where they kept it buried in a cabbage field while they looked for a serious buyer.

A month later, they found Giacomo Barbetti, an antiquarian whose wealthy family owned a cement factory in Gubbio, fifty miles inland from Fano. Barbetti said that he was prepared to pay several million lire for the statue but naturally needed to see it first. When the figure emerged from the cabbage patch, Barbetti brushed aside the dirt, touched its straight nose, and surmised it to be the work of Lysippus, one of the master sculptors of ancient Greece.

Lysippus was the personal sculptor of Alexander the Great, and his fame as a sculptor spread throughout the ancient world on the heels of his patron's conquests. Lysippus rewrote the canon for Greek sculpture with figures that were more slender and symmetrical than those of his predecessors Polyclitus and the great Phidias, sculptor of the Acropolis friezes. Aside from busts of Alexander, Lysippus was famous for depicting athletes, and many of his bronzes lined the pathways of Olympia, birthplace of the Olympic Games. Lysippus is said to have created more than fifteen hundred sculptures in his lifetime, but none was believed to have survived antiquity.

Except, perhaps, this one. The bronze athlete in the cabbage patch may well have been one of those lining the pathways of Olympia, only to become war booty for Rome, whose glory slowly eclipsed that of Athens. As they swept through the Greek mainland and islands, Roman soldiers filled thousands of ships with plunder. Some three hundred years after its creation, around the time of Christ, the bronze athlete was likely torn from its pedestal in one such raid and loaded onto a waiting transport ship headed for Rome. The Adriatic was as fickle then as it is today, whipping up deadly storms without warning. The ship bearing the bronze athlete apparently sank to the sea floor, where it lay for two thousand years.

As Barbetti touched the foul-smelling figure's nose, he clearly saw something he liked. He offered 3.5 million lire—about $4,000, enough to buy several houses in Fano at the time. The money was split among the crew. Captain Pirani's share was about $1,600, double his monthly wages.

The bronze, meanwhile, was on the move.

FEARFUL THAT POLICE would search the warehouse of his family's cement company, Barbetti deposited the statue in a church in Gubbio, where Father Giovanni Nagni wrapped it in a red velvet curtain and hid it in the sacristy. When the stench of the figure became overwhelming, Father Nagni moved it to his house and submerged it in a bathtub of salt water.

A string of cars with foreign license plates began arriving with prominent antiquities dealers from across Europe. One brought with him an Italian restoration expert who, unsettled by the bronze's importance, informed the Carabinieri, Italy's national police. A raid was planned to seize the statue, but someone in town caught wind of it and warned Barbetti. When the Carabinieri arrived days later, the statue was gone. Some said it had been smuggled out of Italy in a car from Milan. Others claimed it had been packed on a boat filled with bootleg cigarettes, headed for France. Some even claimed that the

Barbettis had coated the bronze in cement from their factory and shipped it to a monastery in Brazil.

In 1966, with the statue still missing, the Carabinieri filed criminal charges against Barbetti and Father Nagni. Under Italy's cultural property law, archaeological objects found by chance after 1939 were the property of the state. Anyone found in possession of such objects was guilty of theft. Barbetti and Nagni were convicted and sentenced to jail, but Italy's highest court threw out the convictions in 1968, saying there was not enough evidence to establish that the statue had been found in Italian waters.

The statue resurfaced in London three years later. It had apparently spent those years hidden in a monastery in Brazil before being sold for $700,000 to a Luxembourg-based art consortium called Artemis. When the German antiquities dealer Heinz Herzer, a member of the consortium, saw the statue in a London warehouse, he felt a chill go down his spine. He could clearly see through the crust of shells that it was an athlete—a favorite theme of ancient sculptors. But this was no typical work. This athlete's head was tilted back slightly to the left, as if he was gazing up at a stadium full of admirers. His long body was twisted slightly in the other direction, giving him an exquisite tension. Most striking was the way his right hand hovered just centimeters from the olive wreath on his head: an Olympian caught in a moment of victorious ecstasy.

Herzer shipped the bronze to his studio in Munich, where he and a conservation expert spent weeks removing the centuries of encrustation with a scalpel, careful not to scratch the bronze underneath. He then had the bronze x-rayed, exposing a hollow interior stuffed with debris from the artist's workshop. Freed of its crustacean cocoon, the figure's skin showed an advanced case of "bronze disease," a destructive rust that leaves reddish spots of crystallized copper oxide on an object's surface. To arrest the corrosion, the bronze was immersed in a chemical bath. From then on, it would have to be kept at low humidity to prevent further damage.

Carbon-14 dating confirmed that the statue predated Roman times. Herzer's research led him to the same conclusion as Barbetti. The skill and proportions of the work pointed to Lysippus. Could this be the only surviving example of the great master's work?

To sell the figure for a price worthy of an original Greek masterpiece, Herzer needed only one more thing: the opinion of a reputable expert in ancient art. The German dealer decided to send photos and his detailed report to Bernard Ashmole, the curator of Greek and Roman art at the British Museum.

Ashmole was widely revered for his scholarship and professionalism. He had become the keeper of Greek and Roman art in 1939, after British Museum officials discovered that his predecessor had allowed museum staff to scrub priceless monuments, including the Elgin Marbles, with steel wool. His counsel was widely sought by other curators and prominent collectors. When he received the package from Herzer, Ashmole immediately recognized the bronze as a masterpiece. What's more, he suspected that Herzer's attribution to Lysippus might be correct.

In the spring of 1972, not long after receiving the photos, Ashmole got into his car and drove an hour outside London to a vast Tudor manor called Sutton Place. It belonged to one of the world's richest men and likely the only collector with ancient art who would have the money to acquire this superb piece.

He had come to talk to J. Paul Getty.

WHEN THE BRONZE athlete came his way, Getty was a shrunken, decrepit man. Nearly eighty years old, he hardly filled out the suit and tie he had worn like a uniform since his teens. Getty wasn't an angry man, but he looked like one. His heavily lidded eyes, framed by jowly cheeks, gave him a perpetual scowl. He kept his thoughts hidden behind a stony exterior. Photos invariably captured him in an awkward pose, arms at his side, chin down, expression blank. With a receding hairline, bulbous nose, and stiff demeanor, he bore a passing resemblance to Richard Nixon, a person for whom—along with Adolf Hit-

ler, Charlie Chaplin, Ringo Starr, and Queen Elizabeth II—Getty expressed admiration.

Yet Getty's mind was still sharp enough to run a far-flung empire from an overstuffed chair in his study, surrounded by stacks of reports from Getty Oil and the two hundred other companies he controlled. Money had always been his chief passion, but women were a close second. Having divorced his fifth wife long before, Getty still kept a rotating harem of young women to satisfy his unquenchable libido. For years, he callously led them on with promises that he would "take care" of them in his will. Each evening during dinner, they jockeyed to sit at his right at the long, formal dining table, vying to be the one invited upstairs to the billionaire's bed.

Getty micromanaged his empire down to two decimal places and kept daily tallies of his expenses—35 cents for candy, $1.05 for a sandwich. Visitors at Sutton Place were asked to use a pay phone for outgoing calls. His reputation as a skinflint had been sealed years earlier by his refusal to pay the ransom to free his grandson, who had been kidnapped by the Calabrian Mafia. Getty ignored their demands until the kidnappers sent a package containing one of his grandson's ears, complete with a distinguishing freckle, to a newspaper in Rome.

If Getty was tight with his money, he was tighter with his praise. Of the five sons he fathered by four women, one died young (Getty missed the funeral because he was away on business) and the others were estranged, driven out of the family oil business and their father's life by Getty's incorrigible stinginess. Only his son George had shown promise in the family business and went on to become president of a Getty Oil subsidiary. After years of paternal indifference and disapproval, however, he committed suicide in 1973 by stabbing himself in the stomach, then swallowing an overdose of pills when he was hospitalized.

Now alone, surrounded by servants and sycophants, Getty found his life incomplete. He had no heir to take over, and it was clear that Getty Oil was unlikely to live much beyond him. Only his art offered him the promise of life after death. "The beauty one can find in art is

one of the pitifully few real and lasting products of human endeavor," he once said.

Getty had begun collecting art in the wake of the Great Depression, when loss weakened the strong hands holding many of the world's finest collections. His approach to art was not so different from his approach to business. Getty was a bargain hunter, more interested in discovering the undervalued or overlooked than paying full price for an established masterpiece. He was hungry for that piece of art that, like a neglected plot of land purchased for pennies an acre, would gush fountains of wealth once its true value was recognized. On his annual travels across Europe in the late 1930s, Getty found that the threat of war and the persecution of Jews had opened up even noted collections, such as that of the Rothschild banking family. He went on a buying spree, picking up several bargains, including Rembrandt's *Portrait of Marten Looten*, which Getty picked up at an auction for $65,000 — less, he noted in his journal, than its owner had paid for it a decade before.

His early tastes were eclectic and inconsistent, fostered by his travels as a young man across Asia, Europe, and the Middle East. He bought whatever caught his fancy, giving no particular thought to forming a coherent collection or even to consistent quality. Over time, he came to focus on eighteenth-century French furniture and tapestries; Persian and Savonnerie carpets; Renaissance paintings; and Greek and Roman antiquities.

As his collecting increasingly conflicted with his parsimony, Getty regarded his art habit as a curse, even an addiction. He tried several times to quit, but after *Fortune* magazine dubbed him the world's richest man in 1957, the offers streamed in, and he couldn't help himself. "The habitual narcotics user is said to have a monkey on his back," he wrote in his autobiography. "I sometimes feel as if I had several dozen gorillas riding on mine."

Art satisfied Getty's considerable intellectual appetite. He was fascinated by the science of art, by the mechanics of making it, and by the history it represented. Art was also a vehicle for Getty's intense

fantasy life. It was a side he rarely revealed to those around him but that came out occasionally in his writings. "To me my works of art are all vividly alive. They're the embodiment of whoever created them —a mirror of their creator's hopes, dreams and frustrations," he wrote in *Collector's Choice*. "They have led eventful lives—pampered by the aristocracy and pillaged by revolution, courted with ardour and cold-bloodedly abandoned. They have been honored by drawing rooms and humbled by attics. So many worlds in their lifespan, yet all were transitory. What stories they could tell, what sights they must have seen! Their worlds have long since disintegrated, yet they live on."

Ancient Greek and Roman art, in particular, appealed to Getty because of its ability to transport him back in time. He was a student of ancient history and conversant in Greek and Latin. He often visited archaeological sites on his travels and could name the Roman emperors in order. In a novella set in ancient Rome, Getty unabashedly compared his oil company to the Roman Empire and himself to Caesar. He quietly believed himself to be the reincarnation of the second-century A.D. Roman emperor Hadrian—a patron of the arts, a traveler, and a prolific builder. One of Getty's proudest acquisitions was the Lansdowne Herakles, a statue of the mythic Greek hero that had been salvaged in 1790 from the ruins of Hadrian's villa and remained in the family of the Marquis of Lansdowne in England for decades.

Ashmole knew that Getty could be tempted to pay for a truly exceptional piece such as the bronze. Arriving at Sutton Place, he handed his coat to the butler, Bullimore, and showed himself upstairs to Getty's study. There the Oxford scholar handed Getty photos of the remarkable statue that had been fished from the sea.

As Getty stared at the images, his hands shook with early signs of Parkinson's disease. It is a true masterpiece, Ashmole said, and would most certainly be the centerpiece of Getty's art collection. It would likely be the most important piece of ancient art in the United States.

Getty needed little prodding. To him, the statue held the promise of legacy.

JUST AS GETTY was learning about the bronze athlete, word of the statue reached a potential rival: the Metropolitan Museum of Art in New York. Dietrich von Bothmer, the Met's venerable antiquities curator, heard about the lucky catch from his sources in the European antiquities market and passed the news on to the museum's director, Thomas Hoving.

A tall, handsome man with laser-beam eyes and a commanding voice, Hoving was part scholar, part showman. His background was in Renaissance paintings, but his forte was the grand gesture. Months before hearing about the bronze, however, Hoving's craving for publicity had backfired badly.

In a media blitz, Hoving and von Bothmer had revealed the acquisition of a fourth-century B.C. Greek vase adorned by Euphronios, the master Greek painter. The vase was a large krater, a wide-mouthed vessel in which wine was mixed with water before being served at ancient symposia. The remarkable painting on this krater elevated it to high art: a scene from the *Iliad* depicting the death of Sarpedon, Zeus's son. It was an arresting example of Euphronios's intricate brushwork, down to the individual feathers on the wings of the figures depicting Death and Sleep, who were carrying Sarpedon into the underworld. Only a handful of complete works by Euphronios survived, and none as majestic as the krater. The purchase of such an exquisite antiquity was a coup in itself. The price was $1 million, some eight times the previous record for an antiquity.

More problematic than the price, however, was the krater's provenance, or ownership history. The Met was vague about the vessel's origins, saying only that the museum had purchased it from a Lebanese dealer who had kept it, in shards, in a shoebox since World War II. Soon after the krater was revealed, however, the *New York Times* began running front-page stories suggesting that Italian grave robbers had recently looted the krater from Cerveteri, an area near Rome honeycombed with ancient Etruscan tombs. The revelations continued for months, despite blanket denials by the museum.

The fight over what became known as the Met's "hot pot" publicly aired a practice that museums had quietly followed for decades. Coming soon after the 1970 UNESCO Convention on the protection of cultural property, which Hoving had helped negotiate, the controversy outraged the public and pitted archaeologists against their museum colleagues over the morality of collecting looted antiquities. Archaeologists now openly called on museums and universities to honor the UNESCO treaty and stop buying artifacts that appeared on the market without a traceable pedigree.

Hoving was still dodging questions about the vase when he decided to take a detour from a ski vacation in the Swiss Alps to visit Heinz Herzer's Munich workshop to see the bronze athlete. He ran his hands over the statue's mottled skin, now cleaned of its encrustations. He touched its face, the back of its legs, the underside of its arms. He looked at the modeling of the sculpture's fingernails, the details of the navel, the proportion of the penis. Hoving had studied archaeology, and he knew that Roman sculptors imitating Greek art had often left hidden areas unfinished. By contrast, true Greek sculpture was precise in its most minute details. After more than an hour of examining the piece, Hoving was convinced it was a great Greek work of art.

But how to buy it? The Met might be famous, but it was hardly rich. Hoving had hawked the museum's collection of ancient coins to come up with the money for the krater. And there was no way he could outbid Getty, who wanted the sculpture as a centerpiece for the small museum in his home in Malibu. Hoving decided to propose a joint venture: if Getty would provide most of the money for the statue, the Met would reimburse him with loans from its considerable collection, and the two would share ownership of the bronze. Hoving flew to England to pitch the idea to Getty in person.

After lengthy negotiations, Getty agreed to pay $3.9 million for the bronze—not one cent more. In return, he would receive several long-term loans from the Met, including a set of seventeen Pompeian

frescoes that entranced him as Hoving projected slides of them onto a wall in Getty's study. They had been rescued from the ashes of a villa at Boscotrecase that was destroyed by the eruption of Mount Vesuvius in A.D. 79. The villa had been owned by the grandson of the emperor Augustus.

But before buying the bronze, Getty insisted on a series of assurances about the statue's legal status: clarification of how the bronze had left Italy, legal research certifying that Herzer's consortium had clear title, and a written guarantee from the Italian Ministry of Culture and the Carabinieri that there would be no further claims. He also required Artemis to give him a five-year, money-back guarantee in case the Italians or another foreign government filed a patrimony claim.

They were exceptional precautions, underscoring Getty's unease. Even the Met's von Bothmer expressed some reservations about the statue's "mysterious export." As it turned out, both men's concerns were well-founded.

During negotiations, German and Italian police arrived unexpectedly at Herzer's Munich studio with questions about the bronze. What did Herzer know about the statue's disappearance from Italian soil and its supposed side trip to South America? How had he learned about the statue? When Herzer refused to cooperate, an Italian state prosecutor filed a request to have Herzer extradited to Italy to stand trial for trafficking in looted art. The dealer escaped arrest only because German authorities refused to honor the request.

The deal to buy the bronze came undone. The statue eluded Getty's grasp just as he was building another kind of legacy—one out of concrete and controversy.

TWO DECADES EARLIER, the J. Paul Getty Museum had been born as a tax shelter. When Getty left Los Angeles for Europe in 1951, he left behind a sprawling ranch house in a quiet canyon off the Pacific Coast Highway. The house was filled to the rafters with Getty's growing art collection. There was so much art, in fact, that Getty began giving it away. But after donating two of his most prized possessions

—the sixteenth-century Ardabil carpet and Rembrandt's 1632 *Portrait of Marten Looten*—to the Los Angeles County Museum of Art, Getty grew unhappy with the anemic tax write-offs he received for the gifts.

Getty's longtime accountant and personal aide, Norris Bramlett, suggested a more lucrative way to dispose of the art. Rather than donate it to various institutions, Getty should create his own nonprofit museum and run it out of his Malibu home. That way, the oilman could take even bigger deductions by contributing stock, paying for operational expenses, and purchasing art—all while holding on to the collection. Getty eagerly agreed and signed an indenture on December 2, 1953, creating the J. Paul Getty Museum, a gallery and art library whose mission was "the diffusion of artistic and general knowledge." All future antiquities acquisitions were made on behalf of the museum.

The small museum opened a few months later with no great fanfare. Los Angeles was still a cultural backwater, and at the modest opening ceremony, the city's mayor said that he hoped the new museum would correct the city's "severe cultural deficiencies." Getty did not bother to attend the opening, but in a telegram from Kuwait he said, "I hope this museum, modest and unpretentious as it is, will nevertheless give pleasure to the many people in and around Los Angeles who are interested in the periods of art represented here."

For years, the Getty Museum did the bare minimum to preserve its tax-exempt status. Museum hours were Wednesday and Friday from 3 to 5 P.M., with appointments available on Saturday upon special request. No admission was charged, but visitors had to book reservations in advance for the twenty-four-car parking lot. The museum's five small galleries were so jammed with art that many of Getty's finest ancient statues were kept outside in the courtyard, exposed to the elements.

By the late 1960s, even the house's expanded galleries were so full that a major remodeling was necessary. Getty asked Stephen Garrett, a young British architect who was helping him remodel his sumptuous winter residence on Italy's Tyrrhenian Sea, to fly to Los Angeles

and assess the situation. Garrett was skeptical about his task, but as he turned off the Pacific Coast Highway and wound up a long driveway lined with eucalyptus trees, he became enchanted by what he saw. Before him was a lush canyon with a large Spanish ranch house, surrounded by orchards of lemon, avocado, and orange trees.

Garrett's guide for the day was Burton Fredericksen, a toothy, fresh-faced graduate student who introduced himself as Getty's curator. Fredericksen had started working at the Getty Museum in 1951 as a part-time security guard while studying for a Ph.D. in art history at UCLA. The quiet afternoons had given him an opportunity to read in the museum's library. He never completed his Ph.D. but stayed on at the museum as curator. Despite his youth, Fredericksen knew something about displaying art, and he told Garrett that if Getty was serious, he would have to construct a new building. Garrett agreed, secretly hoping that Getty would give him the commission.

Back in London, Garrett suggested to Getty that a new structure would have to be built on the property, one large enough to accommodate the entire art collection, which had grown by more than a thousand objects since the 1950s. Getty agreed, and by 1970 he had settled on a controversial design for the new museum: a top-to-bottom re-creation of the Villa dei Papiri, an opulent Roman estate outside Naples that had belonged to Julius Caesar's father-in-law. The villa had been buried by Mount Vesuvius's massive eruption in A.D. 79 and been rediscovered only in the eighteenth century by the excavation crews of Spain's King Charles III. The only record of the villa's design was to be found in the careful sketches of the Swiss engineer who oversaw the excavation for Charles.

"It will be a re-creation of what life was like in Roman times, down to its last detail," Getty told his architect. "What better setting to display the antiquities?"

Getty hired Garrett to supervise the construction of what would come to be called the Getty Villa, but the billionaire micromanaged every detail from his study at Sutton Place. Every three months, Garrett flew to London carrying blueprints, color schemes, marble sam-

ples, and photos. He once had a home movie made featuring construction crews endlessly pouring concrete into wooden forms. Getty made his guests watch it and then, with deep fascination, asked to see it again. But the billionaire dedicated most of his attention to the budget, which had to account for every penny spent on the structure. It was not uncommon for Getty to question even the smallest expense. He limited the number of security guards to twenty-five and considered planting electronic bugs in as many as sixty artworks to help monitor the patrons. He resisted plans to install air conditioning, reasoning that works of art had survived for centuries without it. Couldn't the museum staff clean the pool? And was it really necessary for them to have a $23 electric pencil sharpener when a manual one cost just $7?

In January 1974, just as the negotiations for the bronze athlete were falling apart, the new Getty Museum opened to the public. Getty's choice of design was widely mocked. Newspapers from London to New York lampooned it as an intellectual Disneyland, a garish Roman parody worthy of a D. W. Griffith film—hallucinatory, horrid, weird. Most critical was the hometown *Los Angeles Times*, whose art critic pilloried the new Getty Museum as "Pompeii-on-the-Pacific," a monument to "aggressive bad taste, cultural pretension and self-aggrandizement" that cemented the city's reputation "as Kitsch city and the Plastic Paradise."

The public, however, embraced the Getty Villa. A few Sundays after the opening, the queue of cars waiting to get in was so long that it clogged the Pacific Coast Highway for two miles. By March, the new museum recorded its 100,000th visitor, a hundred times the annual attendance of the old galleries.

That the crowds came to see the building more than the art was no secret. Getty's penny-pinching over the years had left him with a collection of largely mediocre art—and deeply resentful staff members. They were chagrined that despite the opulent new building, Getty was still unwilling to dip into his wealth to acquire any artwork of lasting significance. He had idly sat by while his crosstown rival, in-

dustrialist Norton Simon, had scooped up several masterpieces. And it was only at the last minute that Getty's staff, desperate to fill out the new museum's first-floor antiquities galleries, had convinced the billionaire to go ahead with the bulk purchase of four hundred small antiquities—at a 30 percent discount—from a New York antiquities dealer named Jerome "Jerry" Eisenberg. Now, even with the museum open, the staff had to beg and plead to purchase art books for the museum's library.

Hope arrived in early 1976, when an announcement was made at a staff meeting that Getty's health was failing. Over the next few months, there was no word from Sutton Place. Expense requests and the telephone there went unanswered. Getty had been diagnosed with prostate cancer and retreated from the world. The only people allowed to see him were his nurses and a steady stream of alternative medicine gurus and quacks—Chinese acupuncturists, a masseuse, an American Indian with "healing hands" flown in from Florida.

By July, Getty was dead. Three days later, Burton Fredericksen, now the museum's chief curator, drove to the downtown Los Angeles County courthouse for the opening of Getty's will. He hated Getty's parsimony more than most at the museum, having witnessed countless lost opportunities over the past twenty-five years. It would not surprise any of the staff if that stinginess were somehow embodied in Getty's last will and testament. But Fredericksen had a hunch it wouldn't be. Getty supported no charities to speak of and was estranged from his surviving sons, who were already provided for through a family trust. Where else would Getty's personal wealth go?

Fredericksen was led to a nondescript, wood-paneled courtroom, where he felt his excitement grow as he read through the will. Getty had left insultingly small sums to his children, a former wife, and members of the Sutton Place harem. Many of the other people in his life were ignored altogether. But the payoff came in the ninth codicil: "I give, devise and bequeath all of the rest, residue and remainder of my estate . . . to the Trustees of the J. Paul Getty Museum, to be added to the Endowment Fund of said Museum."

In all, Getty had left the museum nearly $700 million in Getty Oil stock. With that flick of a pen, Getty had transformed his neglected provincial museum into the richest art institution in the world.

Racing back to the office, Fredericksen led thirty museum employees in a champagne toast to the old man. Viewed through the lens of the museum's sudden newfound wealth, its art collection looked all the more second rate. People took turns making speeches, hailing the Getty Museum's bright future and the untold acquisitions that would now be possible—so many, no doubt, that soon another new building would be needed to house them.

In a meeting a short time later, Fredericksen and his curatorial staff resolved to make the bronze athlete their first major purchase of the new era. Gone were any concerns about the bronze's price or legal status. The museum's board voted unanimously to acquire the statue for $3.95 million, the very price Getty had recently refused to pay. And no permission was sought from Italian authorities, as Getty had once demanded.

Although Getty family members were challenging the will, the court agreed to advance enough of the estate to the museum to make the purchase. The bronze was shipped from London to Boston and then quietly parked in an exhibit hall in the Denver Art Museum for seven months to avoid paying California taxes. When the statue arrived in Malibu in mid-November 1977, the Getty formally announced its acquisition, enshrining it in its own humidity-controlled room at the new museum. As a final tribute to the founder, the board of trustees dubbed it "the Getty Bronze."

2

A PERFECT SCHEME

A MONG THOSE WHO gathered to toast the death of J. Paul Getty
was Jiri Frel, the museum's roguish antiquities curator.

Frel had been hired by Getty four years earlier while he was work-
ing at the Metropolitan Museum of Art as an assistant curator under
Dietrich von Bothmer. He was a refugee from Communist Czecho-
slovakia, which he fled in 1969 after a twenty-year career as a noted
classics professor and expert in Greek art at Charles University in
Prague. He came to the United States under a fellowship from Prince-
ton University's Institute for Advanced Studies and brought with him
a refugee's state of mind: keen survival instincts and a healthy disre-
gard for the rules.

Frel cultivated a closer relationship with Getty than most of his
colleagues at the Malibu museum. The two met as Getty was pursu-
ing the bronze athlete, an object that inspired awe in both men. Frel's
guile served him well in convincing his stingy benefactor to purchase
expensive antiquities. Mindful of Getty's fear of death, Frel presented
an ancient tombstone to Getty as an "archaic relief." He once manip-
ulated the old man into purchasing a stone Roman chair by having
it delivered to Sutton Place and set before Getty, whom he gently

pushed into the seat. The fit was so preternaturally comfortable that Getty approved the purchase on the spot.

Not long after their first meeting, Getty offered Frel a job. Frel broke his three-year contract with the Met to become the Getty Museum's first antiquities curator. Garrett and Fredericksen, Frel's nominal bosses, gave the imperious Czech a wide berth. They knew of his tendencies. Frel had casually mentioned to Fredericksen that the Met had paid off a Lebanese dealer to help concoct a cover story about the provenance of the Met's famous Greek vase, the Euphronios krater. When Fredericksen expressed shock, Frel shook his head and said condescendingly, "You Americans are so naive."

With wild gray hair, oversize black glasses, and a pathological confidence in his own opinion, the fiftysomething Czech paraded around the museum grounds like an emperor. When not bullying people with his intellect, he was delighting them with his old-world charm. He wore rumpled suits with flapped pockets and open-toed sandals over socks. He hugged colleagues and playfully bumped heads with strangers. A polymath, Frel played the violin, was an accomplished mathematician, and was fluent in six modern languages and Latin. Around him, no conversation was dead for long. Frel was always ready with a Shakespearean quote or the saucy story about why the Lansdowne Herakles, one of the antiquity collection's centerpieces, was missing its penis: Getty had been too cheap to buy the member, which Lady Lansdowne had chiseled off and discreetly hidden away.

While living under Communist rule, Frel had learned to be a charming manipulator, all things to all people. When speaking with Jews, he was quick to pull out the Star of David he carried with him, "in solidarity" with those persecuted in World War II, he would say. Frel spewed vitriol about Eastern Europe totalitarianism but once revealed in an interview with the FBI that he had tried unsuccessfully to join the Communist Party when he was at Charles University. In the same interview, he waxed eloquent about America as a "great and good country." In reality, he detested everything American, from the mustard to the bread to the dummkopf-producing public schools.

Frel was perhaps best known as an uncompromising womanizer. At the Met, female employees devised a telephone code to warn one another when he left his office for the stacks, where he was known to accost young research assistants. Many happily complied, succumbing to his craggy looks, his kiss of the hand, his deep gaze into their eyes as he explained how the likenesses of Jesus and the Apostles in early Christian art were copied from Roman portraits. Left in his wake in Prague, Princeton, and New York was a trail of ex-wives, heartbroken girlfriends, and abandoned children.

But for all his flaws, Frel recognized Getty's death for what it was. As his colleagues hoisted their champagne glasses in gleeful unison, Frel was uncharacteristically quiet. He eventually pulled Fredericksen aside and whispered darkly in his thick accent, "This sudden wealth is going to cause us a great deal of grief."

GETTY'S GIFT CAME with one big string attached: it was to be controlled by a board of six museum trustees, many of whom possessed no knowledge of art.

Prior to Getty's death, the board existed mostly to fulfill the legal requirements for nonprofits in the U.S. tax code. The trustees met quarterly to rubberstamp the old man's decisions. Getty had stacked the board with his accountant, a Getty Oil executive (Harold Berg), the firm's outside attorney, his sons Ronald and Gordon, and his Italian art adviser, Federico Zeri, an outspoken Renaissance art historian who guided many of Getty's acquisitions, often in exchange for a kickback from dealers, some believed. The chairman was Berg, a paunchy Getty Oil vice president who had befriended Getty when both worked as young roughnecks in the East Texas oil fields. Berg's aesthetic sensibilities ran from unfiltered cigarettes to gigantic martinis, and while running museum board meetings, he sometimes nodded off. A blunt Kansan, he once rejected as "bullshit" a plan to excavate the rest of the Villa dei Papiri, where unknown treasures remained untouched under Vesuvial ash. Berg had a better idea: why didn't the Getty pool

its money with other institutions and just buy out the National Archaeological Museum in Naples?

With the founder's death, this was the motley crew that would now control the Getty fortune.

Frel regarded the board with loathing. They were "fucking American morons" who valued their ancient art like pinkie rings—the bigger and shinier, the better. With the exception of Zeri, they didn't understand art or what it took to build a world-class antiquities collection. The Louvre, the National Museums in Berlin, the Metropolitan Museum of Art—these institutions hadn't become great just by buying marquee items. They also gobbled up pottery shards, architectural fragments, second-rate statues, and crumbling votive urns. These pieces might not be worthy of exhibition, but they formed the spine of a deeper "study collection" that attracted scholars from around the world.

Frel was determined to build such a collection at the Getty, hoping to convert the boutique museum into a hub of modern scholarship. The board saw no point to the endeavor. So, even before Getty's death, the antiquities curator set in motion a scheme to work around them: if board members wouldn't buy the objects, Frel would acquire them as donations.

Frel began canvassing everyone he knew for gifts. On a trip through New York, he visited the Manhattan flat of Malcolm Wiener, an investment fund manager and Met board member. Frel found Wiener, an antiquities buff, near tears. Someone had just knocked over a Mycenaean pot, shattering it. Frel got down on all fours to tenderly gather the pieces into a dirty shirt pulled from his travel bag. "I'm going to take every little piece of clay and have the Getty staff glue this back together," he said. A few weeks later, Wiener received a letter thanking him for his "donation." Frel had accessioned the restored piece in Wiener's name.

Frel also put the arm on antiquities dealers who wanted to keep good relations with the newly rich Getty. One donated a bust of the

Greek historian Thucydides. Another contributed a head of Livia, the wife of the Roman emperor Augustus. A third handed over $9,000 worth of ancient silver and gold crowns.

Still, the pace of donations was too slow. Frel was determined to find another way.

THAT WAY APPEARED thanks to a twenty-five-year-old coin dealer named Bruce McNall. A natural-born salesman with cherubic looks, McNall had converted a boyhood fascination with ancient coins into a thriving numismatic business. During the early 1970s, with the Dow bottoming out at 600 and America reeling from sticker shock at the gas pumps, McNall peddled coins as lucrative investments. He threaded his way through the trimmed hedges and tennis courts of Bel Air, California, toting a boxy briefcase of samples. Placing his wares on the table, he regaled prospective buyers with colorful anecdotes about the Roman emperors depicted on the coins. Then he moved in for the kill, explaining that Greek decadrachms had appreciated 350 percent just between 1970 and 1974. His client list quickly grew to include the likes of record mogul David Geffen, *Charlie's Angels* producer Leonard Goldberg, and Motown chief Berry Gordy.

By the time Getty died, McNall had branched out to antiquities. He was co-owner of Summa Gallery, a richly appointed storefront showroom on Rodeo Drive and the only major antiquities dealership on the West Coast. His plan was to upgrade coin customers to ancient art, then start selling directly to museums, taking a slice of business from the Manhattan dealers who had long dominated the market. Summa showed off its artifacts like stars at a Hollywood premiere. They sparkled under spotlights and lined glass cases in rooms with padded velvet walls of ocher and orange, colors intended to evoke a Grecian krater. A portrait sculpture of Caligula stared out from its pedestal. A golden funerary wreath that had once rested on the head of a dead nobleman shimmered under its own Plexiglas dome.

McNall's supplier and silent partner was Robert Hecht, the pre-

eminent middleman of the classical antiquities trade, whose swash-buckling career was legendary in the field. An heir to the Baltimore-based Hecht's department stores, Hecht had served in the naval reserve during World War II before receiving a scholarship to study classics and archaeology at the American Academy in Rome. But his passion for ancient objects couldn't be satisfied by the plodding pace of academia, and poverty held no appeal. By the time his two-year term there ended in 1949 (amid rumors that he had been expelled for punching out a classmate), he was already buying and selling ancient art. His network of loyal suppliers reached deep into the tombs and ruins of Greece, Turkey, and Italy.

Since the 1950s, Hecht had sold some of the finest pieces of classical art to emerge on the market. His clients included dozens of American and European museums, universities, and private collectors, including J. Paul Getty, whom Hecht had once persuaded to buy an intricately carved Roman bust. For decades, Hecht single-handedly dominated the antiquities market with his brilliance, brutality, and panache. He cited Virgil as readily as the lyrics of Gilbert and Sullivan, and he was known to break into operatic arias. He often drank to excess and was known to gamble his money away in all-night backgammon games. He tamed competitors with an unpredictable temper and eliminated rivals with anonymous calls to the police. Even those who sold directly to museums gave Hecht a cut of the deal, earning him the nickname "Mr. Percentage."

But the 1972 Euphronios krater imbroglio with the Met had unmasked Hecht as the source of the museum's "hot pot." In the wake of the scandal, Italian authorities declared Hecht persona non grata and exiled him from his home in Rome. The episode forced Hecht to be more discreet, but he continued to provide a steady stream of freshly excavated objects through middlemen. McNall, whom Hecht had met at a Munich coin auction a few years earlier, presented the perfect frontman for expanding Hecht's access to the American market. Their deal at Summa was strictly fifty-fifty: McNall provided the Rolodex and handshakes; Hecht provided the merchandise.

The arrangement worked beautifully with the important, museum-quality objects Hecht was able to obtain. The problem was what to do with the thousands of lesser objects Hecht felt obliged to buy to maintain his suppliers' loyalty. McNall considered them "crap" and an impediment to getting Summa off the ground. But they caught the eye of Frel, who often walked into Summa unannounced to rifle through the stockroom. "You know, Bruce," Frel purred during one visit, "we actually need these kind of things."

ONE DAY AROUND the time of Getty's death, McNall went to visit Frel at the museum. The two men started talking: what if McNall marketed the bric-a-brac not as long-term investments for his clients, but as quick tax breaks? If he found customers with seven-figure incomes who were willing to buy the objects on the cheap, they could then donate them to the Getty and get tax write-offs for much higher values. Frel said that he could help close the deal by arranging appraisals through his friend Jerry Eisenberg to back up values reported to the Internal Revenue Service.

The plan was brilliant. McNall could clear his shelves of leftover stock. His clients could actually *make* money on their donations. Hecht could keep his suppliers happy. And Frel could acquire objects through donations, without having to go through the Getty's board of trustees for approval.

It also appealed to the triad of forces that drive Hollywood—greed, ego, and instant gratification. Actors, producers, film executives, and others who profit in the halo surrounding the entertainment industry are forever looking for ways to reduce their tax liabilities. The opportunity to make a buck while appearing to be philanthropic donors to the Getty offered a cultural immortality that rolling credits on a movie screen could not.

The scheme might even be legal. McNall ran it past his tax attorney, who said that donors could legitimately argue that the antiquities they bought at "wholesale" values were worth a lot more by the time

the Getty shined them up in its conservation lab and accepted them into its collection. After all, a reconstructed Greek vase was worth more than a bunch of pottery fragments on a shelf.

For a test case, McNall turned to one of his best coin customers, Sy Weintraub, the former chairman of Panavision. The short, wiry, often profane mogul's claim to fame was as originator of the old Superman television series and the producer of a string of schlocky 1960s Tarzan movies with titles such as *Tarzan Goes to India.* What he lacked in taste he made up for in business sense. Weintraub had bank-rolled McNall's coin business in exchange for a piece of the action. He had backed McNall at Summa, steering his friends to the gallery and even buying a couple of sarcophagi and a mummy to scatter around the red-velvet interior of his Beverly Hills mansion.

Weintraub was intrigued by McNall's donation scheme, but only if he could make back at least five times his investment. By the end of the year, Weintraub was on the Getty books as the proud donor of twenty Etruscan terra-cotta roof ornaments, six thousand coins, and the head from a Greek grave marker. The value of the gifts, second only that year to J. Paul Getty's bequest, earned Weintraub a tax deduction of $1.65 million. He followed up by donating two fourth-century B.C. frescoes cut from a tomb fifty miles south of Naples. He paid Summa $75,000 but told the IRS they were worth $2.5 million. He pocketed $1.2 million in tax savings—a return of more than 1,500 percent.

With that, the donation scheme spread like a southern California brushfire.

Weintraub told his pal Gordon McLendon, who had made millions by reformatting AM radio with Top 40 hits and all-talk stations. McLendon's son once joked that his father couldn't even spell the word "art," much less recognize it. But within months, the radio legend had been transformed into a cultural benefactor, giving the Getty more than 120 pieces of ancient amber jewelry carved to look like tiny ships, girls' faces, and animals. The gift, which cost

McLendon $20,000, went on the Getty's books at $2.1 million. Mc-Nall said later that McLendon had claimed as much as a $20 million tax write-off.

The spark of self-serving generosity jumped through the network of McNall's clients and friends. Donations began showing up on the Getty's books in the names of prominent professionals and some of Hollywood's high rollers. Lowell Milken gave an estimated $300,000 worth of antiquities along with his brother, future junk bond impresario Michael Milken. Alan Salke, the president of McNall's new movie production company, gave the Getty a cup painted by the Greek artist Phintias with a claimed value of $300,000. Comic Lily Tomlin gave the Getty a cache of ancient coins with a book value of $123,000. Dozens of donations were attributed to Jane Cody, a University of Southern California classics professor who happened to be McNall's girlfriend (and later wife). Even two of the city's most powerful entertainment attorneys, Skip Brittenham and Ken Ziffren, appeared in Getty records as donors of $405,000 worth of antiquity donations in 1982.

Frel did his part to find customers as well, even approaching two *Los Angeles Times* reporters to see if they wanted in. One was art critic William Wilson, who had written the scathing review of the Getty Museum when it opened but had since become a devotee of the charismatic curator.

Frel invited Wilson home one afternoon for lunch. As the men balanced paper plates on their laps in the living room, Frel described the idea. "Let's say I can get these dealers to give me things for the museum, but I can't be the one who donates them," Frel said. "But I'm able to give them to someone else who needs a tax break, someone who can make a gift to the Getty under their name and use the write-off . . ."

"Jiri, is this ethical?"

Frel paused. "I can see you don't need a tax break," he said, biting into his sandwich.

Frel brought up the subject again at dinner one night in an Italian

restaurant with Wilson and his pal Tim Rutten, editor of the *Los Angeles Times'* opinion section.

"Well, let's say, you know, we were to come into possession of a fragment, an arm or something. Maybe it comes from Syria, maybe not. So you donate it to the museum . . ."

"I donate it to the museum?" Rutten said. "And where did it come from, Jiri?"

"Your aunt donated it. Your great-aunt. You remember, maybe your aunt left it to you and you donate it and get a nice tax write-off."

"Jiri, I'm going to forget you ever asked me this."

The journalists also agreed not to tell anyone else at the paper.

FOR MCNALL, THE scheme was a sideshow, a way to move the lesser material while selling more significant objects to museums and collectors across the country through Summa. Yet the side business was substantial enough to warrant some accommodations. Hecht began shipping objects directly to the Getty, where Frel picked out the items he wanted for donations and took them "on loan" until McNall could arrange for a donation over the phone. Many donors never even saw the items they gave.

McNall, meanwhile, began to use the Getty like an extension of his gallery. He quietly paid museum conservators to work on objects destined for sale at Summa. Some of the gallery's best merchandise found its way into museum exhibit halls, giving McNall's A-list customers the illusion that they were buying from the Getty itself. With a cheery wave to the guards, McNall took his best clients on personal tours of the mock Roman villa with the long reflecting pool before positioning them in front of the object he wanted to sell. Then, with Frel often hovering in the background for support, he closed the deal. Many hard-bitten businessmen tumbled to the psychological seduction, including Nelson Bunker Hunt and William Herbert Hunt, the Texas oil barons who bought several items off the Getty floor.

As the scheme gained momentum, Frel himself seemed to prosper.

He built a swimming pool in the backyard of his Topanga Canyon home with $25,000 in cash from McNall—a "loan" never committed to paper because both parties knew it wouldn't be repaid. One day the curator came to work in a shiny BMW. It bore the tags of an Orange County car dealership owned by Vasek Polak, another Czech refugee and former racecar mechanic. As it happened, Frel got the car around the time Polak showed up on the Getty's books as donating $761,000 in antiquities.

Within four years, the trickle of gifts had turned into a deluge —and one of the largest museum tax frauds in American history. More than a hundred donors had given six thousand antiquities valued at $14.7 million to a museum that had absolutely no need for the help. While older, more respectable cultural institutions cultivated patrons for years before making an "ask," Frel was raking in antiquities from nobodies in embarrassingly huge numbers. Each gift was publicly reported to the IRS on the museum's annual 990 form.

Museum director Stephen Garrett seemed amused, even proud of how Frel wrung donations from the most unlikely of sources. In a 1976 letter to Bernard Ashmole, Garrett bragged about "the panache and intrigue for which Jiri is famous (and dear to us all)."

Others viewed the donations, and Frel's increasingly reckless behavior, with distress. In New York, Eisenberg became alarmed at the increasing prices Frel was demanding for appraisals of the antiquities. He stopped signing the appraisal forms.

Fredericksen began hearing about Frel going in and out of the museum with artifacts stuffed in his pockets. He also noted that a number of the donations came through Frel's new wife, Faya Causey Frel, a UCLA graduate student, and her family in Orange County. And he found the sheer number of gifts suspicious. After all, how many people could there be who wanted to buy antiquities and then give them to the richest museum in the world?

Although Fredericksen was Frel's immediate boss, he knew that he couldn't rein Frel in. He approached Garrett for help.

"Jiri's doing things that could get us in trouble," Fredericksen said.

"I don't know," Garrett said, after Fredericksen listed his reasons. "I don't quite see what the problem is."

Fredericksen then went to Federico Zeri, the Italian art expert and Getty board member. After the curator confided his fears, Zeri said that he wasn't concerned enough to take on the resourceful Frel. "I don't want to make any enemies on the board," he said.

With no support up the line, Fredericksen saw only one option. He asked for a demotion, stepping down as head curator to run the paintings department. The move meant taking a pay cut of $1,000, not an inconsiderable amount, given his annual salary of just $20,000. But Fredericksen was willing to do it. He was no longer Frel's boss, and he wouldn't be in the line of fire if Frel ever got caught.

3

TOO MORAL

Ｂｙ 1981, ＴＨＥ ＧＥＴＴＹ was facing an intriguing dilemma: the rich museum was to become even richer.

What started as a nearly $700 million endowment from Getty had swollen to well over $1 billion as Getty Oil stock climbed during the lengthy dispute among the oilman's heirs. With the dispute now settled, the money would become available in a year. As a nonprofit operating foundation, the Getty would be required to start spending more than $50 million a year.

The Getty board had little idea of what to do with the impending windfall. Most of the great masterpieces had already been snapped up since World War II, and spending millions on lesser pieces could dangerously inflate the art market, casting the Getty in the role of international spoiler. Otto Wittmann, former director of the Toledo Museum of Art, who had joined the museum board in 1979, suggested a bolder plan: establishing an umbrella institution—a trust—that would not only fund the museum but also funnel the institution's riches into a series of other arts-related institutes.

To carry out this vision, the Getty board needed a new kind of chief executive, someone with a knack for managing huge sums of

money, someone with far broader authority and vision than a simple museum director. The board heartily agreed with Wittmann's idea and started a search that ended, suddenly, with a man who seemed to fit the description perfectly.

Harold M. Williams had just stepped down as chairman of the Securities and Exchange Commission (SEC), a ride atop the corporate world that ended with President Jimmy Carter's defeat in 1980. In February 1981, shortly after Ronald Reagan was sworn in as president, Williams resigned. That night, at 10 P.M., he came home to find a message on his answering machine. It was from Harold Berg, wondering if he'd be interested in running the Getty.

It was exactly the kind of challenge Williams was looking for—an institution-building job—and it meant coming home to Los Angeles, where he had once worked as the trusted adviser to industrialist Norton Simon, running a division of Hunt-Wesson Foods before becoming dean of the UCLA Graduate School of Management. The Getty offer also appealed to his interest in art. While serving in the U.S. Army during the Korean War, Williams began to buy Asian paintings. He learned more about art at the side of Simon, one of the world's foremost collectors of painters such as van Gogh, Monet, Degas, Renoir, and Cézanne. On their business trips together through Simon's far-flung food and publications empire, Simon included Williams in private excursions to hunt for art.

Williams accepted the Getty job, convinced that he had an extraordinary opportunity to build something lasting. He moved into a small suite of offices at One Wilshire Boulevard, Getty Oil's corporate headquarters, taking over the desk that had belonged to Norris Bramlett, J. Paul Getty's most trusted aide. After his first week on the job, Williams announced that he would take a year to travel the world, talk to the leading cultural thinkers, and come up with a concrete plan. To help him map the Getty's future, he hired two talented young women. One was Leilani Duke, who chaired the California Confederation of the Arts and worked at the National Endowment for the

Arts. The other was Nancy Englander, an assistant director in the NEA's museums and historical organizations program. Englander was smart and attractive, and she spoke several European languages.

"I don't care what you think," he told Duke and Englander. "I don't care what I think. I want to know what the field thinks."

Duke and Englander identified the leading thinkers in the arts across the United States and Europe — museum directors, conservators, librarians, academics, curators, historians. Williams and Englander picked their brains for ideas about how the Getty could make a difference and kept asking questions until they didn't hear anything new. At times, people were suspicious. The Getty was largely unknown, and many saw its sudden wealth as a threat. At other times, people viewed it as an opportunity — to get money. More than anything else, Williams was struck by how many in the art world lacked a big vision, but then again, most didn't have the kind of money that allowed the Getty to dream such big dreams.

At the end of the year, Williams laid out a plan that built on Wittmann's original suggestion. The new Getty Trust would not just collect art like a conventional museum; it would sponsor a conservation institute that would take in damaged objects and send experts throughout the world to save cultural monuments that were deteriorating from the elements or tourism. The trust would launch an educational institute to strengthen the arts in public schools. It would create an information institute to build a common database for art historians. And to unite these various programs, to give the Getty some cohesion, the trust would build a new public campus, the Getty Center. Once it opened, the original Malibu museum would be transformed into a new home for the museum's growing antiquities collection.

The board unanimously approved Williams's plan. With his vision in place, Williams turned his attention to remaking the administration. As Getty's cronies left the board, the former SEC chairman recruited businessmen with art experience. He also began to clean house at the museum. The first to go was Stephen Garrett, the architect turned museum director. Although Williams's plans extended beyond

the museum, he realized that the museum was still at the core of the institution. And the museum needed a real museum director if it was going to be taken seriously.

THE ARRIVAL OF Williams and the departure of Garrett sent a clear message to Frel. The changes at the Getty presented a threat to the comfortable situation the antiquities curator had carved out for himself, where virtually no one had the courage to tell him what to do. He decided he needed a buffer between himself and the new leadership, so he hired a new deputy who seemed perfect for the job.

Arthur Houghton III was everything Frel was not—an injection of superego into Frel's id-driven world. Whereas Frel was erratic and outrageous and loathed bureaucracy, Houghton was diplomatic, a devotee of process and protocol. Frel was a refugee from Europe who spoke with a heavy Slavic accent. Houghton was a scion of East Coast blue bloods who spoke with a yacht club accent.

Houghton was the great-great-grandson of the man who started a small industrial glass company in Corning, New York. His father, Arthur Houghton Jr., inherited Corning Glass but left his job as its president to combine his passions for glass and art in a subsidiary of Corning, Steuben. Arthur Jr. chaired the boards of more than a dozen New York cultural institutions, including the Metropolitan Museum of Art, where he served for twenty years, and the New York Philharmonic, where he helped create Lincoln Center. Harvard University's Houghton Library was named in his honor, a thank-you for the donation of his rare-book collection. In short, the Houghtons were no strangers to wealth, power, or the arts.

While young Arthur's cousins went to work in the family glass business, he inherited his father's interest in the arts. He began collecting Greek and Aramaic coins at age fourteen and continued to do so through his college years at Harvard and during a career in the State Department. As he bounced from post to post in the Middle East, Houghton found the antique dealers in each city and grew fascinated by the spectrum of cultures that had passed through the region.

Digging through a basket in Damascus, he could find Seleucid, Alexandrian, and Ptolemaic coins in a single handful. It was in the medinas and antique stalls of the Middle East that Houghton became friends with Robert Hecht. The two had dinner every three or four months, whenever Hecht came through town on a buying trip. Houghton soon became a client.

He never thought of the arts as a vocation, but at thirty-nine he tired of the diplomatic life and returned to Harvard to pursue an academic career. It was in 1981, while he was still pursuing a doctorate, that he dropped by the Getty Museum and first met Frel. The men discovered that they had many friends in common, including Hecht. Frel was impressed by Houghton's familiarity with the market and his ability to pass easily from the wood-paneled halls of academia to the back alleys of Beirut's bazaars. Frel was looking to build his staff. He had already hired one of Houghton's Harvard classmates, a serious-minded Ph.D. candidate named Marion True, to whom Frel had assigned the curatorial grunt work of cataloguing the antiquities collection.

Most of the job candidates who came through were graduate students who'd spent their lives in the library and had little clue about the real world. Houghton was older and, more important, knew who he was. Frel offered him a job the next time they met, emphasizing the Getty's immense wealth and need to build the collection. Between the two options facing Houghton—a life in academia talking about objects or a life as a curator buying them for the world's richest museum—the choice was easy. He started as the assistant antiquities curator in September 1982. It would not take long for his differences with Frel to surface.

ABOUT THREE MONTHS after Houghton started his job, he wandered into Frel's office on the main floor of the Getty Villa to ask a question. Frel's desk was in mild disarray, covered with academic papers, letters from dealers, object files, and photographs. Frel was out, but his attractive young German secretary, Renate Dolin, was at her

desk, typing. As Houghton walked past to leave a note on Frel's desk, the stationery she was using caught his eye. Instead of Getty letter-head, it bore the name of "Dr. Jerome Eisenberg, Ph.D.," the New York antiquities dealer.

"Can I ask what you're doing?" he asked.

"Just typing up some appraisal forms for a new group of dona-tions," said Dolin, nodding toward a stack of blank Eisenberg sta-tionery.

"Really. Can I take a quick look?"

Museum curators don't do appraisals, Houghton knew, particularly not for objects they were hoping to acquire. It created a clear conflict of interest. Glancing at the list, Houghton saw several objects whose values looked grossly inflated.

"Who asked you to do that?" Houghton asked.

"Jiri did."

Dolin explained that Frel routinely gave her a list of objects being donated and a value for each. She in turn typed them up on Eisen-berg's appraisal forms and signed the dealer's name. She believed that Dr. Eisenberg got paid for each appraisal, she added.

Houghton thanked her for being helpful and left. When he saw Frel later, he asked about the "procedure" for appraisals.

"Procedure?" Frel replied. "There's no procedure. Jerry gave me a bunch of his appraisal forms, and I have Renate fill them out when necessary. The form is just a formality for the files. If anyone were to question it, Jerry could always say the signature was not his."

"Yes, but why not have Eisenberg actually do an appraisal and sign his own forms?"

Frel saw Houghton's surprised look. "Arthur, I've been doing this for ten years. Trust me, you'll understand when you have to do it yourself later."

"I will not do it later," Houghton replied with a thin smile and walked out.

"You're too moral!" Frel shouted at his back.

· · ·

HOUGHTON RETURNED TO his desk and jotted down some notes. It was a habit he had acquired during his years in the State Department. Diplomats, Houghton had learned, were essentially glorified reporters, and writing detailed accounts of his activities had become second nature. Taking notes helped him think through a matter and had the added benefit of creating a paper trail if push came to shove.

Houghton knew that he'd been hired to moderate some of Frel's excesses, but he had not expected this type of behavior to emerge in his first months on the job. It suggested that his boss not only had a corruptible spirit but also showed a certain shamelessness about it. And this was no isolated incident. Over the next few months, Houghton's discreet inquiries brought to light more of Frel's troubling activities.

The curator was routinely having the Getty overpay for antiquities and "banking" the excess money with various dealers. Frel admitted to Houghton, for example, that the Greek vase with masks of Dionysus, a purchase recently approved by the trustees for $90,000, actually cost $50,000. Frel had used the difference to buy things of scholarly interest—vase fragments, broken statuary, votive objects—that the board would never have approved. These items showed up on Getty records as donations. The scope of the problem was apparent to Houghton from the amount of new material flowing into the department outside the museum's careful accessioning process.

Houghton also learned that Frel had recruited dozens of people to participate in the donation scheme, including several Getty staff members, who were paid cash for the use of their names on donations. Even a board member was among the donors. Assistant antiquities curator Marit Jentoft-Nilsen admitted that she, too, had been coerced by Frel to forge appraisals in the past.

Frel was also benefiting personally from his business relationships. He mentioned in passing that one of the museum's trusted antiquities dealers had given Frel's wife, Faya, a beautiful silver necklace, the type of gift expressly forbidden by the Getty's ethics policy. Staff members told Houghton that Frel regularly stayed as a guest at the homes of

dealers while abroad or let them pay his hotel bills. On a recent visit to New York, for example, Frel and his wife stayed at the posh Carlyle courtesy of a major dealer, who picked up the bill.

That type of behavior would have made most American museum professionals queasy and was clearly prohibited by the Getty. But it was just the beginning. During a visit to the museum, Margaret Mayo, a former employee of Bruce McNall's gallery, told Houghton that she was "personally aware" that McNall had made "massive cash payments" to Frel.

Houghton found that he was scribbling notes to himself after almost every interaction with Frel. Overpaying for art. Unauthorized acquisitions. Inflated and forged appraisals. None-too-subtle bribes. Frel did little to hide his activities. It was as if the curator was bent on getting caught or, more likely, grooming Houghton as an accomplice, teaching him the ways of the antiquities trade.

If that was the case, Houghton felt that Frel had misjudged him. He wanted nothing to do with those activities and felt obliged to stop them. But even Houghton's years in the State Department couldn't help him figure out how to handle his growing mountain of incriminating information diplomatically. He was uncomfortable going over Frel's head and decided to try to guide his boss's behavior in the right direction. That, after all, was most likely why he had been hired.

Then, in June, Houghton learned something that convinced him he had to act.

The kimbell art Museum in Fort Worth, Texas, was exhibiting the collection of Nelson Bunker Hunt, one of the most impressive private antiquities collections built since World War II. Nearly all of it had recently come out of Italy and passed through the hands of Robert Hecht and Bruce McNall. The dealers hosted a splashy evening reception at the Texas museum. Many of the leading figures in the antiquities trade were there for the show, including Frel and Houghton, who had both contributed essays to the exhibition catalogue.

During the reception, a contact in the trade pulled Houghton aside

and whispered a warning in his ear: the IRS was likely to be investigating Frel for tax fraud. The agency was looking at a collection of ancient amber jewelry that Gordon McLendon had donated to the Getty. The IRS had determined that the amber was worth $1.5 million at most, not the $20 million plus that McLendon had claimed on his tax return. When the feds threatened McLendon with a charge of conspiracy to commit fraud, he agreed to pay $2.1 million in back taxes. He was now threatening to tell the IRS everything if McNall didn't reimburse him for the settlement.

"Don't worry," McNall said when Houghton approached him at the show. "Frel hasn't been implicated yet. I'll talk to him tonight and sort things out."

When Houghton ran into Frel later, he asked whether he had spoken to McNall.

"Don't worry about that, Arthur. It's an issue that concerns McNall and McLendon, not us."

Houghton was agitated. Hadn't Frel seen the recent article in the *Los Angeles Times* about the IRS investigating museums for accepting fraudulent appraisals of gemstones?

"Arthur," Frel said dismissively, "we don't collect gemstones."

THE NEXT DAY, Houghton flew to New York and had lunch with his personal attorney. The assistant curator laid out in detail what he'd learned about Frel—a list of criminal activities ranging from forgery and tax fraud to bribery and embezzlement. He asked his attorney to write a legal opinion, based on a "hypothetical curator's activities," that Houghton could use to convince Frel how serious the matter was.

At the end of June, with his legal memo in hand, Houghton asked to talk with Frel privately. The two took a long stroll around the Getty's colonnade bordering the reflecting pool. As they walked, they passed bronze replicas of the statues found at the Villa dei Papiri.

"When I'd talked to you about my concerns about the donations in the past, I was ignorant of the law," Houghton began. "I've asked an

attorney to tell me what laws a curator might be breaking by doing these things. It's called conspiracy to commit tax fraud."

The "hypothetical curator" would expose not just himself but the entire institution to a range of criminal and civil liability under the U.S. tax code. Houghton's legal memo concluded by highlighting the irony of Frel's actions:

> I cannot think of any reason for anyone to engage in the kind of behavior in this hypothetical example, especially if the museum in question was a nationally recognized, well-endowed institution which had no compelling reason or excuse for engaging in such activities. I would not be alone in viewing this sort of deliberate tax fraud as no better than outright theft from the Government.

The blunt memo did not have the desired effect. "Honestly, Arthur, I had hoped to bring you in more," Frel said. "I see that's not going to be possible. I'll have to reveal less of myself to you."

The next day, Frel learned that several other Getty donors had had their appraisals questioned by the IRS, including Alan Salke, president of McNall's movie production company; entertainment attorney Ken Ziffren and his partner, Skip Brittenham; Stanley Silverman, a doctor in Huntington Beach; and Lowell and Michael Milken.

Frel informed Houghton, adding that he had taken home the last of the blank appraisal forms and burned them when he learned the news. Frel vowed that there would be no more donations, aside from the five or so that were still coming in. Frel also said that he had spoken to an attorney friend, who had advised him against discussing the issue with anyone else at the Getty.

Houghton believed that Frel was trying to limit the circle of people who knew about the donation scam. For the first time, Houghton began to wonder if he might be in physical danger. He was, after all, threatening Frel's entire way of life: his position, his income, his reputation. If Houghton was the only one who knew, would Frel be tempted to try to silence him? Houghton imagined himself driving

along the Pacific Coast Highway to work one day and suddenly finding that his car had no brakes. Would Frel do such a thing? His best protection, Houghton thought, was to increase the number of people in the loop. He urged Frel to consider talking to Harold Williams. The antiquities curator said that he would consider it once the IRS cases were settled. But he wasn't exactly contrite.

"You have no idea what goes on in other museums, Arthur. They accept total junk, and the donor takes twenty times the value in his tax write-off. It's the normal practice."

Houghton decided that it was time to go over Frel's head.

AT THE GETTY'S annual Fourth of July party, held at a park not far from the museum, Houghton was introduced to John Walsh, Williams's choice to be the new director of the Getty Museum. Walsh was an expert in Dutch paintings and a rising star in the art world. He had worked at the Met under Thomas Hoving and gone on to become a respected paintings curator at the Museum of Fine Arts in Boston. Tall, sandy-haired, and bespectacled, Walsh was making an effort to be friendly. "I hear things are going great guns in the department," he said to Houghton. "Let's have lunch."

Walsh wouldn't officially start his job for several months, but he was at the Getty often. They chose a lunch date for early August, just as things appeared to be at a breaking point. After they were seated in a Santa Monica restaurant, Houghton didn't waste a moment. "I'd like to tell you what's happening in the department, but I will have to offer my resignation first," he said. "I don't wish to be seen as profiting from what I'm about to tell you."

Walsh was dumbstruck. "What are you talking about, resignation? What is it you have to tell me?"

Houghton carefully detailed how he'd uncovered Frel's activities in recent months. He left nothing out. The situation he was describing was, in his mind, massive, important, and ghastly. Walsh seemed appropriately appalled. He offered to confront Frel immediately. Houghton said he thought that wouldn't be necessary; he would

continue to push Frel to come clean. It would be better if it were Frel's own decision.

Walsh was going on vacation for three weeks but promised to follow up with Williams when he was back at the museum. "I suspect this will blow over," he said.

THREE MONTHS LATER, Houghton had still not heard back from Walsh about the Frel matter. He found the museum's new director reserved and difficult to read. Houghton had expected to be confronted about his accusations, asked for proof, raked over the coals. But nothing. Meanwhile, the problems had not blown over. Far from it. Donations were still coming in, and for some objects Frel didn't even bother with the formality of finding a "donor."

As Houghton was driving Frel to the airport one day, Frel opened his carry-on bag and took out a small marble Egyptian head. His wife, Faya, had brought it back from Switzerland, Frel explained.

"I hope she declared it at customs," Houghton said.

"No, she carried it in her handbag." Frel chuckled. "They never noticed . . . I'd like you to propose it to the board next week while I'm away. Tell them it comes from the Vanderbilt collection." Frel said that the dealer wanted $80,000 for it, "though it's worth more than that."

Houghton was appalled. Having Faya smuggle the piece into the country had been cavalier and unnecessary. Frel's claim about it coming from the "Vanderbilt collection" was laughable. And $80,000 seemed far more than the piece was worth. Frel was asking Houghton to put his signature on it.

A week later, Houghton had a meeting with Walsh to prepare for the upcoming meeting of the board's acquisition committee, when each department would present objects or paintings it hoped to acquire. As the men clicked through slides of various proposed antiquities, the Egyptian head flashed up on the screen.

"Stop there for a moment, John," Houghton said. He could no longer wait for Walsh to bring up the Frel matter.

"What is it?" Walsh asked.

"You need to know about this head. Jiri's wife smuggled it into the country in her handbag. You'll be putting your signature on it when I present it to the board. It's illustrative of the problems with Frel that I told you about, which have still not been resolved."

That got Walsh's attention. The next day, the two met for more than three hours, during which Houghton brought Walsh up to date on Jiri's most recent transgressions. Walsh said that he was thinking about a deal he could make with Frel to stop what he called the curator's "fiddling."

The two decided to meet again the following day with Frel's other deputies, Marion True and Marit Jentoft-Nilsen. The two assistant curators had been at each other's throats for months. True was new and a rising star, while Jentoft-Nilsen had been in the department for years and felt she was due some respect. She complained bitterly about the special treatment True received, penning a series of poison poems referring to True as the "lemon-squeezer" and a "self-seeking snake." But with Frel now under investigation by the new museum director, the two acted as a team, offering to fill out the picture that Houghton had painted.

At a confidential meeting held in Walsh's living room, the women confirmed many of Houghton's allegations. Jentoft-Nilsen added that Frel had forged dealer invoices to support the inflated prices of objects submitted to the board. Houghton said that although he had no hard proof of Frel taking bribes, there was talk of him getting cash from McNall.

In a private moment with Walsh, True later confided what she felt was Frel's true motive for the donation scheme: to build the study collection and disguise the provenance of recently excavated objects, not line his own pockets. The question of his personal gain, she said, should be left out of the Getty's investigation.

Walsh and True both knew that the Getty's antiquities collection had the best chance of setting the museum apart as one of the coun-

try's best cultural institutions. But to reach that goal, the Getty had to fill some big holes in its collection. In particular, the collection needed to find several major statues from the archaic and classical periods —objects that had rarely come onto the market in recent decades. For all Frel's flaws, True and Walsh knew that he was a master at locating first-class antiquities on the market.

Walsh wondered aloud whether Frel might be relieved of his curatorial duties but kept on to look for great antiquities. True thought that would be a good solution. But it would need to be approved by Williams, the Getty's CEO.

By LATE 1983, word of Frel's donation scheme and the IRS investigation had percolated up to Williams. The news came at a particularly tricky time for the chief executive. He had begun having a relationship with his deputy Nancy Englander as they traveled the world together defining the Getty's mission. Williams, married with two children, had subsequently promoted Englander to director for planning and analysis, and she informally acted as his principal adviser. They were inseparable.

Their affair was hard not to notice around the Getty. Staff members spotted them walking hand in hand in a nearby oceanfront park. Board members looked the other way, but their relationship became too obvious to ignore. Some board members were urging Williams to choose between Englander and his job.

The affair compounded existing tensions between Williams and the Getty board over the fate of Getty Oil. The museum controlled an 11 percent interest in Getty Oil, enough to give it the swing vote in a nasty dispute between company executives and Getty's son Gordon, Getty Oil's largest single shareholder. Harold Berg, a Getty Oil executive and chairman of the Getty Trust, wanted to keep Getty Oil intact. Gordon, a trust board member, was despairing over Getty Oil's low stock price and wanted to sell the company. Williams was firmly in the middle of the fight. The former SEC chief believed that it was

folly to have the museum's assets tied up in a single stock. But dumping the museum's shares on the market would be a self-defeating exercise, driving the price even lower. He favored selling the company to a rival that would pay a high price, and he took Gordon's side in opposition to Berg, his nominal boss. Now, as Pennzoil and Texaco circled for a possible takeover, word of an IRS investigation of Frel and the trust could queer the deal.

Williams saw that the problems with Frel would not blow over. The Getty needed to investigate.

A day after a particularly contentious board meeting, Williams and Walsh called Frel into Williams's office. They confronted him with the allegations of phony appraisals and tax fraud and told him that an outside attorney would be asked to look into the latter. Walsh asked Frel to make a list of all the objects that had been donated, along with the price paid for each and the names of the supplier, donor, and appraiser. Meanwhile, Williams asked Bruce Bevan, an attorney with J. Paul Getty's old law firm, Musick, Peeler, to direct the internal probe.

Bevan's investigation yielded a lengthy and disturbing report. Frel admitted to forging fifteen to twenty-five appraisals per year over five years, letting donors suggest the amount of the write-offs they desired. Alan Salke, for example, had taken a $300,000 write-off for a vase worth perhaps $50,000. Met antiquities curator Dietrich von Bothmer told Bevan that he had reviewed some of the Getty donations as an expert for the IRS and had found that some were, "even to a semi-educated eye, grossly, excessively overstated."

Frel also had falsified museum records and had repeatedly and deliberately violated the Getty's policy prohibiting the acceptance of donations from dealers. In Bevan's interview with True, she told him that she had seen Frel ask his secretary to forge not only appraisals but also bills of sale from various dealers at prices of his choosing. Bevan concluded that this was likely "an illegal, excessive tax benefit." Indeed, Frel's desk contained a veritable forger's workshop, with copies of blank letterhead from nearly a dozen dealers and museums

around the world. Frel's explanation of this — that it was to expedite the transactions—was silly.

In short, Bevan told Williams, the donation scheme involved "huge, improper tax deductions" based on "deliberately excessive valuations by Frel." But the donation scheme was just the start.

Bevan also told Williams about the "massive cash payments" McNall was said to have made to Frel. The Czech curator had created phony ownership histories for many of the donated objects, corrupting the scientific record. Frel was also involved in several cases of smuggling, having personally carried one object into the country, besides having his wife smuggle in the Egyptian head that Houghton had already reported.

"Marion True believes this disregard of formalities unnecessarily places the Museum in jeopardy," Bevan noted.

But the most serious concern, Bevan said, was Frel's role in the recent purchase of a Herakles torso. Frel had been offered the piece in Egypt soon after it was excavated and had arranged for it to be brought into the United States. He had had the Getty pay $270,000 more than the dealer's asking price. It wasn't the fact that the head had been looted or smuggled that concerned Bevan, but the overpayment.

"If Frel lied to you and to John Walsh about this transaction . . . you probably would wish to consider whether JPGM should have any further relationship with Frel, including a research and writing relationship," Bevan said. "Presumably," he concluded, the Getty Museum "cannot countenance such irregularities."

Yet Frel was not fired. In late April 1984, Williams, Walsh, and Bevan called the curator into Williams's office and told him that he was being put on paid leave pending further investigation. In the meantime, Houghton would act as interim antiquities curator. Getty staff would be told that Frel was on sabbatical in Paris.

For the next few weeks, the normally upbeat Frel was despondent. He moped around his office, rarely walked through the galleries, and wouldn't make eye contact with Houghton. One day he went home,

packed a bag, and caught a flight for Europe—leaving behind his position at the Getty; his wife, Faya; their young son, Jan; and his son Sasha from his days in Princeton. He continued receiving his regular salary for the next two years, but it was the last most people at the Getty ever heard from Jiri Frel.

THE TRUE STORY of Frel's ignominious departure was kept very quiet within the museum. Only a handful of senior people were told: those who had to know and others who would have figured it out on their own. Outside the museum, von Bothmer was persuaded to remain silent with the argument that any leak could destroy Frel's pride or his ability to work as a scholar.

Meanwhile, there was much to celebrate. Williams proved to be a cunning gamesman in the Getty Oil sale. After helping to lock in a bid at $112.50 a share from Pennzoil, Williams cleverly used the trust's shares to broker an even more attractive $125-a-share offer from Texaco. But he agreed to do so only if Texaco indemnified the trust against any legal action. As expected, Pennzoil sued, winning an unprecedented $11 billion judgment that nearly bankrupted Texaco. The Getty Trust, meanwhile, banked a check for $1.165 billion.

With total assets now at about $2 billion, the Getty was not just the world's richest museum; it was also the world's second-largest charitable trust, after the Ford Foundation. Williams later told his friends that the Getty Oil deal was the smartest thing he ever did.

Flush with money and promise, the Getty Trust expanded its vision. Williams launched a grant program, buying goodwill with multimillion-dollar gifts to several local museums. The Getty built a photography collection nearly overnight with the purchase of three major collections, its first expansion beyond J. Paul Getty's initial collecting mandate, which had excluded contemporary art.

Williams and the board invited leading architects to bid on designs for a new central campus that would unite the Getty Museum and the trust's other programs, which were scattered throughout Los Angeles. It was projected to cost $150 million. The board eventually selected

Richard Meier of New York, a Pritzker Prize–winning architect, for the job.

The new Getty Center would be built atop 110 acres of one of the most visible bluffs in Brentwood, overlooking the perpetually jammed Interstate 405. The plan called for art collections at the Getty Museum in Malibu to be moved "up the hill" to the more than one million new square feet of office and exhibit space. The burgeoning antiquities collection would stay in Malibu and become the centerpiece of a transformed Getty Villa. It would be the only museum in America dedicated to ancient Greek and Roman art.

The future looked bright. Only the lingering issues in the antiquities department threatened to destroy the new image the Getty was carefully cultivating. With Frel gone, Houghton set about cleaning up his predecessor's considerable curatorial mess. There were some eight hundred objects with little or no documentation. The records that did exist were peppered with fraudulent purchase prices, forged appraisals, bogus donor names, improbable attributions, and mythical provenances. Determining what, if anything, was true in the files became a Herculean task.

Houghton started walking through the galleries with experts, identifying objects of questionable authenticity. On their first round, they identified six potential fakes, including two—a bust attributed to the ancient Greek sculptor Scopas and an archaic funerary relief—that Frel had convinced the board to buy for about $2.5 million each. After scientific tests confirmed them as fakes, the pieces were quietly taken off display and given the designation "AK," the museum's code for a forgery. The value of each was reduced on the books from millions to hundreds of dollars. Either Frel had been fooled repeatedly or had taken to advising the Getty to buy fakes on purpose, likely in exchange for some cut of the purchase price.

Amid the cleanup, the threat of an IRS investigation lingered. In particular, donations from the two prominent Hollywood attorneys Ziffren and Brittenham hung over the museum like a cloud. Museum records showed that in 1982, the two attorneys had donated eleven

objects to the Getty. But Houghton had since learned that their signatures had been forged, probably by Frel. The museum was now in a quandary about what to do with the objects.

The issue was sensitive enough to be handled directly by Williams, who ordered the objects returned to McNall without notifying the board or the IRS. Bevan, the Getty's attorney, approved the move. He didn't think the IRS would cause a problem unless it concluded that there had been a conspiracy to commit tax fraud. But he was concerned enough to suggest that all the documents "relating to Frel's corruption" be gathered and removed from the building so they couldn't be subpoenaed.

With that, the cover-up appeared complete.

4

WORTH THE PRICE

I N ADDITION TO the tax fraud scheme, Houghton had inherited
Frel's greatest discovery and a disturbing archaeological puzzle.

Sitting in the Getty's conservation laboratory was a seven-foot tall
marble Greek kouros, or statue of a nude young man. The face bore
the vague smile that was a signature detail of the archaic period, the
end of the sixth century B.C. The man's hands were pinned stiffly to
his sides, with one foot slightly forward, in a pose Greek sculptors had
borrowed from the Egyptians. Dozens of such statues had dotted an-
cient Greece as votive offerings, grave markers, or tributes to the god
Apollo. Today they were among the most prized objects of ancient
art, with only a dozen known to have survived intact. This would be
the thirteenth — if it was authentic.

Frel had produced a sheaf of documents suggesting that the kouros
had been owned by the family of a Geneva doctor since the 1930s but
never exhibited or studied. Still, it was a far more complete ownership
history than existed for most antiquities considered by the Getty. The
person offering the statue was Gianfranco Becchina, a Sicilian antiq-
uities dealer whose Swiss gallery was a major source of material for
the Getty. Becchina wanted $10 million for the kouros — far more
than the Getty had ever paid for an antiquity.

In December 1983, the trustees gathered in the conservation lab to see the sculpture. In one of his last presentations as curator, Frel had extolled it as "the greatest example of ancient art in the world," a piece badly needed to fill a gap in the Getty's antiquities collection. When the curator finished, one trustee erupted.

"But this is an incredible joke!" exclaimed Federico Zeri, the esteemed Italian art historian. He attacked the kouros with troubling specificity, pointing to a flaw in the marble in the statue's forehead. No ancient sculptor would have chosen such a flawed piece of marble for such an important work, Zeri cried. And the fingernails were too realistic, reflecting a naturalism not found in Greek sculpture until a much later period.

"Marvelous. Extremely complex," he told his stunned colleagues. "But it's clearly a fake."

ZERI'S DENUNCIATION ONLY added to concerns that Walsh and Williams had been quietly harboring about the kouros.

Williams, a lawyer by training, was troubled by potential legal problems raised by the statue. In all of Frel's paperwork, there was no indication of where the statue had been found or how it had left its country of origin. Frel had suggested that it had been smuggled out of Athens by a notorious looter in the 1930s—long enough ago that Greece was unlikely to raise any legal claim. But what if Frel was wrong about the Greeks, Williams wanted to know. And how could the museum justify buying any antiquities in a market where, he was being told, much of the supply had been recently looted and illegally exported? "Indeed," he complained to Walsh, "much of the conversation is to the effect that 90% of the objects on the market are presumed to have been recently come out of Italy or Greece." He asked for a detailed briefing on the legal implications and how other museums handled the issue.

Walsh's concerns focused more on public perception. Such a large, important acquisition with murky origins would no doubt further outrage archaeologists. The rift between museums and the scholarly

world that had spilled over into public view in the 1970s with the Met's Euphronios krater controversy had never healed. Indeed, the animosity had deepened and focused on the Getty, whose aggressive antiquities acquisitions were being denounced by the Archaeological Institute of America as "flagrantly unacceptable." Emily Vermeule, a Harvard professor and one of the leading classical scholars in the country, had recently told Houghton that she would never visit or be associated with the museum in Malibu, which had "compromised everyone who had come in touch with it" and did nothing to promote scholarship, while doing much to hinder it.

A few weeks after first seeing the kouros, Walsh asked Houghton in a confidential memo how buying it would affect the Getty's reputation. "I am sorry to make you my tutor in the subject of collecting ethics, but you are surely the best informed and the most concerned colleague at hand," Walsh wrote. "What would it be necessary for us to do in the future to secure the approval and respect of those whose opinion we ought to value?"

In effect, Houghton was being asked to explain a central paradox of American museums: how could institutions dedicated to the diffusion of knowledge justify their participation in an illicit antiquities trade that ultimately destroyed knowledge?

His answer came in a series of memos laying out the rationalization American museums had relied on for generations. There was a clear link between the demand created by the aggressive buying of the Getty and other institutions and the looting of items in source countries, Houghton acknowledged. The result was beneficial in one way: it brought "very significant material into the market." But most archaeologists believed that it led to irreparable cultural loss through vandalism and destruction of ancient sites. Thus archaeologists would "probably be prepared to come down hard against a museum which demonstrably and visibly engaged itself in supporting this process, however laudable the result."

Archaeologists believe that objects should be preserved in context at the source, where they can be carefully excavated and studied,

Houghton explained. Museum curators have a more practical approach. "They tend to accept the troubling and messy realities of unenforceable laws and of a market in antiquities whose more blatant excesses may be curtailed but which will continue to exist whatever the circumstance." Indeed, curators feel that they have a "special obligation" to acquire, study, and publish information about important antiquities, even if their original context has been lost. The Getty's wealth meant that it was better prepared than most museums in the country to preserve, publish, and make available to scholars and the general public the objects it bought.

Looting would continue even if the Getty stopped buying, Houghton said. It was an argument that, he acknowledged, "can seem to be little more than a facile rationalization for the unrestrained acquisition of archeological material."

Ultimately, the ethical question comes down to this: will the acquisition of an object do more to destroy the past or preserve it? Houghton argued that buying antiquities—even those that have been recently looted—does greater good than harm.

The museum's acquisition policy—which required notifying foreign governments of objects it intended to purchase—was already more rigorous than those of most other American museums. Harvard's Fogg Museum, one of the strictest, required just a "reasonable assurance" that an antiquity had left its country of origin before the 1970 UNESCO Convention. The Met did not require any documentation to support the fact, while the Boston MFA's policy made no mention of the country of origin, instead relying on a dealer's word that an object had entered the United States legally. "They are concerned with not being seen to encourage the unauthorized excavation and export of ancient material from its country of origin," Houghton explained, ". . . while permitting maximum freedom of action in regard to the determination of what type of material should be bought."

As for the legal ramifications, the law was in a state of flux, according to Houghton. President Ronald Reagan had recently signed the 1983 Convention on Cultural Property Implementation Act, finally

adopting parts of the UNESCO treaty as American law. Under the act, a source country could ask the United States to place restrictions on the importation of antiquities if it could prove that American demand was fueling looting. Of greater concern, however, was an emerging legal interpretation of the National Stolen Property Act, passed in 1934. American courts were beginning to consider looted antiquities in the same light as hot cars and stolen securities. Under a precedent set in a 1977 case against a Texas art dealer, the feds in some jurisdictions could now seize an object and even bring criminal charges if they could prove that the museum had "certain knowledge" that the antiquity was illicit.

Williams was still uneasy about the legal situation. Given what Getty officials had learned about Frel's behavior, Williams had also begun to suspect that the curator might have arranged to get a sizable kickback in the deal. He asked Bruce Bevan, the Getty's outside counsel, to investigate the museum's legal exposure if the Greeks demanded the kouros back.

The precaution frustrated Houghton, who was blunt with Bevan in making a case for the acquisition. "The reality is that 95% of the antiquities on the market have been found in the last three years," Houghton told the Getty attorney. "The only way one obtains them is if you do not ask the specific question that would elicit the specific answer about provenance that made the material unbuyable . . . Is Frel getting a cut? I don't know. But I'm prepared to make the strongest case possible for the kouros, even if it involves a payment to Frel. It's simply worth the price."

Houghton's recommendation was not to stop buying looted art, but to devise a strategy that would defuse the legal risks. The Getty should create the appearance that the objects it was acquiring had been carefully vetted, but at the same time avoid "certain knowledge" of where they were actually coming from. He called the approach "optical due diligence."

It was a surprisingly cynical position for Houghton to take, given his moral outrage at Frel's transgressions. But in his mind, tax fraud

and forgery were entirely different from breaking the export laws of a neglectful foreign country, especially when the goal was to educate and enlighten Americans. Houghton knew that most of what the museum was buying was freshly excavated. But as long as the object was authentic, neither he nor most American curators saw the issue as a major concern at the time.

Houghton's advice, with its focus on optics over substance, would shape the thinking of Getty officials for years, providing an intellectual foundation for the unbridled acquisition of looted art over the next decade.

THAT WAS THE BACKDROP for Getty officials as the board gathered to see the kouros that day in the conservation lab. Now Zeri's outburst had added a new, more basic worry: was the kouros authentic?

The Getty turned to science for an answer. The geological age of a stone generally told curators nothing about when it had been carved. But a geochemist working as a visiting scientist at the Getty suggested the natural chemical breakdown of the statue's surface might indicate how long it had been exposed to the environment. The museum's conservation lab tested the kouros and found that it was covered with a thin layer of calcite. Forgers routinely used acid baths, tea bags, cow dung, and other tricks to create the weathered skin of ancient marble. But, the Getty concluded, there was no way forgers could fake calcite, which forms over thousands of years. The kouros must be ancient.

Encouraged by the scientific verdict, the Getty then asked leading art historians and archaeologists to weigh in. One expert on classical sculpture refused to participate on moral grounds. Providing her opinion, she said, would only encourage the illicit market, from which the kouros had no doubt come. Most others, however, were eager to see the important and controversial new piece.

In all, thirty-one experts said that they believed the statue was authentic and praised its beauty and unprecedented state of preservation. Only a few echoed Zeri's objections, calling the object an im-

probable hodgepodge of styles that spanned a large geographic area and more than a hundred years. Boston MFA antiquities curator Cornelius Vermeule (the husband of Emily Vermeule) dismissed the scientific tests, saying that skilled forgers could fake any patina. "They read the technical literature too, John," he told Walsh over the phone. With his curatorial staff giggling in the background, Vermeule said that the statue's hair "looked like spaghetti," its ears "belonged to Mr. Spock" from *Star Trek*, and its arms looked like "a hack job." Pico Cellini, an Italian restorer and expert on Italian forgeries, called the provenance presented by Frel "a fairy tale."

Walsh then contacted Dietrich von Bothmer, antiquities curator at the Met and a leading authority on Greek sculpture. Initially, von Bothmer had been skeptical about the statue's authenticity, but Walsh's follow-up found that the crusty curator had changed his mind. Von Bothmer said that he had had a cryptic conversation with Becchina, the Sicilian dealer, about the kouros. Speaking in confidence, Becchina had cautioned von Bothmer to ignore the cover story about the statue coming from Greece or being in the family of a Swiss doctor. He suggested instead that the statue had been found recently in Sicily, an origin that would explain many of the stylistic anomalies that had initially troubled him. It also suggested that the piece was freshly excavated and, by extension, authentic. The statue's suspiciously voluminous ownership history must have been forged to cover the kouros's illicit origins.

Bolstered by the new information pointing to authenticity, Walsh once again recommended the purchase of the kouros. He sent a confidential binder of information to board members describing the object as "among the most important achievements in the entire history of art" and described how the staff's exhaustive research had shown the kouros to be "genuine beyond all doubt."

Zeri remained unconvinced. Outnumbered by his colleagues, he vented his frustration about the dubious kouros in an interview with Italian television. Without naming the Getty, Zeri described a sculpture that "is one of the most colossal jokes of all times" and said that

each time he saw it, "it seems to be uglier and faker." Marion True, the Getty's assistant curator, learned about the interview, got hold of a transcript, and gave it to her superiors. Williams seized on the comments to demand Zeri's resignation for violating the trust's confidentiality clause. With that, the leading critic of the kouros was gone.

Meanwhile, the Getty's Swiss attorneys sent a fax to the Greek embassy in Bern inquiring whether the government had any information about the provenance of six antiquities, including the kouros. The attorneys didn't name their client and gave the Greeks six weeks to respond. The lawyers did not contact Italy, the suspected source country of the kouros.

The Getty didn't bother to wait for an answer from Greece. With Zeri gone and the museum's optical due diligence satisfied, the board voted in January 1985 to buy the kouros for a record $9.5 million.

A MONTH AFTER purchasing the kouros, the Getty continued its buying spree, paying $16 million to acquire eleven Greek antiquities from the private collection of New York diamond merchant Maurice Tempelsman.

Tempelsman had been forced to liquidate his antiquities collection because of a divorce prompted by his open affair with Jacqueline Kennedy Onassis. Tempelsman had left his wife and children to move into the Stanhope Hotel, just down the block from Onassis's Fifth Avenue apartment, and was often seen walking arm in arm with her through Central Park.

In talks with the Getty, Tempelsman proved to be urbane, charming, and a fierce negotiator, one accustomed to haggling over multimillion-dollar diamond sales on the back streets of Africa. Over two years, Houghton had shaved down Tempelsman's $45 million asking price by focusing on only his most choice objects. The deal for the eleven pieces came with a caveat: Tempelsman would need to provide the Getty with a letter of credit for the full amount in case "anything unexpected came up." The step would protect the Getty during

the three-year window within which a foreign country could make a patrimony claim.

The acquisition included some of the most stunning pieces of Greek art ever found, including a remarkably preserved statue of Apollo and a two-foot-wide marble *lekanis*, or ceremonial basin. The basin, adorned with the scene in Homer's *Iliad* where sea nymphs bring Achilles his magical armor in preparation for the Trojan War, still bore vivid crimson, blue, and ocher paint—a rarity for ancient art.

The most arresting piece, however, was a marble sculpture of two mythical griffins ripping into a fallen doe. The scene was carved from a single block of marble and had been used as a table support. It, too, had traces of its original paint, with sky blue on the feathered wings of the griffins and red blood spilling from their prey. Nothing like it had ever been found.

For the debut of the Tempelsman items, the Getty asked Cornelius Vermeule to write a study of the three central objects. He submitted a manuscript arguing that they were likely part of a group made by the same workshop. But Houghton was skeptical of the thesis and decided to check it out. After asking around, he got in touch with the man said to have been the source of the objects, an Italian middleman named Giacomo Medici.

For years, Medici had quietly supplied many of the major dealers in the field with first-rate material recently smuggled out of Italy. His debut as a dealer came in 1982, when he dramatically outbid a wealthy Swiss collector to buy an exquisite Etruscan vase depicting Hercules's struggle with the Hydra. Putting it in a place of honor in his new Geneva showroom, Medici turned away offers to buy it from all over the world until he got the one he wanted: the Getty's. After all, having the richest museum in the world as a client was the dream of every looter and middleman across the Mediterranean.

Frel had acquired the vase for $400,000 but had been careful not to put Medici's name on any of the official documents. He had made

clear to Houghton that it should be kept out of all Getty records. Medici was a low-level Italian gangster who had made good, Frel had said. His objects, like those from Hecht, would have to be purchased through other dealers or private collectors.

Inside the Getty, Medici's name was still mentioned only in a whisper. Yet the dealer's growing significance as a middleman made him an unparalleled source of information. Like most leading curators and collectors around the world, Houghton had once made the pilgrimage to Medici's warehouse in Geneva for a preview of what would be coming on the market. "Two things are important if we're going to do business," Medici had told Houghton. "First, the Getty should say nothing about buying objects from me. I buy and sell thousands of pieces, and if it is known that I sold two to the Getty, it would make the other 998 difficult to sell . . . Second, we should not compete against each other at auctions. There is no reason to go to war when there is business to be done."

Now Houghton called on Medici again with his doubts about Vermeule's theory: was it true that the Apollo, the basin, and the griffins had all come from the same source? Medici said that he had purchased all three from Italian looters in 1975 or 1976. The basin and the Apollo had been found in the same tomb, in some ruins just outside Taranto, a thriving center of art in ancient times. The griffins had been found in the ruins of a villa some 150 to 200 meters away. The objects had passed from the looters to Medici to Robert Hecht and then to the leading British antiquities dealer, Robin Symes, before landing in Tempelsman's collection. Hecht confirmed Medici's account and added specifics: the objects had been looted from a productive site near Orta Nova, a town to the northwest of Taranto, near the Adriatic.

Houghton detailed his discovery in a memo to Deborah "Debbie" Gribbon, the Getty Museum's assistant director: "It had still seemed possible to go back through the chain of individuals through whom the material passed to try to find out exactly where all three originated. It was. At the beginning of this month I had a chance to discuss

the matter with the dealer who had bought all three objects from the excavators . . . Giacomo Medici."

At the time, the issue was merely academic for Houghton and Gribbon—Vermeule's theory would have to be revisited for the publication. The fact that senior Getty officials now had what approached "certain knowledge" that three of the Getty's new acquisitions had been looted and smuggled out of southern Italy caused no concern.

Houghton's memo was filed away and forgotten.

IN THE SUMMER of 1985, John Walsh made a surprising announcement to the Getty staff: "The Getty Museum passed a milestone today. Jiri Frel, after twelve years of service as Curator of Antiquities, ended a sabbatical leave and assumed the title of Senior Research Curator. He will continue for some months to come to work in Paris on various publications." Walsh praised Frel's scholarship, his efforts to connect the Getty to a community of classical scholars around the world, and his role in building the Getty's collection, in particular the museum's "vast trove of important study material."

Walsh's memo concluded, "As collector, mentor and source of inspiration he has had few equals in his field. When Jiri is back in California we will find ways to salute his achievement."

Houghton was thunderstruck. Since Frel's sudden departure a year earlier, word of his activities had trickled back from contacts in the antiquities trade. Still on the Getty payroll, Frel had left Paris and moved in for a time with Gianfranco Becchina in the dealer's hometown of Castelvetrano, Sicily. After a few months there, Frel bought an apartment in central Rome on the top floor of a vine-covered apartment building not far from the Pantheon. (Where he got the considerable money needed to do so was not clear.) He divorced Faya and married a young woman who was now pregnant. He was putting his knowledge to work as a fixer in the antiquities trade. Dealers were routinely paying Frel five-figure commissions for his help selling objects.

Now Walsh appeared ready to bring Frel back to the Getty. When

Houghton raised his concerns, Walsh turned the tables on the acting curator, saying that he was increasingly worried about Houghton's obsessive focus on Frel's "fiddling." Walsh was growing impatient with what he saw as Houghton's determination to seek out problems for the Getty. "He sometimes focuses excessively on side issues, and rather than clarifying a situation, may complicate it," Walsh wrote in Houghton's end-of-year performance review. "I don't know if this stems from an excess of zeal with details or with a lack of clear judgment about what is important."

Houghton had long been expected to succeed Frel as antiquities curator, but now Walsh made it clear that was no longer likely: "I would not judge Arthur's potential for advancement at the Getty Museum to be high, despite his many abilities."

IN EARLY 1986, as the Getty prepared to reveal its acquisition of the kouros to the public, Houghton once again showed his zeal. He knew that Walsh intended to explain the statue's origins using Frel's documents about the supposed Geneva physician. But given Walsh's conviction that the statue actually came from Italy, those documents were likely bogus. Should the Getty even be talking about them?

He sent a memo to Walsh suggesting that the Getty rethink making any reference to the documents. "Do we believe them? We imply that we do. Yet . . . no check was completed on the letters' authenticity . . . Both experience and prudence suggest that we should not only seem to be certain of these documents, but that we are in fact certain of them."

The memo was out of character for Houghton, who had long insisted on optics over substance, but his experience at the Getty had begun to change him. The stakes had gotten higher for him, and optical due diligence, his brainchild, was no longer enough.

Houghton walked downstairs to his old office to show the memo to Marion True. She read it silently, then turned to Houghton and said flatly, "The kouros documents are fake."

"How can you be sure?"

"I'm certain."

True refused to elaborate, but it appeared that she knew more than she was letting on.

Houghton went back to his office. Ernst Langlotz, a German antiquities expert, had signed one of the kouros letters. The name had come up again recently, while Houghton was reviewing another of Frel's major purchases—an allegedly archaic relief bought in 1982 for $2.3 million. The museum and several outside experts had since concluded it was a fake. Houghton pulled the file for the relief and compared the Langlotz signature there to the one in the kouros file. They were completely different.

Which signature was real? Or had both been forged? Had Frel cooked up the ownership histories of both the archaic relief and the kouros?

IN MARCH 1986, Thomas Hoving showed up at the Getty Villa and began asking his own uncomfortable questions about the kouros.

After ten years as director of the Met, where he survived the Euphronios krater scandal and introduced blockbuster exhibits such as King Tut, Hoving left the venerable museum in 1977 and eventually reinvented himself as a muckraking arts journalist. His favorite target was the Getty. As the arts and entertainment correspondent for the ABC newsmagazine *20/20*, he had reported in 1979 that the Getty had acquired the Getty Bronze against J. Paul Getty's express wishes and, possibly, in violation of Italian export law. After leaving *20/20* to become editor in chief of *Connoisseur*, a high-end arts magazine, Hoving had caught wind of the story behind Frel's quiet departure and of the kouros's dubious authenticity. While at the museum to write an article about what the Getty had done with its wealth, he asked Houghton if he could peek at the statue, which had still not been put on public display.

Led into the Getty's conservation lab by Houghton, Hoving looked

at the kouros and felt as if he had been punched in the gut. Something was wrong with the statue's appearance. It was simply too pristine to be twenty-five hundred years old. "Have you paid for this?" Hoving asked. "If you have, try to get your money back."

Later, Hoving met with Walsh in the museum director's office. The two had not seen each other for years, and Hoving still harbored ill will against Walsh going back to their days at the Met. Walsh had led picketing of museum employees to protest Hoving's plans to cut staffing. He had subsequently resigned over Hoving's decision to ship a delicate painting to Russia for an exhibition.

Hoving said that he'd just seen the kouros and shared the doubts about the statue's authenticity that Pico Cellini had expressed. Walsh countered that many other experts disagreed with Cellini and that the piece had undergone scientific testing for fourteen months. He refused to name the owner of the piece or the dealer, but he assured Hoving that the Getty had "solid proof" that the piece had been in a Swiss collection for more than fifty years.

Hoving's questions forced Walsh into defending the statue with documents the museum director believed were suspect, if not outright false. Hoving would no doubt try to poke holes in the story for his upcoming article in *Connoisseur*.

Soon after Hoving's visit, Getty officials moved up the public announcement of the statue by several months. They were determined to reveal their new purchase before Hoving's article went to press.

TWO DAYS AFTER Hoving's visit, Walsh summoned Houghton and True to his office to discuss the kouros documents. Walsh and Debbie Gribbon were sitting next to each other, their backs to the large windows that overlooked the gardens. Walsh asked Houghton to recap the discrepancies he had found between the Langlotz signatures. When Houghton finished, True volunteered her own information.

"Frel told me some time ago that the Langlotz letter supporting the archaic relief had been forged," she said tightly. She had the habit

of pursing her lips when she was nervous. "I think the letters support-ing the kouros were too."

Houghton was stunned. It was the first he'd heard of problems with the archaic relief documents, after months of research to find out whether the piece was authentic. Curiously, neither Gribbon nor Walsh seemed particularly surprised by the news. Houghton won-dered whether the other three had rehearsed this conversation before the meeting.

After a brief silence, Walsh weighed in. The fact that the kouros documents were fake was not a surprise, he said. "It appears to me that the kouros was found recently, most likely in South Italy. Who-ever found it gave it to Becchina, who has now sold it to us. At this point, it is better for us not to know whether the documents are au-thentic or fake. In short, I don't think it's wise to pursue the matter of the letters further."

True agreed. "I just want to say that I do not think we should find out whether these letters were forged. That's what I think."

Houghton walked out. Walsh had decided to shut down any inves-tigation of the kouros documents. True and Gribbon were on board. Soon after the meeting, Houghton began drafting his letter of resig-nation. He now had no doubt that True would be offered the curator position.

A MONTH LATER, Houghton executed a carefully orchestrated plan. He came into the office late one day and went directly to Walsh's secretary. He asked for a 4:30 appointment and gave her a sealed envelope.

Houghton left Walsh's office, got into his car, and drove to Wilshire Boulevard to deliver another envelope to Harold Williams. Both en-velopes contained Houghton's letter of resignation.

The five-page letter addressed to Walsh began:

> My reasons should be no surprise to you. They involve my belief that you have chosen a path of self-enforced ignorance

of fact, and of treating knowledge of the facts as the problem rather than the facts themselves. They concern your decision to bring back to the Museum and even honor the person whose trail of fraud and deceit may still have the most damaging consequences for the institution. They have, in the end, led me to believe that to continue to serve under current circumstances would compromise my better judgment and my own sense of integrity.

The letter outlined Houghton's recent disputes with Walsh, concluding with Walsh's order that no further investigation be done into the kouros documents. "The implications of forgery of the documents are profound, as you know: for the possibility that the kouros was very recently excavated and exported from, for example, Greece or Italy; or for those who do not believe in its authenticity, that it, too, is forged . . . While self-imposed ignorance of the facts in this case may offer some comfort in the short term, it lays the basis for profound embarrassment later."

In closing, Houghton issued a dire warning that later proved to be prescient:

The issues which Frel has left behind are not resolved. Many of the most difficult ones, made so by careless research or curatorial avarice, are still pending. It is virtually certain that others will appear. They may involve the demand by another country or institution for the return of material in the Museum's collection . . . Those issues which do arise will be unavoidable. No "miracle," of the kind which you have suggested has kept Frel's most damaging behavior from the public eye, will shepherd the Museum through them . . . The effect . . . on the Getty's reputation would be catastrophic; its ramifications could extend very broadly, conceivably to the point of a sweeping external investigation of the Getty Museum's records, and possibly to the point of enactment of legislation affecting the activities of all museums in this country.

Houghton had timed his deliveries so that Williams would read the letter before Walsh had a chance to intercede or begin construct-

ing a cover story. At 5 P.M., Walsh called Houghton into his office. Both men were extremely calm.

"I regret that it's come to this," the museum director said, a study in understatement, "but given the circumstances I think it's the right thing to do. Our differences are obvious and we've discussed them many times. But I must say, I'm puzzled by your letter."

"Why puzzled?" Houghton asked.

"Well, why did you feel the need to put all this down in writing?"

Walsh was less concerned about the substance of the serious issues than the appearance they might create — the optics. Perhaps, Houghton thought, he had been too good of an ethics tutor.

As Houghton was getting up to leave, Walsh fired a parting shot. "I must say, it is ironic that this comes now, as I had intended to tell you today that we've completed our search for a new curator of antiquities. We've decided to appoint Marion True."

5

AN AWKWARD DEBUT

M ARION TRUE HAD come to California as a refugee, too—not from the Eastern bloc or the demands of a family fortune, but from her working-class roots and a run of bad luck.

True was born in Tahlequah, Oklahoma, and raised in the Irish section of Newburyport, Massachusetts, then a dying mill town near Boston. Her mother was a secretary at the local bank. Her father was a machinist and war veteran who cluttered the house with military memorabilia, including a shrunken head, a disabled World War I machine gun, and enough other firearms to fill a spare bedroom.

The only daughter and middle child of three, Marion possessed more delicate sensibilities. An interest in ancient art was stirred during childhood trips to Boston's Museum of Fine Arts with her mother, whose fascination had been sparked by the Indian burial mounds scattered around Oklahoma. As Marion grew into a polite and awkward teenager, tall and self-conscious about her glasses, she learned French and became salutatorian of the Newburyport High School class of 1966. Her yearbook photo shows a straight-haired girl with a smoldering look next to a one-word prediction: "artist."

While her brothers went off to fight in Vietnam, True studied Greek masterpieces inspired by the Trojan War. As an undergraduate

at New York University, she was a poised, obedient student who dressed in matronly clothes and blossomed under the rigors of classical scholarship. True demonstrated an early interest in ancient Greek vases, won a prize for Latin and Greek studies, and graduated magna cum laude in 1970. Two years later, she earned a master's degree in classical archaeology after a summer spent toiling in the trenches at Aphrodisias, Turkey, looking for traces of the Greek vase painters of the fifth century B.C.

As a student of archaeology in the early 1970s, True had a front-row seat for the scandal that drove a wedge between museum curators and their peers in academia. The catalyst was the Met's purchase of the Euphronios krater in 1972, two years after the UNESCO treaty. Dietrich von Bothmer had infuriated archaeologists by dismissing questions about where the vase had been found. What interested him was its beauty, not its archaeological context. Weeks later, the Archaeological Institute of America denied von Bothmer a position on its board, with one archaeologist declaring that the interests of curators and archaeologists were no longer in sync. The rift between curators and archaeologists over the ethics of buying looted objects would follow True throughout her career.

Forced to choose between the two camps, True opted not to pursue the sweaty life of an archaeologist. During a 1973 internship at the Boston MFA under Cornelius Vermeule, she discovered a talent for designing museum displays. She arranged an exhibit of Greek pottery according to shape rather than by time period, as was the custom. The public loved it. She also got a taste for behind the-scenes curatorial work, cataloguing the MFA's vases and meeting antiquities dealers such as Robert Hecht and Elie Borowski, who came to the museum offering their latest finds.

True's abilities and ambition soon led her to Harvard University, which accepted her into its Ph.D. program in art history, with a focus on classical art. Her thesis advisers there included Emily Vermeule and von Bothmer, a sometimes cruel taskmaster. In Cambridge, True was thirty miles and a universe away from her old Newburyport

neighborhood. She had little in common with her classmates, many of whom came from privileged families. She came off as eager to please, the one most likely to bring treats to seminars. If she felt left out, she brooded.

It was at Harvard that her bad luck started. Her two-year marriage to a prominent cardiologist, nineteen years her senior, collapsed in 1979. They had been together for eight years, during which time True had shown a growing taste for extravagance. She had convinced him to sell his Victorian home in middle-class Waltham, Massachusetts, and buy a historic seventeenth-century house in the more prestigious Groveland. While his kids bought clothes off the rack, True hired a personal shopper and came home with several pairs of expensive shoes. Eventually, her husband decided to return to his first wife, and the irate True left with the couple's Irish wolfhound and filed for divorce. Her husband later told his daughters that True had cleaned $50,000 out of a joint bank account. True claimed that she had taken only enough to buy a Honda CVCC and make a down payment on a Cambridge apartment.

She was struggling professionally as well. Her MFA internship led to a full-time curatorial assistantship, but it paid precious little. With few museum jobs to be had, she abandoned her doctoral studies before completing her dissertation to look for work on the commercial side of the art world. True took an hourly job working for Steven Straw, a high-flying Newburyport art dealer with a gallery full of O'Keeffes and de Koonings and a growing national reputation. Impressed with True's meticulousness and fluent French, Straw hired her to research nineteenth-century American and European paintings. She quit a year before an art publication exposed Straw's business as an elaborate Ponzi scheme: he never owned much of the art he was selling. True said that she was ignorant of the scheme and testified in bankruptcy court that she was owed back pay by the disgraced dealer, who served twenty months in federal prison for fraud and eventually committed suicide.

True's next job was with Bruce and Ingrid McAlpine, two of Lon-

don's most prominent antiquities dealers. But that arrangement also ended badly. Four months after hiring True to drum up business for a possible New York gallery, the couple canceled the deal, accusing True of frittering away her time on unworthy prospects. True complained that the dealers were being unreasonable, expecting too much, too soon. She refused to return her $900-a-month stipend. Livid, the McAlpines threatened to sue.

By 1981, the once promising graduate student found herself working as an executive assistant to Stanley Moss, a poet, art dealer, and occasional boyfriend. Her tasks ranged from checking galley proofs for his publishing house to painting his dining room.

Then, on a trip to Los Angeles, True was introduced to Jiri Frel. The curator promptly offered her a job doing menial clerical work in the antiquities department at the Getty. True accepted without a contract, hoping to start over in Malibu. She began working at the Getty in January 1982 and spent the first year secluded in J. Paul Getty's old ranch house, creating a central file for the burgeoning antiquities collection, including the thousands of shards that Frel was squirreling away for study. She put new labels on the vase collection, then rearranged shelves of Roman portraits. Before long, she began attracting favorable attention for her handling of the exhibit and catalogue of Athenian vases lent by textile mogul Walter Bareiss, a collection the Getty bought in 1984. Her annual performance reviews swelled with adjectives: dedicated, productive, articulate, creative. Frel believed that she had everything necessary to be a genuine connoisseur. After Frel left, Houghton, a Harvard classmate and friend of True's, promoted her to associate antiquities curator in 1985 and increased her responsibilities, sending her to meet European dealers and make acquisition pitches to the board of trustees.

Among her colleagues, True was known as a perfectly competent junior colleague who otherwise kept to herself. In the Getty's sexually charged atmosphere, where office affairs were common, True hid her buxom figure and kept her long hair swept back from her plain face in fashionable curls. She spoke so little about her private life that some

thought she might be a lesbian. She volunteered little about her family and even less about her brief misfortunes in the commercial art market. There was good reason for the latter: many in the curatorial ranks considered work on the commercial side of the art world an ethical taint. Although her résumé included her time with the McAlpines, she mentioned nothing about how it ended, and she left the controversial Straw off her résumé altogether.

When True did speak up in the office, almost everyone noticed the quality of her voice. It often scaled into a Marilyn Monroe falsetto, a high-pitched trill reminiscent of someone cooing to a baby or a favorite pet. Some thought it gave her an air of unreality; others interpreted it as a sign of insincerity.

True won the antiquities curator position largely by default. After Frel's departure, Houghton was appointed interim curator, and the museum launched a worldwide search for a replacement. It dragged on for months as European scholars and museum officials dropped off the list one by one. Walsh flew to Athens to recruit Angelos Delivorrias, director of the Benaki Museum. But Delivorrias declined when his wife refused to move to California, still regarded as a cultural wasteland. By the time of Walsh's showdown with Houghton, True had emerged as an obvious candidate, having belatedly finished her doctoral dissertation with von Bothmer's help. Still, Walsh held out, much to the growing dismay of True. Shortly before Houghton's resignation, Walsh told her that she had been chosen for the job. The tide had gone out, he said, and True was what was left on the beach.

In the spring of 1986, during Houghton's final days at the Getty, he sent his successor a handwritten note about her dispute with the McAlpines. The London dealers were still considering a lawsuit, and True would no doubt have to do business with them at some point.

"I am more than ever convinced, after much reflection, that you have no alternative but to provide . . . the fullest possible information on your relationship with the McAlpines" to the Getty leadership,

Houghton wrote. "The issue can be as much appearance as substance, and my advice is that you guard yourself and the Museum against even the appearance of a past problem by signaling it to the Trust, now, as you begin."

True never did tell her bosses; she didn't see the need.

IN AUGUST 1986, the Getty hurriedly revealed its purchase of the kouros, months before the statue was ready to be displayed. It was hailed as a major find, "arguably the most important art purchase made in this country in the past half-century," said the *Los Angeles Times*. But it proved to be an awkward debut for True.

She had a personal stake in the piece, even before being promoted to antiquities curator. True's paper defending the kouros was due out in a few months in the *Burlington Magazine*, a London-based art publication that was widely respected. But in the months since she had submitted the piece, new doubts had arisen about the object's authenticity.

Publicly, True revealed far less than she knew. She told reporters that the museum had conducted a "rigorous examination for authenticity" during the three years the statue had sat in the museum's conservation laboratory. The Getty Museum had sought the opinions of virtually every expert in the field, she added, and most thought the statue was authentic. In regard to its origins, True cited the very documents she had privately denounced as forgeries, stating flatly that the statue had been purchased from a Swiss family through a Swiss dealer. Nothing else was known. But True left some wiggle room, saying the field of ancient art was always murky. "We have to be especially careful and not even trust ourselves," she said.

When True's public statements filtered back to Houghton, now living on the East Coast, he was outraged. He had personally warned Walsh and True against publicly referring to the forgeries Frel had supplied. Now they had done so, blatantly lying about something that could easily be exposed. Houghton placed a call to Harold Williams.

"Harold, those documents that were provided with the kouros were forged, just junk, and the museum shouldn't be making statements which, with a little scruffing around, could be shown to be no more than a public lie," he said.

"I understand," Williams answered. "We shouldn't be digging a hole deeper than the one we're in."

Two months earlier, Walsh and True had convinced Williams that there was no need to dig deeper. Now that the statue had been purchased, asking questions about it would only lead to trouble, they had argued. True, in particular, had been concerned that word of their inquiries would leak out. There was no escaping the awkwardness of the Getty investigating the provenance of a piece it had already purchased and defended publicly as authentic. But now Williams believed that the museum needed to know whether the kouros documents had been forged, and if so, why. He asked Walsh and True to revisit the documents, a highly unusual step given the already intense scrutiny of the piece.

True reluctantly picked up where Houghton had left off. He had already tracked down an authentic copy of Langlotz's signature, which confirmed what he had suspected—both of the Langlotz signatures in the Getty's files were poor forgeries. There was only one other person alive who claimed to have seen the kouros in the basement of the Swiss family's home—Jacques Chamay, the curator of classical art at Geneva's Musées d'Art et d'Histoire. During the Getty's first review, attorney Bruce Bevan had been convinced that Chamay was beginning to waver on his story. Since then, no one had talked to the Swiss curator. Was Chamay still credible? Could he be trusted?

Before traveling to Switzerland to find out, True learned what she could in Los Angeles. Renate Dolin, Frel's former secretary, recalled that Frel had been especially distracted and secretive when it came to the kouros. He had shooed her away from the office so that he could have long phone conversations with Gianfranco Becchina, the dealer. At one point, he had had her pull documents from the Getty's files signed by Langlotz and another dealer and asked her to forge a letter

to the museum from one of them. Dolin had refused—this was not just an appraisal for a small gift, but fraud involving the museum's most expensive acquisition. Frustrated, Frel had taken all the kouros files home, then reappeared with them the day they were to be presented to the board.

Faya Causey, the curator's ex-wife, told True that she had caught her husband trying to create fake letterhead, which she presumed was for the kouros. "I told him, 'You're crazy if you think a scheme like that would work,'" she said, adding that Becchina himself had complained to her that he didn't like "any of the provenance stories that Jiri had come up with."

Armed with these statements, True traveled to Geneva in November and met with Chamay. She noted that he was extremely nervous as he recalled his visit to the Swiss doctor's house outside the city, where he had seen "in the basement a large, partially opened crate with a piece of archaic sculpture inside." He said he believed it was the kouros, then quickly added that he wasn't an expert in Greek sculpture. When True probed further, Chamay faltered on the details of his visit.

Three days later, True met with Becchina and his wife, Rosie, at their Geneva apartment. If anyone could solve the mystery, it was Becchina. The Getty had already signed a sales contract for the kouros and had begun making payments on the $9.55 million purchase. But the dealer remained on the hook for the warranty until the object was fully paid off. He refused to say anything until the final payment was made and angrily expressed his displeasure about the Getty's continuing investigation.

"Look, I'm tired of this whole thing, too," True snapped. "This kouros mess has cost me an enormous amount of time—time that I would have preferred to use on research and more constructive activities for the collection. I did my best to defend the kouros in print, all without any help from the people who should have been able to help me—namely you. And Frel."

True's last hope was George Ortiz, a pixyish Bolivian tin magnate

based in Switzerland. He was widely known as one of the antiquities world's richest collectors and an occasional dealer. He was also one of Becchina's loyal customers and closest friends. But when True showed up at Ortiz's Geneva mansion, the collector said that even he couldn't pry any details out of his friend. "It's omerta," Ortiz explained, referring to the Sicilian code of silence.

Back in Malibu, True drafted a confidential report to Bruce Bevan detailing her conclusions. "I believe Jiri was, in truth, behind the creation of at least some of these documents and Becchina accepted Frel's advice in order to facilitate the acquisition," she wrote.

She also complained that the investigation had led to unintended consequences. Many people now knew that the Getty was having second thoughts about the provenance of the piece. Word was bound to get out.

Sure enough, starting on Friday, February 13, 1987, Thomas Hoving began publishing a series of devastating investigative articles revealing the Getty's secrets. The first, whose headline "Huge Tax Fraud Uncovered at Getty Museum" was splashed across the front page of the *Times* of London, revealed Frel's donation scheme and the Getty's attempted cover-up. Hoving and his reporting partner, *Times* arts reporter Geraldine Norman, had used the Getty's tax records to piece together the decadelong fraud. The article called it "the biggest financial scandal in museum history." When the reporters tracked Frel down at his apartment in Rome, the curator said darkly, "It was bigger than they know." Indeed, a few months later, Hoving published an article in *Connoisseur* denouncing the kouros as a fake.

The Getty was forced to admit that Frel had been put on leave two years before he resigned in 1986. The trust would not comment on the donation scheme, other than to say there was no evidence that Frel had benefited personally. Getty officials went to great lengths to dismiss Hoving as a washed-up crank with a grudge against Walsh, his old rival from the Met. But the revelations triggered follow-up stories in the *New York Times* and *Los Angeles Times*, as well as outcries in the

archaeological community. For months, the Getty was embroiled in a painful public scandal as its secrets spilled into public view.

For Getty CEO Harold Williams, the onslaught of negative press underscored his concerns about antiquities collecting at the museum. For True and Walsh, the museum's frustrated quest for the truth, which they had opposed from the start, now made them look silly and only exacerbated the Getty's dilemma.

THE WINDBLOWN GODDESS

I N JUNE 1986, while Marion True was in Europe investigating the kouros, she paid a visit to the London boutique of Robin Symes, the world's premier dealer of ancient art.

Symes was a fair, round-faced Brit, reserved by nature but possessed of an exceptional ability to sell to high-end clients. His lover and business partner was Christo Michaelides, a lean, swarthy risk taker with a keen eye for quality antiquities, whose sister had married into a wealthy Greek shipping family. Symes and Michaelides had fallen in love years earlier after Michaelides had wandered into Symes's shop in Ormond Yard. Symes was married at the time but left his wife soon after. Their nickname in the trade was "the Dioskouroi," Greek for the constellation Gemini, the Twins. Together they changed the tenor of the antiquities business by catering to elite collectors. They sold ancient art but specialized in attitude, tooling around London in a maroon Bentley or a silver Rolls-Royce. Their London house —actually two residences joined to make one—featured an indoor swimming pool surrounded by backlighted alcoves framing columns topped with ancient busts. Their Manhattan townhouse had been converted by architect Philip Johnson in 1949 for the wife of John D. Rockefeller III. They also owned apartments in Athens and a summer

compound on the Greek island of Schinoussa. Much of the energy
between them came from putting other people down.

Most of their clients were private collectors; few museums could
afford their prices. But Symes held a special status at the Getty, hav-
ing sold directly to the founder himself years before. The oil tycoon
had often visited Symes's shop, where the two engaged in good-
natured arguments over who was the greatest, Julius Caesar or Alex-
ander the Great. Getty argued for Caesar, but Symes eventually won
the billionaire over and sold him a bust of the Macedonian conqueror.
Since those early days, Symes had built his business into the most suc-
cessful antiquities dealership in the world.

True knew that her relationship with Symes could be pivotal to her
success as a curator. He dealt only in the highest end of the trade, the
very objects the Getty would need to make its collection stand apart.
Symes knew that True, as the newly appointed curator of the world's
richest museum, could be just as valuable to him.

So it wasn't surprising that on True's first official visit as curator,
Symes said that he had something special to show her. He took her
to Battersea, a rundown section of London filled with aging indus-
trial plants, and entered a dark warehouse. Standing alone, illumi-
nated from above, was a huge limestone and marble statue of a Greek
goddess.

Rising seven and a half feet high, the figure was a cult statue — a
larger-than-life object of worship that would have served as the cen-
terpiece of an ancient Greek temple. The goddess's delicately carved,
windblown dress hugged her wide, voluptuous body, giving her a
sense of mass and majesty. Her legs were slightly bent, the right foot
in front of the left, as if she were walking through a storm. Her body
was made of limestone, while her head and right arm and hand were
of milky marble. The combination of limestone and marble made the
figure a rare "acrolith," the kind found in Greek colonies of southern
Italy or Sicily, where fine marble was extremely expensive to import.
Archaeologists had recovered only fragments of such statues. The
goddess in Symes's warehouse was almost intact. With its sense of

movement and grace, it seemed to be an exemplary fifth-century B.C. Greek sculpture, representing the ideals of form and balance from the height of Greek culture.

The precise identity of the goddess was difficult to fix. The statue was missing its headdress, which would have been a telltale sign. It was also missing its left arm, and the fingers of the right hand were broken at the knuckles, as if something it had been holding had been ripped away. Its size and matronly figure suggested Hera, the wife of Zeus. But it also could be Demeter, the goddess of fertility and agriculture, who was widely worshiped in the ancient Greek settlements of southern Italy and Sicily. True, however, noted that the statue's voluptuousness and clinging gown suggested another deity—Aphrodite, the goddess of love and sexual rapture.

True immediately recognized the statue for two things. First, unlike the kouros, it was unquestionably authentic. There was nothing similar upon which a fake could be based, and it still had traces of its original pink, deep red, and blue paint clinging to the folds of the limestone dress. Second, if the Getty could acquire this statue—an acquisition that would be more significant than the Getty Bronze—it would instantly catapult the museum into the top ranks of world cultural institutions and erase the searing embarrassment caused by the kouros.

But a third thing was just as apparent: the partially reconstructed statue bore clear signs of looting. The torso had been broken into three nearly equal parts, a tactic used by smugglers to transport large objects. The edges of those breaks were sharp and the surfaces clean, indicating that they were relatively recent, not made in antiquity. The statue was also dirty. It had sandy clay in the folds, and the rest of the surface was covered with a thin rind of minerals and dirt.

True asked Symes how he had come by the statue. He would say only that he had bought it from a collector in Chiasso, a Swiss town just north of the Italian border known as a smuggling hub. The statue had been in the collector's family since 1939, Symes said. There were no documents to support the claim, and the date conveniently coin-

cided with the year Italy had passed its cultural patrimony law banning the export of archaeological objects without government permission.

Symes was sketching the kind of fanciful story that accompanied many of the best objects that appeared on the market seemingly out of nowhere. Something as important as this cult statue would have been difficult to hide from generations of nosy scholars and dealers. But Symes said that he was willing to sign a warranty vouching that the statue had been legally exported from Switzerland. The Getty would have only his word to rely on.

For the moment, however, the most disturbing thing about the Aphrodite was its price tag: $24 million, more than twice the cost of the kouros and far more than had ever been paid for a work of ancient art.

IN THE MONTHS following True's visit, John Walsh traveled to London to see the statue in person, as did Jerry Podany, the museum's antiquities conservator, who conducted a detailed study of the piece. In late July 1987, the museum asked its law firm in Rome to try to find out whether the Italian Ministry of Culture was aware of the statue. The firm sent the ministry photos of the Aphrodite, accompanied by a cryptic note saying that "an important foreign institution might be interested in buying it." Did the government have any information or objections?

The query arrived at the ministry shortly before Ferragosto, the mid-August holiday when Rome shuts down and people flee to the coasts to escape the heat. It was not passed along to regional archaeology directors until well after the break. Some of them later claimed that it never arrived.

True, meanwhile, asked four leading scholars to come to London and give their opinions of the Aphrodite. After examining the statue in the warehouse, the two British and two Greek experts agreed that it was undoubtedly authentic and probably found recently in southern Italy or Sicily. One of the experts, Nicolaos Yalouris, the former

director general of the Greek Archaeological Service, asked True whether the statue had been illegally removed from its country of origin. "Not to worry," she assured him. "It's legal."

True also showed black-and-white photos of the Aphrodite to Iris Love, a well-known American archaeologist. Love had often warned True away from objects that were so rare as to invite unfriendly scrutiny by foreign governments. Less important items would likely never be noticed, but major pieces were a different story. The Aphrodite was so exceptional, Love warned, that it would almost certainly kindle the ire of Italian officials.

"Couldn't it have come from Greece?" True asked. "Or Libya, where acroliths have also been found?"

"Anybody who knows about southern Italian sculpture is going to know it came from Italy," Love replied. "This is really dangerous, Marion. Italy doesn't have a statue of this size and of this style, and there aren't any statues in any European or American museum like it. How are you going to explain this? I beg you, don't buy it. You will only have troubles and problems."

True simply nodded her head.

THE GETTY'S EXISTING acquisition policy prohibited the purchase of suspect objects. It stated that the museum would abide by all U.S. and international laws and pledged that the Getty would not purchase anything "suspected of being illegally exported." The policy also committed the museum to "inquire into the provenance" of any antiquities acquisition. As the kouros affair had so painfully shown, such an inquiry into the Aphrodite was almost certain to turn up more troubling information.

Walsh disagreed with much of the policy. He had long felt that collecting first-rate classical antiquities was at the heart of what museums like the Getty did, more fundamental to its mission than the preservation, exhibition, or interpretation of the works. The Getty could not afford to turn down such objects. When the Getty Villa in Malibu became solely occupied by the antiquities collection, it would

become the country's first museum dedicated exclusively to classical antiquities. Filling it with the country's finest ancient art would finally make the Getty an institution worthy of Getty's generous legacy.

In a memo to Harold Williams, Walsh proposed a solution: a new acquisition policy specifically for antiquities, one that would take into account the realities of the market while providing the museum with the necessary legal protections. A new policy also would prevent another self-defeating investigation like the one the museum had done for the kouros. In fact, Walsh was proposing that the museum not investigate its antiquities acquisitions at all.

The idea made Williams, a lawyer by training, nervous. On September 2, 1987, he asked Walsh to come to his Century City office to mull over the Getty's dilemma. The discussion took place as the museum was weighing its decision about the Aphrodite. The statue would be a test case for Walsh's proposed new policy. As Walsh jotted notes on a legal pad, the two discussed the various legal risks of adopting a "no questions asked" policy for buying antiquities.

"We are saying we won't look into the provenance," Williams said. "We know it's stolen . . . We know Symes is a fence."

Williams was being provocative, but not without reason. As he had learned in the kouros episode, it was widely known that the Getty's antiquities dealers routinely peddled looted art.

What would happen if a foreign government challenged the provenance of an object? If the dealer didn't defend it, would the Getty have to surrender it? Could the Getty be held liable under the 1977 Foreign Corrupt Practices Act if bribes were paid to foreign officials? Williams suggested that Bruce Bevan, the Getty's outside counsel, review the UNESCO Convention and the statutes of limitations relating to American laws governing the receipt of stolen goods.

They agreed that Walsh would discuss the new acquisition policy with Bevan, then meet with Bevan and True to go over it. In the meantime, Williams asked Walsh to consider two big-picture issues: First, legalisms aside, what was the appropriate moral position? And

second, what would the Getty say publicly about such acquisitions? In other words, how would it look on the front page of the *New York Times*?

The discussion marked a pivotal moment in American museum history. For generations, museums had acquired looted ancient art with no questions asked. Williams was now challenging the Getty to consider the morality of that practice and to decide whether it made sense to continue it. Few American museums at the time had confronted the issue as directly as the Getty was now doing.

Two days later, Williams and Walsh met again, joined by Bevan and True. Bevan outlined the proposed policy. The museum would buy antiquities no questions asked, relying instead on warranties from the dealers that the objects had been legally excavated and exported. Before buying important objects, the museum would notify the likely country of origin, giving foreign governments an opportunity to present any concrete evidence they had before the purchase was finalized. And lastly, the museum would publish all acquisitions, providing yet another opportunity for anyone to raise objections. If the museum was presented with substantial evidence that an object had been recently looted, it would give the piece back. But it would not aggressively seek out such information on its own. In effect, the policy shifted the burden of proof onto others.

Once again, Williams was concerned. How can we be good-faith buyers if we knowingly buy stolen goods, accept warranties from dealers we know to be liars, and choose not to investigate their claims? he asked. In his typically blunt way, he boiled the issue down to a simple question: "Are we willing to buy stolen property for some higher aim?"

With that question hanging in the air, Walsh retreated to his office and began working through the knots of the problem on his legal pad. The Getty could simply stop buying antiquities, but that would accomplish nothing. If the Getty didn't buy the objects, the looting would continue, and the objects would be bought by competing museums or slip into private collections, out of public view. Was this the

moral high ground to take? The museum could investigate objects before acquiring them, as it had done with the kouros, but it might learn nothing. Worse, the inquiries might confirm that the object had indeed been looted. What then? Asking too many questions of dealers and curators also created an incentive for them to lie about an object's origins. The real moral approach to the problem, Walsh concluded, was to continue buying the objects regardless of their origins.

Walsh met with True to go over the proposal. The two drafted a memo that laid out the rationale for changing the current policy. Walsh and True framed the move as setting a brave and rigorous new standard, one that went far beyond that of any other major museum in America. "The policy we propose . . . is far reaching in its ramifications," they wrote in a confidential memo to Williams on November 4, 1987. "We believe we should go beyond what is demanded by the law . . . and abide by the highest possible ethical standards in our collection policy."

In fact, the policy paved the way for the Getty to ignore the law and continue to buy looted antiques.

NOT EVERYONE INSIDE the Getty considered the new policy an ethical improvement. Luis Monreal, the director of the Getty Conservation Institute, exploded over what he considered to be a bold hypocrisy. The Spanish-born, slightly built Monreal was an expert in antiquities conservation. He had served as secretary-general of the International Council of Museums, a UNESCO affiliate responsible for establishing museums and training curators in third-world countries. He had taken the helm of the Getty Conservation Institute in 1985, running a staff of forty-seven people from twenty different countries out of nondescript offices in Marina del Rey, about ten miles down the coast from Malibu. From the beginning, the museum's appetite for tainted antiquities was anathema to the Conservation Institute's mission of preserving and protecting cultural patrimony around the globe.

This institutional infighting at the Getty was exacerbated by the

personalities of Walsh and Monreal. Though strong willed, Walsh was aloof and hard to read. Monreal, meanwhile, was flashy and incapable of keeping an opinion to himself. Like brooding siblings, they often clashed at directors meetings. They were technically equals on the Getty Trust's organizational chart, but the museum had a bigger budget than the institute and had always been favored by trustees. Still, Walsh knew that institutional courtesy called for running the proposed antiquities acquisition policy by his fellow program directors, so he set up a lunch meeting at an Italian restaurant near the Santa Monica airport.

After the men placed their orders, Walsh pulled a paper from his jacket pocket and rattled off the policy's bullet points. As Monreal listened, he felt his face grow hotter and hotter. Who was Walsh trying to fool? Everyone knew that source countries such as Italy, Greece, Lebanon, Syria, and Cyprus didn't have the manpower or technology to keep up with the rampant looting. Asking them to provide proof that an object had been looted was an empty exercise, a flimsy attempt to make it look as though the museum was acting morally. And Monreal was sure that Walsh felt that way, too.

"John, let me look at it. I want to think about it," Monreal said.

Walsh refused to give up the paper.

"John, this policy is at a minimum unreasonable and at a maximum cynical and deceptive. It's just window dressing to allow you to keep buying from this illicit market. You're putting the Getty on a road to future disaster with foreign governments and public opinion."

"Well, Luis, you don't see it clearly," Walsh said softly. "I've studied these things properly, and this is the result of a major effort and lots of consultations."

Walsh apparently wanted to be able to say that he had consulted Monreal, but he didn't really want to hear what Monreal thought.

"John, I think we have nothing else to talk about."

Back at his office, Monreal called Williams to register his protest. The Getty chief said that he was fully behind Walsh. They presented the new antiquities acquisition policy to the board on November 13.

It was approved, with Monreal sitting silently nearby. Neither Williams nor Walsh indicated to the trustees that there had been any opposition.

A week later, the Getty's Italian lawyers received an answer to their inquiry about the Aphrodite. The Italian Ministry of Culture had no information about the statue.

THREE WEEKS LATER, the 1,300-pound Aphrodite was put into two crates and loaded onto a Pan American flight from London's Heathrow Airport to Los Angeles International. The customs form listed its country of origin as Great Britain. Its insurance value was $20 million. Upon their arrival in Los Angeles, the crates were immediately hauled to the Getty's conservation laboratory, where they were carefully unpacked.

Symes had loaned the Aphrodite to the Getty for a year of study, but there was little doubt what would happen next. The statue soon began drawing crowds of curiosity seekers from among the Getty staff and board members. Many who came to see it were in awe. It was the kind of acquisition that could put the Getty on the map.

Monreal was among those who made the pilgrimage to see the goddess. Walking into the museum's conservation lab, he spent twenty minutes studying the clay-filled folds of the flowing gown, the sharp edges of the breaks through the torso. The surfaces of the breaks were clean, showing no sign of the calcite rind that covered the outer surfaces. They were recent. Monreal figured that the looters had broken the statue with a large object, using a piece of wood to blunt the impact.

As he left the lab, he bumped into a colleague in the hall. "Have you seen the Aphrodite?" the man asked, excited.

"Yes," Monreal answered darkly. "How could the museum even consider buying this thing?"

"But it's fantastic!"

"Are you kidding? This thing is a hot, hot potato."

Word of Monreal's public criticism reached Walsh even before the

conservation director had time to get back to his office and call him. "John, it's downright irresponsible to consider this piece for acquisition," Monreal said angrily. He offered to have his staff analyze the dirt in the statue's folds. If it contained pollen, it might help pinpoint where the statue had been dug up, allowing archaeologists to reconstruct something of its context.

Walsh ruled out a pollen test. "Luis, we've done everything necessary to make sure the statue wasn't illicit."

Rebuffed, Monreal went over Walsh's head, bringing up the issue with Williams. He asked the CEO not to go forward with the acquisition unless the tests were done. "Harold, it's not a good idea for the Getty to buy this piece. It has all the signs of being illegally traded and recently excavated, and this could be a delayed time bomb . . . This isn't the kind of piece you want to be playing with."

Williams was unmoved. With the new policy on the books, the CEO closed ranks with his museum director. He considered Monreal an alarmist and believed that the museum was taking all the appropriate precautions.

ON MAY 11, 1988, True submitted her formal nine-page acquisition proposal for the statue to the full board. She wrote:

> It is impossible to exaggerate the importance of the proposed statue for this museum or, indeed, for any other collection in the world. It surpasses even the kouros and the bronze Victorious Athlete in rarity and importance. Original stone sculpture of the fifth century BC came to be considered the acme of human artistic achievement by the Romans under the Empire, the Italians of the Renaissance, and every succeeding western society in various phases of Classical revival.

What set the sculpture apart, and confirmed its creation in the fifth century B.C., was the goddess's intricate windblown dress, a technique first developed by Phidias, the greatest Greek master of the high classical period. He used it when supervising the creation of the Parthe-

non's east pediment, a scene that depicts the birth of Athena. The goddesses gathered around her wear damp, diaphanous gowns that readily reveal their naked bodies underneath. The "wet drapery" style swept through Greek civilization and was imitated by sculptors in the Greek colonies of Sicily and southern Italy, where the Aphrodite was likely created.

"Such sensitivity is never completely understood or recaptured by later sculptures . . . She is the perfect embodiment of the greatest achievements of Greek sculptors of the 5th century BC," True wrote. Indeed, her only peers were the Parthenon marbles that Lord Elgin took from the Acropolis and that now resided in the British Museum. True continued:

> The proposed statue of Aphrodite would not only become the single greatest piece of ancient art in our collection; it would be the greatest piece of Classical sculpture in this country and any country outside of Greece and Great Britain. In our effort to assemble a collection of objects of the highest artistic quality and importance, we will find no finer piece of sculpture to represent the accomplishments of the Greek artists of the fifth century BC, the culmination of two centuries of artistic and intellectual development that would become the standard against which all later European art would have [to] be measured.

The statue's price had been negotiated down to $18 million — nearly twice what the Getty had paid for the kouros. The Aphrodite was worth it, True argued.

THREE THOUSAND MILES away, the phone rang at *Connoisseur* magazine in New York. Thomas Hoving answered. On the other end was one very upset antiquities dealer. Would Hoving be interested in an even bigger story than the Jiri Frel tax scam or the fake kouros?

A top Sicilian smuggler had offered him a large limestone statue two and a half years ago for $2 million, the dealer said. The smuggler had said that the statue had been found in Morgantina, Sicily, in 1979,

and had already been turned down by a private collector and dealers in Paris, Switzerland, and New York. The dealer told Hoving that he had turned it down because it was "too hot." Now the Getty was going to buy it, and the dealer was steamed: the Getty had put a purchase from him on hold because it needed the money for the statue. The dealer told Hoving that True had bragged that the Getty had "pulled the wool over the eyes of the Italians" by sending them photos of the object but not revealing who was going to buy it.

Hoving hung up, delighted. He would have another shot at the Getty. He asked his reporter in Europe to call the Getty and ask for a comment on what they had learned. The call came a week before the trustees were scheduled to take their final vote on the Aphrodite purchase and sent True scrambling again.

THE CULT OF PERSEPHONE

THE BRIGHT YELLOW DHL van carrying photos of the Aphrodite looked out of place as it jostled down the winding, potholed road to the ruins of the ancient Greek city-state of Morgantina, which sits much as it did twenty-five hundred years ago, surrounded by olive and wheat fields atop a promontory in central Sicily.

Watching the van with bemused curiosity was Malcolm Bell. The wiry, bespectacled University of Virginia archaeologist was standing knee-deep in a trench, wearing his signature floppy hat. Bell had been digging at Morgantina on and off since 1967, his final year as a Princeton graduate student. A decade before his arrival, a team of Princeton archaeologists had discovered the site when a graduate student dug up a coin stamped with the word *Hispanorum*, Latin for "of Spain." Looking back through the ancient sources, the student found that the only time Spaniards were linked to the region was in the chronicles of Livy, the Roman historian, who wrote that the Greek city-state of Morgantina had been given to Spanish mercenaries when it was conquered by Rome in 210 B.C. The storied center of wealth and fertility had finally been found.

Morgantina was laid out in typical Greek fashion: a neat grid of streets radiating from a central agora, a large square that served as the

political and economic heart of the city. Morgantina's agora was the largest in the ancient world, covering six city blocks and lined on three sides by long stoas, two-story covered colonnades that held shops, government offices, and a public bank. At its peak, the city supported some ten thousand people, mostly families that each owned a plot of land. It was an egalitarian society that reached its apex just as the Roman army rolled through western Sicily. Soon after, Morgantina's residents were driven out. Nearly 250 years after its founding, one of Greek civilization's most glorious outposts was abandoned.

Morgantina's ill fortune proved a boon to the Princeton archaeologists. Excavations uncovered signs of a dedicated cult following of Demeter and Persephone, the mother-daughter goddesses of fertility. The story of Persephone's abduction by Hades, god of the underworld, was the Greek explanation for the changing of the seasons. After the beautiful young woman disappeared while gathering wildflowers along the shores of Lake Pergusa, Demeter searched the earth for her, in vain, carrying an outstretched torch to light her way. Eventually, Demeter learned of the abduction and threatened to leave humankind in a perpetual winter if her daughter was not returned. Zeus brokered a deal that let Persephone out of the underworld to be with her mother for nine months every year — the harvest cycle of spring, summer, and fall. For the three months of winter, Persephone had to return to Hades, leaving the fields barren.

As the breadbasket of southern Europe, central Sicily had a strong link to this fertility myth. Indeed, Morgantina was a short walk from Lake Pergusa. In the late 1970s, Princeton archaeologists unearthed a complex of twenty small temples used for centuries to worship the goddesses. Nestled along a steep hillside thick with orchards of figs and pomegranate trees, the temple complex contained dozens of terra-cotta busts of Persephone and Demeter.

If Morgantina's discovery was a boon for archaeologists, it proved a bonanza for local looters. After the excavators returned home from a summer of digging, the site fell prey to looters from the nearby hill town of Aidone. Bell did what he could to fend them off, hiring guards

to watch the site during the winter months. But the tomb robbers, or *tombaroli* as they were known locally, proved tenacious competitors for the relics of the ancient city. Bell once returned to the ruins after Sunday supper and stumbled upon a group of men hastily emptying a tomb of some 350 objects. Among the men was Giuseppe Mascara, the well-known boss of local looters. Mascara and his men were arrested by the Carabinieri, the national police, but soon released. The next time Bell caught the looter, he was prowling the ruins with a metal detector. Bell chased him over the city wall and into a bramble patch.

For his vigilance, Bell suffered some strange mishaps. He discovered two nails pounded into the tire of his Volkswagen Beetle. A Bunsen burner in his lab was found leaking gas, its line severed. When someone smashed his windshield, Bell realized that the Mafia was sending him a message: if he wanted to stay in Sicily, he would have to learn to live with them. Bell accepted an awkward coexistence with his archaeological enemies, who ransacked Morgantina much like the Spanish mercenaries had done nearly two millennia before.

By 1988, when the DHL truck wound down the road to Morgantina bearing a package from Marion True, Bell had all but given up the fight.

A FEW DAYS earlier, Bell had received a hasty phone call from the Getty antiquities curator asking if he knew anything about the discovery of a limestone statue of a goddess at Morgantina. True promised to mail him several black-and-white photos of the statue.

Now opening the yellow pouch, Bell found the photos and a brief note. "Recently a rumor has reached us that the object may have come from Aidone or Morgantina," True wrote, referring to Hoving's inquiry. "Although we do not wish to be at the mercy of every journalist's unfounded attack, we also do not wish to pursue the acquisition in obvious disregard for the laws of Italy."

Looking at the photos, it was hard for Bell to imagine that such a large and important piece could have been found at Morgantina with-

out his having heard about it. But he couldn't rule it out. In a nearby museum was a similar limestone statue of a woman that archaeologists had found in the city's agora in 1956, although that statue was likely 150 years later than the one in the photographs.

Bell believed that a cult statue the size of the Getty's Aphrodite would have been housed in a large temple, but in thirty years of excavation at Morgantina, no one had found such a shrine. If it was truly Aphrodite, as True suggested, that was additional evidence against a Morgantina provenance. There was little evidence of the ancient worship of the love goddess there. Looking closely at the photos, Bell thought that True's identification of the statue might be wrong. It appeared that the Getty's goddess had worn a veil, suggesting a more matronly figure than Aphrodite. Perhaps it was Hera, Zeus's wife — or Persephone, which might very well point back to Morgantina. Without the statue's headdress or any indication of what the figure's outstretched hand once held, it was impossible to tell.

Most important was the dating. The statue's "wet drapery" style and naturalistic features clearly belonged to the late classical period, putting the probable date of creation between 410 and 390 B.C., a time when Morgantina was in economic decline. It didn't make sense to Bell that the city would have commissioned such a monumental statue during an economic depression.

Bell wrote back to True a week later with a carefully mixed message. There were reasons to doubt that the statue came from Morgantina, but looters had found important objects there in the past. "I would therefore not rule out as a possible provenance for the piece at Morgantina," he wrote. "At the same time I can say that, at the time of writing, I know of no reason to argue that it was found at Morgantina."

Bell made copies of the photographs and brought them to Italy's regional director of archaeology, Graziella Fiorentini, who had dug at Morgantina in the late 1970s. It was the first time Fiorentini had seen the photos — the same photos the Getty's lawyers had sent to the Culture Ministry in Rome. The photos had failed to make it to her desk

in Agrigento. Fiorentini was instantly reminded of the rumors she had heard in 1978 during her last season at Morgantina, the year before Bell had returned. That year, the town had been abuzz with talk of the large, intricately carved statue of soft stone that looters had found in the temple complex, where busts of Demeter and Persephone also had been discovered.

Digging in her files, Fiorentini uncovered two handwritten reports that lent support to those rumors. The site's guards had documented illegal excavations in November 1977 and December 1978 in the temple complex. The tombaroli had left behind several large holes in the ground and what appeared to be a limestone pedestal for a life-size statue. Armed with the circumstantial evidence, Fiorentini cabled True to say that she believed the Getty's statue may have been found at Morgantina.

The cable wasn't welcome news at the Getty, where the board had already approved the acquisition and was preparing to close the transaction. Fiorentini's warning was infuriatingly vague. True tried calling the archaeologist repeatedly, hoping to get more information, but Fiorentini played coy, refusing to come to the phone. She was worried that True would seize on any admission that Fiorentini lacked concrete evidence to support her hunch. Fiorentini hoped to stall until a proper investigation could be launched.

The ploy backfired. "If you have no information, your negative response confirms the answer we already received from the Ministry," a frustrated True fired back in a cable.

Fiorentini contacted the Carabinieri's stolen art squad in Rome, providing copies of the photos and requesting a formal investigation. Then she sent True a Mailgram putting the Getty on notice that Italian officials had opened an international investigation into the statue's origins.

The Mailgram arrived on the afternoon of July 22, 1988. That same day—the precise timing isn't clear—Harold Williams signed the final documents consummating the purchase of the Aphrodite.

• • •

FIORENTINI'S REQUEST LANDED on the desk of the Carabinieri's art squad, the Tutela Patrimonio Culturale. Established in 1969, it was the first police unit in the world dedicated exclusively to tracking stolen art, a monumental order for a country that virtually bleeds culture. The art squad was headquartered in Rome's rococo Piazza di Sant'Ignazio, a few blocks from the Pantheon and around the corner from the Ministry of Culture, to which the unit reported.

In its early days, the unit was given only a handful of agents to accomplish its impossible task—protecting the millions of cultural treasures along the length of Italy's boot. Constructing a highway, excavating a building foundation, or even digging a simple rural well routinely unearthed dozens of archaeological treasures, all of which could be spirited away to the antiquities market.

Tips poured in, but the guardians of Italy's cultural heritage could pursue only the most significant cases. Limited resources made compromises inevitable. Unlike colleagues in the drug unit, the art squad concentrated on recovery, not arrests. When caught in the act, a drug dealer might flush the cocaine down the toilet. The art squad couldn't take the risk that an art thief would try something similar, cutting to ribbons a priceless painting or smashing an ancient vase to avoid prosecution. The squad often let a looter go if he agreed to return a valuable antiquity. Although that meant recovering some prized objects, it relegated looting to little more than a traffic violation. The squad's poor track record was compounded by the fact that a number of agents were either incompetent or marking time before retirement.

To compensate for its limited effectiveness, the squad indulged in elaborate recovery ceremonies, featuring Carabinieri in their signature blue paramilitary uniforms standing at stiff attention around a velvet-lined table holding the prodigal object. The spectacles masked a deeper political problem: in the constantly shifting landscape of Italian bureaucracy, no one had the political will to stop the looting or set aside more than a token budget for the art squad. A fraction of 1 percent of Italy's national budget went to protect its vast cultural heri-

tage—less than other European countries with far less significant archaeological resources spent.

By the 1980s, Italy had yet to reckon fully with the escalating loss of its vast archaeological heritage. Looting remained rampant across the country, with corrupt officials often working in cahoots with the smugglers. Still, those spectacular pieces that got away—the Met's controversial Euphronios krater, the Getty Bronze, and now the Aphrodite—were sources of shame for some Italians.

One of those angered by the antiquities trade was Silvio Raffiotta, a state prosecutor in Sicily and an amateur archaeologist who had grown up in a house that overlooked the ruins of Morgantina. Many of his boyhood friends had turned to looting as a second job. Raffiotta felt that they were merely pawns of the real culprits—the cartel of foreign dealers, mostly based in Switzerland, who paid diggers pennies while getting rich on the illicit antiquities trade. Determined to shut down the trade, Raffiotta launched an investigation into the looting shortly after he became state prosecutor in Enna, the regional capital, not far from Morgantina. Wiretaps on the phones of a few local tombaroli soon uncovered a far more organized criminal network than he had imagined. The recorded conversations revolved around one man, Giuseppe Mascara, the local boss whom Bell had once chased into the brambles. Armed with transcripts, Raffiotta arrested Mascara and some forty other looters from the surrounding towns.

In a jailhouse interview, Mascara admitted that he had been involved in selling some of the smaller finds in the area. But the three truly great discoveries pried from Morgantina's soil had gone straight to middlemen able to pay up-front, he said. The first of these discoveries was an ancient silver service. The second was a group of three marble heads. The third was a large, intricately carved statue of soft stone.

The member of the Carabinieri art squad assigned to the investigation was Fausto Guarnieri. He developed sources among the loot-

ers around Morgantina. They were men of little education but great pride, men who considered themselves amateur archaeologists—and victims. They were paid peanuts for great masterpieces now on display in foreign museums. Guarnieri appealed to their resentment against those who made more money up the distribution chain.

The sources were able to fill in details about the discoveries Mascara had mentioned. The silver service had been found in the ruins of an ancient house just off the main road through Morgantina. Orazio di Simone, an alleged smuggler from the nearby coastal town of Gela, had bought it. The silvers fetched $875,000 when di Simone sold them to Robert Hecht in Switzerland. Rumor had it that they had been purchased by the Metropolitan Museum of Art in New York for far more.

The three marble heads had been discovered by two shepherd brothers in 1979 after heavy rains had unearthed one of the objects in the temple complex dedicated to Demeter and Persephone. Two of the heads were smaller in size and older than the third, which bore the finely modeled features and serene face of the classical era. All three were also sold to di Simone through middlemen for $1,000.

Raffiotta turned to Bell, whom he had befriended over the years, for help in tracking the heads down at the other end of the market. The objects were so unusual that doing so proved rather easy. The archaeologist learned that the Getty Museum had recently put two marble acrolithic heads on display. He had a colleague go to the museum to take photos of them. The placard said that they were on loan from an unnamed New York collector. Bell gave the photos to Raffiotta, who confirmed with Mascara and the other tombaroli that they were the same heads that had been found in Morgantina.

But Bell couldn't find the third head, the one from the classical era. The same was true for the large statue of soft stone that Mascara had described. Guarnieri found that there had been persistent rumors about the statue—even the local mayor and his assistants knew of it—but that its current location was a mystery.

Assessing the case, Raffiotta and Guarnieri felt that the tombaroli's

testimony and the photos of the two heads gave them enough evidence to press a criminal case that would charge the Getty Museum with possession of stolen property. It was a bold step. Not since the controversy over the Euphronios krater had an Italian prosecutor accused a foreign museum of playing a role in looting. Just as they were preparing to take their case public, Fiorentini's demand for an investigation into the Aphrodite landed on their desk.

IN LATE JULY 1988, less than a week after buying the Aphrodite, the Getty Museum revealed its marquee purchase. True told the press that it was "unique to the world . . . the only complete acrolith known to exist" and a "critical addition" to the museum's collection, which had lacked a centerpiece for its objects from the classical period. As to its origins, a Getty press release was circumspect. The statue had been acquired from a European dealer representing a private collector, it said, adding that such acroliths were most commonly found in southern Italy and Sicily, where marble was scarce.

The announcement provoked awe in the art world. Once again, an important piece of classical sculpture had seemingly appeared out of nowhere and was now on display at the Getty. For Thomas Hoving, however, it was confirmation that his disgruntled dealer had been onto something. After receiving the tip, Hoving had deployed one of *Connoisseur*'s best researchers to Sicily to investigate the origins of the statue. His reporter contacted Fiorentini, who described her suspicions about the statue and mentioned the pending criminal investigation. Hoving had a hot scoop.

Fearing that the story wouldn't hold for *Connoisseur*, which wasn't due out for another month, he shopped it around to several newspapers. On August 3, 1988, the *International Herald Tribune* ran an exposé on the Aphrodite across two columns on the front page. The *Los Angeles Times*, which had turned down Hoving's story, had its own staff-written story the same day. It quoted Fiorentini as the source of allegations that the statue may have been looted from Morgantina. The case against the statue, the story noted, was "rooted less in hard

clues than in scholarly deduction and rumors of archeological grave robbing."

The allegations caused a public scandal reminiscent of that stirred up by the Euphronios krater sixteen years earlier. Newspapers throughout Europe followed up, and journalists descended on Morgantina to track down the origins of the Aphrodite. Once there, however, they were greeted with confusion.

In Enna, Silvio Raffiotta was fuming. Circumstances had conspired to steal his thunder about the two marble heads at the Getty. Instead, everyone was focused on the Aphrodite. As the international press swarmed the area, the prosecutor called a hasty press conference to announce that there was indeed loot at the Getty—but not the loot the reporters were asking about. The two marble heads, Raffiotta claimed, were historically and artistically "much more interesting and valuable" than the goddess. And whereas there was no concrete evidence concerning the Aphrodite, Raffiotta declared that he could unequivocally prove that the two heads now sitting in a Getty showcase had been looted from Morgantina.

Raffiotta's pique deflected journalistic attention from the goddess, sending reporters back to the Getty to ask about the heads. The museum said little. The night after Raffiotta's press conference, the heads were hurriedly taken off display, boxed up, and sent back to Maurice Tempelsman, the New York collector who had bought them from Robin Symes.

The next day, the museum announced that the objects in question had been returned. "Any discussion of the possible provenance of these objects should be between their owner and the Italian government," a spokeswoman said, refusing to name the owner.

The story of the two heads soon died. Meanwhile, the Aphrodite remained on display, almost forgotten in the swirl of controversy.

Within the Getty, the Aphrodite's debut brought the feud between John Walsh and Luis Monreal to a head. Monreal, who had so bitterly protested the statue's acquisition months earlier, read about

the statue's raucous debut in Greek, Italian, French, and British papers while vacationing in the Greek islands. He fired off a four-page screed to Walsh and Harold Williams on August 7, repeating his warnings about the statue and calling on the museum to stop buying undocumented antiquities.

Walsh fired back a bare-knuckle response, bristling at Monreal's criticism. Monreal's plea was "unduly restrictive," Walsh wrote.

> When you wrote that any policy should recognize that a high percentage of the best archaeological material is illicit, if not illegal, did you think that we or the trustees don't already know this? Your corollary, that we should refrain from purchasing antiquities which do not have clearly established status, sounds good but what does that mean? . . . This kind of guilty until proven innocent approach . . . is an alternative that has been advocated by some of our colleagues and one that we presented to the trustees and discussed at great length. The trustees concluded that such an approach is not only unrealistic, but in many cases works against the preservation of works of art.

The Aphrodite was the perfect example, Walsh concluded. If Italian cultural officials ever mounted a credible claim for the piece, they'd "find the Getty to be more reasonable and generous than a dealer would be, since we're obligated to return the piece regardless of the statute of limitations."

Monreal saw Walsh's response as merely another smokescreen. He simply couldn't countenance what the Getty had done and began making plans to leave.

MEANWHILE, ITALIAN ART squad investigator Fausto Guarnieri was just beginning his investigation into the Aphrodite's origins. After receiving Fiorentini's files, he inquired among his Sicilian sources, showing them photos of the Getty's new goddess. Was this the same statue of soft stone found at Morgantina in the late 1970s? It was, the local diggers assured him—but it had been found without the head

now attached to it. The goddess's delicate marble face was the missing third marble head, they claimed. It had been found separately at the same time as the two smaller heads and only later placed on the statue. Mascara, the boss of the local looters, took Guarnieri to the site in Morgantina where the statue had been found, not far from where the three heads had been discovered.

From Morgantina, the statue had followed a similar path to the market as the silvers and two marble heads, Guarnieri's sources told him. After its discovery, middlemen had sold it to Orazio di Simone. Some had seen the body of the statue—without the head—in three pieces at the house of a looter in Gela, di Simone's hometown. The huge statue had been toppled over onto a blunt object, breaking it cleanly into three pieces that would be easier to hide during transport. The clean breaks also would make the statue easier to reassemble. The pieces were then driven to Milan, buried under a load of carrots in the back of a Fiat truck, and transported north across the border to Chiasso. The smugglers used a carrot truck because the vegetables were transported loose, rather than in crates, making it difficult for customs agents to dig through the pile. Guarnieri's sources said that the statue was later put back together in Switzerland and topped with the marble head.

Unknown to Guarnieri, the account he pieced together from his sources matched an anonymous tip that had been passed on to the Carabinieri by Interpol. A confidential source told Interpol authorities in Paris that the statue had passed through the hands of Nicolo Nicoletti, a reputed looter from Gela who worked with di Simone. The tipster maintained that di Simone, who had a second residence in Geneva, had sold the statue in December 1987 to Robin Symes through a Swiss front company called Xoilan Trading.

The Italians believed that they had enough to prove that the Aphrodite had been taken out of Italy illegally. In June 1989, Raffiotta filed criminal charges against di Simone, Nicoletti, and others. Nearly all of the evidence came from confidential sources. Hoving refused to divulge the name of the antiquities dealer who had initially tipped him

off about the statue's origins. Those who had cooperated with Guarnieri were silenced by omerta.

To fill in the gaps, Raffiotta began the tedious task of issuing a series of requests for judicial cooperation to the various foreign governments where other witnesses lived. He asked the U.S. Customs Service to interview the New York dealers who Hoving said had been offered the statue. After a year's delay, the Customs Service conducted brief interviews with the dealers and informed the Italian authorities that all of them denied Hoving's account. At Raffiotta's request, Scotland Yard interviewed Robin Symes in London. The dealer claimed to have purchased the statue from a family in Lugano, Switzerland. Asked to name the family, Symes demurred, saying it would be "a breach of professional ethics and confidence."

Guarnieri eventually managed to track down di Simone in Switzerland. In an interview, the alleged smuggler described himself as an expert in ancient coins and denied having ever sold an object of significance, including the marble heads or the statue. He claimed not to know anyone at the Getty, although he admitted visiting the museum in 1979.

Desperate, Guarnieri shut off the tape recorder and asked di Simone for his help. "You only made a little money on this deal, but they made millions," the investigator pleaded. "Help us. It would be a shame if the statue didn't come back to Sicily."

Di Simone appeared sympathetic and offered to "look into it."

"Tell me one thing," Guarnieri said. "Did the statue come from Sicily?"

Di Simone nodded his head yes, while mouthing a different message: "I can't tell you . . . I don't know."

Guarnieri took the mixed message to be a signal. It was as close as anyone in Sicily ever came to making a confession. Di Simone couldn't admit it out loud, but he was telling Guarnieri that he was on the right track.

After four years of investigation, Raffiotta and Guarnieri had exhausted their leads. The results were disappointing. They believed

they knew where the statue of Aphrodite and the marble heads had been found, how they had left the country, and who was responsible for the crime. But no one involved would agree to come forward.

In June 1992, a Sicilian judge dismissed the case against di Simone and the others, ruling that there was insufficient evidence. Soon after, Guarnieri retired. His file on the Aphrodite was tagged for the archives, where it sat with hundreds of other unsolved art cases.

PART II

THE TEMPTATION OF MARION TRUE

THE APTLY NAMED DR. TRUE

S LOWLY, THE WORLD was changing. Even as the Getty was ac-
quiring the Aphrodite, a group of European museum and cultural
officials took the first steps toward repudiating such purchases.

At the 1988 International Congress of Classical Archaeology in
West Berlin, a conclave of archaeologists, museum officials, and cul-
tural attachés from the primary collecting countries—Germany,
France, and Britain—and the major source countries—Cyprus,
Greece, Turkey, and Italy—deliberated over the pressing dilemma
created by the illicit antiquities trade, which now dominated the mar-
ket. How could conscientious museums stop buying from the market
but continue to build their collections and educate their patrons?

Leading the discussion was Wolf-Dieter Heilmeyer, chief of antiq-
uities for West Berlin's Museum of Classical Antiquities. A contem-
porary of Marion True's, Heilmeyer was among the leaders of a new
generation of curators filling key positions in Europe's cultural insti-
tutions. They had come to authority with a broader vision than their
mentors, one that favored international cooperation over colonial-
style domination. They were also closer to the damage being wrought
by looting. And unlike their American counterparts, which were by
and large running private collecting institutions competing against

one another, European curators were managing state-run institutions often closely affiliated with archaeologists and researchers. Heilmeyer, for one, had begun to question the basic premise that had sustained museums from the beginning: did museums really need to own art?

Heilmeyer's radical thoughts grew out of legal necessity. He had joined the West Berlin museum in 1978 and was well acquainted with the shady corners of the antiquities trade. In the 1980s, a well-known antiquities dealer had sold him sections of an ancient sarcophagus that was supposedly part of a nineteenth-century Swiss collection. The sarcophagus turned out to have been recently looted. An Italian museum in Ostia, just outside Rome, notified the West Berlin museum that it had located some adjoining pieces of the object. Heilmeyer saved face by convincing his board to make a long-term loan of the object to the Ostia museum, where it was reunited with its other portion. In return, Ostia loaned Heilmeyer's museum two invaluable second-century A.D. frescoes featuring large griffins.

Heilmeyer saw the exchange as the path to resolving similar disputes between collecting countries and source countries, which had grown increasingly hostile. But when he asked to put a discussion of his ideas on the agenda for the archaeological conference, the organizers refused, fearing the topic was too "political" and would invite nationalist sentiments to taint the scientific proceedings. As a compromise, they offered him the use of an empty room on the afternoon after the conference had concluded.

A standing-room crowd of more than one hundred people packed in as Heilmeyer led a panel of twelve prominent museum and archaeological officials in a sometimes charged discussion, perhaps the first of its kind to tackle the thorny political issues of national identity and the illicit antiquities trade. When he presented a statement of principles, there were heated exchanges over the wording. Vassos Karageorgis, the director of antiquities from Cyprus, refused to sign the statement because it did not explicitly condemn the rampant looting in the Turkish-occupied part of Cyprus. "We will never give a loan to Tur-

key!" he declared. But he eventually backed down, signing only the portions of the document he agreed with.

Europe's most influential antiquities curators—including Brian Cook of the British Museum and Alain Pasquier of the Louvre—affixed their signatures to the entire document, which became known as the Berlin Declaration.

The statement urged museums to investigate the ownership of objects to make sure they weren't illegal and called on antiquities-rich countries to loosen their grip on artifacts in their vast inventories and make them available for long-term study. Italy was particularly supportive of the measure and vowed to double the length of its loans, which at the time were limited to six months, barely enough time for a traveling exhibition. But many American museums took the declaration as a direct attack on the values they held most dear: a deep belief in the free trade of cultural goods, the right of museums to collect, and the conviction that an object's aesthetic value is as important, if not more so, than its historical significance.

As word of the statement reached America, most museum leaders there shrugged it off. Met director Philippe de Montebello, who had succeeded Thomas Hoving in 1977, seemed amused when Heilmeyer later discussed the Berlin Declaration with him. "Well, this is a good idea," de Montebello said, "but it will never work."

Marion True did not attend the conference. But in a stroke of good timing, she was soon presented with an opportunity to wrap herself in the same mantle of reform.

IN OCTOBER 1988, while the Aphrodite controversy was still white-hot, True took a cold call from a European art dealer she didn't know. The dealer was offering the Getty four sections of a large Byzantine mosaic.

The Getty, thanks to its famed wealth, was a favorite target of unsolicited offers. They came in as often as twice a week, often from cranks and goldbrickers offering some knickknack their grandfathers

had picked up during World War II. Most of the time True ignored them, leaving her staff to fend them off with polite refusals. But this phone call intrigued her. The mosaic was a remarkable relic featuring carefully arranged chips of colored glass portraying biblical scenes in jarring detail: an archangel; the Apostles Matthew and James; Christ as a boy. True suspected that the piece had come from Cyprus, where looting was rampant in the northern part of the island, which had been under occupation by Turkish forces since 1974. Yet what really caught her attention was the price tag: $20 million. Not even the record-setting Aphrodite had cost that much.

"Holy doodle," she muttered to herself.

There was no chance of the Getty acquiring the mosaic; the museum did not collect Byzantine art. So True placed a call to Karageorgis, one of the Getty's strongest allies in the Mediterranean. Karageorgis had started out as an adversary, calling out the museum three years earlier over its display of a Cypriot idol his government believed to be looted. After lengthy negotiations, True's predecessor, Arthur Houghton, had fashioned a peace that only the Getty could afford. The Getty kept the idol and in turn underwrote a major conservation project in Cyprus. At the time of True's call about the mosaic, the Getty was about to fly Karageorgis to Malibu to be honored at a colloquium on Cypriot art—another sweetener in the deal.

Karageorgis became alarmed when he heard about the mosaic. He believed that it had been illegally removed from the Church of the Panagia Kanakaria in northern Cyprus. The government and Greek Orthodox Church had published it extensively as being stolen. He moved quickly to have American authorities seize the fragments. With True's help, investigators learned that the mosaic was not owned by the European dealer after all, but by a smalltime art dealer in Indianapolis named Peg Goldberg. The government of Cyprus and the Greek Orthodox Church filed a lawsuit against Goldberg and called on True to give a deposition on their behalf.

"I am always very concerned about being offered objects that come from countries which objects are known to be removed from illicitly

because one wants to know the nature of the business this person does and credibility," True said in her deposition. "You question how that person came into possession of it."

The curator chided Goldberg for her decision not to notify Cypriot officials, as well as the dealer's cursory check with American officials—who knew nothing about the piece—before buying it from a suspicious middleman. She offered the Getty as a contrast in curatorial conscience.

"We as an institution would not want to be buying art against the wishes of the country of origin. First, it would be encouraging a traffic that we have no interest in encouraging, and [second] . . . we really would like to have as good relations with art-rich countries as we can develop . . . We also as a matter of policy contact the countries . . . and make inquiries if we think that it is appropriate."

With the Aphrodite scandal still fresh in their minds, Goldberg's attorneys sought to portray True as a hypocrite. They asked during the deposition whether she had ever been offered stolen antiquities. The Getty's attorneys blocked the questions with a series of objections, repeatedly threatening to end the proceeding and seek a protective order. "It is annoying, oppressive, harassing of the witness to inquire with respect to what the Getty has done or not done with respect to other acquisitions," said one. "It is simply not relevant here."

True's side prevailed. The defense attorneys' remaining questions were read into the record with no response from True: Had the Getty ever purchased a work of art contrary to the claim of a foreign government? Had the Getty ever refused to return a work of art claimed by a foreign government? And, specifically, what is the current controversy between Italy and the Getty Museum over the Aphrodite?

The Goldberg trial caused a media frenzy. In the end, the mosaic pieces were ordered returned to Cyprus. In upholding the decision, an appellate court recognized the moral weight of the 1970 UNESCO Convention. While the treaty could not be directly applied to the civil case, the court found that "the policy that the Act embodies is clear: at the very least, we should not sanction illegal traffic in stolen cultural

property." The case, the court concluded, served as a reminder "that greed and callous disregard for the property, history and culture of others cannot be countenanced by the world community or by this court."

In art circles, the case of the Cypriot mosaic became an often-cited lesson about the need for due diligence when purchasing ancient art. Goldberg had ignored obvious warning signs, prompting one expert witness to testify, "All the red flags are up, all the red lights are on, all the sirens are blaring." It also marked True's emergence as a model of curatorial ethics, earning a note of praise from the appellate court, which referred to her in its decision as "the aptly named Dr. True."

In the midst of the case—and a year after the Berlin Declaration—True organized what was billed as the first American summit to bring together the warring factions in the debate over antiquities. In a sign of the growing tensions, the symposium at the Getty was an off-the-record affair. There were no minutes of meetings, and participants were guaranteed that their involvement, as well as their names, would be kept confidential.

After the symposium, True lent her support to the country most harmed by rampant antiquities looting. Meeting with Italian officials at an October 1991 conference in Rome, the Getty curator offered to bridge the divide between American museums and source countries. She suggested that Italy and the Getty join forces to protect Italy's cultural heritage. Picking up the cause of long-term loans that had been articulated in the Berlin Declaration, she said that if Italy was more generous in lending valuable items in its museum basements, American museums would not be forced to buy similar artifacts on the market and could spend their acquisition money helping preserve Italy's cultural heritage.

As a sign of her sincerity, True offered to return one of the Getty's pieces that had raised questions: a fifth-century lead tablet acquired ten years before. The Lex Sacra, as it was called, was inscribed with instructions for a religious ritual and had been traced to a sanctuary of Demeter near the ancient Sicilian town of Selinunte. Despite the tab-

let's historical significance, the Getty had never taken it out of storage because it was not deemed beautiful enough for public display. Now, without any prompting, the curator was willing to give it back.

WHILE BUILDING HER credentials as a reformer, True discreetly maintained her contacts in the art market, keeping her eye open for pieces of interest. As a curator, her primary job was still acquiring objects for the Getty's antiquities collection.

In March 1992, True received another unsolicited offer, similar in many ways to the one she had received about the Byzantine mosaic. This one came via fax from someone in Munich. In slanting, awkward English, the handwritten note offered a "fantastic examplar [sic]": a funerary wreath crafted in Greece four hundred years before Christ, finely wrought in more than a pound of pure gold. The note was signed by a "Dr. Victor Preis," who claimed to be a Swiss antiquities collector. True had never heard of him.

"If the museum is interest to buy it," Preis wrote, "please contact me." The words "as soon as possible" were crossed out and replaced with the word "today." He left two Munich phone numbers. His asking price: $1.6 million.

The photos Preis sent soon after showed a gleaming halo of delicate foil leaves sprouting from two intertwined solid-gold branches. Even in the wreath's slightly crumpled state, the craftsmanship was remarkable, far grander than that of a smaller wreath the Getty had acquired several years earlier. This wreath's dense foliage included dozens of leaves and some thirty flowers with finely wrought pistils and stamens—detailed enough to distinguish them as bellflowers intermingled with myrtle, apple, and pear blossoms. Several had an inlay of what looked like deep blue glass applied to their petals. True noted a signature touch that dated the wreath to the peak of Hellenistic naturalism: the branches were sculpted in such detail that she could make out the thin skin of bark at their cut ends. The effect was mesmerizing—a funerary adornment fit for the head of a king.

No wreaths of this quality had come on the market in the past

twenty-five years. True recognized that if the Getty bought the wreath, it would possess a uniquely important specimen of ornamentation used by the elites of ancient Macedonia, perhaps even the family of Alexander the Great. True also knew that an object of such beauty and rarity had not appeared out of nowhere. Had it been on the market long, word of its existence would have already reached her from various sources.

On a business trip to Switzerland, True described the wreath and the circumstances surrounding its offer to the Zurich antiquities dealer Frieda Tchakos. The dealer was painfully direct: she had heard talk in the market about the men behind the object. "Don't touch it. These guys are not people you should deal with," she warned.

But True ignored Tchakos's advice and made arrangements to see the wreath. She checked into the Hotel zum Storchen, distinguished by its flower-draped balconies overlooking the Limmat River in Zurich's historic section. The day before the appointed meeting, a cable arrived from an associate of Preis's named L. J. Kovacevic. "First of all verey welcome in Zurich," the cable said. "Meeting to show gold wreath to your respectable self will be . . . at 10:30 am Zurich time in the present of the owner."

The next morning, True took a taxi to the Swiss Volksbank on Kirchgasse, just across the Limmat from her hotel. Preis and Kovacevic were waiting for True in a private vault.

The details of what transpired in the bank vault remain unclear. True engaged in a troubling conversation with the two men, who appear to have attempted a heavy-handed impersonation of wealthy European collectors. There was confusion, a confrontation. The meeting ended badly, and True left without making a deal.

Days after the botched meeting, Christoph Leon, the Austrian antiquities dealer who had acted as a middleman in the deal, sent an apologetic note to the rattled curator. The wreath's "actual owners" had no connection to the men in the vault, Leon insisted. The owners, he said, were "profoundly shocked, realizing the full dimension of the disaster."

"I must say that the happenings in Zurich were certainly bizarre," True replied via fax when she arrived back at her office. "I do not think that I have ever had an experience quite like that one! Mr. Kovacevic and whoever was impersonating Dr. Preis have done tremendous damage to a great object."

True said that the Getty was no longer interested in buying the wreath. "I hope that you will find a possible buyer for it, but I am afraid that in our case it is something that is too dangerous for us to be involved with," she explained.

GREEK AND GERMAN investigators later concluded that the men True had met with in the vault were likely antiquities smugglers, part of an increasingly sophisticated supply chain run by second-generation Greeks who acted as "mules," carting the fruits of looters in Greece and Turkey to the small circle of antiquities dealers in Zurich, Basel, Geneva, and Munich.

Kovacevic and two Greek partners had shown up in Munich a year earlier with the banged-up wreath in a cardboard box, shopping it around like a secondhand hat. But rather than sell it through an established dealer, who would reap most of the profits, a friend suggested that they try going directly to the Getty. Kovacevic had sent the initial fax to True, inventing "Dr. Preis" as a cover story. The men had almost pulled the deal off but had blown it with their performance in the bank vault.

Or so it seemed.

Four months after turning down the wreath, True changed her mind. Perhaps it was the reduced price, down to $1.2 million, that caused her to reconsider. Or the fact that Leon, a dealer the Getty had done business with before, now presented himself as the sole owner of the piece. Whatever the motivation, True wrote to Leon saying that the Getty intended to go ahead with the purchase.

A month later, the museum sent the standard inquiries to Greek and Italian authorities about the wreath. Both countries scrambled to stake a claim. Italian archaeologists concluded that the wreath was an

important, unique object entirely unknown to scholars and almost certainly looted. Greek officials, meanwhile, informed the Getty that because no record of the funerary wreath existed, it was likely "the product of illicit excavations in Greece."

Although the funerary wreath was obviously a recent find, neither country could provide any hard evidence about where or when it had been looted, and True proceeded with the acquisition. In June 1993, she presented her proposal to the board of trustees' acquisition committee, which had gathered in the museum's Founders Room. The room was dominated by an oil painting of J. Paul Getty—one of the museum's few reminders of its founder. True's report failed to mention her meeting with the unsavory characters in Zurich or the wreath's suspect history. The only hint of its origins came in this clinical assessment: "Virtually all surviving examples [of such wreaths] come from tombs."

The following afternoon, the wreath was one of eighteen art objects, including a Michelangelo, that the full board voted unanimously to buy. In the museum's paperwork, Leon said that the wreath came from "a private Swiss collection." He left the box for "country of origin" blank. The Getty wired $1.2 million to a Swiss bank account in the names of Leon and the two Greeks.

On the same day that the board voted to buy the wreath, Angelo Bottini, the archaeological director for Basilicata, the region in the arch of Italy's heel, sent a stern letter to True. "Do you have any idea how many archaeological sites have been plundered so that a single object can reach the market? How much scientific evidence we have lost? How many other objects have been destroyed?" he wrote. "Acquiring from the market is a crime against science and against the cultural and historic patrimony of another country."

True replied defensively, "I have proposed publicly to your Ministry that we would agree to stop collecting (which is our legal right and privilege) if and when your country would be willing to lend us works of art for display long term. Our greatest hope is that someday the

funds that now go for acquisition could be put to more constructive use conserving the monuments that so badly need them."

True added that the Getty's new wreath had almost certainly come from northern Greece, where two similar wreaths were on exhibit at a local archaeological museum. Italy, she concluded, had no claim to it.

Later, when Greek authorities demanded the wreath's return, True cited the Italian claim to argue that the wreath was almost certainly from Italy. The Italians had already investigated the wreath, she added, and found "nothing amiss."

THE FLEISCHMAN COLLECTION

O N OCTOBER 12, 1994, the Getty Museum inaugurated a stunning exhibit of ancient art. A Passion for Antiquities presented the collection of Barbara and Lawrence Fleischman, wealthy New Yorkers who had accumulated some of the finest Greek and Roman antiquities in private hands over a decade of aggressive collecting.

The exhibit was a coup for Marion True, whose friendship with the couple had begun eight years earlier, while the curator was helping colleagues at other museums scout ancient bronze statues for a traveling exhibit called The Gods Delight. A close friend had suggested that True take a look at what the Fleischmans had acquired. The curator was skeptical—few private collections had museum-quality pieces. But after visiting the couple's modernist apartment at United Nations Plaza, where the pieces were displayed in rooms featuring full-length windows overlooking the East River, True was impressed.

It was the start of a close relationship, one of those art world entanglements that mixes business with pleasure, friendship with money, a shared passion for art with mutual back scratching. Like True, the Fleischmans came from modest origins. Larry was the son of Rus-

sian immigrants who operated a Detroit carpet distributorship. While serving as a GI in France during World War II, he developed an interest in art after a visit to the Roman ruins at Besançon, an ancient French city near the Swiss border. There he met a local doctor who invited him home to view his collection of artifacts, which were lovingly integrated into the décor. When Larry returned to Detroit, he and his new wife, Barbara, a onetime public school teacher and insurance company secretary, began collecting American paintings as a hobby. Larry quickly found that he had a natural eye for art, and buying paintings became a compulsion, consuming his time and much of his money. He sought out and befriended the artists whose work he acquired. Even when he grew rich as one of the original investors in Milwaukee's first color television station, he found himself in debt because of his art habit. Although Larry was the one constantly looking for new pieces, Barbara had the final say on every purchase.

As the couple's holdings grew, so did their reputation within Detroit's social set. The Fleischmans were the first Jews to be listed in the blue book of exclusive Grosse Pointe. Larry befriended the director of the Detroit Institute of Arts, was appointed by the mayor to chair the institute's board, and spearheaded efforts to raise money for a new wing. In the early 1960s, Larry finally surrendered to the passion that had overtaken his life. The Fleischmans moved to New York City, center of the American art scene, and Larry bought an interest in the Kennedy Galleries, one of the country's oldest and most prestigious American art showrooms. He and Barbara threw their support behind the venerable Met, eventually underwriting a chair in American art and endowing two related galleries.

They also mingled gingerly with the East Coast glitterati. Overweight, outgoing, and at times pushy to the point of obnoxiousness, Larry disliked the pretentiousness of the collecting crowd, particularly its tendency to favor the opinion of academics over self-taught connoisseurs such as himself. Art, he preached, should be accessible to everyone. For Barbara, the preferred art form was theater, which she had majored in at college. Though petite, she had a presence that

could fill a room, and she was far more comfortable than Larry navigating Manhattan's elite social circles. Yet she retained the midwestern touch. When she threw one of her splendid parties, she refused to have it catered and instead made all the food herself.

By 1982, when Larry became sole owner of the Kennedy Galleries, he stopped collecting American art to avoid any conflict of interest that might result from competing with his customers. But he couldn't shake the collecting bug. The Fleischmans began selling off their American art, reaping a windfall on Edward Hopper watercolors they had bought for $500 that were now going for one hundred times that amount. With the profits, they bought Greek and Roman antiquities. Larry haunted the Met's antiquities department for advice on acquisitions. He regularly picked the brain of assistant curator Maxwell "Max" Anderson and took stern advice from Anderson's boss, Dietrich von Bothmer. His buying power often exceeded that of the Met, a fact that allowed Larry to learn about pieces before either of the Met curators. He developed a direct line to Robert Hecht, whom Larry regarded as an archaeological genius and a mercurial character. He did most of his buying, however, from Robin Symes of London. The flashy high-end dealer represented exactly the kind of mean-spirited arrogance that Fleischman abhorred, but Symes consistently came up with the best stuff. Like others, the Fleischmans came under the spell of the dazzling presentations Symes staged for preferred customers in his private studio. There he often unveiled his best merchandise by sweeping aside a velvet curtain to reveal a dramatically lit object mounted in the center of the showroom.

As they had with American art, the Fleischmans bought only those antiquities that appealed to them personally. They favored artifacts related to everyday life — mirrors, bracelets, weights. They steered clear of objects that glorified war and chased other, more idiosyncratic pieces that reflected Barbara's love of the theater, such as pottery decorated with dramatic masks of Dionysus. All the items had to be small enough to fit in the custom-built alcoves of their Manhattan apartment. Larry doted endlessly on the collection, often getting up to dust

or rearrange the pieces in the middle of the night when he was restless. By 1990, although concerns about the illicit antiquities trade were growing, the collection was so impressive that academics and curators from around the country regularly made pilgrimage to United Nations Plaza to study the Fleischmans' menagerie of small masterpieces.

"Larry Fleischman has bought up nearly every great piece available recently," Princeton University Art Museum curator J. Michael Padgett wrote to one of True's deputies at the Getty. "I have to admire the way he has stretched himself to get the great things while he can."

As for the provenance of his artifacts, Larry showed little interest in finding out where the things came from or how they arrived on the market. "Everything comes from somewhere," he would say with a shrug. His main criteria were whether the objects were authentic and beautiful. He did take some precautions: he never bought objects in Italy or Greece, and eventually he started making dealers sign a one-page form guaranteeing that they had been legally exported. But Larry, like most antiquities collectors, knew that if he dug much deeper, he might get into trouble.

The Fleischmans' relationship with True and the Getty grew stronger in 1991 when the couple flew to Los Angeles to participate in a symposium on Greek marbles led by True. Larry left California impressed with the curator's poise and acumen. He knew that the Met was looking for a replacement for von Bothmer, who had retired from his curator position the year before. Fleischman supported Met director Philippe de Montebello's interest in hiring True as the new head of the Greek and Roman department. The Met's wooing of True sparked a bidding war that the Getty won when it promised the curator a raise, a trust-financed low-interest loan to buy a Santa Monica condo, and a future promotion.

That same year, Fleischman turned to True for help with a personal problem. Despite outward appearances, he was hurting financially, having lost money in a bad gamble on petroleum stocks. An

economic downturn was also dragging down his art business and real estate investments. He needed some quick cash, a sale that he considered a "surgical strike." He wanted to know whether True and the Getty would like to buy a collection of ancient jewelry and a group of eight second-century B.C. Hellenistic objects. His price was firm: $5.5 million.

True urged her bosses to make the deal. "There is no question that each of these objects is of exceptional quality and importance," she wrote in an acquisition proposal to John Walsh. "Any one of these pieces would be a welcomed addition to the collection. The possibility to purchase all together is an extraordinary opportunity."

She noted that moving so quickly would leave foreign governments little if any time to respond to the inquiries that the Getty's 1987 antiquities policy required. But that wasn't much of a concern, True told Walsh. Scholars from all over the world had studied the Fleischman collection. "I think it is unlikely that the inquiries should raise any problems," True said. The deal went through.

From then on, when business brought True to New York, she often stayed with the couple free of charge. Accepting favors or gifts from someone with whom the Getty did business was expressly prohibited by the museum's conflict of interest policy. After all, the Getty was relying on True's unbiased judgment in matters such as its $5.5 million purchase from the Fleischmans. Yet the Fleischmans were also potential donors to the museum and close friends of True's. Indeed, they were fast becoming the worldly, sophisticated parents True never had. She often dropped their names in conversations with colleagues.

True informed Walsh about her relationship with the couple. He encouraged it. Perhaps it might lead to something bigger for the museum.

THERE WAS REASON to hope. Larry Fleischman hinted that he didn't expect to keep his antiquities forever. Collectors, he often said, were just stewards of artifacts for the next generation.

From Los Angeles to London, curators had their eye on the Fleisch-

man collection, but the assumption within the museum world was that the valuable objects adorning the couple's apartment were bound for the Met. Larry and Barbara had extended their largesse from American art to the museum's classics department, helping revive a dormant fundraising support group called the Philodoroi, which included Arthur Ochs "Punch" Sulzberger, the publisher of the *New York Times.* They had ponied up $1.5 million to help establish a position in von Bothmer's honor upon his retirement. And during the Met's exhibition of antiquities owned by Wall Street hedge fund manager Leon Levy and his socialite wife, Shelby White, the Fleischmans even underwrote the cost of a seminar for the event.

In 1993, von Bothmer's recently appointed successor, Carlos Picón, quickly turned his attention to negotiating a temporary exhibit of the Fleischman collection. The show not only would give the museum a new draw for the public, but it also would give the Fleischmans a glimpse of the future, subtly demonstrating how the objects might someday look in Met display cases with donor cards bearing the couple's names. In addition, the show would yield a bonus for the collectors: an illustrated catalogue of their collection. The Fleischmans had grown weary of enthusiasts tromping through their apartment to ogle their art. An exhibit catalogue would be a handy way for Larry to let academics see what he owned without having to open his front door. It would also create the appearance of a legitimate provenance for a collection whose objects had no documented history.

True was unaware of the Met's plans when she approached the couple about displaying their pieces at the Getty, but she was undaunted when she found out. She offered the Getty as cosponsor and the West Coast venue for the exhibit. Plans soon mushroomed to include the Cleveland Museum of Art and Boston's MFA. Six months into the planning, however, arrangements for the Met opening blew up. The dapper Picón called Larry Fleischman into his office to discuss a new wrinkle. Despite the beauty of the pieces, he said, the museum couldn't find a corporate sponsor willing to underwrite the exhibit. If the Fleischmans wanted the exhibit to go forward, they'd have

to pay for staffing and advertising the event, as well as donate twelve of their best antiquities up-front.

Fleischman was stunned. In business and art, he was renowned for being a fierce, even belligerent, negotiator. But once he made a deal, he always kept his word. In his view, Picón was trying to strong-arm him into paying for everything and then make a donation as well.

"I can't afford to pay for all of this," he said, pointedly reminding Picón that he had already offered to pay for the inaugural dinner party and photography for the exhibit. "This is totally inappropriate. If we end up paying for all this, that makes it nothing more than a vanity exhibit."

The spat was an embarrassment for the Met. One of the museum's biggest backers was now griping to others in the field. When MFA antiquities curator John Herrmann went to the Fleischmans' apartment to study the objects in anticipation of the show, Larry complained, "I have a wonderful collection, and I don't have to give a chunk of it away to get a good showing."

Not long after the Met was eliminated from the lineup, the MFA pulled out. Museum director Alan Shestack vetoed the exhibit. He knew Larry as a crafty dealer, one who surely understood that a public exhibit would almost certainly increase the value of his pieces, which could then be sold off or donated for great personal gain. Shestack suspected that Fleischman had a business deal up his sleeve.

The stumble by the Met and withdrawal by the MFA opened the door wider for the Getty. True jumped through, promising that if the Getty was designated as lead institution, it would pay all the costs.

ON OPENING NIGHT of the Fleischman exhibit in October 1994, more than two hundred VIPs assembled in the Getty's gardens before walking through galleries displaying nearly two hundred objects dating to the period 2600 B.C. to A.D. 400.

Larry Fleischman was delighted with the catalogue—a 358-page

hardcover volume printed on glossy paper and wrapped in an ocher jacket cover featuring one of the couple's favorite pieces, an Etruscan roof ornament depicting two satyrs. The catalogue was filled with large color photos and entries based on research conducted by Getty staff and Larry's part-time curator, Ariel Herrmann, former wife of the MFA's antiquities curator.

True didn't stop there. Seizing on Barbara Fleischman's fondness for the theater, the Getty curator arranged for a number of Greek plays to be performed on a replica of an ancient Greek stage built in the museum's inner peristyle. Comedies by Menander and Plautus, along with musical compositions specifically written for the exhibit, were performed by actors wearing costumes modeled on Fleischman bronzes or vase paintings. True also arranged for a series of exhibit-related lectures, including one given by Larry Fleischman on the subject of collecting. In a sometimes stumbling speech, Larry—who was known for his frequent mispronunciations and spoonerisms—led the audience through a slide presentation of his favorite pieces.

More than 100,000 people came to the exhibit before it moved on to Cleveland. The reviews were glowing. On October 18, 1994, the *Los Angeles Times* declared it "hands down, the best thing of its kind we've seen in living memory" and the "sort of event the public should embrace and artniks revere." The *Christian Science Monitor* heaped praise on True's tasteful arrangement of the objects. Taking a cue from how they were displayed in the Fleischmans' apartment, True had placed them thematically throughout the Getty, rather than grouping them more traditionally by culture or era.

The Fleischmans were thoroughly charmed. They had finally gotten their catalogue and the recognition they wanted. For all the hoopla, the incident that left the deepest impression came as the Fleischmans and True were walking to the auditorium for Larry's lecture. They met a group of ten-year-old schoolchildren, who began peppering him with questions: How did you get all these things? Where did you store them? What will you do with them?

Suddenly, one boy called out, "Mr. Fleischman! Is this about the best thing that has ever happened to you?"

"Yes," the collector said, laughing. "It surely is."

NOT EVERYONE WAS tickled. The exhibit and the Getty's relationship with the Fleischmans drew protests from archaeologists, who accused the museum of glorifying the fruits of the looted antiquities trade. More than 85 percent of the objects on display had no documented ownership history, a good indication that they had been recently looted.

The Getty came in for scorching criticism from Boston University archaeologist Ricardo Elia, who accused the museum of helping the Fleischmans legitimize their loot, which could now be sold off at higher prices or donated for major tax deductions. He also accused officials at the Getty and the Cleveland Museum of Art of cozying up to the collectors in hopes of obtaining the collection down the road.

"Collectors create the demand for antiquities and provide, however indirectly, the financing for lootings," Elia wrote in an October 1994 opinion piece for the *Art Newspaper*. "The link between collecting and looting is so strong that it is no exaggeration to say . . . that collectors are the real looters."

Elia had good reason for his suspicion that the Getty was after the Fleischman collection. Getty management and board members were well aware that the Fleischmans were potential major donors. True and other senior Getty officials took the Fleischmans on a tour of the museum to explain the planned renovation, which would transform the Getty Villa in Malibu into the nation's first museum dedicated exclusively to antiquities. The museum's hope was obvious: the collectors would be so impressed with the plans being spun out by their dear friend that they would agree to donate some of their antiquities to the Getty.

ELSEWHERE IN THE Getty, the Fleischman exhibit brought to the surface unresolved tensions, the same crosscurrents that had provoked

the fight between Luis Monreal and John Walsh over the Aphrodite six years earlier. Staff at the Getty's Conservation Institute complained that while they traveled the world protecting archaeological sites from degradation through tourism, weather, and plunder, the museum's staff was effectively encouraging looting. The institutional hypocrisy was such that conservators were often given the cold shoulder by foreign officials, who suspected that they were actually staking out the country's archaeological treasures for the museum's voracious curators. The staff members sometimes found themselves drawing crude diagrams on paper napkins to explain the institutional "firewall" between the Getty folks who were eager to preserve their cultural heritage and those who wanted to buy it.

The tension had become particularly acute when the Conservation Institute hosted a series of classes for senior archaeological officials between 1989 and 1992. The location was Paphos, Cyprus, an ancient Roman settlement and World Heritage site featuring a number of stunning mosaics. The Getty flew in cultural administrators from Poland, Tunisia, Chile, and other countries for seminars on how to protect the Paphos mosaics and other celebrated sites from the increasing rush of cultural tourists. Over dinner and drinks, however, conversation invariably drifted back to the Getty's own appetite for art and the dilemma it created. Foreign officials puzzled over how the Getty Trust could give them grants to preserve patrimony with one hand while using the other to pay for all the ancient art it wanted. Back at home, conservation staff counted every acquisition of an unprovenanced antiquity as a moral setback.

In early 1993, the bad feelings erupted. Miguel Angel Corzo, Monreal's replacement, invited Harold Williams in for a discussion with his staff. Sitting around a large table in a conference room, the conservators began speaking out about the museum's ethics—an astonishing event within the top-down culture of the Getty Trust, where dissent was rare.

Politely but firmly, the staff discussed how the Getty was undermining its own image: The museum's acquisitions were becoming a

problem. They were getting in the way of what the conservators were trying to do. It was high time the trust changed the museum's acquisition policy. The Getty should do the right thing.

As always, Williams was a polite and curious listener. He asked good questions and was not dismissive. Without giving away how he felt, he thanked everyone, then left.

A HOME IN THE GREEK ISLANDS

I N T H E S U M M E R O F 1 9 9 4, True was vacationing on the Greek island of Páros at the home of her friend, Dutch archaeologist Stella Lubsen, when Lubsen mentioned that a nearby house was going on the market. True had always longed for a holiday home in Greece. Páros holds a special meaning among those who have dedicated their lives to studying the classical world. The island was a hub of the Cycladic culture of the early Bronze Age, and its quarries of semitranslucent white marble have been coveted through the centuries. The Greeks prized the marble so highly that they used it in their best works, including the *Venus de Milo*, the *Winged Victory of Samothrace*, and the head and arms of the Getty's Aphrodite. Now largely known as a backpackers' paradise, Páros is blessed with white beaches and rolling hills dotted with traditional Greek "sugar cube" homes. Many of True's new friends spent their summers on nearby islands.

True's position at the Getty had given her a passport into the upper reaches of Greek society, which revolved around Greece's oldest private museum, the Benaki. Founded in 1930 by Antonis Benakis, an art collector and scion of a prominent family of Greek expatriates in Alexandria, Egypt, the museum was located just around the corner from the Presidential Palace in Athens. Like the Getty Trust, the

Benaki was run by a private foundation that, in addition to housing a large art collection, sponsored scholarship and education. Its donors include Greece's oldest, wealthiest families, and the white neocolonial family mansion housing it served as a de facto embassy of Greek elites. The Benaki's director was Angelos Delivorrias, a charismatic, chain-smoking expert in classical Greek sculpture and a close friend of True's. They had met years earlier when Delivorrias was a visiting scholar at the Getty. When the museum banished Jiri Frel, Delivorrias had emerged as a leading candidate for the job, until he turned it down because his wife refused to relocate to California. That paved the way for True to be promoted from within. The Benaki director maintained close ties to the Getty and True. Indeed, True so trusted Delivorrias that he was one of the first people she had asked to look at the Aphrodite.

Just down the road from the Benaki was the younger Museum of Cycladic Art, founded in 1986 to hold the private collection of billionaire shipping magnate Nicholas Goulandris. Since his death, the museum had been artfully run by his prominent widow, Dolly Goulandris, the famous but reclusive queen of Greek society. She and her husband, who had built a shipping empire second only to that of Aristotle Onassis, had amassed an enviable collection of Cycladic sculpture over twenty-five years with purchases in both Greece and abroad. Almost all of the collection came from undocumented excavations. The Goulandrises bought freely from looters, dealers, and auction houses alike. Dolly often did so with the permission—at times the encouragement—of Greek government officials, who occasionally asked her to snatch up objects the state could not afford. The Goulandrises considered their purchases of illicit antiquities a public service. Dolly tapped New York antiquities collector Shelby White, one of her closest friends, to serve on the museum board. White, a socialite and Met trustee, and her husband, Leon Levy, had built their own impressive antiquities collection. The Fleischmans were regular members of the Greek crowd as well.

True had fallen in with this group during her regular visits, when

she joined gatherings of the cultural elite at Dolly Goulandris's house on Skyros. The crowd also flocked to the luxurious compound of Robin Symes and Christo Michaelides, whose extended family owned an entire peninsula on the nearby island of Schinoussa. When elites from around the world docked their yachts there for cocktails under the setting sun, True was among them. She found it increasingly difficult to avoid the occupational hazard of curators becoming chummy with collectors and dealers who stood to benefit financially through flattery and friendship. "I have to say, I enjoyed it," she later said. "I enjoyed these people."

Now Lubsen was offering True membership in the club. The small villa for sale next door to Lubsen included a renovated 1,400-square-foot farmhouse, a converted chicken coop that served as additional sleeping quarters, and a swimming pool. True was desperate to buy it. "I don't want anyone to have this house but me," she told Lubsen. "I don't know how to do it, but I would love to buy it."

Of course, on her curator's salary of about $80,000 a year, True couldn't afford to buy it outright. And finding financing would be a problem. She couldn't get an American bank to loan her money for a foreign house, and Greek banks wouldn't give mortgages to foreigners. She was already burdened by monthly payments on her Santa Monica condo, where she had taken in a housemate for a time to help pay the mortgage. She would need a private loan on generous terms to buy the Páros home. Her thoughts turned to her friends the Fleischmans.

When True returned to Malibu, she approached John Walsh about the ethics of asking the couple for a loan. He advised against it, pointing out that such a personal favor would be "problematic" and "misinterpreted" as a quid pro quo. After all, the Getty had just exhibited their collection and was hoping to acquire it in the future.

For months, True fretted over how to make the purchase. Lubsen and her husband offered to make the down payment, but True still had to come up with the rest. The dream of owning her own hideaway in the cradle of ancient civilization appeared to be beyond her

grasp, until she turned to another friend, Christo Michaelides. He had wealth and connections, both from his sister Despina Papadimitriou, who had married into a prominent Greek shipping family. "There is a lawyer . . . who arranges loans for shipping companies," Michaelides told True. "Why don't you talk to him?"

The lawyer, Dimitrios Peppas, had done legal work for Michaelides' family and had arranged loans for Christo himself. With Peppas's help, True obtained a four-year loan of $400,000, with a balloon payment due at the end. The arrangement allowed True to buy the house and gave her four years to find other financing. Peppas passed the loan through Sea Star Corporation, a Panamanian shell company created exclusively for the transaction. Michaelides later told a relative that his family was the true source of the money.

BACK IN MALIBU, True was hard at work forging a new acquisition policy that would break with other museums and put the Getty firmly in the camp of those who wanted to discourage looting. Her partner in the endeavor was an Australian archaeologist named John Papadopoulos, whom True had lured away from the University of Sydney a few months earlier. Papadopoulos's wife worked at UCLA, and he'd been desperately searching for a position in Los Angeles. As an archaeologist, however, he had been reluctant to accept a position at what was widely considered to be the museum world's leading consumer of black-market antiquities. When True approached him in 1993 with an offer to become an associate curator in the Getty Museum's antiquities department, he said as much. That's perfect, True replied. "I want someone with an archaeological background. I want to start moving in new directions."

That direction, she explained, included drafting a tougher antiquities acquisition policy, one that would closely mirror the ethical guidelines of the American Institute of Archaeology, which called on members to refrain from publishing unprovenanced artifacts. The idea was to prevent academics from lending any legitimacy to looted objects or boosting their value by assigning dates. True admitted to Papadopou-

los that the Getty's 1987 policy, which relied on the word of antiquities dealers and notification of foreign governments, was deeply flawed. She said it had led to needless tensions inside the Getty, as well as between curators and archaeologists around the world who shared the same broad goals.

Convinced of True's sincerity, Papadopoulos took the job in January 1994. Even before he began working with True on the new policy, the curator assigned him to another delicate task. The archaeological director at Francavilla Marittima, located in Calabria and one of the oldest known Greek outposts on the Italian peninsula, had alerted the Getty that several objects donated to the museum under Jiri Frel had almost certainly been looted from an area of the site where ancient religious items were buried.

"Can you look into this?" True asked Papadopoulos. "I don't want to just give this material back. I want to do it in a way that will fully document it, so it won't just go back into the market in two or three years and then end up in some private collection."

Papadopoulos began digging through the Getty's archives. What he found confirmed their worst fears. The objects in question were among hundreds of Corinthian and Greek vase fragments, ivory pendants, small sculptures, and amber and bronze objects that Frel had lumped under two nonsensical categories. One bore the title "Favissa," Latin for "pit"; the other "Monte Testaccio," the name of an Italian hill region renowned for its rich layers of discarded ancient pottery. The headings didn't make any sense to Papadopoulos. Then it dawned on him: this was one of Frel's jokes, wrapped in a riddle.

The initials, "F" and "M," stood for Francavilla Marittima, the true origin of the items. Frel had acquired the material as donations between 1978 and 1981, precisely the time when looters were mining the ruins of Francavilla Marittima. Some of the shards matched others at the Institute for Archaeological Sciences at the University of Bern, which also had acquired hundreds of items apparently looted from the same sixth-century B.C. pottery dump. In all, the two museums had more than three thousand plundered objects from the site.

Since the objects weren't worthy of display, the matter didn't draw wide public attention. But archaeologists and curators knew that they represented one of the most massive collections of illicit objects ever discovered.

After alerting the grateful Italians, True had Papadopoulos coordinate with representatives from Bern and the Italian Ministry of Culture to publish photos and detailed descriptions of the pieces before returning them, a laborious process that would take seven years. They hoped that this approach would serve as a model for repatriations and right some of the wrongs committed by Frel.

Although most curators in True's position would have done nothing, hoping not to draw attention to the mess, True's boldness only enhanced her reputation as forward-thinking and an ally of source countries. Italian newspapers carried glowing comments by the Carabinieri about the Getty curator.

TRUE AND PAPADOPOULOS'S first draft of the new acquisition policy committed the Getty to a "bright-line" provision, one that barred the museum from accepting antiquities lacking a documented ownership history dating back to 1972, the year the American Institute of Archaeology had recognized the 1970 UNESCO Convention. Only a handful of university museums, such as those at Harvard and the University of Pennsylvania, had adopted such strict acquisition policies, and even they did not always follow their own guidelines.

The policy met with immediate resistance from Debbie Gribbon, the museum's assistant director. She considered it too severe and worried that it would put the Getty at a competitive disadvantage. Drawing the bright line at 1972 would also be embarrassing, since the Getty's shelves were overflowing with objects that would be deemed tainted under the new guidelines. Gribbon had lived through four-alarm cultural patrimony drills before, only to watch them disappear. She considered the growing concerns about provenance just another passing fad.

Others at the museum also pressured True to back off. True's cru-

sade was at cross-purposes with the basic job description of a cura-
tor—to acquire. And conceding legal ground on antiquities could
lead to such concessions regarding paintings and drawings, which had
their own peculiar problems.

George Goldner, the Getty's drawings curator and one of the
brightest minds at the museum, expressed more personal concerns
before leaving the Getty in 1993. A friend who had helped act as a go-
between to keep True from leaping to the Met, Goldner began won-
dering whether the curator was trying to whitewash history. He re-
called approaching True years earlier with his misgivings about the
Aphrodite, which he felt was certain to spark the interest of Italian
authorities. "Do you know where this thing is from?" he'd asked. "Yes,
I do," she'd said mysteriously, in a way that suggested she knew more
than she could say. Now she was touting a stringent antiquities policy.
Goldner feared that such a policy might come across as taunting the
Carabinieri, who still wanted back their "Morgantina Venus," the
name Italian authorities used for the Aphrodite.

You're getting yourself in trouble here, Goldner told her at one
point. You're not dealing with dumb people. They're not going to say,
What a nice girl in a nice dress! She's not buying looted antiquities!
They're going to say, Why is she here when no other curator is here?

True said that the Getty was doing the right thing and that she
wanted everybody to know that it had a great acquisition policy.

TRUE'S PUSH FOR the new policy coincided with the end of con-
struction at the Getty Center, the massive new hilltop campus in
Brentwood. The center stood as Harold Williams's greatest accom-
plishment—nearly one million square feet of new floor space to ac-
commodate the museum's burgeoning art collection and unite the
Getty Trust's programs, long scattered throughout the Los Angeles
area.

Williams and the board of trustees turned their attention back to
the museum's original home, the Roman villa in Malibu. Their plan
called for shutting it down right before the Getty Center opened in

1997, then giving it an extensive makeover before reopening it as the nation's first museum dedicated exclusively to classical antiquities. By moving the other art collections to "the hill," there would be more room at the reborn Getty Villa to showcase its more than 40,000-piece collection of ancient art, much of which was now in storage because of lack of space. The plans also called for establishing the villa as an international center for scholarship and conservation. Making good on his earlier promise, Williams appointed True to oversee the $275 million renovation.

True saw the project as an opportunity to heal the deep rift between the Getty's museum and conservation staff. Miguel Angel Corzo, the head of the Conservation Institute, was a member of the Getty Villa planning committee and supported True's push for the tougher acquisition policy.

Pressured by colleagues, director John Walsh eventually buckled, agreeing to the reform but only with major concessions. Instead of drawing the bright line at 1972, the revised policy drew the line at November 1995, when the board was scheduled to approve the measure. It grandfathered in the looted objects but guaranteed that going forward, the Getty would adhere to the tighter restrictions.

Even in its watered-down state, the policy represented nothing short of an institutional conversion. Long the bête noire of the archaeological world, the Getty was effectively taking itself out of the business of buying looted antiquities. Fearful of infuriating other museums, it avoided bragging about the change. The announcement of the new policy appeared in the sixth paragraph of a November 1995 press release, which otherwise touted the villa project as an attempt to "promote a deeper understanding of, and critical appreciation for, comparative archaeology and culture."

"We have bought cautiously and only after diligent research and consultation with governments in archaeological countries," Walsh was quoted as saying, almost apologetically, in the press release. "But circumstances have changed. We're more and more involved in joint

projects with our Getty partners in the fields of archaeology and conservation, and we will have a broader mission at the Getty Villa. We want the overall effort not to be hindered by the issues raised in collecting undocumented material. We are willing to make this change in the interest of a common purpose."

The reaction to the change was predictably mixed. At the Met, Philippe de Montebello was furious. Curators at other institutions complained that after a decadelong binge, the Getty was now acting like a reformed alcoholic, trying to shame everyone else into sobriety. Meanwhile, former critics, such as outspoken archaeologist Ricardo Elia at Boston University, hailed the new policy as a genuine change from the old, self-serving standard that had allowed the museum to ask no questions while acquiring undocumented pieces.

True had kept her word to Papadopoulos; she was pushing the Getty to reform. But Papadopoulos soon learned that his boss still had a few blind spots.

WHEN THE FLEISCHMAN exhibit completed its Cleveland run in the spring of 1995, Getty experts packed up the objects and transported them back to the couple's Manhattan apartment, where each piece was returned to its original place. Despite the falling-out with the Fleischmans, the Met still held out hope of receiving part of the collection, as did the Cleveland and even the British Museum, where the Fleischmans had joined fundraising groups. But now most assumed that the Getty, with its first-rate exhibit, had an inside track on landing most of it. Barbara Fleischman would later claim that it was not until a year later, around his seventy-first birthday, that Larry came home from his art gallery one day and asked, "How would you feel about giving the collection to the Getty? You know, we don't have as good a relationship with the Metropolitan Museum as before—in that department—and their collection is so vast that they really don't need a big collection to be added. They may want it, but they don't need it." By contrast, the Getty had a "small, choice" collection that

could use the help. Why not help a West Coast institution improve its inventory of ancient art? Barbara agreed, and the couple called True to share the news of their decision.

The offer, which could not have come as a total surprise, nevertheless put True in a terrible bind. Aside from J. Paul Getty's founding gift, the Fleischmans' would be the largest the museum had ever received. The collection perfectly rounded out the Getty's antiquities holdings, especially in the weak areas of bronzes and Etruscan art. For any other curator, at any other time, the gift would have been a career capper. But for True, who had just pledged the Getty to stop buying looted antiquities, it was cause to agonize. The Fleischman collection was filled with suspect pieces.

True's internal strife was obvious to Papadopoulos, who was with his boss at a meeting in Rome soon after she received the call from the Fleischmans. Arriving on a separate flight, Papadopoulos found True sitting at a breakfast table in the Hotel Raphael early in the morning, her face glum.

"What's wrong, Marion?" he asked. "It looks like your best friend just died."

Ashen, True told Papadopoulos about the Fleischmans' offer. Both knew that by taking the gift, True would be undermining the new antiquities policy she had championed. "What should I do?" she asked.

"What do you want me to say, Marion?"

True was silent.

SHORTLY THEREAFTER, WALSH and True flew to New York and, under the gaze of a silversmith etched on an ancient sarcophagus, worked out the rough outlines of a deal with the Fleischmans that covered all the items in the 1994 exhibit. The Fleischmans were not offering their entire collection as a gift. Ever the hard bargainer, Larry said that they would donate 288 items to the museum, but only if the Getty bought 33 others for $20 million. With the terms broadly defined, the small group toasted the transaction with wine.

Word of the deal bubbled through the Getty for months, creating a huge rift between those who rejoiced in the museum's good fortune and those who, like Papadopoulos, considered the transaction a grand hypocrisy. Eventually, True convened a meeting of her staff in a tiny annex to the museum kitchen. With her hands shaking slightly and her words coming quick and clipped, she announced that the Getty would, in fact, accept the Fleischmans' gift. The acquisition did not violate the new policy, she said, because the collection had been published before the 1995 cutoff date—by the Getty itself in the 1994 exhibition catalogue.

Papadopoulos was appalled. The thin rationalization would make the Getty look as if, expecting the gift all along, it had written a loophole into its policy. After the meeting, he pulled True aside and said, "What do you think this does to our reputation in terms of our new acquisition policy? Look, if you come out and accept this, this is something that is going to live with you and haunt you for the rest of your days. You can't get around that."

"Don't rub it in," she said.

Papadopoulos began looking for another job. True had done much to lead the way in reforming the antiquities market, including pushing for the Getty's new policy. But the Fleischman acquisition was a giant step backward and exposed the museum as being duplicitous. He was disappointed and a bit angry, but he didn't blame True. It was the nature of the job. But he didn't want to stay in a profession so riddled with temptation.

On June 13, 1996, the Getty publicly revealed the Fleischman acquisition, calling it a "quantum leap" for the museum's antiquities collection. As Papadopoulos predicted, the news didn't sit well with archaeologists, who felt that they had been snookered by the museum's "tough" new acquisition policy, announced just seven months before. Ricardo Elia howled that the museum had gotten the collection through a loophole. Robin Symes was livid at True, feeling that she had squeezed him out of the commission he expected to receive

for helping broker the sale of the collection. Somehow, True had managed to anger people on all sides of the antiquities debate.

THE DAY AFTER Larry Fleischman signed the contract with the Getty, he and his wife had breakfast with True in Los Angeles. Larry brought up the subject of her house in Greece. True was still looking for someone who could refinance the loan she had received through Peppas, the Greek lawyer.

"Now that this is settled, would it help if I lent you the money?" Fleischman asked. He proposed an unsecured loan of $400,000 at 8.25 percent interest, a "wonderful gesture" toward a good friend who had been so generous with her scholarly knowledge over the years.

Days later, True signed a promissory note for the loan. In mid-July, she wrote to Peppas saying that she was prepared to pay off her original loan.

"I am happy to inform you that I have finally found an American source for a 20-year mortgage and would therefore like to repay the full amount of my remaining debt to the Sea Star Corporation," True wrote. "You must know how grateful I am to you for helping me to purchase the house in Greece, but as you can imagine the longer pe-riod of time will make the repayment process much easier for me."

On July 10, the Getty officially closed the deal with the Fleisch-mans, who received their first $7 million installment. A week later, True repaid her loan to the Sea Star Corporation. She had agreed to pay $3,007 a month to the Fleischmans for the next twenty years. Many years later, it was unclear whether she actually made those pay-ments. The Getty's lawyers could find no proof that she had.

11

CONFORTI'S MEN

JUST MONTHS BEFORE the Fleischman exhibit opened at the
Getty in 1994, a captain in the Rome headquarters of the Carabi-
nieri art squad was thumbing through a stack of unresolved cases. He
stopped at the file on the Aphrodite.

The lead investigator on the case, Fausto Guarnieri, had retired
years earlier, leaving the matter to the few overburdened investigators
in the Sicily field office. When occasional documents trickled in from
forgotten judicial requests, they were stuffed into the file without so
much as a glance. Eventually, the file was returned to Rome, bound
for the archives.

The captain glanced through the yellowing pages. He noted that
the alleged looters and smugglers of the statue had been indicted but
released for lack of evidence. Despite the high-profile target, he saw
little point in pursuing a case in which the statute of limitations had
nearly run out. But before dumping it, he dropped the paperwork on
the desk of a young investigator named Salvatore Morando. Take a
look, the captain told him, and tell me if you see anything.

Morando was a dark-eyed, soft-spoken Sicilian whose bashful de-
meanor belied a dogged nature. Tougher than he looked, he also had
an unassuming manner and the patience needed to cultivate under-

world sources and to clear the complex legal hurdles blocking his ability to follow leads outside Italy's borders.

As Morando browsed through the paperwork, he paused to look at the large black-and-white photos of the statue. It had been found just an hour from Ragusa, his hometown. Reading Guarnieri's notes, he saw that the case had been foiled by omerta, the Sicilian code of silence. Guarnieri and Silvio Raffiotta, the state prosecutor, had tried to take the investigation abroad, but the trail had gone cold in Switzerland.

Morando then came upon new records that had been added to the file since Guarnieri's retirement. Some came from Mat Securitas, the Geneva-based shipping company that had transported the 1,100-pound statue to Robin Symes in London. Mat Securitas had shipped the statue from Lugano, a large Swiss city just north of the Italian border, a notorious smuggling zone that had churned for decades with an underground economy. The black market there had begun with bootleg cigarettes, smuggled over the mountains after World War II by locals who carried them in large rucksacks at night. The trade had spawned a network of tobacco shops and money exchange houses catering to Italian consumers, who drove up from Lake Como to buy cheap smokes, then smuggled them home in hubcaps and secret linings in their car doors. In more recent years, the smugglers had diversified, dealing in drugs, guns, credit cards, jewelry, rugs, diamonds, fake passports, and art.

A sales receipt in the file, also sent after Guarnieri's retirement, showed that the Aphrodite had emerged from that murky world. Scrawled on a piece of stationery from a Swiss money exchange house, the one-page note was dated March 1986 and acknowledged the receipt of $400,000 from the London dealer. It said, "I am the sole owner of this statue which has belonged to my family since 1939. Sincerely, Renzo Canavesi."

Who was Renzo Canavesi? Had anyone questioned him?

Canavesi's name didn't appear anywhere else in the case file. A quick check by Morando revealed Canavesi to be a former Swiss po-

lice officer who owned the money exchange shop named on the stationery. He also owned a cigarette and pipe shop in nearby Chiasso, called Tabaccheria Canavesi. A more perfect profile for a smuggler was hard to imagine. The receipt's reference to 1939, the year Italy's Mussolini-led government passed its strict patrimony law, struck Morando as no coincidence. Canavesi's assertion conveniently legalized the statue by putting it on Swiss soil at the time.

The documents had the potential to crack the Aphrodite case open. But years had elapsed since Canavesi had sold the object to Symes in 1986. The statute of limitations for trafficking was ten years. It was now 1994. Morando had less than two years to build a case against Canavesi. It might be possible for a prosecutor to argue that the offense was aggravated, tacking on another five years to the deadline. Even then, it would require authorities in Italy, Switzerland, the United Kingdom, and the United States to move with unprecedented speed.

Morando faxed a copy of the Canavesi receipt to Raffiotta in Enna. That same day, Raffiotta wrote two requests for foreign judicial assistance. The first went to Swiss authorities, asking them to arrange an interview with Canavesi. The second went to American authorities, asking them to have the Getty provide a sample of the Aphrodite's limestone for testing.

MORANDO REPRESENTED A new breed of detective recruited into the art squad by General Roberto Conforti. A highly respected Neapolitan Mafia investigator, Conforti had won distinction by pursuing the Red Brigades and other terrorist groups before taking over the Tutela Patrimonio Culturale in 1992. He inherited an anemic, politically impotent appendage to the Carabinieri. In the two decades since its founding, the art squad had become a retirement queue, filled with aging investigators who had one eye on their work and the other on the calendar. Their methods were so haphazard and their record so spotty that they were considered the Keystone Kops of the art world.

In a short time, Conforti turned things around. He played on na-

tional pride—and the potential for votes—to coax Italy's venal politicians into loosening public purse strings. With the extra funding, he opened offices in Sicily, Florence, Naples, and beyond. Taking a page out of Italy's successful Mafia prosecutions of the early 1990s, he centralized the reporting of all art crimes so as to track the overall pattern. He built the first database to catalogue Italy's vast artistic treasures and hired younger, more agile investigators who were comfortable with technology and steeped in sophisticated techniques. Many were also multilingual and had traveled extensively overseas, where Conforti hoped to take the squad's investigations.

A slight, dapper man with a pencil mustache, Conforti inspired their devotion with a stern but generous style. His mantra became, *Tell me what you need to do your job, and I'll get it.* Helicopters to patrol remote archaeological sites? Done. A suitcase full of cash for a sting? Done. He also led by example. Shortly after taking over the unit, he and two of his investigators were jailed for a week for obstruction of justice. They refused to give up a confidential informant who led them to the recovery of Saint Anthony's jaw, a Christian relic stolen from a church in Padua. When pressed, Conforti remained tight-lipped, saying the informant's life was in danger. A lengthy investigation led to Conforti's vindication and the transfer of the investigating magistrate. When the general emerged from jail, the art squad lined the street, all standing at attention, some with tears in their eyes.

More important than the man, however, was his approach to attacking the illicit antiquities trade. He wanted to snare the big bosses, not just the tombaroli scraping up ancient vases at night to feed their families. Conforti encouraged his men to think beyond Italy's borders. They were to conduct international investigations aimed at apprehending the top dealers, who had long been untouchable in Basel, Zurich, London, and New York. The new art squad made extensive use of surveillance, including wiretaps, to reach higher in the chain of command. He also had his men comb through auction catalogues for suspect pieces, then work their way backward through the supply chain. At the same time, Conforti played the good cop by launching

his own brand of diplomacy, reaching out to foreign judges, prosecutors, and academics to help close the enforcement loopholes that allowed the illicit trafficking to thrive.

Conforti's multipronged approach soon paid off during an investigation of Pasquale Camera, a corrupt former captain in the Naples section of the Guardia di Finanza, Italy's finance and customs police. In August 1995, Camera crashed his Renault into a guardrail, flipping the car and killing himself. Searching through the wreckage, agents found Polaroids in the glove compartment depicting dozens of recently excavated antiquities. That led to a raid of Camera's house and a major coup. Stashed inside the dead man's dresser was a single sheet of lined paper on which he had sketched a diagram of the key players in the flow of illicit antiquities out of Italy.

The graphic showed a wide base of tombaroli spread across Italy's boot, with arrows pointing up to two key middlemen. One was Giacomo Medici in Rome, the other Gianfranco Becchina in Sicily. Arrows from these middlemen branched off to the European dealers and collectors they supplied — Elie Borowski, Nikolas Koutoulakis, George Ortiz, Frieda Tchakos. Atop the pyramid, most prominent of all, was Robert Hecht, whose name was written in large letters. From Hecht, arrows pointed to American museums and collectors. This was an organizational chart confirming the level of sophistication that Conforti had suspected in the looted antiquities trade.

Meanwhile, the squad was pursuing a separate investigation that helped unlock the secret workings of the trade. In a catalogue for an upcoming Sotheby's auction, the Carabinieri had discovered a sarcophagus stolen from a museum on Rome's Aventine Hill. When agents contacted the London auction house for details, Sotheby's directed them to the Swiss holding company, Edition Services, that had consigned the object. At the address listed for Edition Services in Geneva, a dozen unrelated companies were listed on gold nameplates outside the door. It was, in fact, a bookkeeping service that served as the "headquarters" and mail drop for all the firms. Its proprietor was a large, pokerfaced man with a mustache named Albert Jacques. After

some prodding, Jacques disclosed that the real owner of Edition Services was an Italian, Giacomo Medici, one of the middlemen named in Camera's diagram.

Jacques directed the agents to a three-room warehouse that Medici rented in Geneva Free Ports, a five-story, jagged-roofed fortress of anonymous storage suites a few miles away. As its name suggests, Geneva Free Ports had been carved out as a tariff-free zone, allowing merchants of all types to move their inventory in and out of the country without paying taxes.

In September 1995, Italian and Swiss officers raided Medici's premises on the fourth floor of Sector D. They were taken aback by the treasure-trove of looted antiquities they found.

The front room of the warehouse served as a small exhibit space, featuring a wood floor and velvet-lined shelves containing dozens of neatly arranged Etruscan, Villanovan, Corinthian, Rhodian, Boeotian, Mycenaean, and Cypriot vases, grouped loosely by style and age. Many of the objects bore tags from Sotheby's that showed the date and lot number of the auction at which they were bought. The coffee tables were made of pieces of thick glass set on sections of ancient Greek capitals.

The backroom was a large, unfinished storage space with white walls and concrete floors. It held dozens of artifacts in their raw state, before restoration. Large marble fragments of statuary and architectural pieces, many broken and still dirty, lay on the floor or rested atop wooden pallets. There were many large vases and, in one corner, sizable chunks of Roman wall mosaics. Packing material was scattered about. The shelves contained wooden fruit boxes from Cerveteri, home to the famous Etruscan archaeological site north of Rome. The boxes were crammed with shards and architectural fragments still covered with dirt and wrapped in Italian newspapers dating from the mid-1990s.

A middle room, which served as Medici's private office, included a walk-in safe and a desk. Its drawers were jammed with plastic-sleeved photo albums containing thousands of Polaroids. They showed antiq-

uities, apparently fresh from the ground, in various stages of restoration.

The Swiss court ordered the warehouse sealed. Word of the raid spread quickly through the antiquities trade. After all, Medici was the source of many of the museum world's most prized classical antiquities.

By CHANCE, SIXTEEN days after the raid, an assistant U.S. attorney from the Los Angeles office drove out to the Getty Museum to depose Marion True. The federal prosecutor was there to question the curator on behalf of the Italian government about an Etruscan bronze tripod the museum had purchased in 1990.

The visit was not unexpected. Count Guglielmo of Florence had reported the tripod stolen from his family's collection. The object had been previously photographed and registered with Italian authorities, so it was only a matter of time before the Italians contacted the Getty. True took the initiative and invited the Culture Ministry to examine the piece, indicating her willingness to send it back. The Italians asked the U.S. attorney's office to question the curator first.

In a museum conference room, True testified under oath that she had first seen the tripod and its companion candelabrum at the Zurich restoration shop of Fritz Bürki. When asked about Bürki, she described him as one of the "world's leading suppliers of world-class antiquities." Both statements were false.

In fact, True had first seen the objects in 1987 during a tour of Medici's Geneva Free Ports warehouse, where Medici and Hecht had personally offered them for sale to the Getty. And while True made it appear that Bürki was the source of the suspect pieces, Bürki, a former university janitor, was actually well-known as Hecht's antiquities restorer and frontman. Medici and Hecht had used his name often to ship objects to California. Indeed, when the tripod had arrived in Los Angeles, True had written to Medici, not Bürki, to confirm its receipt.

Before True's testimony could boomerang, the Getty announced

that it was giving the tripod back to Italy. True personally carried it to Rome the following year, using the occasion to meet senior cultural officials for Italy and the Vatican. On the Getty expense form, True stated the purpose of the trip as "public relations."

THE ITALIANS' REQUEST for samples from the Aphrodite went unheeded for more than a year. When True responded, she did so informally and in the most favorable context: during discussions with cultural officials over returning the Francavilla Marittima material. Pietro Guzzo, the archaeological head of Pompeii and a close friend of True's, was visiting the Getty when she handed him a baggie with some fingernail-size chips from the back of the statue.

Italian authorities hoped that science might be able to accomplish what their criminal investigators had not. A team of University of Palermo geologists examined the specimens under an electron microscope and found an abundance of nanofossils—microscopic organisms that had become entombed when the stone was formed. Using the fossils like a geological fingerprint, the scientists eventually matched the sample to limestone found in an ancient quarry near the Irminio River, fifty miles south of Morgantina. The sample was also strikingly similar to the limestone of another acrolithic sculpture discovered in Morgantina in 1956 and on display in the city's small museum. The team delivered its conclusion to Italian investigators: the Aphrodite's stone could be linked with near certainty to a location half an hour's drive from Morgantina, where rumors about the statue had first sprouted.

But as one evidentiary door opened for Italy, another closed. The Swiss end of Morando's criminal investigation hit a dead end.

The Carabinieri had waited two years to receive permission from Swiss authorities to interview Renzo Canavesi, now retired and living as a recluse in his mountain home in Segno. An imposing, barrel-chested man with a mane of thick hair, Canavesi showed up for his interrogation alone and refused to say anything. His silence brought the Aphrodite investigation to a halt. Time was running out.

Morando conferred with Raffiotta, who by now had been chasing the statue for eight years. The prosecutor knew that the statute of limitations would expire before Canavesi's trial could be completed, but he hoped to convince the court that the Getty's delays in providing the limestone had stopped the clock. If the argument bought him time, he and Morando might be able to squeeze out more evidence as the case ground its way through the Italian courts. It was a gamble.

The government of Italy indicted Canavesi for trafficking in stolen property.

As Italian investigators were closing in on Canavesi in 1996, the Aphrodite's former owner sent a letter to Getty CEO Harold Williams introducing himself and offering to provide the museum with several missing pieces of the statue. He also wanted to supply information about the original position of the statue's missing right hand — information that had the potential to solve the central mystery of the figure's identity.

Was this Hera, the wife of Zeus? Was it Aphrodite, as True had long suggested? Or was it Demeter, holding a torch aloft to find her kidnapped daughter? If it was Demeter, Canavesi's offer could point once again to Morgantina, where an ancient cult devoted to the goddess had thrived.

To show that he was serious, Canavesi enclosed two photocopies of photographs taken of the statue years earlier. The copies were of poor quality, but one showed the outlines of the statue's head, and the other showed what appeared to be its body. Williams promptly forwarded the letter to Walsh, who relayed it to True with a note: what did she make of this?

An academic known for her thorough research, True reacted strangely. She ignored the potential for acquiring crucial evidence and questioned Canavesi's motives. Did he want money? Perhaps. Or maybe his intentions were more sinister. Why hadn't he simply provided the missing pieces and the information he offered?

True called Symes and Michaelides in London. With obvious an-

noyance, Michaelides confirmed that Canavesi was indeed the previous owner of the statue, but he said that Canavesi had agreed never to contact the Getty directly.

True sent a letter to Canavesi vaguely committing to meet with him when she was next in Europe. In a fax, Canavesi upped the ante by asking for a meeting in Switzerland, adding that he had dozens of photos of the statue he could show her. True answered with vague but polite interest, then dropped the matter.

MORE THAN A year later, in October 1997, True traveled to Italy's University of Viterbo as a featured speaker at a conference titled "Antiquities Without Provenance."

The audience was full of leading experts on the subject. Some were friends—such as archaeologist Malcolm Bell, Wolf-Dieter Heilmeyer of the Berlin Museums, and even General Conforti. But many had had run-ins with the Getty and its curator: Silvio Raffiotta and Graziella Fiorentini from Sicily and several senior Italian Ministry of Culture officials and archaeologists. True's task was to convince them that the Getty had changed its ways.

Before she could, however, an outspoken Italian archaeologist named Maria Antonietta Rizzo had a surprise for the Getty curator. Rizzo delivered a paper on an important Greek vase in the Getty's collection, one potted by Euphronios and painted by Onesimos, two of ancient Greece's most acclaimed artists. The museum was especially proud of the piece, which True had assembled painstakingly from shards purchased from several different dealers. But rather than praise the vase's artistry, Rizzo revealed convincing evidence that the fragments had all been looted from the Etruscan archaeological site at Cerveteri. She claimed to have spoken to the tombarolo who had excavated the Onesimos fragments from one of the underground tombs there. The Getty should have suspected the Etruscan origin of the vase, she continued, because Cerveteri was home to a thriving cult of Hercules. The Getty's own publications noted that there was an in-

scription on the foot of the vase containing the word "Ercle," the Etruscan name for Hercules.

"Will the P. Getty Museum, represented here in the person of Marion True . . . give back to Italy a piece that has been trafficked in such an obvious way?" Rizzo asked, locking eyes with True, who sat in the front row of the audience.

The curator was visibly stunned. Her face turned deep red, but she kept her composure until it was time for her own presentation, titled "Refining Policy to Promote Partnership." As she stood to speak, she looked angry and nervous.

"It is unfortunate that this information and substantial evidence has never been formally presented to the Getty Museum," True said. She promised that the Getty would investigate Rizzo's allegations. If they proved true, the museum would return the vase.

True soldiered on with her prepared remarks, painting herself as the broker of a new peace. In the wake of the ambush by Rizzo, however, her words struck some as ironic.

"Confronted with the brutally direct evidence of destruction of sites presented by the archaeologists at this meeting, it seems hard to understand why the process for change has been so long and frustrating," True said.

The blame, she continued, rested with all sides—the collectors, archaeologists, museum curators, and government officials sitting before her. Each group had let their personal feelings and professional vitriol get in the way of reform. She called for a new understanding, a staking out of the middle ground. She endorsed Heilmeyer's solution of long-term loans from source countries to museums and noted her own efforts at the Getty, recounting in a slide show her role in the Goldberg mosaic case and the museum's 1995 acquisition policy, as well as the return of the Lex Sacra and tripod.

She then displayed a slide of the Aphrodite, going on at length about the museum's openness in the dispute over the object. She said that the Getty had acquired its limestone and marble goddess only

after "no information or objections were offered" by Italy and under-scored the museum's cooperative spirit in supplying the limestone chips to help Italian geologists ascertain the origins of the statue. Al-though a preliminary analysis of the limestone suggested that it had come from Sicily, there was still no proof that the statue was from Morgantina, she added.

It was a bold performance—too bold for some in the audience. True was staking out a public position she would not be able to sustain for long.

12

THE GETTY'S LATEST TREASURE

IN DECEMBER 1997, the Getty Trust officially opened the new
Getty Center, a cluster of brilliant white structures set atop a
promontory in Brentwood, overlooking the sprawling Los Angeles
basin.

The unveiling was a cultural coming-out party, noted around the
world. The Getty Center had taken fifteen years and well over $1 bil-
lion to build—an obscene amount that far exceeded even the most
inflated estimates produced over the years. But unlike the original
Getty Museum, which had been greeted with scorn, Richard Meier's
modernist creation was received with breathless reviews. Critics hailed
the center's six buildings, clad in white aluminum and fourteen thou-
sand tons of Italian travertine, as a monument to the growing sophis-
tication of southern California. Los Angeles, it seemed, had finally
outgrown its reputation as the vapid capital of Hollywood kitsch.

For the Getty, the new campus fulfilled the vision of its founding
CEO, Harold Williams. The trust's seven far-flung programs were
now gathered together on one site from the anonymous office suites
and warehouses around the city where they had been located for years.
A circular building housed the Getty Research Institute, with its
900,000-volume library. Others housed the Conservation, Education,

Information, and Leadership institutes, as well as the Getty Grant Program. But the centerpiece was the five pavilions dedicated to the Getty Museum's art collection, expanded in the 1980s from J. Paul Getty's original collecting areas of antiquities, decorative arts, and paintings to include drawings, illuminated manuscripts, and photography.

As the Getty entered a new era, it was intent on shedding its image as aloof and elitist. More than seven hundred dignitaries and guests took their seats on the center's massive open-air plaza for the inaugural ceremony, a carefully choreographed display of Los Angeles's diversity. After a youth orchestra introduced the program, the all-black Crenshaw High School Elite Choir, in blue robes with billowing yellow sleeves, swayed to a hand-clapping Gospel rendition of "America the Beautiful." Actor Denzel Washington spoke movingly about the Getty's commitment to bringing high culture to inner-city black and Latino schoolchildren. A giant temporary screen lit up with a video of First Lady Hillary Clinton walking through the galleries with a group of minority youngsters while discussing the emotional impact of Monet's haystacks and van Gogh's irises. The headline act was Los Lobos, the Latino rock band that had its roots at Garfield High School in East Los Angeles.

The event also served as a triumphant sendoff for Williams, who was scheduled to retire on his seventieth birthday, just seventeen days after the ceremony. He was being replaced by Barry Munitz, who was largely overlooked during the ceremony. When Munitz was called up to the stage at the last minute, he made a statement without saying a word. While most of the honorees were dressed in white shirts and dark suits, the Getty's incoming CEO made his debut in a turtleneck and sports coat.

Munitz, former chancellor of the California State University system, already had his marching orders to revamp the Getty Center's image. His goal was to change the Getty's profile from that of an aloof, gluttonous institution to one that was leaner, more focused, and intent on "coming down the hill" to connect with the diverse me-

tropolis it served. A small, high-strung man of fifty-six with a walrus mustache and perpetual tan, Munitz couldn't have been more different from his avuncular, wattle-necked predecessor. Whereas Williams was usually quiet and discreet, Munitz was an incorrigible schmoozer and name-dropper who fancied himself a man of the people.

Munitz had grown up in a Russian Jewish immigrant family in the Flatbush section of Brooklyn. His father got up from the dinner table one day and disappeared for years, leaving the young Munitz to help his mother and clubfooted sister scrape by. He managed to parlay his smarts into a Woodrow Wilson Fellowship at Princeton University, where he eventually received a Ph.D. in comparative literature. He taught briefly before launching into the political side of education, rising through the academic ranks to become chancellor of the University of Houston–Main Campus at age thirty-five.

Munitz's charm cut a swath through Houston society. He left his third wife for his fourth, the associate director of the Houston Grand Opera, and then left academia for an excursion into high finance with a tennis buddy, corporate takeover impresario Charles Hurwitz. By the late 1980s, Munitz was vice president of MAXXAM, which through its subsidiary Pacific Lumber had enraged environmentalists by harvesting old-growth redwoods in northern California. He also became chairman of a Texas savings and loan association, which federal regulators seized in 1988, making it the fifth-largest thrift failure in American history. The federal government accused Munitz and the association's board members of enriching themselves through hefty pay raises while hiding millions of dollars in losses from junk bond and tanking real estate investments.

By the time regulators sued, Munitz was four years into his chancellorship of the 369,000-student California State University system, the largest degree-granting institution in the world. He steered it through a severe financial crisis by cutting costs and hiking fees, winning praise from the business community and outrage from students and faculty. He emerged as a national spokesman for higher education, speaking of students as "customers" and education as a "prod-

uct." He drove a purple Camaro with the license plate CSU CHIEF and indulged his childhood passion for chess, displaying fifty sets from around the world in his Long Beach office.

Munitz's decision to take the Getty post stunned his friends but delighted political observers. Those closest to him, including Paramount Pictures CEO Sherry Lansing, immediately saw a mismatch. Munitz fancied himself a crusader for the working class but was about to start taming a notoriously headstrong and snobbish high-culture crowd at the Getty. Others lauded the Getty's coup in landing such a "visionary populist." A *Los Angeles Times* editorial called Munitz "the Getty's latest treasure" and predicted that the trust would soon take on his qualities of being "extroverted and socially involved."

Not long after his appointment, Munitz and others charged in the Texas savings and loan debacle settled for $1 million, paid by the thrift's insurer. (A federal judge in Dallas later ruled that government regulators had been overzealous in their efforts to punish Hurwitz and his associates.) The settlement barred Munitz from working in a bank or similar business for three years, but it said nothing about managing one of the largest nonprofit endowments in the world, estimated at $4.3 billion, second only to the Ford Foundation. To the Getty board members who selected him, Munitz's track record at Cal State and the prospects for a change in culture at the Getty overcame any lingering doubts about his past.

WITH THE GETTY Center opening, attention within the trust turned to transforming the original Getty Museum. Munitz considered it a rejoinder of sorts to the Getty Center, which was a monument to Williams. He privately badmouthed the Getty Center for its outrageous cost overruns and poor planning, which had prompted a front-page story in the *New York Times* about the embarrassing lack of toilets. Adopting the Getty Villa renovation as his own, Munitz persuaded the board to undertake the $275 million project in one shot, rather than in stages as originally planned. The trust would finance

much of the work through tax-free bonds so as not to raid the endowment as Williams had done.

Meanwhile, True relished her newfound prestige as the person in charge of the villa project. She traveled to Europe to inspect other museums for ideas and became the Getty's public spokesperson for the renovation project. She led a contingent of trust officials and lawyers to a Los Angeles Planning Commission meeting, where they unveiled their plans. The contentious meeting dragged on for a record seven hours. True also attended coffee klatches with nearby homeowners, showing up with her trademark scarf and brooch to discuss their concerns. Their main complaint was about the proposed outdoor Greek amphitheater, a feature True specifically wanted. Fearing that the plays and other events would ruin their seaside peace, the neighbors filed a lawsuit to block the theater. The case went to the California Supreme Court, where the Getty prevailed. But residents delayed construction long enough to force important concessions about when the Getty would use the theater.

As True took charge, friends and colleagues noticed a change in her personality. The intelligent, quiet assistant curator of the 1980s with the mousy brown hair had become an imposing, matronly woman with a platinum-blond upswept bouffant. Insiders began referring to her as "the Mayor of Malibu" or "the White Goddess of the Villa." To cross or contradict her was to risk provoking her volatile temper. She cut people off with a hot glare or piercing remark and banished anyone who was judged guilty of disloyalty. When drawings curator George Goldner, a close friend, took a job at the Met, True stopped speaking to him.

True also exhibited the sense of entitlement that seemed to infect many at the Getty. She used the trust's wealth as if it were her own, flying the Concorde to Paris and spending lavishly on fine hotels, chauffeured trips around Europe, and fancy dinners with foreign officials and friends. A recurring name in her expense reports was that of her new husband, French architectural professor Patrick de Maison-

neuve. They had married in the summer of 1998 in a private cere-
mony at her Páros home attended by Greek elites, including Robin
Symes and Christo Michaelides. When she went to visit her husband
in Paris, it was often on the Getty's dime.

Paradoxically, the change in True also involved increasingly stri-
dent calls for reform. She touted the Getty's new acquisition policy
wherever she went. At an international conference on art, antiquity,
and the law at Rutgers University in the fall of 1998, True signed
a resolution calling for long-term loans of ancient art from source
countries, which gave the countries the power to blacklist museums
that continued to acquire looted antiquities on the open market. The
Getty had abandoned its acquisitive past, she declared, and was look-
ing toward a new era of "sharing of cultural properties, rather than
their exploitation as commodities."

Six months later, she appeared at a National Arts Journalism Pro-
gram event at Columbia University, where she increased the pressure
on her peers by expressing "serious reservations" about the curatorial
appetite of museums that kept buying "simply to put material in the
basement." In the American museum community, such anti-collecting
talk amounted to heresy.

The curator had put herself on the side of the angels as the debate
over cultural property turned increasingly nasty. Academic panels,
normally erudite affairs laced with platitudes and pleasantries, fre-
quently flared into shouting matches. Archaeologists accused collec-
tors of enabling looters. Collectors condemned their accusers as "re-
tentionists" beholden to the governments of the countries where they
dug. Italian officials were dismissed as "nationalists," accused of hold-
ing the cultural world hostage with a patrimony law passed in 1939
under the fascist dictator Mussolini. At the Columbia University
event True attended, Greek partisans charged the stage when a panel-
ist suggested that the Elgin Marbles should stay at the British Mu-
seum because Greece was unable to care for them.

Legal opinion, too, had begun to tilt against museums. Italian cul-
tural officials had scored a coup in 1995 when they persuaded the U.S.

Customs Service to seize a $1.2 million golden phiale, or libation bowl, from the Fifth Avenue apartment of Michael Steinhardt, a wealthy hedge fund manager and benefactor of the Metropolitan Museum of Art. The ensuing legal case revealed that the dealer who had sold Steinhardt the bowl had first seen it in Sicily, purchased it in Lugano, and brought it to the United States in a carry-on bag, lowballing its value on customs forms and falsely claiming its country of origin as Switzerland.

Steinhardt appealed an initial court ruling that supported the seizure. The appeal rallied opposing camps to file heated amicus curiae briefs. The Archaeological Institute of America and similar groups disputed Steinhardt's claim that he was an "innocent owner," unaware of the object's questionable provenance. On the other side, the American Association of Museums led a coalition of institutional and private collectors who called the case "the most serious threat in memory to U.S. museums and the American cultural values which they long have promoted. Vast numbers of cultural objects acquired in the public U.S. marketplace and long exhibited in American museum collections will immediately be in jeopardy."

The appellate court also upheld the seizure. Steinhardt then appealed to the U.S. Supreme Court, which refused to consider the case, leading to the return of the phiale to Italy. Although on the face of it the museum community had suffered a setback, it breathed a collective sigh of relief. The Supreme Court had let stand an appellate decision that ordered the bowl returned on the narrow grounds of the falsified customs forms. It left unanswered the more important question of whether the bowl could be considered "stolen" under the National Stolen Property Act, something that could have criminal consequences for the dealer and Steinhardt. For several more years, that issue remained unclear in New York, the heart of the antiquities trade.

TRUE'S REFORMIST RHETORIC was soon put to the test. In 1998, amid her parade of conference appearances as a reformer, someone

contacted her with the incredible offer of a fourth-century B.C. bronze statue. A note faxed to her office said:

> Marion: Thank you for your immediate reply to my phone call. It was found in the Ionian Sea, very far away from the Greek boundary. We prefer not to send you a photo by fax. We have the intention to deal anywhere in Europe and when you come to Europe, any place and any time, you can come and inspect the object. After that, you can tell us if you're interested . . . Time is very important because we have no alternatives and for reasons that I can't tell you now but if we can meet face-to-face, our choice is that this object would be offered to the Paul Getty Museum.

The offer bore all the warning signs of a recent illicit discovery. The fax was sent from an Athens phone number and was signed "Jack Wynn," someone True had never heard of. It was followed up by a phone call not from Wynn, but from Christoph Leon, the Basel dealer who had intervened in the acquisition of the golden wreath five years earlier. The seller wanted $6 million, Leon said. He provided a picture of the statue, which was still covered with barnacles collected during two thousand years underwater.

The bronze was the kind of piece the Getty desperately wanted. It was extremely rare and would be a perfect complement to the Getty Bronze. True told Leon that she would come to Germany sometime in mid-May. She wanted to see the piece.

True arrived at Leon's apartment on May 19. The statue was lying on the living room carpet in a wooden box. Leon said that it had been found in international waters, meaning it was up for grabs legally, but he offered no proof.

UNBEKNOWNST TO THE curator, the Greek art squad had been in hot pursuit of the bronze for three years. An informant had alerted the Greek national police about the statue's illegal removal from the waters off Préveza, on the Ionian Sea. Investigators had narrowly missed catching its smugglers several times. Like their Italian coun-

terparts, the Greek art squad had grown in numbers and sophistication, spurred by the 1990 theft of 274 artifacts from a museum in Corinth that had shocked the Greek government into action.

When the informant passed word of True's visit to see the bronze, it sent the Greek art squad scrambling. They knew the curator's name from their ongoing investigation of the Getty's golden funerary wreath. Now the informant said that True had expressed interest in the bronze and agreed to the $6 million asking price, beating out a Japanese collector who had offered only $5 million. The bronze had been transported to the German town of Saarbrücken, where the deal was about to be closed.

The chief of the Greek art squad dashed off an urgent request to his superiors for 500,000 drachmas to set up a sting with German authorities. They hoped to seize the statue, the smuggler, and perhaps even the curator.

"Tomorrow one of our officers will fly to Germany via Frankfurt and he will pretend that he's a buyer," the chief wrote. "If you don't issue a ticket and give him the money, then there's a possibility . . . this object is going to be bought by the curator of the Paul Getty Museum. She is now in Germany to see the object."

To add urgency to the request, the chief alluded to the case of the funerary wreath, which still galled the government. "Christoph Leon and Marion True are well known to our department because they were well connected to a similar case."

The money came through, the undercover agent was dispatched, and the trap was set. On May 29, undercover officers swooped down on a hotel parking lot in Saarbrücken, arresting a Greek citizen with a record of smuggling drugs, guns, and cigarettes. They recovered the statue and other antiquities in a wooden box locked in the trunk of his Volkswagen Golf. The box was stamped U.S.A.

True's trip to view the object did not remain a secret. Around the time of the Rutgers conference, the Germans asked the FBI for help. Leon, they said, had "previously come to the attention of our organization in regard to a Greek gold funerary wreath of illegal origin . . .

Subject is of record with Swiss authorities in connection to U.S. bond fraud, forgery of documents and embezzlement in 1996." FBI agents went to the Getty to question True and associate curator John Papadopoulos, who had sent a form letter turning down Leon's offer without knowing that his boss had already gone to see the statue.

With Getty general counsel Christine Steiner in the room, True admitted that she had seen the statue at Leon's apartment but said that she had never intended for the Getty to buy it. She had gone to the apartment, she said, because she was "very interested to personally see it." As for Leon, True confirmed that he had sold the Getty the funerary wreath five years earlier. The curator claimed that she was now having second thoughts about his "unorthodox" ways.

"When Dr. Leon offered the bronze statue, Dr. True let us know she was very suspicious about the provenance of this statue," the FBI agent reported back to German authorities. The FBI agent never asked True why she had failed to alert authorities about her suspicions. In the end, the incident was a near miss.

13

FOLLOW THE POLAROIDS

THE CASE AGAINST the Aphrodite reached what appeared to be another dead end when Silvio Raffiotta, the Sicilian prosecutor, abruptly abandoned the investigation in 1998.

Raffiotta had been pursuing leads in Switzerland when he received a clear warning not to go any further. A Sicilian tombarolo accused him of protecting looters and their regional boss. Raffiotta denied the charge but believed that the powerful cabal of European dealers was behind it and knew that the next warning would not be so subtle. He asked to be reassigned to Palermo, where he took what he felt was a safer job hearing Mafia-related cases as an appellate judge. The allegations eventually faded but succeeded in stopping the prosecutor's chase of the Aphrodite.

Salvatore Morando, the lead Carabinieri investigator, turned for help to a newly formed pool of state prosecutors specifically designated to take on art theft cases. Unlike regular prosecutors, who were largely ignorant of how the looted art trade worked, the five prosecutors appointed to General Conforti's special pool in Rome became experts in illicit antiquities. They could discern the links between disparate cases and target the big bosses rather than the foot soldiers. Conforti also convinced the Ministry of Culture to appoint several

government archaeologists to the pool to serve as technical scientific consultants.

In the case of the Aphrodite, Morando turned to a gnomish, red-bearded prosecutor in his mid-forties whose expertise was international cooperation on criminal investigations. For most of his career, Paolo Ferri had slogged away in the Italian justice system as an investigative magistrate in the public prosecutor's office. He cut his judicial teeth early trying juvenile cases, including prosecuting members of the Red and Black Brigades during Italy's fight against domestic terror in the early 1980s. He became known for his meticulousness inside the courtroom, as well as his easygoing, self-deprecating manner outside it. His fine-honed sense of procedure also earned him a position representing Italy on a European Union group developing new protocols for pursuing criminal investigations across the continent's recently opened borders.

Ferri had jumped at the chance to join Conforti's pool of art prosecutors in 1995. He had no formal training in antiquities, yet he fancied himself an amateur archaeologist, having spent several summers prowling the ruins of Greece. Conforti was delighted. Ferri had exactly the kind of methodical legal mind the art squad needed to navigate the cumbersome system of petitioning foreign governments for judicial assistance.

Morando brought the Aphrodite case file—several binders, bound with red cloth ties—to Ferri at his nondescript office in the rust-laced concrete judicial complex on Piazzale Clodio, not far from the Vatican. Looking at the photos, Ferri admired the statue's size and intricately carved drapery. The Venus of Morgantina, he thought. She was like Helen of Troy, a national beauty that had been stolen by foreigners. I want this back in Italy, he said to himself. Such loveliness belongs at home.

For the moment, little could be done. But the Aphrodite stuck in Ferri's mind, even as he turned his attention to another case he was wrestling with—the investigation of Giacomo Medici.

· · ·

IMPORTANT AS IT was, the Medici case had languished in a bureau-cratic eddy for two years after the warehouse raid. The first thing Ferri did was fire off a series of requests to authorities in the countries where Medici's tentacles led: the United Kingdom, the United States, and Switzerland. Ferri knew that the process could drag on for years. Antiquities "market" countries such as the United Kingdom and United States did not give a high priority to such matters. But the Swiss were worse. Even in rhetoric, they continued to resist the notion that looting was a serious crime. With no archaeological heritage to speak of, the country had no law against trafficking in looted art and had not signed the 1970 UNESCO Convention. Ferri knew that he would need to come up with evidence of a more serious crime to gain the cooperation of the Swiss government.

Surprisingly, one request soon hit its mark in the UK. It went to Sotheby's, which had been linked to the looted antiquities trade in an unrelated journalistic exposé. Two months after the Medici raid, a London television station aired the first of three documentaries by arts reporter Peter Watson, who used leaked documents and undercover work to show how the venerable auction house regularly sold smuggled art, including artifacts dug up illegally from ancient Italian graves and trafficked through Switzerland. The revelations resulted in criminal convictions of two Sotheby's employees and forced Sotheby's to move its antiquities auctions from London to New York.

Hoping for a foothold, Ferri turned the Sotheby's files over to the archaeologist assigned as technical adviser to the Medici case. That was Daniela Rizzo, an attractive, middle-aged government archaeologist with a supple mind. She was working at the Villa Giulia, a sixteenth-century papal palace that served as the nation's premier, if seldom visited, museum for Etruscan antiquities. Rizzo set about analyzing Sotheby's records with her museum colleague, Maurizio Pellegrini. A former photojournalist who couldn't stomach shooting human tragedies, Pellegrini was in charge of children's programs at the museum and made amusing educational films explaining the ancient world. For Ferri's purposes, his eye for detail was an invaluable asset.

Rizzo and Pellegrini combed through the auction house's documents, familiarizing themselves with the blizzard of images and numbers. They spent weeks making various lists of the objects. What did they show chronologically? What about the companies involved? Why were many objects offered again and again? As time slipped away, they sensed that Ferri was becoming impatient.

The breakthrough came late one afternoon in Rizzo's office, after everyone else had gone home. Under the light of a small desk lamp, Rizzo and Pellegrini were flipping once again through Sotheby's documents. Something clicked.

"Stop!" Pellegrini cried as Rizzo leafed past a photocopied picture of a hydria, or water jug. "I've seen that vase before. It was in Medici's warehouse."

Rizzo checked the photo in Sotheby's records. The vase was one of hundreds that Medici had sold at auction in London. The records showed that it had been offered for sale several times but never purchased. Then, on November 12, 1994, the vase, lot number 295, had finally sold.

"It can't be in his warehouse," Rizzo said. "It says here he sold it a year before the raid."

But Pellegrini was already pawing through photos of Medici's warehouse taken by investigators during the 1995 raid. "Here!" He pointed at a photo showing the same vase. It had a small tag around its neck that read SOTHEBY'S 11/12/94 LOT #295.

The light went on for both of them. Medici must have sold the object to himself, perhaps through a frontman. But why?

They called Ferri and told him that they had found something but didn't know what it meant. The next morning in his office, they carefully walked him through their discovery.

Ferri looked up from the records, a boyish grin on his face. "It's laundering!" he said. "It's wonderful!"

IN ALL, RIZZO and Pellegrini found twelve vases that were presumably sold at the November 1994 auction by Medici and seized at his

warehouse a year later. Swayed by that evidence, the Geneva court agreed in February 1998 to unseal Medici's warehouse suite and let a panel of three prominent Italian archaeologists study the thirty-eight hundred objects and fragments inside. Pellegrini accompanied the experts to the Geneva Free Ports to help review the thousands of documents and photographs sequestered there.

The rules established by the Swiss court for the inspections allowed the Italians to take notes, but not to take pictures or to remove any of the objects or documents. It took six visits over two years for the Italians to slowly digest the contents of the warehouse.

The Italian archaeologists were horrified at the scope of the inventory. They had spent their careers conducting painstaking excavations in which any one of these objects would have been a noteworthy find. They calculated that thousands of tombs must have been destroyed to produce such a cornucopia of ancient treasures. Based on the cultures represented in the objects, those tombs had spanned all of Italy, from Sicily to Genoa. In some cases, the experts were able to identify precisely where the objects had been looted from because matching fragments were left behind and now resided in Italian museums. The survey of objects in the warehouse shattered any illusion that looting in Italy was limited either to a particular region or to archaeologically important objects.

Pellegrini focused his attention on the boxes of documents and photographs found in the back office of the warehouse. The documents filled 173 binders—tens of thousands of letters, receipts, bills of lading, and auction results. But it was the photos that caught the former photographer's eye. Medici had kept thirty albums of Polaroids, plus another thirty or so envelopes with negatives, prints, and undeveloped rolls of conventional film. Pellegrini guessed that there were some thirty-six hundred images in total. Taken together, they formed an inventory of the thousands of objects Medici had trafficked during his career.

Some of the photos showed objects encrusted with dirt, as if they had just been hauled out of the ground. Others captured priceless

antiquities wrapped in newspaper, stuck in the trunk of a car, laid out on a cheap carpet, sitting on a tile floor, or propped up on a kitchen table. Some of the photos were of objects now locked up in the warehouse. Pellegrini was aghast. He thought the album looked like a murder book—a voluminous catalogue of archaeological corpses stripped of their context.

After the initial shock wore off, he began to notice details. Many of the photos were low-quality Polaroids taken with a 1970s model camera. Two such cameras were found in the warehouse. Pellegrini knew that looters and middlemen liked using Polaroid cameras, which spit out self-developing photos. It was far safer than using conventional film, which had to be developed by an outsider, who might tip off police. The cameras themselves were essential pieces of evidence, proving that the objects had been excavated and photographed sometime during the 1970s, long after Italy's 1939 patrimony law had gone into effect. Each picture had a serial number on the back that indicated more specifically when the film had been manufactured.

Medici had scrawled notes in a primitive code along the white borders of some of the Polaroids. Pellegrini eventually deciphered the markings. "V" stood for *venduto*, "sold"; "12" meant $12,000; "CRO" was Christo Michaelides, Robin Symes's partner; "Bo" was Robert "Bob" Hecht.

Pellegrini went home from his first day at the warehouse stunned by what he had seen. Aching to talk about it, he called Rizzo in Rome.

"It's—it's incredible," he stuttered. "It's terrible."

"What is? What did you see?" Rizzo asked.

"You have no idea what there is here . . ." Pellegrini's voice trailed off.

"Look, whatever you see, look for the auction tags and write down the lot numbers and dates. We can use them to trace the objects."

During his return visits to the Geneva warehouse, Pellegrini constructed a written record of what he saw in the Polaroids. One scene in particular sucked the wind out of him. The photos showed an un-

derground room half-filled with volcanic ash. The walls were covered with intricately painted frescoes in deep reds, blues, and ochers. The room obviously belonged to an undiscovered Roman villa in Pompeii or Herculaneum, ancient cities buried by the eruption of Mount Vesuvius in A.D. 79. Subsequent photos showed the same frescoes cut into dozens of suitcase-size squares and laid out carelessly on a table, ready for export. Still other photos depicted the squares after they were roughly plastered back together, ready for restoration. The end product was in the warehouse room next door. Pellegrini recognized two of the frescoed walls, packed in bubble wrap, ready for shipment. One was already gone. Where was it today? The question hung in the air.

Ferri and his investigators recognized the significance of the Polaroids. For decades, Italian efforts to recover looted antiquities had been stymied by the fact that it was almost impossible to find definite proof that an object had been illicitly excavated. By the time the Carabinieri caught up to a smuggler, the plundered piece had been wiped clean through restoration or was gone altogether. Looters in Italy were, for the most part, too careful to keep detailed records of their wares. By the time the piece showed up on a museum's doorstep, there was no way to trace its progression through the trade.

Now, in the warehouse of one of the principal middlemen, authorities had stumbled upon an archive filled with that kind of proof. The Polaroids detailed the step-by-step process, from fresh find to clumsy restoration, when the object's value could be discerned by academics or collectors. Finally, they depicted the object at its most glorious—professionally restored and in a museum display case.

One task remained. Ferri's team needed to figure out just where the looted artifacts had ended up. Who were the end buyers?

That job required matching pieces from Medici's photo albums to those in glossy publications of the world's greatest antiquities collections. But until Swiss officials let Italy have Medici's Polaroids, it had to be done by memory and notes.

Pellegrini burned the images into his brain, then returned to Rome

and retreated with Rizzo to her home to search through the museum catalogues. It became an obsession, a high-stakes game of Concentration. The search required an amazing ability to distinguish subtle variations in vases that, to untrained eyes, all looked alike.

As Rizzo and Pellegrini painstakingly linked Medici's objects to museums, the scope of the investigation grew far beyond anything they had previously imagined. Looted artifacts had ended up on museum shelves in Germany, Switzerland, France, Spain, Japan, the Netherlands, and Denmark. But by far, the most had gone to American museums. There were Medici objects at the Met in New York City, Boston's Museum of Fine Arts, and smaller but significant museums in Cleveland, Tampa, Minneapolis, Princeton, San Antonio, and Fort Worth. Not surprisingly, the single biggest buyer of Medici's antiquities appeared to be the world's richest cultural institution — the J. Paul Getty Museum.

Medici himself had marked the trail to Malibu. He tagged some of the Polaroids with "PGM," shorthand for Paul Getty Museum, as the Italians called the Getty. There was also a batch of conventional negatives that Medici had labeled "Trip to LA," which included snapshots of Medici and Hecht visiting the Getty and posing before several of the museum's masterpieces.

In one, Medici stood smiling in front of the Getty's griffins, which had been purchased from the Tempelsman collection. Sure enough, Polaroids in Medici's binders showed the sculpture broken into three sections, one of which was sitting on an Italian newspaper, another lying on a blanket in the trunk of a car. The progression from archaeological contraband to museum showpiece appeared incontrovertible.

As they raced through the catalogues, making match after match over pizza late at night, Rizzo and Pellegrini also felt an adrenaline rush of a different kind. Bound by a common purpose, working closely together, they found themselves falling in love.

IN FEBRUARY 1999, the Getty announced that it was returning three more antiquities to Italy, including the vase painted by Onesi-

mos that had caused the skirmish at the Viterbo conference nearly a year and a half before. The public confrontation had forced the museum's hand. The Getty decided to give back the vase and two other pieces that had troubled True for some time. One was a torso of the Roman god Mithra, a limbless second-century A.D. sculpture acquired in 1982. A graduate student had recently alerted the antiquities department that the torso bore a striking resemblance to a piece that was once pictured in a private eighteenth-century Italian collection. When True called the collection's curators, they discovered that the sculpture was indeed missing. The second object was a bust of the famous Greek athlete Diadumenus, acquired as part of the Fleischman collection. A German scholar had notified the Getty that the stone head had once been in the inventory of a government-sanctioned dig at Venosa, in southern Italy.

In February 1999, the *Los Angeles Times* called the return of the three pieces "a graphic illustration of the Getty's continuing attempt to position itself as a model of ethical behavior in the notoriously shady world of collecting antiquities." It quoted a Greek vase expert as saying that the Getty's decision to return the Onesimos vase was a "courageous move." Assistant museum director Debbie Gribbon gave all the credit to True, who told the paper, "Reliable sources in the market confirmed the allegations to be true. And once I had that information, I felt the best thing was to return it."

As she had with the return of the tripod three years earlier, the curator personally accompanied the objects back to Italy for the repatriation ceremony at the Villa Giulia. She was signing paperwork when a member of the Carabinieri art squad standing nearby called over a smallish man who seemed to be browsing the collection. It was Paolo Ferri.

"I would like to talk to you about several objects in your museum," Ferri said to True after introducing himself.

True was silent, taken aback. It was the reaction Ferri had been looking for. He wanted True to know that he was watching the Getty.

"Securing the repatriation of the Onesimos is only a starting point," he continued with a smile. "The Getty must do more."

"I'm sorry. I can't . . ." The curator blanched, then scurried around Ferri and the Carabinieri and started walking away.

"Maybe next time," Ferri called, "you'll bring back the Venus of Morgantina."

"Maybe next time," True snapped, "you'll have evidence it came from there."

14

A WOLF IN SHEEP'S CLOTHING

THE RETURN OF the Onesimos vase galvanized a growing resentment toward Marion True.

Most American museums would have returned the two objects that were obviously stolen from documented collections. But the Onesimos vase was not stolen in the traditional sense — it was the product of looting, like thousands of other ancient objects in museums across the country. By giving back the Onesimos, True and the Getty were suggesting that looting was the moral equivalent of theft, a notion museums had fought for generations. And given the growing severity of the Italians, many colleagues thought it was like waving a red cape in front of an angry bull.

Inside the Getty, the return aggravated a nasty feud between True and Debbie Gribbon, True's immediate boss. Still stung that True had been given control of the Getty Villa renovation, Gribbon began complaining to Getty CEO Barry Munitz about True's crusade against looted antiquities. She argued that it was dangerous, given the Getty's past acquisitions, and put the museum at odds with the rest of the museum community.

"She's wandering all over, speaking out on all these issues, but is she speaking her own opinion? Or is she speaking for the institution?"

Gribbon asked Munitz. "Are we comfortable with how she's behaving? She's calling attention to us and making things uncomfortable. A lot of other museums think we're holier-than-thou."

True had to be reined in, Gribbon insisted.

Munitz tried on various occasions, calling the women together to hash things out. Invariably, True defended her position as the right thing to do. Gribbon countered that the antiquities curator was not a free agent and should not to be "proselytizing." The curator promised to tone it down, but it was often only a matter of weeks before Gribbon stuck her head inside Munitz's office to say, "She's doing it again."

Gribbon was not imagining things. Other museums that collected antiquities felt burned by the Getty's 1995 acquisition policy, which, by requiring an ownership history, had effectively ended the Getty's active collecting. Now True's gratuitous outspokenness was threatening to bring other museums legal trouble.

Few were angrier at True than Philippe de Montebello, director of the Met. Since succeeding Thomas Hoving in 1977, he had become the undisputed lion of the museum world and the longest-serving director of a major cultural institution. The descendant of French aristocracy and World War II resistance fighters, de Montebello had a master's degree from Harvard in European paintings, but his administrative shrewdness surpassed his scholarship. Whereas Hoving was a playfully self-obsessed populist, de Montebello was elitist and haughty. Constantly surrounded by people with much more money than he possessed, he never let them forget that he had the better family name.

Nothing galled de Montebello as much as the changing tide in the cultural patrimony debate, which cut to the core of his institution's identity. De Montebello was a hawk on the antiquities issue, a firm believer in museums' right to acquire what they wanted from the art market. He viewed demands by Italy, Greece, Turkey, and other source countries as naked nationalism, exercises in hypocrisy. The same cultural ministries had for decades ignored or winked at the an-

tiquities trade, with their bureaucrats often benefiting directly from bribes. Now to cry foul and paint American collectors and museums as the bad guys offended de Montebello's sense of fairness. He was likewise disdainful of the "dirt archaeologists" who opposed the antiquities trade. If they had their way, he argued, they would lock up priceless artifacts in anonymous storage sheds or conservation labs, depriving the public of a chance to learn about them.

The Met's acquisition policy allowed the museum to acquire anything that had a documented history going back ten years. It also made an exception for any object deemed of sufficient beauty or cultural significance—a huge loophole that angered archaeologists. Although most of his own staff favored the bright line offered by the 1970 UNESCO Convention, they knew better than to incur de Montebello's occasional wrath with suggestions to change the Met's antiquities acquisition policy. De Montebello's prominence and his resistance to reform set the tone for many major American museums. In the annual meetings of the Association of Art Museum Directors, the profession's most powerful group, de Montebello and others beat back an effort by younger museum directors to introduce a model policy that hewed closely to the UNESCO treaty. Now True's outspokenness represented a challenge to his authority.

De Montebello had another reason for being upset. Quietly, the Met had been fighting its own battles with Italy over claims of looted art. Besides the occasional noise the Italians made about the Euphronios krater, the Met had become locked in a tug of war over a collection of ancient silver vessels that it described as "some of the finest Hellenistic silver known from Magna Graecia."

The silver service, which included an ornate medallion of Scylla, a sea monster who threatened sailors with shipwreck, was acquired in two installments during the early 1980s for $2.74 million. Italian officials claimed that the hoard had been taken illegally from the ruins of an ancient house in Morgantina, then smuggled out of Sicily along with the marble hands, heads, and feet that were subsequently sold to Maurice Tempelsman. Indeed, these were the same silver vessels that

Fausto Guarnieri, the art squad investigator, had learned about while investigating the Aphrodite.

In 1996, after General Conforti met Met president William Luers at a social event, he wrote a series of letters to the museum chief asking for the voluntary return of the hoard. He warned that Italian officials were prepared to file a formal judicial request with U.S. authorities if the museum didn't comply. Met general counsel Ashton Hawkins deflected Conforti's efforts several times, claiming that the silvers had been purchased from a Lebanese antiquities dealer and had a long history of previous ownership.

What the Met lawyer didn't tell Conforti was that U.S. Customs Service officials had already punched holes in the museum's story about how it had acquired the silvers. Investigators found no trace of the Lebanese dealer. Instead, the Customs Service learned that Robert Hecht had carried the pieces to the United States on a Swissair flight from Germany. The middleman's involvement and the Lebanese antiquities dealer cover story were reminiscent of the Euphronios krater scandal of the early 1970s. In the two decades between the cases, it seemed, the Met had not changed its way of doing business.

The exchange between Conforti and the Met soon spilled into public view. In 1998, the *Boston Globe* revealed the sordid tale of the silvers in a front-page story. The Met still refused to relent. Hecht would not comment, other than to say coyly, "Until someone proves this Euphronios vase or this silver treasure was excavated clandestinely and shows us the hole it came out of, it's as innocent as the Virgin Mary."

Morgantina archaeologist Malcolm Bell then joined the fight. Bell had first seen the silvers in 1987 and immediately connected the pieces to reports he had heard about a hoard looted from an ancient home on the outskirts of his dig site. But when he asked the Met for a closer look, the museum declined his request. That refusal stood for nearly twelve years, until 1999. By then, Bell had dug at the suspected find spot. He had found two holes in the ancient floor, a sign that the site had been sacked by looters, and a deed nearby identifying the resi-

dence as the home of a person named Epolemous. At the Met, Bell looked carefully at the display and found that one of the pieces bore this inscription: "From the house of Epolemo."

It was as close as an archaeologist could get to a smoking gun. Yet the Met still refused to budge.

IN OCTOBER 1999, Italy brought its fight against the illicit antiquities trade to the U.S. government with a formal request to the State Department for strict import quotas under the U.S. Convention on Cultural Property Implementation Act. The request wasn't the first to be considered under the 1983 law implementing UNESCO treaty protections. Canada, El Salvador, Cyprus, Guatemala, Peru, and Mali had already succeeded in getting similar quotas established. But Italy's request was by far the most important.

The country gushed ancient art from its dry riverbeds, construction projects, and farm fields. Italian officials now wanted to stop the flow by petitioning for sweeping protection of nearly everything originating from the eighth century B.C. to the fourth century A.D. They argued that demand from collectors in America and elsewhere had fueled the systematic plunder of hundreds of graves, temples, sanctuaries, villas, and public buildings. They cited statistics showing that between 1993 and 1997 alone, the Carabinieri had recovered more than 120,000 items from rings of tombaroli, which nibbled away at government-protected archaeological sites throughout their country.

The State Department's decision rested largely on the Cultural Property Advisory Committee, an eleven-member panel of political appointees chosen to reflect all sides of the contentious antiquities issue—collectors, archaeologists, dealers, and the general public. The committee hearing on the matter was shaping up to be an epic fight. On October 12, 1999, more than fifty collectors, dealers, academics, lawyers, archaeologists, and journalists squeezed into a stuffy hearing room in Washington, D.C., to have it out.

The emotions and rhetoric ran high. Collectors and dealers went up to the microphone first, accusing Italians of being unreasonable

and duplicitous. Frederick Schultz, a New York antiquities dealer and president of a national dealers association, said that Italy's request was motivated by its totalitarian past. He emphasized that Italy's 1939 patrimony law had been passed under Mussolini, the "same man who wrote the laws expropriating the property of and stripping national identity from Italian Jews."

Arielle Kozloff, former Cleveland Museum of Art antiquities curator turned private dealer, was even more direct. "Ladies and gentlemen, don't let Italy fool you," she told the committee. "She is a wolf in sheep's clothing. She is predatory. And if you support this application, the result will be the intellectual fleecing of America."

The archaeologists present fought back. Ricardo Elia led the committee through the results of his study showing that only 5 percent of the fourteen thousand southern Italian vases sold at auction or written up in scholarly catalogues had come from sanctioned excavations. The rest appeared on the market with no provenance and were presumably looted.

Elia was followed by Bell, who had ghostwritten the Italian request. Soft-spoken yet blunt, the director of the Morgantina dig ticked off a litany of looting horrors, saying that the illicit trade had become so lucrative that the local Mafia in the region of Campania had begun using illegal immigrants from North Africa and Albania to dig for artifacts. "It is a dirty business, quite analogous to the trade in illegal drugs, or to prostitution," Bell said.

While the battle raged, representatives of museum groups were conspicuously quiet. They had already antagonized Italian officials by backing Michael Steinhardt, the Met trustee, in his unsuccessful court battle with Italy to keep his golden libation bowl. Fearful of offending Italy's cultural officials even more, they sat back and let the dealers mount the attack. Yet one museum official did rise to speak during the marathon public meeting.

Marion True stepped to the microphone late in the day. She wore a sky blue scarf wrapped around her neck and draped over one shoul-

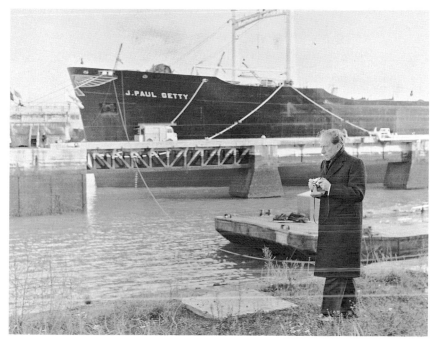

Oil tycoon J. Paul Getty was a millionaire with a miser's heart. He considered ancient art an addiction he could not shake. When Getty died in 1976, he left most of his personal wealth to his small museum in Malibu, making it the world's richest art institution overnight.

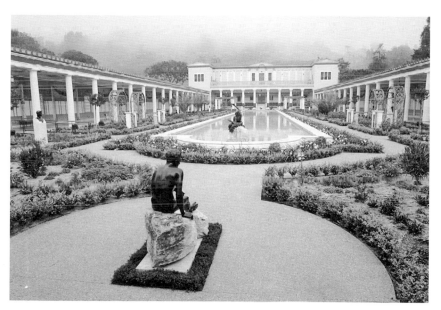

The reflecting pool and garden of the Getty Villa, which first opened in 1974. It was extensively remodeled and reopened in 2006 as the home of the Getty Museum's world-class antiquities collection. Soon after, many of the Getty's prized objects on display there were returned to Italy.

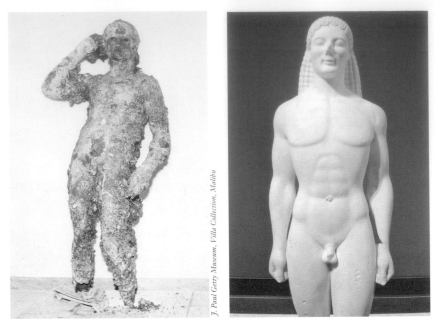

J. Paul Getty Museum, Villa Collection, Malibu

LEFT: A photo of the Getty Bronze soon after it was hauled out of the Adriatic Sea in the 1960s by Italian fishermen. The statue was buried in a cabbage field and smuggled out of Italy before resurfacing in Europe in the 1970s, when J. Paul Getty first saw it. RIGHT: The kouros, or statue of a young man. The Getty bought the marble Greek statue for nearly $10 million in 1985, believing it was authentic and had been looted recently from southern Italy. After a lengthy investigation, many at the Getty concluded the kouros was a fake. Today it remains on display, labeled, "Greek, about 530 BC or modern forgery."

The Getty's Aphrodite, which the museum purchased in 1988 despite obvious signs it was looted. For the Italians, the towering figure became a symbol of cultural plunder fueled by American museums.

Getty's first antiquities curator, Jiri Frel, sitting next to his prized acquisition, the Getty Bronze. J. Paul Getty never bought the statue, concerned that it had been smuggled out of Italy. Frel pursued the acquisition after Getty's death, and later embarked on a tax fraud scheme that brought thousands more illicit antiquities into the museum's collection.

LEFT: John Walsh, former Getty Museum director, wrote a 1987 policy that allowed the Getty to appear prudent while continuing to acquire looted antiquities. Soon after, the Getty bought the Aphrodite for $18 million. RIGHT: Marion True became antiquities curator in 1986 after her predecessor resigned, warning that the museum would someday become a victim of its own "curatorial avarice."

RIGHT: The Getty's statue of griffins attacking a fallen doe. It was purchased from diamond magnate Maurice Tempelsman in 1985, along with a statue of Apollo and a lekanis, or ceremonial basin, for $10.2 million.

BELOW: Italian antiquities dealer Giacamo Medici in front of the griffins on a visit to the Getty Museum in the late 1980s. The museum continued to make payments on the griffins, Apollo, and lekanis after Medici told Getty officials he had bought the pieces from Italian looters. It was returned to Italy in 2007, after Medici was convicted for trafficking in looted antiquities.

A seized Polaroid showing the Getty's marble griffins resting on Italian newspapers and in a car trunk, soon after being illegally excavated.

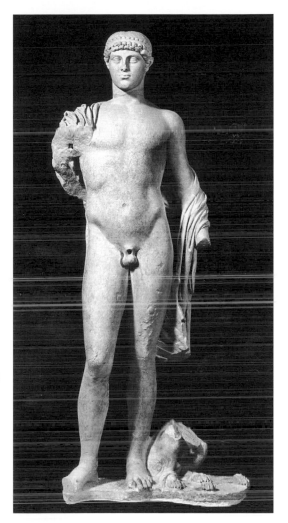

The Getty's statue of
Apollo, purchased with
the griffins in 1985.

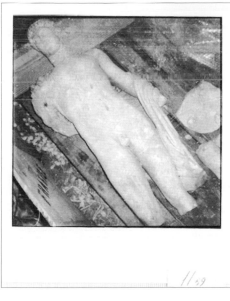

A Polaroid seized from Giacomo
Medici's warehouse showing the
Apollo — on a pallet and in
pieces — shortly after it was
illegally excavated from southern
Italy. The statue was returned
in 2007.

The Getty bought the golden funerary wreath for $1.15 million in 1993. Months earlier, Marion True was shown the wreath in a Swiss bank vault by a man she later concluded was an impostor. She was shaken by the experience and concluded the wreath was "too dangerous" for the Getty to purchase. A few months later, she changed her mind.

Barbara and Lawrence Fleischman, here in their Manhattan apartment, were close friends of Marion True. In 1996 the Getty acquired their antiquities collection, valued at $60 million. Days later, the Fleischmans gave the curator a personal loan to refinance her Greek vacation home. Both transactions came back to haunt True, leading to her 2005 indictment in Italy and her firing by the Getty.

Deborah Gribbon, who succeeded John Walsh as Getty Museum director in 2000. Her determination to continue buying suspect antiquities angered the Italians. She resigned suddenly in 2004 after clashing with Getty Trust president Barry Munitz.

Italian prosecutor Paolo Ferri. His investigation of Italian antiquities trafficker Giacamo Medici uncovered a trove of Polaroids showing thousands of objects soon after they had been looted from Italian tombs and ruins. Ferri's investigators traced the objects to dozens of museums across Europe and the United States. The investigation led to the 2005 indictment of Getty antiquities curator Marion True in an Italian court.

Former Getty antiquities curator Marion True pushes through a crowd of paparazzi outside a 2005 hearing in Rome, where she faced charges of conspiring to traffic in looted art. The case led to the return of hundreds of illicit antiquities to Italy and Greece from museums, dealers, and private collectors.

der, making her blue eyes stand out even more than usual. Despite the wilting stuffiness of the room, her blond hair remained perfectly coifed. As she started to talk, people stopped shuffling papers and looked up.

Saying that she spoke with the Getty's blessing, True strongly defended the Italian request. She deemed "improper" the suggestions of some that it was better to have illicit antiquities on well-tended American shelves than to let the careless Italians keep them in dusty exhibits. American museums were just as careless with their objects, True said. Many still didn't have updated inventories or pictures of their own items. As for those who, like Schultz and Kozloff, accused the Italians of being cultural "retentionists," True noted that Italy was becoming more generous with loans of ancient art. Policies that expected Italy to be able to document objects that had been looted, like the one the Getty used to rely on, were irretrievably flawed. The Italians couldn't be expected to identify looted objects if they didn't know they had been looted in the first place.

The curator went even further in her written remarks submitted to the committee, exposing the museum world's dirty little secrets. She wrote that the illicit trade had thrived because "museum curators like myself and private collectors have profited greatly" from a mishmash of international laws that permitted the flow of undocumented material to American institutions. Museums had "readily ignored" the UNESCO Convention's ideals as well as their own ethical codes to snap up headline-grabbing antiquities. And she conceded that the old saw about items coming from unnamed "established collections" was, in fact, a convenient fiction. True concluded that approving the Italian request would lead to "a decrease in the illicit excavation and traffic in antiquities, and a cleaner art market that is free of the kind of sordid associations that have sullied it for the last three decades."

True's frank assessment had an impact on some of the committee members. Although they were already leaning toward the Italian request, the fact that one of the country's leading antiquities curators

was for it helped to solidify their position. The committee eventually recommended approval, prompting the State Department to impose the requested import restrictions. The tide had turned.

FOR MUNITZ, THE activities of his antiquities curator were of little concern compared to the challenge he faced making sweeping changes in the Getty's structure, politics, and culture.

He had inherited an institutional flow chart from Williams that had each arm of the trust reporting independently to the CEO, like children competing for their father's attention. Each program was operating in its own little world. The programs had secretive budgets and jealous turf fights that included exclusive passkeys to their own buildings at the Getty Center, where togetherness was an unfulfilled notion. There was no system of centralized control over spending, leaving each division on its own to order supplies as it pleased. "The org chart is like Versailles under Louis XIV," Munitz complained to his friends.

Munitz also did little to hide his jealousy over the residual loyalty employees showed toward Williams, who, to the new CEO's horror, refused to go away. In retirement, Williams continued to draw a large pension and occupy an office at the center.

But Munitz lost little time in making his own mark. Days after taking office in January 1998, he met with the trust's top one hundred managers and declared a new "dimension of reality." The days of spending without a care were over, he warned. The endowment, which was tied to the stock market, was not going to grow forever. It was time people at the Getty started thinking about how to raise money, as other cultural institutions had to do. He also attacked the practice of "aesthetic obfuscation," in which managers handed in phony budgets to hide from one another what they were really doing. Pulling out a list of staff members ranked by seniority, Munitz said that the Getty needed new blood. He pointedly encouraged so-called Getty babies—those who had been at the institution from internship through management—to consider other work. Word raced through

employee lunchrooms that when someone asked where, Munitz had facetiously suggested Starbucks.

Munitz knew that, months after opening the $1 billion-plus show palace, his talk of austerity would be greeted derisively by the staff. But he was remarkably tone-deaf to their reactions. His hearing was tuned instead to board members, who felt that Williams had let costs get out of hand while building the Getty Center. Time and again, the Getty had dipped into its endowment to make up the difference. Munitz took a cue from board chair Robert Erburu, CEO of Times Mirror and a trustee of the Huntington, a library and museum complex in San Marino, California, which had burned through money from a neglected endowment left by railroad baron Henry Huntington in 1927. Both Munitz and Erburu were determined not to make the same mistake in Brentwood.

Munitz began retrenching. After setting up peer-review committees to evaluate how each unit was performing—something many insiders considered a Darwinian exercise, pitting Getty employees against one another—Munitz disbanded the Information and Education institutes, considered the weakest of the bunch. Other programs faced cuts.

The only Getty enterprise excused from scrutiny was the museum, where allegiance to Williams had been the weakest. Museum director John Walsh had openly clashed with Williams over the years. Munitz seized on that poorly concealed animosity, allowing Walsh to ride out his time to retirement in the newly created post of trust vice president. The CEO then threw his support behind Walsh's deputy and confidante, Debbie Gribbon, to take over as museum director.

A tall strawberry blonde with a sharp mind and acid wit, Gribbon came from a family of overachievers. Her father was a prominent Washington, D.C., attorney, and her sister was a high-ranking U.S. appeals court judge, widely considered a possible candidate for the Supreme Court. Gribbon had earned her Ph.D. in fine arts at Harvard and was a curator at the Isabella Stewart Gardner Museum in Boston when Walsh recruited her to the Getty in 1984, shortly after

his own appointment. Although she could be charming, even disarmingly vulnerable, Gribbon had the instincts of a tiger when it came to protecting her turf.

Some board members were dubious about Gribbon's appointment. They wanted a nationwide search for a better-known, more widely respected replacement. Others doubted whether Gribbon was ready for the job. There was also the matter of her personal life. As Walsh's deputy, Gribbon had carried on a yearlong affair with drawings curator George Goldner, who was junior in rank but reported directly to Walsh. The affair, which was an open secret, ended in 1991. Goldner soon moved to New York City, but Walsh agreed to let him keep running his department by commuting to Malibu twice a month. In 1993, he left the Getty for a job at the Met.

The episode would have remained a quiet part of the Getty's institutional lore except that Gribbon ended up tangling with Goldner's successor, Nicholas Turner. She demoted him over allegations that he had sexually harassed his secretary. Turner left for another job, and the episode was forgotten—until days before the Getty Center opening, when Turner struck back. He filed a defamation lawsuit accusing Gribbon of trying to sabotage his career and characterizing his indiscretion as part of a sexually charged Getty culture. As evidence, he cited Gribbon's affair with Goldner. Scrambling to keep the charges quiet, trust officials negotiated a $650,000 settlement with Turner. One of Munitz's first acts as CEO was to approve the settlement, which spared Gribbon public humiliation but left a bad taste in the mouths of trustees.

Now hoping to promote her to museum director, Munitz argued that Gribbon should be forgiven. The board should move on. He assured trustees that she was ready to head the museum and warned that the Getty risked losing her to a competing institution if it dithered. Eventually, board members backed down, figuring they should let their new CEO have his way.

Gribbon's appointment was a political victory for Munitz. In the

same vein, he sought to reshape the board itself. He soon found an opening through Barbara Fleischman.

In January 1997, Larry Fleischman had a fatal heart attack in London. The Getty held a memorial service for him, and at Barbara's request, Harold Williams accelerated payment on the antiquities acquisition, costing the trust an extra $2 million. Since then, Barbara had heard nothing from Malibu, a silence that offended the longtime socialite and Met trustee, who understood the necessity of maintaining close ties with donors.

When True passed word to Munitz that Fleischman was peeved, the gregarious CEO swung into action. With a 1999 board meeting scheduled in New York around the time of Fleischman's birthday, Munitz arranged to throw a lavish party for the widow at the Four Seasons Hotel. He also invited her to speak to trustees about how the Getty could improve its poor record of raising outside money. Fleischman urged trustees to capitalize on the villa renovation by organizing a "Villa Council" made up of donors willing to give $5,000 a year in exchange for special perks, ranging from previews of exhibits to going on summer antiquities tours arranged by True. Getty trustees were so charmed by Fleischman's enthusiasm that they put her name on a short list of candidates for upcoming board vacancies. They also voted to waive their mandatory retirement age so that the seventy-four-year-old donor could be eligible.

Fleischman was sworn in as a trustee at the June 2000 board meeting, which fell on an unexpectedly chilly day in Malibu. Munitz was triumphant, believing that he had sent a clear signal down the line that he was serious about cultivating and rewarding donors. It was also a sign to the rest of the museum world that the Getty, once thought to be above such things, was ready to woo and reward generous patrons.

Gribbon's appointment was announced at the same meeting, but the circumstances proved less felicitous. Minutes before Gribbon showed up glowing—hand in hand with her husband, a UCLA psy-

chiatry professor—a fax from Nicholas Turner's attorneys had come through to the general counsel's office. The former curator was preparing a second lawsuit accusing the Getty of reneging on its earlier settlement agreement, which not only paid him money but also allowed him to question the collecting acumen of Gribbon's former lover, Goldner, in an upcoming Getty journal. The Getty had changed its mind about publishing Turner's comments after Goldner had caught wind of the article and threatened a lawsuit of his own.

Rather than have the entire mess, including Gribbon's affair, blow up in public, Munitz recommended paying Turner another $450,000. In the end, the Getty paid Turner $1.1 million to spare its new museum director embarrassment.

BETWEEN THE PROMOTION of Gribbon and the appointment of Fleischman, True came out ahead. While Gribbon, an enemy, seemed to have greater authority to derail the curator's crusade against looted antiquities, Fleischman, an ally, now had the institutional clout to give the curator political protection from above.

The same month the board approved Gribbon and Fleischman, True took her reformist message to the Association of Art Museum Directors' annual meeting in Denver. The theme of the gathering was "Who Owns Our Collections?"

As she had at the Cultural Property Advisory Committee's meeting in Washington, True dismissed fears within the museum world that accepting reforms would open the floodgates to new claims that could empty the shelves of American museums. The museum community had long used arguments that were "distorted, patronizing and self-serving," she said, singling out for criticism the popular mantra among curators that unprovenanced objects were innocent until proven guilty. "Experience has taught me that in reality, if serious efforts to establish a clear pedigree for the object's recent past prove futile, it is most likely—if not certain—that it is the product of the illicit trade and we must accept responsibility for this fact," True said. "It has been our unwillingness to do so that is most directly responsi-

ble for the conflicts between museums, archaeologists and the source countries."

It was a remarkable denunciation. With these few words, she had exposed the rationalization American museums had used for decades.

The date was June 1, 2000. The next day, in a courthouse halfway around the world, a Swiss judge ruled that Italy could take possession of the contents of Giacomo Medici's warehouse. Soon after, two trucks filled with crates of photos, artifacts, and documents began the journey to the Villa Giulia in Rome. As soon as they arrived, Paolo Ferri began building a criminal case that would lead him to Marion True.

PART III

"AFTER SUCH KNOWLEDGE, WHAT FORGIVENESS?"

15

TROUBLESOME DOCUMENTS

O N OCTOBER 17, 2000, an outside lawyer for the Getty received an alarming inquiry from an acquaintance at the U.S. attorney's office in Los Angeles. Would he be representing the Getty in the Italian criminal investigation into looted antiquities?

What investigation? asked Richard Martin, a partner in the Manhattan firm Heller Ehrman. His source explained that Paolo Ferri, a magistrate in Rome, was asking the U.S. attorney's office to subpoena all Getty documents related to eleven antiquities the museum had bought while Marion True was curator. Ferri was looking for proof to support the seizure and return of the items, which he claimed were looted. He also wanted to interview True.

News of the investigation blind-sided the Getty's attorneys. They had never heard of Ferri and knew nothing about his investigation. It was not surprising, however, that the U.S. attorney's office assumed that Martin would be representing the Getty in the case. He had powerful friends in both the American and Italian legal establishments and had been advising the Getty about a lengthy dispute with Italy over the museum's acquisition of a painting.

Martin had started his legal career as a highly regarded assistant U.S. attorney in the southern district of New York, where he'd helped

another assistant U.S. attorney, Louis Freeh (the future director of the FBI), and his boss, Rudy Giuliani (the future mayor of New York City), bring a massive Sicilian drug ring to trial. During the famed "Pizza Connection" case, one of the most complex Mafia prosecutions in U.S. history, Martin had forged close alliances with Italian authorities, particularly anti-Mafia prosecutor Giovanni Falcone, who was later assassinated in a spectacular car bombing. After winning convictions in the case, Martin had landed a post at the American embassy in Rome, where he had handled international judicial assistance requests like the one now targeting the Getty.

The consequences of this request were immediately clear to Martin and the Getty's in-house attorneys. If it was honored by the U.S. attorney's office, it could expose the Getty to a vast Italian fishing expedition aimed at taking away some of the museum's art and impugning the reputation of its respected antiquities curator. That could not be allowed to happen. Martin asked his contact for a little time to try to clear up the apparent misunderstanding with Ferri directly. The U.S. attorney's office told Ferri that his request needed to be redrafted. It was overly broad and would have to be more focused if it was to be honored.

Martin contacted the Getty's acting general counsel, Penny Cobey. An East Coast transplant, Cobey had assumed control of the legal department in September 1998 after the departure of Christine Steiner. Cobey was a tall redhead with a law degree and a Ph.D. in English literature, both from Harvard. But it was her background in real estate and construction law that had helped her secure the coveted job at the Getty, which needed to push the Getty Villa project through its final phases of construction.

Cobey and Martin decided to learn more about the Italian investigation before notifying Munitz or the board. In conversations with Gribbon and True, Martin was soothing, explaining that the Italians probably didn't consider True a target; they just wanted to talk to her. True was not overly concerned. After all, she was on friendly terms

with the Italians, including General Conforti, who had once welcomed her appearance at a conference with a VIP escort of Carabinieri and a bouquet of flowers in her hotel room.

As museum staff began researching the eleven objects, Martin suggested that the Getty hire his colleague Francesco Isolabella, a debonair young criminal defense attorney from Milan, to represent the Getty and True in Italian court. At the time, there was no reason to think that the interests of True and the Getty would diverge. Martin and Isolabella set up a meeting with Ferri in Rome with little idea what to expect.

At ferri's small office on December 11, 2000, the greetings were warm. But after the visitors sat down across the desk from Ferri, the prosecutor was blunt. He believed that True was part of a criminal conspiracy that was bleeding Italy of its cultural artifacts. That belief was based on a lengthy investigation of Giacomo Medici, Robert Hecht, and other antiquities dealers from whom he had seized documents directly implicating the Getty curator. Ferri said that since his request to interview True, the investigation had grown to include forty-two objects traced from Medici's Polaroids to the Getty Museum. Surely, True must have known that such objects were recent finds and thus illegal. They had no established provenance predating 1939 and had never been published or publicly exhibited. Ferri urged the Getty to cooperate in his case against True. If the museum presented itself as a victim of her excesses, he said, it would save face during her eventual trial.

Ferri was, as Italians say, putting "salt on the tail," testing the Getty to see how far it would go to protect True. If he could squeeze True for information, he could gain additional legal ammunition against Medici and Hecht, his primary targets.

Speaking in fluent Italian, Martin assured Ferri that the whole thing was a big misunderstanding. He urged Ferri to go to Los Angeles to talk directly to True, whom he would find to be cooperative and

forthright. In the meantime, the Getty would happily give the prosecutor the documents he'd asked for; there was no need for a formal subpoena.

During several follow-up meetings, Ferri softened. He would reconsider charges against True if he could gain her cooperation under oath. Martin agreed, and they set a date in June 2001 for Ferri to go to Los Angeles to depose the curator. Giuseppe Proietti, a senior Ministry of Culture official, would accompany Ferri to talk about potential cultural cooperation with the Getty.

Martin left convinced that the prosecutor was sending a message: return the contested objects, and True would go free.

THE FORTY-TWO objects that Ferri had identified included some of the best in the Getty's collection. There was the statue of Apollo, the marble basin, and the griffins from Maurice Tempelsman; several of the Getty's best vases; the bronze candelabrum and tripod; and a few prominent marble statues. The Getty had spent some $44 million to acquire the objects over the years. Given their rarity, most were priceless.

True had been involved in the acquisition of thirty-two of them. The rest had been recommended by Jiri Frel or Arthur Houghton or were donations. Most had been bought from Robin Symes, Robert Hecht, Frieda Tchakos, or Christoph Leon. Nine had come from the Fleischman collection, an ominous sign now that Barbara Fleischman was on the board. Thankfully, neither the Aphrodite nor the Getty Bronze was mentioned.

Martin and Cobey kept the Italian situation close to the vest as they tried to wrap their heads around the problem. Only True, Gribbon, and a few other senior museum people knew. Munitz didn't find out until two months later, when his chief of staff, Jill Murphy, told him.

Murphy, in her early thirties, had a sharp mind and a sharper tongue. She had been plucked from obscurity by Munitz a few years

earlier while waiting tables at the Jammin' Salmon, a Sacramento restaurant. At the time, she was an undergraduate at Sacramento State University, active in student government, and twenty dollars away from flat broke.

When Munitz, then Cal State system chancellor, walked into the empty restaurant with the California budget director, Murphy recognized him immediately. After the budget director excused himself to go to the bathroom, Murphy set down the water glasses and launched into a scathing critique of Munitz's budget plan, which had been responsible for immensely unpopular tuition increases. Impressed, the chancellor asked her to keep in touch, and within a year he hired her to work on a task force at Cal State headquarters in Long Beach. Within five years, Murphy was among his most loyal staffers and followed him to the Getty. She saw herself as a champion of the working class and bridled at the Getty's culture of entitlement. She had no arts background and limited administrative experience, but she quickly became the Getty's second most powerful figure—Munitz's eyes, ears, and, more often than not, voice.

She had been out of the office recovering from tonsil surgery when the Italian problem began to mushroom. Back at the Getty one day to pick up her mail, she stopped by Gribbon's office to say hello.

"We have a problem," Gribbon said, looking up from her desk, worried. "A big problem. It's the antiquities issue."

"What antiquities issue? Why don't I know what you're talking about?"

"Marion is being investigated by an Italian prosecutor. He's accusing her of knowingly buying looted art. We had a lawyer talk to the prosecutor, and it sounds serious."

"What! When did you learn about this?"

"We've been handling it, but it has gotten more serious. You need to tell Barry."

Murphy immediately called Munitz.

"What do you mean we have a problem?" Munitz said. "I don't

want to know we have a problem. I want to know what the problem is, what the implications are, and what we should do about it. Get me answers."

Murphy went to Cobey, but the lawyer hemmed and hawed, saying they were still studying the issue. So Murphy called Martin. "Dick, here's what we need to understand," she said, barely keeping panic out of her voice. "How serious is this? Is she going to be indicted?"

MARTIN'S ANSWER ARRIVED on January 30, 2001, in the form of a confidential memo to Munitz. It wasn't good news. Based on documents Ferri had seized from Medici and others, the prosecutor had "ample evidence" to prove that a conspiracy existed, Martin wrote. And although Ferri couldn't prove that True knew she was buying looted antiquities, it would take very little to connect True to the alleged scheme, since she had been a regular customer of the suspect dealers for years.

"The prosecutor believes that Dr. True knew, or should have known, that many objects acquired by the Getty were illegally excavated from Italy," the memo said. Recently, True herself had said publicly that antiquities without a provenance were likely, if not certainly, illicit, Martin noted, referring to her Denver speech.

Even more "troublesome," Martin added, was what had been revealed in a hasty review of the antiquities files by Cobey and him. There were letters between True and Hecht and True and Medici in which looted objects were openly discussed. In these letters, Martin noted, True did not raise any objection to "the plain suggestion that the Getty would be interested in such items."

The lawyers also had found a number of Polaroids of objects offered by the dealers. "Unfortunately, the Polaroids look very similar to the Polaroid pictures which were seized from Medici's offices, a small portion of which are now posted on the Carabinieri Website . . . To the extent they show objects in a state of disrepair or in a location from which they may have been excavated, they would provide addi-

tional evidence that the dealers were trafficking in illegal objects," Martin explained.

Further, for many of the Greek and Roman antiquities in question, the Getty had listed Switzerland or Great Britain as the country of origin on U.S. customs forms. Obviously, that was where the objects had been purchased, not found. The misrepresentations could lead to the seizure and possible forfeiture of the objects, as had happened in the Steinhardt case. Martin believed that the five-year statute of limitations had expired for such charges, but the false statements could add weight to Ferri's overall theory of conspiracy, he suggested.

The implications were grim. True was much more deeply involved than the attorneys had first believed. And because she refused to provide the written "confession" Ferri was demanding, her indictment was all but certain. A criminal trial in Italy "would be a disaster for her reputation and that of the Getty," Martin wrote, "and would prolong for years the public airing of these issues." Clearly, Ferri was trying to drive a wedge between True and the Getty. There would be a "great advantage" to the Getty and True maintaining a common defense, Martin advised.

Ferri clearly didn't understand the Getty's unusual organizational structure, in which the museum was just one part of the Getty Trust. When the prosecutor had asked for "J. Paul Getty Trust documents" related to the contested objects, he had unwittingly left the Getty ample wiggle room. Interpreted as narrowly as possible, Ferri's request didn't obligate the Getty to turn over anything from the files in the museum, which was arguably a different entity from the trust. And the fact that Ferri had made his request orally meant that there would be no legal consequences if the Getty didn't fully comply.

U.S. government officials wouldn't be so casual. Martin warned that a formal subpoena "prepared by a competent US Attorney's Office would almost certainly be more detailed and specific than the prosecutor's requests, and could well require the production of documents which we would rather not provide. In contrast, if instead [we]

continue to cooperate with the prosecutor voluntarily, we can proceed under our own interpretation of the prosecutor's requests . . . arguing they demonstrate the absence of any possible criminal claim against Dr. True."

Once again, the Getty found itself trying to cover up what the antiquities department had been doing.

Although the aphrodite was not on Ferri's list, his confrontation with True at the Villa Giulia in 1999 made it obvious that the Italians were still after it. Martin and Cobey decided that they needed to broaden their internal review, starting with the statue.

Cobey knew something about the statue's controversial past, and she had come across Arthur Houghton's letter of resignation, which spelled out the long history of problems in the antiquities department. The museum staff had always seemed blasé when asked about improprieties. Walsh himself had once fondly referred to Hecht as "an old pirate from way back." Now, in the wake of Martin's memo, the staff's responses were more guarded. Gribbon was tightlipped about the Aphrodite and chose her words carefully. True responded similarly when Cobey finally sat down with her to discuss the statue.

The curator was polite but terse, answering questions without elaboration. Her mandate was to buy the very best objects on the market, she said. Everyone involved in the acquisition of the Aphrodite knew that there would be many questions about its provenance, she said. The trustees, in particular, were completely aware of the risks involved in acquiring such an unprovenanced, high-profile piece. True acknowledged that the statue could have come only from southern Italy or Sicily, but she suggested that it might have been *found* elsewhere. She was insistent on this point: there was no proof that it had been found in Italy, even if it had come from there.

True recounted her efforts to contact Graziella Fiorentini, the archaeological director for the Morgantina area, just before the purchase. The Getty had continued conducting tests of the statue during the 1990s "to keep the Carabinieri happy that we're doing some-

thing," True said. She also talked about her verbal duel with Ferri at the Villa Giulia. True told Cobey that she had been the first one to urge the Getty to return objects when persuasive evidence was presented. But, she said, it was her professional opinion that the return of the Aphrodite was not appropriate, as Italy had never provided conclusive evidence of its illicit excavation from Italian soil. The outspoken reformer was backpedaling.

Studying the acquisition files later, Cobey found additional problems. The Getty had listed the statue's country of origin as "Britain" on the official customs form. Obviously, the Getty had known that the statue wasn't from Britain. The Getty's purchase agreement with Symes also had some unusual provisions. Rather than making the dealer say that the statue had not been illegally exported, which was standard wording, the agreement allowed Symes to state that he had no reason to believe that his statements about the statue were incorrect.

But perhaps most telling was the fact that the Getty had required Symes to provide more than $9 million in collateral during the period covered by the warranty. True told Cobey that it was Williams who had insisted on the collateral, something the museum had never done before. Obviously, the Getty had been worried about foreign claims.

Only later would the extent of what True hadn't revealed become clear. The curator made no mention of the 1996 letter and photographs the Getty had received from Canavesi, or her reasons for not taking him up on the offer to learn more about the piece. There was no mention of the warnings True had received about the statue, the dirt in the folds, the clean breaks, or the pollen tests that were never pursued.

By pure coincidence, the day after Cobey sent Martin a memo reviewing the Aphrodite purchase, Renzo Canavesi was convicted in absentia by a Sicilian court in Enna for profiting from the trafficking of the statue. The results of the limestone tests had reinvigorated Italy's pursuit of the statue, and it had finally brought charges against the Swiss man.

Canavesi's trial lasted all of thirty-three minutes. He refused to appear, and his attorney asked a single question of the sole witness, the Carabinieri captain who had overseen the original investigation. The judge returned an hour and a half later and sentenced Canavesi to two years' imprisonment and a twelve-million-lire fine. Canavesi's absence and unwillingness to defend the purchase, the judge ruled, "clearly indicates the defendant's attempted concealment, logically explained by a bad faith purchase."

A few months later, Martin and Cobey reviewed another of the Getty's controversial transactions, the Fleischman collection.

Rumors swirled that everyone had known the collection was "hot" when the museum acquired it. The records did little to refute that notion, indicating that the Getty staff had been well aware of the risks. In Christine Steiner's records, Cobey found scribbled notes of a conversation between Steiner and Gribbon a week before the contract was signed.

"How clean is this stuff?"

"Not very dirty."

Below the notes was a small chart laying out the installments to be paid to the Fleischmans:

> $7 million — provenance OK.
> $13 million — mixed group;
> donation — uncertain

The transaction appeared to have been structured so that the Getty paid for the most legally defensible objects first and received the rest as gifts. None of the donated objects came with the standard warranties about legal export and import.

Another note by Steiner suggested that she was nervous about the transaction. In a reference to the International Foundation for Art Research, a nonprofit that compiled an international database of sto-

len artworks, Steiner wrote, "IFAR noticed—published—displayed—risk . . . due diligence . . . *Trustees must decide!*"

The contract signed with the Fleischmans allowed the Getty to rescind the purchase and get a refund if claims were brought against an object. Oddly, True, who had openly agonized over the purchase, had objected to the provision as "unduly untrustworthy" and said that the Getty would never exercise it. She was correct. When in 1999 the Getty returned the bust of Diadumenus to Italy, the museum bypassed Barbara Fleischman and went to Symes, the London dealer, for reimbursement.

Cobey also found that after Larry Fleischman's death, the Getty had agreed to accelerate its final payment to Barbara—at an additional cost of $2 million, a move that Steiner worried Williams had never run by the board.

The Fleischmans had built a large collection in a very short time, the Getty lawyers concluded, using the same dealers who were now being investigated by the Italians. The bad facts, as attorneys call them, were mounting up fast.

Cobey and Martin now turned their attention to preparing True for what would likely be the most important meeting of her life.

MOUNTAINS AND MOLEHILLS

P AOLO FERRI HAD BUILT his case against the illicit antiquities trade like a restorer of Greek vases, carefully binding one shard of evidence to another. Since the Medici raid, it had been a slow, halting process that left the prosecutor and his investigators awash in documents and photographs that seemed to lead everywhere. It also left Ferri groping for answers to larger questions.

Just how did the trade work? Who were the key dealers? Did they conspire to fix prices, or were they rivals? Or both? What about the academics and experts who seemed to abet the trade by appraising objects without any provenance: did they receive any personal benefit? And how about the clients—curators and private collectors: were they part of the scheme? Amid the blur of facts, Ferri lacked a compelling narrative to drive his case.

Then, on a February afternoon in 2001, the story line was delivered in a neat package when four Paris policemen and two Carabinieri knocked on the door of a second-floor flat on the Boulevard de la Tour Maubourg. The residence belonged to Robert Hecht, whose name had appeared at the top of the antiquities trade's organizational chart discovered nearly six years before.

Hecht wasn't home, and his wife initially resisted. But when the

officers threatened her with arrest, she showed them into the study, where sitting on top of the desk was a plain beige folder. Hecht had often boasted that he was writing a tell-all book about his life, using the threat to intimidate his rivals and keep them in line. Now Ferri's agents discovered that he had been telling the truth. Inside the folder were eighty pages of a handwritten memoir.

It chronicled the modern history of the antiquities trade, beginning with the turbulent years after World War II, when Hecht and a handful of European dealers began visiting Greece and war-ravaged Italy to buy cheap artifacts. By the 1960s, the trade had grown more professional, with middlemen organizing regional teams of looters, some of whom were supplied with electric saws by their European sponsors. Hecht wistfully recounted his partnership with antiquities dealer Bruce McNall and his early dealings with Jiri Frel. He boasted of outwitting customs agents and Carabinieri, Italian judges, forgers, dealers, diggers, and American grand juries.

He lingered on his defining moment, the sale of the Met's famous Euphronios krater. He gave two versions. The first followed the Met's official story. But the second, a long anecdote, revealed that he had obtained the renowned vase from a necropolis in Cerveteri via his most "loyal supplier" — young Giacomo Medici, who "rose early each morning and toured the villages of Etruria, visiting all the clandestine diggers."

Ferri nearly wept as he read it. The memoir proved second only to Medici's Polaroid collection as a key to unraveling the largest antiquities cartel of the past century. It was a history of the inner workings of the criminal network Ferri had been chasing. Hecht had provided a road map, a confession, and, most important, a story line on which the prosecutor could hang an unprecedented prosecution.

It would undoubtedly lead to Hecht's downfall and might finally pry the famous Greek vase from the Met's grip. If the Met fell in line, so would the other American museums, especially the Getty.

Two months after the raid, True received a telephone message from Hecht's wife, who said that she urgently needed to speak to

the curator. On the advice of Martin and Cobey, True didn't return the call.

It was the whiteness of the Getty Center that struck Ferri the most. As the van he was riding in inched its way through the morning traffic on the I-405, the public prosecutor craned his neck to look at the museum looming above him. He couldn't get over how clean the complex looked. It was encased in a skin of creamy travertine — quarried, he had heard, not far from where he was born. How absolutely magnificent, Ferri thought. On its promontory in the Santa Monica Mountains, the museum complex seemed removed from the realm of the harried mortals at its feet.

Ferri's trip to the Getty in late June 2001 would have been unimaginable when he first joined Conforti's prosecutorial team six years earlier. But over those years, the prosecutor had continually found himself being pulled back to the Getty. He had tracked the museum's purchases through scores of subpoenaed invoices, shipping records, Polaroids, and confidential letters. Skittish tombaroli had referred to the faraway museum with awe and longing. Middlemen and dealers had smacked their lips over the Getty's unlimited resources and insatiable appetite for their finest and priciest relics.

The van squeezed out of the tangle of traffic, took the exit for Getty Center Drive, and was waved through the gates by security. It slowly climbed the winding road to the upper parking lot, where Getty employees were waiting to escort Ferri and his team of investigators across an open plaza. It was a Monday, and the museum was closed to the public. The Italians were whisked up a private elevator into a windowless conference room, where a bust of J. Paul Getty brooded over a table brimming with bagels, fruit, coffee, and cakes. An enormous still life, complete with a dead rabbit, hung on one wall. The Italians took their seats on one side of a massive conference table and waited.

At last the door swung open, and in walked True. Ferri now took the full measure of his witness, whom he had met only briefly at the

Villa Giulia in 1999. Flanked by four attorneys, the curator was composed, the picture of a well-bred art cognoscente—not a conspirator with tombaroli.

After a round of stiff handshakes and formal introductions, the session began with an off-the-record discussion, an approach the prosecutor hoped would signal his willingness to work with True and the Getty. Ferri described his investigation and outlined his hopes for the cooperation of American museums. As the conversation turned to the Met and Italy's long-standing claim on its prized Greek vase, the Euphronios krater, True interrupted him.

"Can I talk to my lawyers?" she asked.

"Of course," Ferri replied.

True and the Getty lawyers marched out of the conference room. Minutes passed before one of the lawyers came back. "Dottore Ferri, would you please join us?"

Ferri found True and her attorneys huddled in a small staff kitchen, the only place they could find privacy in a building with an open floor plan. As he walked in, Ferri pretended to put a priest's stole over his neck.

"I am ready to take your confession," he joked, hands clasped in mock prayer.

True spoke. "I want to be honest about something, but it's very difficult for me to talk about . . . people that I don't like to drag in. I mean, this is my interrogation. And Dietrich von Bothmer was my *Doktorvater*," she said, using the German term for academic adviser or mentor.

Then she came out with it: von Bothmer had once confided in her that he knew the precise tomb from which the Euphronios krater had been looted. In fact, he had shown her the location on a map of Cerveteri that he kept in a drawer.

It was a stunning betrayal, yet it struck Ferri as curious. He had come to talk about the Getty and True's role in the illicit trade, but the curator seemed all too eager to lead him in another direction. Still, her comments might help the Italians solidify their claim to the

krater. The prosecutor agreed with the Getty attorneys to include True's statements in the subsequent deposition. They all went back into the conference room, and the morning slipped away, consumed by discussions of legalisms and procedures. The official session started at 2:34 P.M.

Over the course of several hours, Ferri plumbed the curator's business dealings and personal relationships with the key players in the antiquities trade. Medici's Polaroids and Hecht's memoir had given the prosecutor a view of the trade from the bottom up. Now True was describing it from the top down.

Her world was glamorous but not pretty. Hecht was a compulsive gambler, she said, and a serious alcoholic, who could quickly turn from charming to "very hostile, very sarcastic, very sinister." Robin Symes had once pushed George Ortiz, one of the world's most prestigious private collectors, down a flight of stairs and referred to Medici disparagingly as "the Butcher's Boy." Nicolas Koutoulakis, another dealer, was called "Cyclops" because he had only one good eye. Gianfranco Becchina, the dealer for the ill-fated kouros, had threatened to blackball her when she had questioned him about the piece.

Ferri found True surprisingly willing to dish the dirt on the characters who inhabited the spiteful environment in which she operated. Yet the prosecutor began to identify a familiar pattern. She admitted no transgressions of her own. She complained about the backbiting, dirty tricks, vicious gossip, and blackmail committed by others, but she always came away as untainted, somehow apart.

When Ferri questioned True about Medici, she described the five meetings she had had with the middleman. They included a 1989 meeting in a Swiss bank vault, where he had tried to give her a vase fragment while offering her a small statue of Tyche, the goddess of fortune.

"He offered a bribe, basically," True volunteered. "The . . . fragment was presented to me, that this was for me, if I wanted it personally . . ."

"Personally?"

"Personally."

Ferri sat stone-faced. He simply didn't believe her. His investigation showed that by 1989, Medici was already the museum's major supplier of antiquities, although his name never appeared on museum records. Why did he have to bribe her? Why risk offending the curator if he already had her business?

"Was Medici an expert for the J. Paul Getty Museum?" Ferri asked. It was a trick question. He knew from letters captured at Medici's warehouse that True had sought the dealer's "expertise" on where certain Getty objects had been found.

"Absolutely not," True said. "Was he an expert for anybody? . . . I wouldn't have considered Medici an expert."

Ferri settled back in his chair. Another contradiction.

While discussing her dealings with Hecht, Ferri raised her earlier, off-the-record revelation about von Bothmer.

"He confided in you in a major way . . . ," Ferri said. "Can you tell me what that is?"

"At one point, I was in his office, and he had a photograph, an aerial photograph, which showed the Necropolis of Cerveteri. And looking at the Necropolis, he pointed to a certain spot on the photograph and said, 'This is the place where the Euphronios krater was found.'"

The betrayal was complete.

FERRI STARTED THE second day of the deposition by raising the stakes. He put on record that True was now being considered a "person of interest" in his investigation.

"We'd like to state to Professor Marion True that this office will be taking action against her for these charges," Ferri said, before laying out his theory. True, along with Medici, Hecht, and Hecht's Swiss restorer, Fritz Bürki, had trafficked in objects taken from illegal excavations, resulting in archaeological damage. They had conspired to hide the origins of these objects by making false declarations to customs officials.

Ferri's maneuver was a technical one. Under Italian law, True could have legally disavowed what she had said the day before. Now, with the official warning, her words were part of a court record that could be used against her.

Throughout the remainder of the deposition, True responded with a studied detachment. Yet Ferri knew that she must be roiling inside, and he sharpened his attack. True had said that the Getty didn't buy from Medici. But the prosecutor produced a letter that True had written to Medici in 1992, after the attempted bribe. "During one of these visits I hope we'll be able to get together and have some further discussions about future acquisitions," the letter said.

If Medici had tried to bribe you, Ferri demanded, why were you making plans to buy from him? "It's very important that you clarify this," Ferri said menacingly. "Because if Medici is interrogated on this point and he says something different than what you're telling me, it would be very unfortunate, a very unfortunate piece of evidence against you."

"That may be but . . . I am not going to be rude to a person who has tried to do something helpful. The reality is I was writing a letter to him trying to be appreciative of the help he had given."

"Yesterday you told me that Medici was not an expert."

"He's not an *expert* . . ."

"And how come that in this case he gave you information on the provenance of proto-Corinthian olpae [pitchers]?"

Ferri was referring to a letter True had written to Medici asking for information about certain pitchers in the Getty's collection. An assistant curator was writing a Ph.D. dissertation on the olpae, and True had queried the middleman on her behalf, asking where they were from. Medici had written back, informing True that the objects had been found in Monte Abatone, a necropolis in Cerveteri. He'd described the type of tomb in detail and offered her other objects found there.

True struggled to explain the exchange. "The main thing we were trying to find out was where the person who gave the objects to the

museum had gotten them. That was the answer. They had come from Giacomo Medici. And Giacomo Medici offered the additional information that they came from Monte Abatone."

True's attempt to downplay the letters was particularly galling to Ferri. Here, in black and white, Medici was informing the Getty that the objects were looted. And he was offering more objects from the same tomb. Yet True was trying to spin it as some prosaic exchange of academic information.

"Hiding oneself behind somewhat calculated answers might be useful to your defense, but only up to a certain point," Ferri warned, the strain evident in his voice. "Because it leaves certain areas of shadow that might be illuminated by other people. And that could be dangerous for you. Giacomo Medici is not the person you met only five times. He's a very important character that is behind a lot of various transactions and I need to know from you, if you had even any suspicion that he was behind these transactions."

"I can't say it better than that," True replied weakly.

After the lunch break, True came back with a different version of her relationship with Medici. The curator said that she had continued contact with Medici for "opportunistic" reasons. Despite her personal distaste, she needed Medici's cooperation to prove whether the kouros was fake or real. She never told anyone about Medici's bribe attempt because she was worried that he might exact revenge by badmouthing her in the market. "I just want to make clear that my intention is not to protect Giacomo Medici," she said.

Unconvinced, Ferri turned the floor over to his experts, Maurizio Pellegrini and Daniela Rizzo, who spent the next hour with True reviewing more than seventy images from the Medici Polaroids. She helped place them at museums in Toledo, Boston, Richmond, New York, Minneapolis, and Cleveland; in Sydney and Copenhagen; —and at the Getty. When asked if she would be willing to draw up lists of other items that Medici, Hecht, and others had sold to her museum peers, True didn't hesitate to say yes. By the time she was done, she had helped the Italians trim months, if not years, off their investiga-

tion by identifying where they could find the looted pieces in private collections and museums.

At 6:04 P.M. on the second day, the deposition ended. The two sides shook hands, and Ferri took a last look at True. The curator gave the prosecutor the faintest of smiles before disappearing out the door.

Once the van was safely away from the Getty and swallowed up in freeway traffic, the Italians relaxed. True had resisted initially, but in the end she had cooperated, saving the investigators untold hours and grief.

"I guess there's no reason to prosecute Marion True now," Daniela Rizzo said later, at dinner. Ferri was uncharacteristically solemn. Except for True's help identifying where the suspect antiquities were now exhibited, he felt that his trip to the Getty had produced no more leads than if he had come as a tourist.

"True still isn't telling us everything she knows," he said. "I think I have no choice but to bring her to trial."

True's deposition changed things inside the Getty.

Getty officials were already nervous before Ferri showed up. Prompted by Richard Martin's gloomy memo months before, the board had formed a three-member committee to monitor the crisis. The board members hoped it would go away once Ferri came to Brentwood and realized that True would be helpful and sincere.

But True's easy betrayal of museum colleagues and surprising revelations startled even her own attorneys. Martin and Cobey left the first day of the deposition dumbstruck. They had spent two days prepping True, peppering her with questions, asking her if there was any-thing—*anything*—that they should know about. She had insisted there wasn't. As a result, her disclosure about von Bothmer and the Euphronios krater had blind-sided them. Why would she volunteer that? How many times had they told her only to answer what was asked? And what else had she kept from her own attorneys? "The Met's never going to speak to us again," Cobey groaned.

By the second day, it was also painfully obvious that the Getty had underestimated what it was up against. Rather than the usual myriad of disorganized regional officials, the Italian cause was now represented by a single, focused man: Ferri. He was obviously smart, cagey, and startlingly well informed. He had grilled True for hours without once consulting his notes. He had asked questions to test the curator's honesty, to trap her, and had exhibited intimate knowledge of the antiquities trade, showing clearly that these "competitors" had acted in concert to take the Getty for more money. And he wasn't easily impressed. By volunteering what she knew about von Bothmer, True may have miscalculated. Instead of impressing Ferri, it may have left him with the idea that she knew far more than she was telling. Hope faded among Getty officials that the Italians merely wanted to consult with True. The prosecutor had her firmly in his sights.

Worse, the curator's evasiveness during the deposition began a slow, creeping realization among some Getty officials that over the years, the Getty had come to believe its own lies. It had glossed over the messy details in its files and embraced the reformist story line it had eagerly peddled in press releases and at professional conferences. True's performance now had some beginning to ask uncomfortable questions: Could the Italians be right? Did the Getty knowingly buy looted art?

Those doubts, of course, could not be spoken of openly. Getty veterans such as Debbie Gribbon and True's supporters continued to dismiss such suspicions as absurd. After all, the Getty had set the agenda for reforming the antiquities trade. True had courageously stood up against her colleagues in defense of the Italians. Wasn't she in charge of a nearly $300 million program to remake the Getty Villa into a temple to venerate the science of archaeology? They refused to entertain the notion that both things could be true, that the Getty and its curator had played both sides of the issue, never dreaming that the Italians would stumble onto a cache of photos and documents that might reveal the museum's duplicity.

As for Munitz, he seemed unwilling to get his hands dirty. He met

briefly with Ferri at the start of the deposition and promised coopera-
tion, but otherwise refused to get directly involved. The Italian prob-
lem was best dealt with by Gribbon and his bosses, the board of trust-
ees. He also made sure that Martin, not Cobey, was the one to brief
the trustees. Munitz was beginning to consider Cobey, his acting gen-
eral counsel, as something of an alarmist.

Cobey had begun to raise questions not just about antiquities but
about Munitz's personal use of Getty resources. She objected when he
used Getty money to pay for his wife's travel. She objected when he
ordered gifts for departing board members. She wrote a long memo
opposing his proposal to modify J. Paul Getty's original 1953 inden-
ture, so that board members could start being paid for their service.
Such moves would likely violate IRS rules against self-dealing, she
warned.

Jill Murphy, Munitz's lieutenant, began to think that Cobey was
using these issues to grab some of the institutional power her position
had never had in the trust hierarchy. Cobey was supposed to be put-
ting out the legal fires, not sounding the alarm every time she sniffed
smoke, Murphy complained. Board members also grew weary of what
they considered the attorney's increasing shrillness. After one closed
meeting in which Cobey gave a presentation, one trustee whispered
to Murphy, "Time to get a new general counsel."

IN SEPTEMBER 2001, the Getty did just that. Munitz informed
Cobey that she would not be named permanent general counsel and
hired Peter Erichsen to fill the post. Erichsen had been associate
White House counsel under President Bill Clinton, for whom he
helped select federal judges, and later general counsel at the Univer-
sity of Pennsylvania. He was smart, loyal, and politically astute, but he
knew nothing about the complex legal terrain of the Italian case,
which now fell into his lap. On September 11, Erichsen was attending
his first board meeting in Washington, D.C., where the trustees and
senior staff had gathered for a tour of the National Gallery, whose

massive plate-glass windows looked out over the Capitol. They were in the middle of a presentation when someone interrupted: there had been a terrorist attack in New York City, and another attack was expected soon on the Capitol.

Before scrambling to safety, members of the board watched the Twin Towers collapse into dust on a wide-screen television. For many, the attacks on the World Trade Center hit very close to home. Lewis Bernard was a board member of Marsh & McLennan, which lost all its employees and offices in Tower 1. Luis Nogales had an office in the American Express Tower, which was adjacent to the Twin Towers and sustained damage. The children of Agnes Gund, president of the New York Museum of Modern Art, lived not far from Ground Zero.

A whole year would pass before the board would hear about the Italian problem again. By then, the implications had become darker. Just weeks after 9/11, Martin flew to California to brief Erichsen on the case. New problems were emerging as Martin and Cobey, who stayed on as Erichsen's deputy, continued hunting through internal files, hoping to find some way out. It soon became clear that the Getty was entangled in a legal Catch-22.

Maurizio Fiorilli, a senior government lawyer representing the Italian Ministry of Culture, was demanding that the contested objects be returned as a gesture of the Getty's goodwill. Yet it was almost certain that Ferri, who answered to the Ministry of Justice, would use any return as an admission of guilt in a criminal case against True. The Italians portrayed the two ministries as acting independently, but Martin knew that Ferri and Fiorilli were in lockstep. Indeed, if there was a trial, the two lawyers would sit at the prosecution table together. The Italians were whipsawing the Getty.

The dilemma paralyzed the museum. Could the Getty cut a deal with one ministry without a guarantee that it would not get burned by the other? And to what extent were the fates of True and the Getty linked? Should the Getty risk a withering legal and public relations assault by the Italians to protect its temperamental curator? Board

members were loath to consider cutting the curator loose. Yet, as Martin's January 2001 memo to Munitz had hinted, at some point the interests of the museum and its star curator might diverge.

"Dr. True is anxious to start a systematic campaign of promotion" of her innocence, Martin had written. "I have told Dr. True that we cannot begin that process until we have completed our review of all of the files . . . It is important that we be certain of what our position is before we undertake such a campaign."

There was no evidence to suggest that True had been acting as a rogue curator. Indeed, documents unearthed in the internal review suggested that Gribbon, Walsh, and Williams had been fully aware that the museum was buying looted art and had approved all of the objects around which the Italians were building their case. Cobey and Martin considered these documents to be "radioactive."

There was Houghton's 1986 resignation letter, eerily predicting dire consequences if Walsh failed to deal with problems in the antiquities department, including the potential for "a sweeping external investigation of the Getty Museum's records." The impact of such an investigation on the trust's reputation would be "catastrophic."

There were the funerary wreath documents, in which True declared the object "too dangerous" to buy, only to mysteriously reverse herself and recommend its purchase—a recommendation endorsed by Walsh.

Finally, and most damaging, there were Walsh's own handwritten notes of two 1987 meetings with Williams to discuss the antiquities acquisition policy on the eve of the Aphrodite purchase. In languid script scrawled across yellow legal paper, the museum director had recorded his boss's troubling words: "We are saying we won't look into the provenance . . . We know it's stolen, Symes a fence." Walsh and Williams knew very well whom True was dealing with. A few days later, Walsh's notes quoted Williams again laying the issue on the table: "Are we willing to buy stolen property for some higher aim?" Also, "We knowingly buy stolen goods. We knowingly deal with liars by accepting their warranties."

The notes not only implicated True's bosses; they also appeared to destroy a key element of the Getty's defense: that it had acted in "good faith" while buying the suspect antiquities. Even if Italy was able to prove that several of the artifacts had been looted, it was important that the Getty be able to argue that it had had no knowledge of the fact at the time. If revealed, these documents could be used to prove that the Getty had violated not only Italy's cultural patrimony law but American criminal law as well, specifically the National Stolen Property Act.

As the full implications of the documents became obvious, Martin sent an e-mail to Cobey. "When we were speaking yesterday about our unfortunate documents, a line from T. S. Eliot kept coming back to me," he wrote. "It's from 'Gerontion':

"'After such knowledge, what forgiveness?'"

IN MARCH 2002, eight months after being deposed by Ferri, True proposed a remarkable purchase to her superiors at the Getty. It was a magisterial third-century bronze statue of Poseidon, god of the sea. Valued at $4 million, the one-half life-size figure was to take its place next to the Getty Bronze as one of the most valued antiquities ever found.

True had seen the statue at the 2002 Winter Antiques Show in New York, an annual event sponsored by the nonprofit East Side House Settlement and featuring the wares of dozens of exhibitors. She immediately put it on reserve. As she detailed in a draft acquisition proposal, the Poseidon was the first full-figured bronze to appear on the market in a long time. It was being offered by Rupert Wace, a reputable London antiquities dealer, on behalf of the British Rail Pension Fund, which had owned the statue since the late 1970s. It had been exhibited at the Royal Museum of Scotland and the Detroit Institute of Arts, as well as the antiquities fair in Basel in November 1999. Wace had even published the statue in 2001. The Poseidon appeared to meet all the stringent requirements of the Getty's 1995 acquisition policy. Missing from True's draft proposal, however, was the

name of the statue's original owner: Robin Symes. William Griswold, the museum's deputy director, noted the omission and alerted the Getty's lawyers.

Martin responded with some alarm. "What we have learned about Symes since June of last year means that we can not place any reliance on anything he says as to provenance . . . We have been put on notice that he is part of a group which has dealt in stolen objects and systematically falsified provenance documents. The story Symes has given us about this object fits exactly the profile of stories used to cover objects which were, in fact, recently looted from Italy."

Symes had given True a sheaf of documents to support his claim that the statue had been found near Alexandria, Egypt, during the early 1930s and sold soon after to a Greek collector. The statue had been transferred to Switzerland in 1956, then sold to Symes in September 1973, the documents claimed. But Cobey thought that the two affidavits looked suspicious. Some quick checking confirmed her fears. One of them had supposedly been signed at the American embassy on June 4, 1978. Cobey looked up the date and found that it was a Sunday—an unusual day to be doing business. The more recent U.S. customs forms also seemed strange. The Poseidon had been imported into the United States with a number of other objects, whose country of origin was given as "multi."

More alarming, the statue had been the subject of a major controversy in the late 1970s after the Carabinieri told the British media that the statue had been found in the Bay of Naples and smuggled out of Italy. Articles about the incident included a curious comment by Symes: "If I knew about it, I wouldn't talk. If I didn't, I couldn't." The Italian investigation had apparently petered out.

With Erichsen's approval, the Getty went ahead with True's suggestion that the museum take the statue on loan for study. No harm could come from looking more closely at the object, Erichsen felt. Others knew that once the statue arrived, there would be considerable pressure to acquire it. In the meantime, Erichsen suggested that True contact Wace with the Getty's questions about the provenance

documents. Cobey and Martin objected, warning that relying on True to check out the statue's story would be a mistake.

The Getty also turned to a London attorney named Ludovic de Walden for advice about the bronze. De Walden occasionally acted as outside counsel for the Getty. A Bloomsbury Square lawyer who dressed in colored shirts with white collars and flashy cuff links, de Walden had been busy spearheading a legal attack against Symes. His clients were the family of Christo Michaelides, who had died on July 5, 1999, the day after he fell down the stairs of a Tuscan villa rented by clients Leon Levy and Shelby White. When Michaelides' family asked Symes to return Christo's valuable personal effects as keepsakes, Symes had sent them only a cheap watch and some playing cards. Irate, the family filed suit against Symes and hired de Walden to investigate the dealer's holdings across Europe, arguing that half of his assets belonged to them. De Walden's relentless pursuit exposed Symes as a pathological liar, earning the dealer time in prison for perjury. It also unearthed several caches of unreported antiquities.

When approached by the Getty, de Walden didn't mince any words. Marion True, he said, had to be "insane" to propose buying the Poseidon. If the Getty were to look into the "Greek collector," de Walden hinted, it would find that she was Michaelides' poor aunt, an eighty-year-old woman who was unlikely to have inherited any art, much less a precious Greek bronze. Symes had often used the story of an object that had "left Egypt before the Suez War" as a fake provenance, de Walden said. In short, the Poseidon was clearly hot, and Symes had used the British Rail Pension Fund to launder it.

De Walden provided another, more troubling reason for the Getty to be skeptical of the purchase. His investigation had uncovered the fact that True's relationship with the dealers had gone from professional to personal and financial. De Walden believed that Symes had loaned True money to help her buy her vacation home in Páros. If True had accepted a loan from one of the museum's dealers — be it Symes or, as was actually the case, from his partner Michaelides — she had a serious, undisclosed conflict of interest when it came to doing

business with Symes. In the museum world, such an ethical breach was unacceptable.

Armed with this information, Cobey told Erichsen that if the Getty insisted on pursuing the Poseidon, True should recuse herself. Whatever benefit the museum might gain from acquiring the object would be more than canceled out by the legal risks the curator's involvement would incur. During her deposition, True had given Ferri the clear impression that she wasn't particularly close to Symes or Michaelides. But quite the opposite was true, and Ferri wouldn't take it lightly when he found out.

Martin sounded a similar alarm, expressing shock that True's draft acquisition proposal had left out any mention of Italy's attempt to recover the statue in the 1970s. True was making "materially misleading" statements to her superiors, he said. If the Getty went ahead with the purchase, Ferri would certainly indict her. How could True even consider the purchase knowing she was the target of an Italian investigation? It was reckless.

But Erichsen was reluctant to believe the worst. He was still new to the antiquities world and deeply influenced by Gribbon. Even if Symes had falsified the affidavit, it probably only meant that he was too lazy to do the research, he ventured. Surely, the British Rail Pension Fund had investigated and concluded that the piece was safe to buy. Erichsen likewise brushed aside suggestions that the Getty investigate the Greek collector or force True to recuse herself. The museum had a better chance of getting to the bottom of this with her than without her. Pulling True off the acquisition would signal the institution's lack of confidence in its curator.

As for the possibility that True might have obtained a personal loan from the Getty's principal antiquities dealer, Erichsen and Gribbon were skeptical, but they promised to raise the issue with True. "We may be making a mountain out of a molehill here," Erichsen said.

A few days later, Erichsen called Cobey into his office. The battle over the Poseidon had been only the latest conflict between the two

since Erichsen had arrived the previous September. Cobey's knowledge of the antiquities problems had kept her at the table, but Erichsen found opportunities to remind her that she was his subordinate. He scolded her for discussing a minor legal matter with Gribbon without going through him. He also pulled a month's worth of her expense accounts and questioned several of her purchases, much as she had done with Munitz, who had made it clear he wanted Erichsen to mute Cobey's shrill warnings.

When Cobey came into his office, Erichsen brought her up to speed on recent developments. Gribbon had met with True for two and a half hours to talk about the Poseidon. After consulting with her attorney, Francesco Isolabella, the curator had recused herself and asked to withdraw the acquisition proposal. In the end, it didn't matter: the Getty's questions about the statue's origins had led the dealer to withdraw the offer. It was no longer for sale. Erichsen said that he and Gribbon had asked True if she had ever taken a loan from Symes. She'd denied it. Erichsen was satisfied; there was no reason to look into the matter any further.

Erichsen now raised the real reason for the meeting. Cobey's handling of the Poseidon had been the last straw, he said. Her memos on the Poseidon had a judgmental tone, and he was "flabbergasted" over her most recent one suggesting that the curator recuse herself. "Truth or justice issues should not be prejudged," he said. Cobey had come to see the world through Ferri's eyes, he continued. Her position had become "excessively independent," and her interest in the possible legal consequences for the Getty was "hysterical."

Erichsen told Cobey to start looking for another job. Fifteen years after the resignation of Arthur Houghton, the former acting curator who had warned about an investigation by a foreign government, the Getty was once again killing the messenger.

17

ROGUE MUSEUMS

IN FEBRUARY 2002, Paolo Ferri's investigation got another big break when a Cyprus customs agent in the Limassol airport detained an elderly Swiss woman who had come off a plane. Antiquities dealer Frieda Tchakos had stepped into a snare set by Ferri, who had quietly issued an international arrest warrant for her based on her involvement in an unrelated looting case.

Informed of Tchakos's arrest, Ferri pulled the legal net tighter. As he and Salvatore Morando scrambled to catch a plane to Cyprus, the prosecutor refused to lift the warrant, leaving Tchakos to spend the night in a prison cell, where she slept on a wooden table, shivering under a thin wool blanket. Ferri was determined to send a message: I can make your life miserable. "I won't pull the warrant until I get a statement about Hecht, Medici, and everything she knows about the illicit antiquities market," he told the dealer's attorney.

Tchakos agreed and after her release played host to Ferri and Morando at her brother's apartment. Tchakos served her interrogators cheese sandwiches, then sat across from them at the dining room table, coolly answering questions for the next two days, her two attorneys by her side and a hairless cat in her lap.

Tchakos was a tough woman who had cracked the tight circle of men who ran the antiquities trade. A player for thirty years, she icily divulged the colorful background Ferri wanted, filling in more details about the trade's dominant characters. Hecht, she said, was a very knowledgeable but "frightful character" who dominated the market with his temper and threats to blackmail competitors with his tell-all memoir. His nickname in the trade was "Mr. Percentage," because he insisted on taking a cut of everything sold. Medici had been an important middleman as far back as the 1970s. She recalled wondering where he got the money for his aggressive purchases at auction, until she realized that he was buying items from himself.

Ferri was elated. Tchakos was confirming the very laundering scheme that Pellegrini and Rizzo had deduced from the auction records and photos. He pushed for more.

"Do you know anything about the Aphrodite?" Ferri asked.

Only that it was rumored that Robin Symes had acquired it from Orazio di Simone, Tchakos said, referring to the reputed Sicilian antiquities smuggler.

And what about Marion True?

"What can I say about Marion True?" Tchakos said, her face souring. "She did not like me very much."

Tchakos recounted how she had at first enjoyed a cordial, even chummy, relationship with True. The two women had exchanged affectionate banter about cats—at one time, True had one named Ajax—and Tchakos had thought she was making inroads with the wealthy Getty. But eventually she realized that the Getty was interested only in objects that came through Hecht.

True also seemed to have had a hand in building the private antiquities collection of Larry and Barbara Fleischman, Tchakos added. The mention of the Fleischmans surprised Ferri. He leaned in and said, "Fleischman?"

"Well," Tchakos said, "it became clear how things went . . . Each time I showed something to her, she would say, 'Beautiful. Interest-

ing. I can talk to Fleischman about it.'" Later, Tchakos added, Fleischman would call and express an interest in the very same object.

One piece in particular made Tchakos wonder: a 2,500-year-old marble head from the Cyclades—an exquisitely simple preclassical piece depicting an elongated face. The object, which still bore the original tattoo marks, had caused a sensation at a 1988 Sotheby's auction when it fetched a record $2 million. It turned out that the Getty, through Symes, had been the losing bidder on the piece. Fleischman later acquired it, presumably at a much higher price, and the Getty got it when it acquired his collection.

The strange thing was that the head didn't seem to fit in the Fleischman collection, which tended toward Greek and Roman pieces from the later classical period. Tchakos told Ferri that she had offered Fleischman several Cycladic pieces, to no avail. "Each Cycladic is like any other Cycladic," he had said. She was surprised at his change of mind, until she heard the market rumors.

"It was learned later that Fleischman bought it through a merchant who was at the auction, and to end up in some museum," Tchakos said. The museum, it was clear, was the Getty.

American curators often offered free advice to wealthy collectors with the hope that someday the collector would donate or sell a particular object to the curator's museum. But Ferri believed he now had confirmation of something far more sinister: True had used the Fleischman collection as a front to launder illicit antiquities. As Tchakos spoke, the prosecutor's feet were dancing involuntarily under the table.

The deposition gave the prosecutor enough on-the-record corroboration to indict True on conspiracy charges. During another deposition a short time later in Rome, Robin Symes confirmed Tchakos's suspicions but added his own twist: "I believe that Fleischman put the collection together in order to sell it . . . to the Getty, but I don't think the Getty knew that."

The allegation regarding the Fleischman collection would become

a central part of Ferri's case against the Getty curator. The circumstantial evidence — the speed with which Fleischman had built his collection; the way Larry Fleischman kept buying, especially the Cycladic head, at a time when he was supposedly experiencing financial difficulties; the all-too-convenient way the Getty used its publication of the Fleischman exhibit to justify the acquisition of the largely unprovenanced collection — all pointed in the same direction.

Energized by his recent breakthroughs, Ferri met with General Roberto Conforti to plot a strategy for the prosecution. Like the drug trade, the illicit antiquities trade had to be attacked from both the supply and the demand sides. Prosecuting a few dealers or middlemen would not stop the trade for long. To eliminate looting, the Italians would need to force museums — particularly the world's biggest buyers, American museums — to change the way they collected. And for that to happen, the museums would need to be publicly brought to account.

In the fall of 2002, Conforti began putting American museums on notice. In an interview with *ARTnews*, he said that Italy was launching a "coast-to-coast" campaign to "systematically scour . . . every major collection of Etruscan, Greek and Roman antiquities in the United States" and to recover those artifacts that had been looted. What he didn't say was that his plan included making an object lesson out of the Italians' three biggest targets: Hecht, Medici, and True.

AS FERRI WAS nailing down the details of his criminal case, a federal district court in New York stripped American museums of their most important legal defense for buying unprovenanced antiquities.

In February 2002, Manhattan antiquities dealer Frederick Schultz was convicted on one felony count of violating the National Stolen Property Act for trafficking an illicit Egyptian antiquity into the United States. Schultz was president of the leading association of antiquities dealers. Just a few years earlier, he had argued at the State Department hearing against the Italian request for import quotas,

saying that smugglers could easily get around them by faking prove-
nance for any items they desired. Now he was accused of doing exactly
that—colluding with an English smuggler to import a fourteenth-
century B.C. head of the Egyptian pharaoh Amenhotep III that had
been dipped in plastic, disguised as a tourist knockoff, and later attrib-
uted to a fake collection.

In ruling after ruling, presiding U.S. district judge Jed S. Rakoff
had dismissed the arguments of Schultz's attorneys, who claimed that
Egyptian patrimony laws had no standing in America. "If an Ameri-
can conspired to steal the Liberty Bell and sell it to a foreign collector
of artifacts, there is no question he could be prosecuted," Rakoff
wrote. "The same is true when, as alleged here, a United States resi-
dent conspires to steal Egypt's antiquities."

The lethal blow came in Rakoff's instructions to the jury, which
took direct aim at the "no questions asked" approach that collectors
and museums had hidden behind for decades. "A defendant may not
purposefully remain ignorant of either the facts or the law in order to
escape the consequences of the law," Rakoff told jurors. With that in
mind, the jury deliberated for four and a half hours before delivering
a guilty verdict. Rakoff sentenced Schultz to thirty-three months in
prison and fined him $50,000. The era of "don't ask, don't tell" in the
American antiquities trade had come to a sudden, rude end.

The lurid account that dribbled out of the Schultz trial accelerated
a change in attitude about looted antiquities, both within and outside
the museum community. Following up on the Berlin Declaration,
four German antiquities museums agreed to adopt strict guidelines
forbidding the acquisition of undocumented ancient art. In return,
Italy loosened its restrictions on cultural loans, offering German in-
stitutions a series of unprecedented four-year loans of some of its best
pieces. The pact represented a new way forward for museums.

Closer to home, the Met's Philippe de Montebello received his
own crash course in the shift of the public's mood. Before the Schultz
verdict came down, he was invited in for a discussion with the *New*

York Times editorial board, which was responsible for determining the paper's official positions on major issues. He expected the usual gentlemanly conversation with the board, this time about the museum's plans to reopen its renovated Greek and Roman gallery. What he got was an angry debate over the Elgin Marbles. The Acropolis figures were back in the news because, two years in advance of the Athens Olympics, the Greek government had asked the British Museum to loan them to Greece for display. The British Museum had refused the request.

The Met director was shaken by the editorial board's attack on his position that restitution demands of source countries were a product of excessive nationalism. A subsequent editorial in the *Times* accused Britain of "cultural imperialism" and called on the British Museum to return the Elgin Marbles to Greece for good. "Museums around the world fear establishing a precedent that would cause a broad new look at the legal status of their own antiquities," the editorial said. "But that look has already begun. And there can be few instances where the case for repatriation seems so reasonable as this one."

De Montebello was also quietly wrestling with his own Italian problem. Months earlier, Ferri had followed up Conforti's warning by filing a detailed judicial request to the Met for documents about several of its antiquities, including the Euphronios krater and the Morgantina silvers. The prosecutor also had asked for an interview with Dietrich von Bothmer and other museum officials. Not long after that, Conforti had sent a letter to museums around the world asking for their help in identifying the location of some five hundred looted antiquities depicted in Medici's Polaroids. Several were strikingly similar to objects in the Met's collection.

In the past, de Montebello had haughtily brushed aside Italy's requests, saying he would be happy to entertain them when Italy had gathered "irrefutable proof" that an object had been looted—a standard beyond that required even in capital murder trials. After the Schultz trial, however, that kind of prove-it bravado was not just out

of step with public opinion; it was no longer legally tenable, de Montebello's advisers told him. The way was now clear for some ambitious federal prosecutor to make a name for himself by escorting a curator, or even a museum director, out of his or her wood-paneled office in handcuffs.

The in-house lawyers at the Met and other major museums decided it was time to bring their bosses together for a dose of reality. In March, as Schultz awaited sentencing, de Montebello sent invitations to the directors and top attorneys of the Getty, the Cleveland Museum of Art, and the Art Institute of Chicago to join him for a "confidential discussion" about the recent changes in cultural patrimony law. "Because of the sensitive nature of this discussion," de Montebello wrote, "I would ask that you not circulate the agenda."

The group met on April 22, 2002. As the guests began to pick at their salads in a conference room off his office, de Montebello shared the story of his harsh treatment at the *New York Times* editorial board meeting. Then Stephen Urice, an expert on cultural property law from the Pew Charitable Trusts, presented an overview of how museums and archaeologists, once partners in the early twentieth century, had become enemies over the question of buying ancient artifacts. He ended with a pointed warning: "Acquisition today of any substantial antiquity will be subject to withering scrutiny from an organized and activist archaeological community, from investigative journalists and possibly from editorial boards. In other words, acquisition today of an important unprovenanced antiquity is tantamount to the museum's acquisition of a major public relations battle."

The group then discussed a legal case study of a hypothetical curator who acquired a Greek vase from a hospital that had purchased it twenty years earlier from a dealer under criminal investigation. The example, epitomizing a problem that all of the museums had encountered at one time or another, was a thinly disguised version of True's ill-fated proposal to buy the Poseidon. The consensus around the ta-

ble was that the make-believe museum curator would most likely be indicted and convicted of trafficking in looted art.

Most of the museum directors in the room appeared to be getting the message. One, however, sat stone-faced and silent throughout: Debbie Gribbon of the Getty.

TWO MONTHS AFTER the secret Met conference, the Getty dispatched Gribbon and Peter Erichsen to Rome to explore a possible settlement with Italian cultural officials. Richard Martin had been urging a rapprochement for months. He figured that if the Getty could draw the Culture Ministry into a collaboration with the offer of money and the services of Getty conservation experts, it might loosen Ferri's prosecutorial grip on True. It was the Getty's best shot at settling its differences with Italy.

"I'm here to propose that the Getty and the Italian government work on a cooperative scientific agreement for conservation efforts," Gribbon said as the two sides met around a conference table in the Carabinieri headquarters near Rome's Collegio Romano.

Giuseppe Proietti, a senior Culture Ministry official, blanched. Was Gribbon suggesting that Italy was too poor or inept to take care of its own cultural objects? This was the old argument American museums had long used to justify their acquisition of looted art.

"Italy has had plenty of experience in the field of conservation," Proietti answered stiffly. "We don't need the Getty's cooperation in conservation."

What Italy wanted, he continued, was for the Getty to return the looted antiquities that Italy had requested. And it wanted a promise that the Getty and other American museums would stop buying art from criminal dealers.

"We have evidence that your curator was in touch with known traffickers," Proietti said. "You don't have to buy from these people. We're prepared to loan the Getty our artworks for long-term exhibitions, up to four years, and we want nothing in return."

It was a handsome offer, but Gribbon bristled. "If what you're intending to discuss is the criminal case, then we have nothing to talk about," she said. "And it will be the Getty trustees who decide what the Getty will buy."

"I'm surprised by your statement," Proietti replied, clearly insulted. "Here in Italy, when we refer to bad museums, we use the same term as we do for bad governments — 'rogue.' I think the Getty and the Met are rogue museums."

Gribbon stood up. "I don't think we have anything to talk about," she said, then walked out.

A stunned silence filled the room. What was to have been two days of meetings had ended in less than two hours. As the Getty attorneys collected their papers, a conciliatory Carabinieri official asked them to join him in a nearby office for an off-the-record chat.

"We have to come up with some kind of solution before we mess up our relationship," one of Conforti's deputies told the Getty attorneys. "This isn't personal. It's the evidence that's guiding us. We are not talking about the Getty. We're talking about what Marion True did wrong, in her position at the Getty."

If the Getty was willing to give back several of the looted objects as a gesture of good faith, the Italians suggested, they would back down. Otherwise, the Carabinieri official added, "this will go on for years and years, and in the end you're going to give it back to us anyway."

Show us your evidence, a Getty attorney said, and we'll consider your request.

Italian officials provided files on six objects, including the Aphrodite. They gave the Getty its first glimpse of the evidence Italy had mustered against its curator.

Much of it was based on Medici's Polaroids, which appeared to show many of the objects soon after excavation. The most compelling photos were of the marble griffins, broken and dirty in the trunk of a car, spread out on an Italian newspaper. The conclusion was inescapable. Other photos were suggestive but may not have held up in

court. The file on a small Greek oil decanter the Getty had bought from Larry Fleischman in 1992, for example, contained a photograph showing it in pieces, which Italian authorities said they had obtained from a person "familiar with local excavations." The weakest case was the one against the Aphrodite. The file on it contained only a rehash of largely circumstantial evidence, including a copy of the limestone study supporting claims that the stone was from Sicily.

Erichsen summarized the evidence in a memo to Munitz and the board of trustees. The photos, he said, were "arresting," but the evidence "does not compel a decision to return." His analysis appeared to be driven not by ethics or evidence, but by his anger at what he and Gribbon perceived to be Italy's attempt to extort the Getty.

"To submit to blackmail—and the circumstances here justify the use of the term—is different in every sense from a collaborative evaluation of archaeological evidence or the decision to return property we know to be stolen . . . The Italians' attempt to use the investigation of Marion True to cow us into submission is morally repugnant."

Six months after her disastrous trip to Rome, Gribbon wrote a curt note to Italian authorities, ignoring their request for the return of the six objects and repeating her insistence that the Getty would continue to buy what it deemed fit. In doing so, she was ignoring the advice of the Getty's own lawyers, who had recommended a speedy settlement.

The letter infuriated the Italians. Gribbon's delay had put them up against a statute of limitations deadline for bringing the case. But more than that, the Getty was now choosing to ignore direct evidence that its antiquities had been looted. There would be no more negotiating. The only thing the Getty and other American museums would understand, the Italians concluded, would be a criminal prosecution.

THE REIGN OF MUNITZ

RESENTMENT WAS SPREADING through the Getty like a virus. Between 2000 and 2002, the trust's endowment had plummeted $2 billion because of falling financial markets, just as the museum was preparing to open the newly remodeled Getty Villa. For the first time since the windfall provided by J. Paul Getty's will, the operating expenses were threatening to exceed the earnings on the endowment. The tough days Barry Munitz had warned about when he first took over were now at hand. The CEO had already done all that he could to avoid the pain.

Munitz asked chief financial officer Bradley Wells to initiate a cost-cutting campaign, a radical proposition for an institution used to bottomless resources. A reorganization led to several rounds of layoffs of blue-collar workers and security guards, many of whom were well-regarded veterans. Wells also instituted a centralized procurement system that forced departments to run their requests for everything from catalogues to Wite-Out through the trust's central administrative office. Some of the changes were petty but struck at popular perks. Holiday parties were canceled. Staffers were asked to pay for tea and coffee in the break rooms. And, as he had at Cal State, Munitz did away with across-the-board raises and initiated performance bo-

nuses. Employees grumbled that the incentive scheme was just a ruse for Munitz to reward his loyalists. Morale hit a new low, however, when the front office disbanded the Getty softball league, in which each department had a team. The reason: too many workers' compensation claims.

The cuts were an insult to the deep sense of entitlement at the Getty, especially when coupled with Munitz's own profligate use of Getty money. Days after laying off seven of the most popular security managers, the CEO drove past their colleagues at the front gate in a new silver Porsche Cayenne. Munitz had ordered the $72,000 SUV at the trust's expense a few weeks earlier, supposedly for transporting board members. He'd demanded that it come with "the best possible sound system, biggest possible sunroof and power everything." Raul, his full-time Getty driver, crisscrossed the city in the Porsche running personal errands for him—picking up a bow tie at Barney's for a formal event, delivering his newspapers and office mail, making the weekly one-hour drive to Long Beach to pick up copies of Munitz's favorite TV shows, *The West Wing* and *Law & Order*. Munitz had them specially taped because he couldn't figure out how to use his VCR. All of it was paid for by the nonprofit Getty.

After his intense first years at the Getty, Munitz had grown bored with his job and become an absentee CEO. He began spending more time at home by the pool, reading, thinking, dictating hundreds of messages. He boasted that he never touched a computer keyboard, leaving it to his pool of five secretaries to transcribe his musings and send them out to the world. All his Getty calls were routed to his private line, extension 6658, which rang through to his Santa Monica residence, preserving the illusion that he was in the office. He governed via voice mail.

The system worked with staggering efficiency. All office appointments were scheduled for the day of the week when the maids came to the house. No one remembered the last time Munitz had held a staff meeting. Still, Munitz was remarkably productive, though little of what he did related directly to the Getty. There were tricky demands

involving his wife, Anne T. Munitz. "ATM saw in Europe but can't find here Tropicana blood orange juice, no pulp, not from concentrate," he dictated to an assistant while on the road. "Can you look on the website and find out where we can get this on a regular basis locally?"

Most of his energy went to obsessively cultivating and maintaining a network of well-placed acquaintances. He lavished attention on Hollywood friends and minor European royalty, Los Angeles power-brokers, and players in higher education and politics. His specialty was making connections between players on the dozen or so corporate and nonprofit boards on which he served.

He fed this network with a steady stream of thoughtful notes, bits of gossip, and witty insights attached to clippings from the morning papers. Nothing escaped his studied gaze. A casual reference by someone at a cocktail party about a good book resulted in Munitz sending along the favored author's next work a year later. His roots may have been in Brooklyn, but he had perfected an easy California intimacy, signing even his business correspondence "Warm hugs, Barry." All of it was driven by a seemingly insatiable need to be accepted, liked, and admired in the highest circles.

Mostly, Munitz spent his time traveling. In his eyes, that was precisely what he had been hired to do, to plug the navel-gazing Getty into the real world. The board had wanted him to be the Getty's ambassador to the world, to woo big donors and build partnerships, and Munitz was determined to play that role to the hilt.

He took his wife and friends on lavish cultural tours around the globe. Many were thinly disguised vacations, billed to the Getty by virtue of the touch-and-go cultural stops he had his secretaries add at the last minute. The opportunity to view Getty conservation projects in Italian hill towns helped pay for $13,000 first-class airfare and half the $21,000 cost of renting a fifteenth-century Tuscan farmhouse, where the Munitzes partied at night with their Hollywood friends. A Munitz birthday jaunt to Australia's Great Barrier Reef with Paramount Pictures CEO Sherry Lansing and her husband, director Wil-

liam Friedkin, became a Getty business trip with the addition of a few cultural meet and greets in nearby Sydney. The foreign trips, sometimes a dozen a year, were interspersed with excursions throughout the United States to catch up with friends, attend board meetings, or, when traveling alone, meet one of the fresh-faced young women he had a habit of taking under his wing.

In Munitz's absence, running the Getty fell to his protégée, Jill Murphy, now thirty-one. Besides having a penetrating mind, she was adept at pitting people against one another and playing favorites. With Munitz out of their sight, Getty staffers began focusing their growing anger on her.

IRONICALLY, THE ILL will ran deepest within the Getty Museum, which Munitz had coddled early on. In 2000, the CEO had convened an acquisition task force and agreed with its recommendation to plow serious money—more than $1 billion—into acquisitions over the next ten years to upgrade what remained a mediocre collection. That pledge came while Munitz shuttered the Education and Information institutes. Now there were whispers that the museum's acquisition budget would have to be rolled back. No one was more disturbed about that than Debbie Gribbon, the Getty Museum's new director.

Gribbon already had a hard time swallowing the fact that, unlike her counterparts at the Met or the British Museum, she had to run every acquisition through Munitz before presenting it to the board. That collecting might have to be scaled back only guaranteed closer scrutiny by the CEO or, worse, Murphy. Gribbon's worries helped destabilize what was always a fragile alliance between the museum and the trust. Munitz had gone out of his way to back Gribbon's appointment to curry political favor with John Walsh, her mentor and close friend. After Walsh's retirement in September 2000, the relationship between Munitz and Gribbon became strained.

Gribbon was a literalist. She dealt with facts and did not look beyond them for meaning—an unusual personality for someone with a Ph.D. in the arts. By contrast, Munitz lived in a relative world, where

concepts and facts were often fluid. Impressions were everything. At first Murphy was able to mediate between the two, but as her own relationship with Gribbon grew cold, a steeliness set in. Gribbon often signaled her disdain for her boss by referring to him as "Mr. Munitz," despite his repeated requests that he be called "Dr. Munitz," so as not to be outdone by the proliferation of Ph.D.'s working at the Getty.

Within the museum, Gribbon had stopped talking to True, tired of the curator's insistence on defying her by speaking out on patrimony issues. The rift grew into a yawning chasm after Gribbon's disastrous trip to Rome in the summer of 2002, creating a paralysis within the department that threatened the much-delayed opening of the renovated villa.

True, meanwhile, had sunk into despair over her legal predicament. The board prohibited her from engaging in discussions about the conflict with Italy—the very type of cultural conflict she had prided herself on resolving. She lived under an information blackout, complaining that no one could even explain the specific charges she faced. Francesco Isolabella, the Italian lawyer hired by the Getty to defend her, was half a world away. Board members had turned down her repeated requests to hire a second attorney in Los Angeles to help her sort things out.

What little True learned about the legal deliberations came from Barbara Fleischman, and the news wasn't encouraging. Erichsen, still a novice at patrimony law, urged the board not to give in to the Italians' strong-arm tactics but couldn't determine who in the labyrinthine Italian bureaucracy to approach for a settlement. Even as Fleischman demanded that her fellow trustees stand by True, the realization was dawning that the legal interests of the trust and its curator were at odds.

One day, True called Fleischman in tears. "Barb, I don't know what to do," she said.

"For heaven's sake, Marion. Pick up the phone and call Barry."

"I'm not allowed to see him," True said.

Fleischman was outraged. Munitz was clearly insulating himself

from the antiquities scandal. Fleischman promised True to do all that she could. Her complaint to the board's executive committee was the strongest distress signal yet received by the trustees, and it came outside the official lines of communication that Munitz and Murphy jealously guarded.

IN THE FALL of 2002, board chairman David Gardner called Munitz at home on a weekend with a warning. "I want you to know, Barry, that I hope you will be in your current position forever," Gardner began. "But there are problems brewing that you might not be aware of."

Gardner ticked off the complaints he was hearing from board members: Murphy was running the Getty through intimidation and fear; Gribbon and True were at each other's throats; work on the villa had stalled; the Italian problem was getting out of hand. Gardner told Munitz that board members had talked it over and agreed that the CEO was away too much.

Munitz was blind-sided by the criticism. Keeping a board happy was his forte, a topic on which he lectured to corporate governance groups. Suspecting that the whispering campaign was timed to undercut negotiations for his next contract, Munitz pushed Gardner for more information. But Gardner wasn't giving up his sources. He suggested that Munitz conduct a quiet assessment of how he was perceived among top management. Munitz should present the results, along with an explanation of his work schedule, at the board meeting in January.

Munitz had good reason to expect that Gardner would take care of him. The two had been friends for years. While president of the University of California system, Gardner had thrown a welcome-to-California party for Munitz, the incoming chancellor of the California State University system. Later, as director of the William and Flora Hewlett Foundation and a Getty board member, Gardner had helped recruit Munitz for CEO.

Recently, Gardner had made it clear that he, too, expected to be

taken care of. Even before becoming board chairman in 2000, Gardner had been hounding Munitz and his staff for perks and pay from the Getty, which had never provided compensation to its board members. Gardner's demands had become a recurring problem, consuming staff time and thousands of dollars for outside legal opinions. As a condition of taking the chairmanship, Gardner wanted the Getty to provide him office space in his Utah home. When the request was turned down because it would violate private foundation tax laws, he pressed for the Getty to pay for his wife to travel with him first-class to board meetings. Staff members gave her tours of the museum or escorted her to her favorite Westside hairdresser while he chaired the sessions. It was at Gardner's insistence that Munitz began investigating how to amend the trust indenture so that board members could be paid.

Munitz appeased Gardner as often as possible, but he wanted to leave nothing to chance when it came time to defend his performance. He spent hours drafting and redrafting his response to Gardner, an eight-page letter in adjective-encrusted prose that flattered Gardner, promised emphatic but vague changes, and recast his supposed shortcomings as strengths. He gave a lengthy defense of the "dramatic transformation" he had accomplished at the Getty during the past five years and maintained that the "complex challenge with Italy" was being adequately handled. "Our interest in that international question increases with each new insight regarding our special curator and our Board member," Munitz added, unable to resist a swipe at True and Fleischman, whom he suspected of starting the complaints.

THE ITALIAN INVESTIGATION was the main item on the agenda for the January 2003 Getty board of trustees meeting. The executive committee handling the issue—Gardner, attorney Helene Kaplan, and investment guru Lewis Bernard—had a lengthy conference call with Munitz and Erichsen in November 2002 to discuss how to broach the subject with the other trustees. Erichsen had spent months

preparing a briefing paper laying out the facts and legal issues. It contained explicit references to the troubling documents the Getty's attorneys had found in their review of the museum's files three years earlier but had kept from Ferri.

The committee agreed that the documents raised uncomfortable questions that the Getty had long avoided answering. What if True had done something wrong? Erichsen thought the Italians were using the charges against the curator to shake the Getty down, but as Bernard noted during the conference call, "It's only blackmail if Marion True didn't do anything wrong."

Kaplan, an expert on governance for the high-powered Manhattan law firm Skadden, Arps, went further. Obviously, True wasn't doing all this on her own, she pointed out. "How do John Walsh and Harold Williams fit into this?" she asked. "Vast sums were spent on the Fleischman collection. This had been going on for a long time. Their approval had to be there. What is our strategy to deal with this?" She wanted to know whether there was any link between the Getty's 1995 policy change and the 1996 acquisition of the Fleischman collection. Was the policy a way of justifying the acquisition? Why was the collection acquired if most people suspected it of being hot? It was Gardner who asked the clincher: what was the board's legal exposure?

The questions kept coming, and there were far too few answers. The search of Getty files so far had turned up several troubling bits of information, but it wasn't a comprehensive investigation. Only a thorough inquiry—one that questioned Gribbon, True, and others directly—would get to the bottom of what had really happened at the Getty. The executive committee had considered the step but backed down each time, concerned about the public relations ramifications.

"At what point must we give the board an honest appraisal?" Kaplan asked. She had doubts about the discretion of her fellow trustees and recommended that Erichsen's briefing paper be kept from the full board. Erichsen pushed back. The trust had a moral and legal duty to keep the board informed, he said. Withholding his briefing paper

would look like a cover-up, and he and other members of Munitz's management team wanted to make sure all the board members were fully informed so that no one could plead ignorance later.

In the end, the committee reached a compromise. There would be no deeper investigation. All the references to "troubling" documents and "arresting" Polaroids would be excised from Erichsen's briefing paper, but the trustees would be briefed orally on them. Even the sanitized document would be guarded closely, with numbered copies passed out at the beginning of the board's discussion and collected at the end. Faced with an opportunity to find the truth, the Getty leadership once again opted for only the appearance of due diligence.

The precautions worked too well. During the board meeting, trustees had time only to scan the briefing paper, and none saw the photos. Erichsen's presentation dwelt on legalisms. He glossed over the Getty's own disturbing discoveries, emphasizing instead what he considered Italy's immoral conduct. "Our attempt to accommodate them has only drawn us deeper into a one-sided, even in some respects sordid, effort on their part," he said. "We may yet be able to negotiate with them successfully, but we believe that to do so we need to establish a credible position in the public debate over cultural patrimony."

As Munitz sat through the discussion, he seemed to have other things on his mind. His primary concern was not Italy, but the next topic on the agenda: his raise. Munitz was already being paid more than $1 million a year in total compensation—more than any other museum director, university president, or foundation chief in the nation. His income was essentially tax-free. As part of his contract, the Getty reimbursed him for all the state and federal taxes he paid. He had an SUV at his disposal, a personal driver, and a pool of five secretaries. But that wasn't enough for Munitz. He had a copy of Harold Williams's final contract in a file, and he felt that his benefits paled by comparison. For the rest of his life, Williams was to receive more than 100 percent of his final Getty salary of $600,000, along with secre-

tarial support and office space at the Getty Center. By contrast, the board had put a cap on Munitz's generous retirement package. And whereas Williams had received a completion bonus for bringing the Getty Center in over budget and behind schedule, Munitz would receive nothing for accelerating the completion of the Getty Villa. It was simply unfair.

Munitz had been lobbying Bernard, who as head of the board's compensation committee was responsible for recommending the CEO's annual raise. Bernard was concerned that giving Munitz a large raise in the midst of other, wide-sweeping cuts would send the wrong message to Getty employees and the public. Munitz countered that the tough times had made his job more demanding and therefore more deserving of a reward.

In the end, the board decided that Munitz's performance had been "very strong" but voted to give him only a 4.5 percent increase, on the low end of the range. Although he was the only person at the Getty to get a performance raise for the year, he was furious. Over the next year, he would make it his mission to see that he was fairly compensated.

OF ALL THE uncomfortable information facing the Getty during the escalating Italian investigation, one of the most agonizing was sitting at the board table: Barbara Fleischman.

Fleischman sensed that board members were wavering over what to do about their embattled curator and became stridently defensive of True. She urged the Getty to launch a public relations campaign on behalf of True, touting her role as a reformer in the antiquities trade. She called on colleagues to approach their powerful friends—former secretaries of state James Baker and Warren Christopher, or even National Security Advisor Condoleezza Rice—to broker a diplomatic solution with Italy. This was, after all, not just a Getty issue, but an issue that affected all American museums. Fleischman accused the Italians of "raping and pillaging" the Getty. At one point, she said that

True was taking the fall for Walsh and Williams, much like the Nazi generals who were prosecuted for following the orders of their superiors. "It's just like Nuremberg," she cried.

The board was reluctant to act. With the Italians increasingly focused on how Fleischman and her husband had built their own collection, it was evident that she might soon be a target as well. At the behest of board leadership, Erichsen and Martin had already visited Fleischman in her Manhattan apartment to offer some awkward advice: she should retain her own legal counsel. And since the matter involved her actions before she became a board member, she would have to pay for her own attorney. Fleischman had already racked up $30,000 in legal fees consulting with her attorney about how she might defend herself while also helping True. She was adamant that the Getty should pay the bill and threatened to go over Erichsen's head by raising the issue with Munitz and Gardner. Erichsen warned the board's executive committee that paying Fleischman's legal expenses would be a violation of the U.S. tax code, which would consider it illegal compensation for a board member. Erichsen got the reaction he wanted.

"I agree . . . completely," Helene Kaplan told Erichsen in a voice mail delivered from outside a board meeting of the Carnegie Corporation, which she chaired. "I think we would be jeopardizing our potential tax exemption . . . and I think that's the way it has to be presented.

"But truthfully, secondly, I think it equally important for the Getty to keep our distance. I don't want us to be implicated any more than we have to."

Munitz's fears of a whispering campaign, it turned out, were well-founded. He just had the wrong suspects.

Gribbon had become increasingly angry at Munitz and Murphy, and they with her. The relationship ruptured over the Getty's purchase of Titian's *Portrait of Alfonso d'Avalos* for $70 million. Relying

on Gribbon's word, Munitz assured reluctant board members that the masterpiece had been cleared for export from France, only to discover later that the paperwork hadn't been completed, creating a potentially embarrassing complication. Murphy, feeling betrayed, stopped talking to Gribbon. By then, Gribbon had begun looking for support from her former boss and mentor, Walsh, who had retired but remained close to her and others at the Getty. Munitz was turning his back on the commitment he had made to build the museum's collection, Gribbon complained. The institution was headed in the wrong direction. Gribbon and Walsh concluded that they had to act before Munitz destroyed the museum they had worked so hard to build. Perhaps if a number of key board members could be briefed, they might be able to do something before it was too late. The CEO served at the pleasure of the trustees, who were the trust's ultimate authority. It was time to go over Munitz's head.

In the fall of 2003, Walsh approached Agnes Gund, one of the few Getty trustees who came from a museum background and a member of the Getty task force that had recommended the $1 billion for new acquisitions. As president of the Museum of Modern Art, Gund had been hearing troubling rumors about Munitz and Murphy. Despite a $1 million Getty grant that Munitz had arranged for MoMA, endowing a curatorial position in her name, Gund had become disillusioned with him. Gribbon, meanwhile, sought out Lewis Bernard, complaining that Munitz and Murphy were destroying the institution by reneging on promises to build the collection. The board needed to do something and had a perfect opportunity when Munitz's contract expired in January 2004.

By November 2003, the whispering had become a murmur. Bernard and Kaplan pulled Gardner aside at a conference in New York to express their concerns again. Despite the previous warning, Munitz hadn't changed. He was still away too much. He was disengaged. There were no regular staff meetings. Munitz had strained relations with Gribbon and True. The Italian issue was complicating every-

thing. Bernard began asking whether the board should give Munitz a six-month or one-year contract extension and reevaluate the situation at the end of that time.

Gardner was stunned by the suggestion and pushed back hard. Anything short of a three-year contract would be tantamount to a vote of no confidence, he argued. "Look, I understand Munitz has some outspoken critics," Gardner told Bernard. "But my job as chairman is to represent the consensus, and I think the consensus of the board agrees with extending the contract. Keep that in mind."

Bernard relented, agreeing to let the full board decide what to do at its meeting in January. Gardner immediately made an appointment to talk with Munitz. "Your job is at risk, Barry," he warned.

With two months until the meeting, Munitz kicked his personal PR campaign into overdrive. He set up a meeting with his four program directors and promised to resume regular meetings. No more going through Jill Murphy, he told them, adding that he knew some of them had gone behind his back to board members. "You should have come to me directly," he said. "But here we are. Let's make this work." Gribbon wept through much of the meeting.

Munitz then threw himself into his specialty, what he called "board-touching." He had already deduced that Gund and Bernard were lost causes. He concentrated on the other trustees. He and his wife flew to Hawaii, where they spent a weekend with Lloyd Cotsen, former CEO of the Neutrogena cosmetics firm and an avid archaeology buff. UCLA had named its archaeology institute for Cotsen after he donated $7 million, the largest gift ever to a social science program at the school. Among Getty trustees, he was the most openly sympathetic to the Italians. If the Getty had anything that was even suspect, the museum should give it back, he urged. He had also been after Munitz to forget about buying new art altogether, suggesting that the museum focus instead on seeking loans. In Hawaii, Munitz agreed to abandon the acquisition plan—and with it the $1 billion commitment he had made to the museum.

The next weekend, Munitz was in New York, attending church

services with board member John Biggs, the recently retired chairman and CEO of the gigantic TIAA-CREF retirement investment company. Biggs, a bespectacled St. Louis native with a straightforward midwestern approach, had commanded national attention during the Enron scandal when he'd testified before Congress against the kind of chummy accounting practices that had led to the spectacular collapse of the energy firm. His testimony had earned him a torrent of protests from the profession and derailed his candidacy to head a new federal accounting oversight board established under the Sarbanes-Oxley Act. On the Getty board, Biggs chaired the audit committee, and Munitz was lobbying for him to replace Gardner as chairman of the board.

After attending church with Biggs, Munitz had lunch with the disgruntled Fleischman. He promised to redouble his efforts to support True during her travails.

Gardner, meanwhile, was lobbying other board members, urging them to back the CEO.

The payoff came on January 16, 2004, when the board gathered at the Getty Center for its annual meeting. Before the board retired to closed session to consider Munitz's contract, he delivered an impassioned and carefully prepared defense, one that cleverly turned the tables on his detractors. What was considered by some to be a management problem, he argued, was in fact the board's failure to settle on a governance philosophy. At the board's direction, Munitz said, he had been focused outward, playing the hands-off visionary. Now he laid out several other options, saying it was up to the board to decide what it wanted its CEO to do.

After placing the issue squarely on the trustees' shoulders, Munitz left the room. Bernard proposed waiting to see if Munitz's performance improved before renewing his contract. Gardner countered that Munitz was making progress and that the board had its CEO's attention. During the discussion, Fleischman received a call on her cell phone from a dealer who had heard about the contract dispute and wanted to urge her to vote against Munitz. But Munitz's board-

touching had secured him a solid majority. By the time the votes were counted, Bernard had caved in to the pressure, casting his vote with ten others to give Munitz a new contract. Instead of the three-year contract he was expecting, however, they upped it to five years. The vote was 11–0. Gund abstained.

The coup had failed. By defeating the old guard led by Gribbon and Walsh, Munitz had finally wrested control of the Getty from the ghost of Harold Williams. Or so he thought.

Once again, the other major item on the board's agenda was Italy. Peter Erichsen and Richard Martin reported that the news was grim. A month earlier, as the Getty was preoccupied with the attempted mutiny, the trial of Giacomo Medici had begun in Rome. Paolo Ferri was publicly introducing evidence that directly implicated True. The prosecutor seemed to be laying the groundwork to formally indict the curator.

Erichsen's briefing papers for the day's discussion had again been cleansed by Kaplan of references to the Getty's possible institutional culpability. But the troubling facts had not disappeared, and as Erichsen explained in his presentation, many new ones had emerged. The Getty had learned that dealer Frieda Tchakos had said in a deposition that the Fleischmans had been a "front" to launder looted antiquities bound for the Getty. Letters unearthed in the Getty's own files showed that True had urged Tchakos to sell certain objects to the Fleischmans.

The worst piece of correspondence, however, was the one that senior staff had begun referring to as the "smoking gun": Houghton's 1985 memo to Gribbon, which detailed a discussion with Medici about the illicit origins of three of the museum's most prized objects—the Apollo, marble basin, and griffins from the Tempelsman collection. Nearly twenty years later, Houghton's breezy connecting of the dots from an ancient Italian tomb to the shelves of the Getty was met with silence when projected on a screen.

If the memo were to fall into the Italians' hands, Martin delicately

explained, it "could hurt Marion True at trial." The larger message was left unsaid. Problems in the antiquities department predated True and implicated her superiors, including the museum's current director.

Gribbon, clearly pained, shifted in her seat. "Do you want me to leave the room for this?" she asked. No, board members murmured. You did nothing wrong.

MUNITZ WASTED NO time turning the screws on Gribbon. Having been criticized for being aloof and disengaged, he was determined to show Gribbon just how engaged he could be. In the weeks following the failed coup, Munitz began a barrage of e-mails, memos, voice mails, and meeting requests. He questioned Gribbon's leadership, noting each of her shortcomings, which he described as "pending Museum leadership questions." He met with Gribbon and her staff to analyze the museum's management structure, then stripped away key people. As he had promised Fleischman, Munitz took True's side in the turf war over the Getty Villa renovation, having the curator report directly to him on the project rather than going through Gribbon. And as he had promised Cotsen, he began backing away from his commitment to spend $1 billion in acquiring new art. The acquisition fund, he informed Gribbon, needed to be pared down because of the trust's economic issues.

The unrelenting pressure had its desired effect. Gribbon could barely keep her composure, often leaving meetings in tears. In a last-ditch attempt to undermine Munitz, she once again broke with protocol and committed the institutionally treasonous act of complaining directly to the trustees during their April 2004 meeting about Munitz's new centralized procurement program. In private conversations, Gribbon's fellow directors had seemed just as dismayed as she was. But when she turned to them for support during the board meeting, they remained silent. Munitz had carefully cultivated them over the past couple of months, further isolating Gribbon, who had stumbled fatally while making a desperate lunge at Munitz.

Within two weeks, the CEO brought things to a head in Gribbon's annual review. Obsessively prepared, he flogged the tearful museum director with a cat-o'-nine-tails of items she had failed to complete to his satisfaction. Then, noting that she often appeared unhappy, Munitz asked—twice—whether she was truly committed to staying at the Getty. Wouldn't she be happier at a museum that she could run as her own? As if to give her additional motivation, he continued his litany. Gribbon's relationship with True was "dysfunctional," caused by a power struggle between the two women. Gribbon was unreasonably hostile to Murphy. He offered at least half a dozen examples from recent months in which Gribbon had exhibited an "unfortunate pattern" of emotional outbursts. In fact, the trustees themselves had fretted over Gribbon's performance at their last meeting, Munitz said. "Several people subsequently remarked that if they were your colleagues, they would have murdered you," he remarked.

When Gribbon asked Munitz to meet with the trustees to discuss their differences, the emboldened CEO slapped her down. "As long [as] the Board wants me to serve as CEO, if I perceive that you are having a difficulty, then you must accept that there are problems," he snapped. In other words, you work for me.

Gribbon was shaken, but she replied to Munitz's criticisms with a lengthy memo, noting that this was "the first time in 20 years at the Getty" that she had received a negative review. Munitz responded with a nine-page letter documenting his earlier complaints for the record.

In the months that followed, a strange peace settled over the Getty. Munitz even tried to dial back some of the rancor, noodling with board members about whether to hire a professional coach to help Gribbon. Perhaps David Gardner could be a paid mentor. He was going off the board in June and had been pestering Munitz to find some way for him to earn money from the Getty afterward.

Gribbon herself seemed tamed. She and Munitz worked together on a new acquisition plan and met for a full day to discuss how Gribbon might improve her job performance. She was sanguine, almost

solicitous, thanking him for his support. Munitz welcomed the change in attitude. He desperately wanted to present a unified management team to trustees at an upcoming board retreat scheduled for October at a Palm Springs resort.

Then, on September 21, a messenger walked into Munitz's office with an envelope marked URGENT. Munitz was out of town, so Murphy opened the package. Inside was a letter from Gribbon's attorney. The museum director was resigning her post. She threatened to sue the Getty for harassment and "constructive discharge." As one staff member later said, it was checkmate, the biggest "fuck you" Gribbon could muster.

Gribbon's attorney sent a similar letter to the new board chairman, John Biggs. Attached to it was a copy of Munitz's nine-page letter ripping Gribbon to shreds—no doubt exhibit A in what would be one very tawdry lawsuit. How could you write that in a letter, Biggs asked Munitz when they spoke. "It's her performance review," Munitz replied with a shrug.

Biggs and Bernard worked with Erichsen to negotiate a deal with Gribbon's attorney. Concerned that she would speak out about Munitz, the Getty agreed to pay Gribbon $3 million. Both sides agreed not to go to the press.

The board was asked to approve the agreement after it had already been struck. Some were enraged. It was extortion, they felt, and it was naive to think that Gribbon wouldn't go to the press. Munitz, too, was furious. As part of the settlement, the board would issue a press release attributing Gribbon's departure to "philosophical differences" with Munitz, but the settlement prevented him from speaking publicly about those differences.

In mid-October, Debbie Gribbon walked out of the Getty Museum for the last time. Unaware of the lucrative deal she had struck, many saw her as a tragic heroine, the only person who had dared to stand up to Munitz.

THE APRIL FOOLS' DAY INDICTMENT

THE TRIAL OF Giacomo Medici was a rare exception to the parade of inefficiency and bureaucratic dysfunction that is typical of the Italian justice system. Medici had invoked his right to a "fast-track" trial, a maneuver that forced a verdict at the end of an abbreviated proceeding. Medici's lawyers hoped to catch Ferri off-guard, unable to scale the mountain of evidence he had gathered since the raid on Medici's warehouse nine years before. The tactic also severed Medici's trial from that of his alleged coconspirators, Robert Hecht and Marion True, who faced preliminary hearings to determine whether there was enough evidence to indict them.

But under Italy's creaky Napoleonic court system, even the fast-track trial, which began in December 2003, proved to be a lurching slog. What would have been a two-week case in an American court stretched into a year. Hearings were scheduled once a month. When not delayed by holidays or lawyers' strikes, the sessions degenerated into procedural tussles between Ferri and Medici's lawyers. Outside the courtroom, Medici provided a colorful counterpoint, prowling the hallways carrying paper bags filled with his own "evidence," complaining loudly to the handful of reporters following the trial that he was being railroaded. The Polaroids weren't even his! He had met

Marion True only four or five times! He'd never sold her a thing! "They are trying to make a monster out of Medici!" he bellowed in raspy Italian, his hands shooting through the air, spit springing from his lips.

Judge Guglielmo Muntoni showed a bemused tolerance for Medici's fiery rants about the corruption of the Italian state and Ferri's lengthy courtroom ramblings. After both sides had had their say, he methodically plowed through the facts about each artifact implicated in the case, throwing hundreds out because there was insufficient evidence that they had been excavated after Italy's 1939 patrimony law.

In December 2004, Muntoni issued his verdict: Medici was guilty of trafficking hundreds of antiquities that had been looted from Italy. The objects had been smuggled to Geneva, laundered through auction houses, and sold via Hecht, Bürki, Symes, and others dealers to high-end clients, including True. The unprecedented decision was delivered in a 650-page ruling that had taken Muntoni five months to write. He sentenced Medici to ten years in prison and fined him ten million Euros, to be paid in part by confiscation of the dealer's rambling villa outside Cerveteri, the Etruscan site that had been so notoriously looted. It was the stiffest sentence ever given to an antiquities trafficker in Italy.

THE VERDICT WAS a major victory for Ferri. In addition to being Italy's biggest looting conviction, the Medici case signaled the likely indictment of Hecht and True, whose trials would be largely based on the same evidence. As alleged coconspirators, they were not required to attend Medici's hearings, although Hecht often did. Outside the courtroom, he played the whole thing as a farce, answering questions from journalists with renditions of Gilbert and Sullivan show tunes. Hecht had good reason to be lighthearted. Although he could be found guilty, Italian law prevented him from ever going to prison because he was over seventy years old.

True clearly had the most to lose and stayed away from Medici's proceedings. The Getty had beefed up her defense team considerably

by hiring the well-known Italian attorney Franco Coppi, who had successfully defended the former Italian prime minister Giulio Andreotti on Mafia charges. Yet Ferri was more worried about Judge Muntoni. Would he hesitate to order a foreign curator to stand trial in Rome, a step no country had ever taken? Muntoni had mastered the complex Medici case, educating himself not just on the facts but also on the history of the archaeological pieces. But the judge also exhibited skepticism about some of Ferri's claims when it came to True. Clearly, Muntoni was struggling to accept the notion that such a highly regarded curator, best known as an ally of Italy and critic of the illicit trade, was part of the criminal conspiracy.

In the fall of 2004, Muntoni had called Ferri over to his office in the next dreary cement block of the Piazzale Clodio judicial complex. In a last-ditch effort to prevent True from being indicted, the Getty and True's attorneys had offered for deposition Barbara Fleischman, John Walsh, and True's deputy, Karol Wight. It looked to Ferri like just another stalling tactic. But Muntoni showed interest in the Getty's side of the story and soberly informed the prosecutor that he would attend the American depositions.

On September 20, Muntoni, Ferri, and twelve other American and Italian lawyers and diplomats crammed into a conference room at the U.S. attorney's office in Manhattan for the examination of Fleischman. Muntoni was aware that Ferri's case against True rested heavily on the notion that the Fleischman collection was a front for laundering looted antiquities. The judge put the question to Fleischman directly.

"Did Marion True ever exert her influence in the purchase of antiquities from various people, and also from Frieda Tchakos more specifically?" he asked, referring to the Swiss dealer whom Ferri had deposed in Cyprus.

"Categorically no," Fleischman said.

Muntoni asked for any invoices or documentation from the couple's purchases over the years. Fleischman acknowledged that she had never supplied any to the Getty but said that she had recently located

them all. "Up until a short time ago, I am ashamed to say, I had forgotten all of these files," the Getty trustee explained. "And when my lawyers had said to me, 'You know, you should look and see what there is' of course I went into another room where I had very carefully put them away, and found all the files that related to the sale of the objects, plus a little black book of my husband's which I had never noticed before or seen before."

The book, she added, listed the price of every object, the check number, even the banks on which the checks were drawn. The idea that Fleischman had never mentioned or supplied the information to the Getty aroused Ferri's prosecutorial suspicion. But when he tried to press further, Muntoni reined him in—ordering him to rephrase his questions, forbidding him to ask others, and bickering with him during long sidebars.

During the next day's questioning, John Walsh said that the Getty was especially cautious about buying antiquities because it knew the market contained illicit objects. He portrayed True as the institutional conscience behind the 1987 and 1995 acquisition policies, which he described as "radical" for their time. With no hint of irony, he said that the handful of times the Getty had been forced to return objects were proof that the policies worked.

"In my time, I think I never presented to the board an object whose circumstances, provenance, were such as to make me worry about the propriety of the acquisition," Walsh said. It was a bold statement, omitting two decades of internal handwringing over Frel's sins, the kouros, the Aphrodite, the funerary wreath, and his own handwritten notes from his September 1987 conversations with Harold Williams. When Ferri attempted to bore in, Muntoni once again held him back, summarily dismissing his questions.

Two days later in Los Angeles, Ferri suffered what he considered his most embarrassing run-in with Muntoni. During the deposition of Karol Wight, the prosecutor became irked by Wight's constant requests to speak to her attorneys before answering questions from him and others. One response in particular revealed how heavily Wight

had been coached. When Muntoni asked what had prompted the Fleischmans to donate their collection to the Getty, the associate curator turned to her attorneys and asked, "Is this the time for the story?" Then she launched into the anecdote about how the Fleischmans had been charmed by a group of kids admiring the antiquities during their 1994 exhibit.

Muntoni drew Wight out about the Getty's procedures for accepting the collection. Under his persistent questioning, Wight conceded that the museum had accepted the pieces before receiving any information about their provenance—an exception from the usual practice. When Muntoni asked what the Getty had relied on for the provenance, Wight cited the museum's own 1994 exhibit catalogue.

"So, basically, the only documentation you had was the information that was—produced in the catalogue, but you didn't have actual documentation of the ownership, the chain of ownership of each individual art piece or object?"

"No . . ."

During a break, a fed-up Ferri tangled with Richard Martin over Wight's constant consulting with her attorneys in the midst of the deposition. Ferri claimed that it was a violation of Italian procedures, but when he appealed to Muntoni to intervene, the judge deferred to the American rules. Ferri felt betrayed.

Muntoni's repeated rebuffing of Ferri gave hope to Getty officials. Erichsen advised the trustees at their February 2005 meeting that Fleischman, Walsh, and Wight had "hit the ball out of the park." Muntoni appeared to be leaning toward the Getty, but he was still under pressure to indict the curator. Erichsen suggested that the museum should do something to give him a nudge, a "Hail Mary pass" to save True. "I think we're going to get this but we need to give back something," he said.

THE DEPOSITIONS AND Muntoni's steely contrariness had rattled Ferri. Back in Rome, the prosecutor decided to do a painstaking review of his nearly decadelong investigation. He needed something

that would convince Muntoni that the Fleischman collection was a front, or his case against True would be precariously thin. The collection accounted for about half of the items traced from Medici's warehouse to the Getty. Ferri began writing a lengthy memo to Muntoni laying out a road map of the evidence.

On a Sunday afternoon in October 2004, Ferri was sitting in his office surrounded by reams of documents from the case when his gaze fell upon the invoices Fleischman claimed to have recently unearthed. One showed that her husband had bought a certain Greek vase in 1988 for $400,000. But something was curious about the handwriting on the document. Ferri recognized the distinct style as belonging to Robert Hecht.

He began searching through the photographs seized from Medici's warehouse and found a Polaroid showing the vase. Medici had written along the border, "Okay con Bo, tutta mia, 1991"—Okay with Bo [Medici's shorthand for Bob Hecht], all mine, 1991. A second Polaroid showed the vase in Medici's warehouse. More printing on the border: "Da Bob"—From Bob.

How could a Greek vase that the Fleischmans purchased in 1988 still be in Medici's warehouse in 1991? The receipt, Ferri concluded, was either backdated or a fake. Given the handwriting, it had almost certainly been concocted by Hecht.

Ferri began jumping around the room with the forged receipt. Then he dashed to the phone and called his investigator, Maurizio Pellegrini. "I got them!" he shouted. "I got them!"

Ferri was convinced that Fleischman's recent "discovery" of the receipt was a cover-up, a way to deflect suspicion from the fact that True had been guiding their purchases. In her deposition, Fleischman claimed she had not met True until 1991. Pushing the purchase date back to 1988 would blur any link to True and avoid another embarrassing question: how could Larry Fleischman afford the pricey antiquity after 1991, the same year he had sold the Getty objects because he was supposedly experiencing financial difficulty? Either the Fleischmans had been lying about their finances, or they were acting

as surrogates for the Getty, Ferri concluded. Later in court, Hecht volunteered spontaneously that Ferri's theory about the vase was right; it was not sold in 1988, as the receipt indicated. How, then, had the vase ended up in the Getty? Hecht didn't say, but he left the impression that it had gone directly from Medici to the Getty, with the Fleischmans acting only as a pass-through on paper. Hecht seemed to be purposely shredding Fleischman's story, sending a message not to the prosecutor or the judge, but to True.

TRUE'S PRELIMINARY HEARING dragged on for a year and a half. By early 2005, as the proceedings lurched toward the final arguments, Ferri still had no idea whether Muntoni would rule that there was sufficient evidence to indict the curator.

In a final bid to demonstrate her innocence, True's attorneys called the curator to the stand in March to answer questions directly from the judge. Muntoni had treated everyone with respect during the proceedings, even showing a kind of admiration for Hecht, who had obviously lived his life unapologetically. But as True took the stand, Muntoni's line of questioning became unusually direct, revealing for the first time that he was leaning Ferri's way.

Muntoni had come to America mentally prepared to drop the case against True. All he needed to see was some documentation, any documentation, showing that the Getty had made some effort to check the provenance of the Fleischman collection, the most compelling part of Ferri's case. But no one—Fleischman, Walsh, Wight, their attorneys, or the attorneys for the Getty—could show him that documentation. Instead, Muntoni became dismayed at how Larry Fleischman had simply bought up what he could, regardless of its legal status, and how the Getty had later rushed to acquire the collection, ignoring its own policy about checking into the origins of the objects. Muntoni found it incredible that the Getty would accept such important antiquities without verifying their provenance. And with Ferri's subsequent discovery of the apparently backdated invoice, Muntoni's attitude toward the museum and True hardened. Over two days, he

pushed the curator with questions reflecting his thorough knowledge of the case, the facts of which he appeared to have memorized.

In particular, Muntoni homed in on one transaction that Ferri had covered only in passing. It concerned the fragments of three proto-Corinthian pitchers that True had written to Medici about in 1992. The middleman had revealed in his letter to True that they had come from a tomb in Cerveteri. Medici had gone on to describe in detail the style of the tomb and other objects found in it. Clearly, he had been there when it had been illegally excavated, or he had been told about it in detail by the looters.

"When you received the communication from Medici that these objects were sold by him and were excavated from Cerveteri, why didn't you inform Italian authorities?" Muntoni asked True. "What else did you need to know that they were looted and illegally exported from Italy?"

True looked as if Muntoni had pricked her with a pin.

"Probably nothing," she said.

As the curator stepped away from the stand, Muntoni gave her a sympathetic smile.

"I'm sorry," he said softly.

On April Fools' Day 2005, Muntoni indicted True for trafficking in looted antiquities and ordered her to stand trial in Rome. She was the first American curator to be criminally charged by a foreign government.

THE NEWS PROMPTED amazement and anger within the Getty, but the secrecy surrounding the investigation kept word from leaking out for weeks. American newspapers, unaware of the agonizing back-and-forth with the Italians or the preliminary hearing, picked up the story late. The *Los Angeles Times* ran a front-page article about True's indictment nearly two months after Muntoni handed down his decision. Public reaction was muted, even puzzled, seeing as the matter involved arcane legal arguments in a faraway courtroom. Getty officials called the indictment a mistake, predicted that True would be exoner-

ated, and reaffirmed that the museum had never knowingly bought looted art.

Within the art community, the indictment provoked an odd sense of cognitive dissonance. True was widely known (and often quietly criticized) as the country's most outspoken proponent of reform, an ally of Italy in its quest to end the illicit trade. No one had done more to end the practices she was now being accused of engaging in. More than two dozen of her colleagues at Los Angeles area museums signed an open letter lambasting the charges as politically motivated and calling on Munitz to spare no effort in defending the Getty curator. Marion True didn't lack supporters as she braced for an unprecedented legal fight.

20

LIFESTYLES OF
THE RICH AND FAMOUS

A FTER DEBBIE GRIBBON abruptly resigned her post, a team of reporters at the *Los Angeles Times* began investigating the troubles at the Getty. In December 2004, a series of investigative stories detailing Munitz's misuse of Getty resources began hitting the front page. With $1.2 million in total compensation, he was one of the highest-paid nonprofit executives in the country and had demonstrated his "grand appetite" for lavish perks—even as he imposed budgetary austerity on the rest of the trust. A June 2005 story detailed Munitz's use of Getty staff for personal errands, his purchase of the Porsche Cayenne amid layoffs, the Getty grants he steered to friends, his first-class flights around the world with his wife on what appeared to be thinly disguised vacations—expenditures that seemed to violate IRS rules against self-dealing.

For those inside the Getty, the series displayed an alarming level of access to the Getty's confidential records, including transcripts of Munitz's dictation pool and years of expense records from the CEO's office. More than once during the back-and-forth with reporters, the Getty denied something, only to be confronted with follow-up questions citing specific details about the transaction. At one point, Munitz's top staffers made a list of the most damaging things the report-

ers could find. Over the course of the next year, the reporters asked about almost all of them.

Publicly, Munitz dismissed the stories, saying the complaints about his behavior came from a few disgruntled employees angry over the necessary institutional changes he had made. John Biggs, the board chairman, defended the CEO and his spending. But the June story drew a notably tart remark from U.S. senator Chuck Grassley, the Republican from Iowa who chaired the Senate Finance Committee and was moving legislation to overhaul laws governing tax-exempt organizations for the first time in thirty years. "Charities shouldn't be funding their executives' gold-plated lifestyles," Grassley said in the June 23 issue of the *Los Angeles Times*. "I'm concerned that the Getty board has been spending more time watching old episodes of 'Life-styles of the Rich and Famous' than doing its job of protecting Getty's assets for charitable purposes."

The comment caught the eye of attorney Ronald Olson, a tightly wound, square-jawed litigator. Olson was a partner in and principal rainmaker for Munger, Tolles & Olson (MTO), a boutique Los Angeles law firm brimming with former federal prosecutors and attorneys who had clerked for the U.S. Supreme Court.

He had become one of the most powerful lawyers in California by riding to the rescue in some of the most controversial corporate cases in recent history. He had helped Merrill Lynch atone for its role in Orange County's 1994 bankruptcy—the largest municipal failure in U.S. history—with only the glancing blow of a $400 million set-tlement. And he had brokered an agreement that allowed Salomon Brothers to avoid criminal charges by paying a $290 million civil pen-alty for its 1990 bond fraud scandal.

Now that the Getty was beginning to bleed in public, Olson paid special attention, and not just because of the trust's deep pockets. The Getty board had recently tried to recruit him, and he and his wife were close friends with vice chair Louise Bryson and her husband, John, CEO of Edison International, where Olson was on the board. Olson saw trouble coming for his friend. Grassley was known for his

public investigations of errant nonprofits, and after landing a blow on Munitz, it was unlikely the *Los Angeles Times* would stop digging. Olson placed an urgent call to Louise Bryson. "You're in trouble here," he told her.

As Grassley had hinted, it was the board that was ultimately responsible for Munitz's behavior. As if to underscore the point, the California attorney general opened an investigation into whether the Getty board and high-ranking trust officials had allowed the misuse of the Getty's nonprofit assets. The attorney general's list of concerns was cribbed directly from the *Los Angeles Times* reports. Bryson got on the phone to senior Getty staffers. We have to get serious about this, she said, recommending that they hire Olson's firm for protection.

While the Getty mulled the decision over, the newspaper launched a second salvo of front-page stories, this time revealing True's legal woes and the Getty's long struggle with the issue of looted antiquities. A September 2, 2005, article quoted from the January 2001 memo written by Richard Martin, the Getty's outside counsel, to Munitz, noting that it would take "very little" to link True to the smuggling network and advising the Getty to withhold damaging documents from Italian authorities. When called for comment, Martin attempted to get a temporary restraining order against the paper to prevent the publication of the story, but it was posted on the newspaper's Web site before he could do so.

A second story later that month went deeper, citing "thousands of internal Getty documents"—including many of the "troubling" documents withheld from Italy—and tracing the Getty's purchase of suspect antiquities. The article detailed how Frel, Houghton, True, Gribbon, Walsh, and Williams had continued to buy such antiquities over twenty years despite concerns about the legality of their actions. It recounted Walsh and Williams's discussion just before the Aphrodite acquisition and quoted Williams as saying, "We know it's stolen, Symes a fence." On its Web site, the *Times* posted a copy of Houghton's 1985 "smoking-gun" memo to Gribbon, which showed that he had learned from Medici that the Getty's recent acquisitions had been

looted. For the first time, it was clear to the public that the Getty's problem with illicit antiquities had neither started nor ended with Marion True.

The *Times* articles punctured decades of flat denials by Getty officials that they had never knowingly purchased looted art. An October 2005 *Times* editorial headlined "Just Say No to Plunder" accused the Getty of not living up to its ideals and called on the trust to swear off buying any antiquity that came to the market after the 1970 UNESCO Convention. Trust officials accused the newspaper of reporting on "privileged documents that have been stolen from the Getty," then hired a crisis management firm and hunkered down behind a series of "no comments." But the *Los Angeles Times* was not done. Reporters had caught wind of True's $400,000 loan from antiquities dealer Christo Michaelides to buy her Greek vacation home. Now they were asking why the Getty hadn't done anything when officials were alerted to the loan three years earlier.

Munitz called True into his office. Hadn't Erichsen and Gribbon questioned her about the loan already? True said that Gribbon had asked only whether she had received "a loan from Robin Symes." She had accurately answered no, she said, and Gribbon had let the matter drop. "Anyway," she added, "some friends gave me the money to repay the loan. And I'm paying interest on it. That's all you need to know."

"Who are these friends?"

True refused to answer, despite Munitz's insistence.

The Getty stalled for time with the newspaper. It wasn't until the following weekend that Munitz learned the identity of True's mysterious benefactors. Racing home to change clothes before a business dinner, he checked his answering machine and found a message from Barbara Fleischman. "No matter how late it is, call me," she implored. Munitz dialed her number immediately.

"I'm only calling because I thought it's important for you to know something," Fleischman told him. "I understand you've been pressing

Marion True about this loan. You need to know that Larry and I were the ones who made it."

Munitz was floored. "Don't say another word," he blurted. "Here's Peter Erichsen's number. Call him."

Even to the ethically challenged Munitz, the conflict was clear: True, the paragon of curatorial virtue, had taken not one but two personal loans from people who had sold tens of millions of dollars' worth of antiquities to the Getty on her recommendation. Worse, True and Fleischman, now a board member, had apparently conspired to keep the deal secret. Munitz and Erichsen alerted John Biggs at his office in New York. By that time, Biggs had already concluded that it would be necessary to hire Olson's firm.

IN LATE SEPTEMBER 2005, a team of MTO attorneys began digging through Getty documents, trying to get ahead of the *Los Angeles Times*. Olson was adamant the Getty had to fire its popular antiquities curator. "I don't know why you're not just biting the bullet," he angrily told Biggs and Munitz. The Getty chairman polled the other trustees. True had to go. Her answer to Gribbon about the first loan had been an evasion, and she had failed to disclose the second loan from Fleischman on the Getty's conflict-of-interest form.

Munitz never questioned the decision and volunteered to have Erichsen fire the curator via letter. Biggs was shocked. "You can't do that," he told the CEO over the phone. "I'll talk to her." Biggs flew in from New York for a meeting with Munitz, True, and Harry Stang, the Los Angeles attorney the Getty had arranged to represent True after she was indicted.

The curator appeared in Munitz's office teary and upset. The loan had been Larry Fleischman's idea, she said, and she had agreed to take it. But there was no relationship between it and the acquisition of the Fleischman collection, which had been completed just two days earlier. True said that it was Barbara who had counseled her not to dis-

close the loan. Fleischman said that she had called her own attorney and he had concluded that disclosure wasn't necessary.

"Marion, it's time to give us your resignation," Biggs said, adding that the Getty would continue to pay for her defense against the Italian charges. Technically, True could be asked to repay the attorneys' fees if she was convicted, but that was not likely to happen, Biggs said. She would not get the sizable bonus she had been promised for completing the Getty Villa, but she could keep her pension.

The deed done, Biggs walked out with the remorseful curator. She turned to him and said, "I know I made a big mistake."

The Getty announced True's "retirement" late Saturday, October 1, just before the *Times* published a story exposing her first loan from Michaelides. The press release was carefully timed to allow the Getty to take credit for the discovery and made no mention of the second loan or the Fleischmans: "The Getty has determined through its own investigation that Marion True failed to report certain aspects of her Greek house purchase transaction in violation of Getty policy. In the course of the Getty's discussions with Ms. True on this matter, she chose voluntarily to retire."

The story in the *Times* reported that Getty officials had known about the first loan since 2002 and done nothing. There was no mention of how True had repaid the loan, something the reporters were only beginning to learn.

Days after the article appeared, True put her condo up for sale at $949,000. She told her friends that she was leaving for Paris, where her husband had a home, and never coming back.

True's "retirement" stripped the Getty of any claim to the moral high ground, either in its public relations fight with the *Times* or its legal struggle with the Italians. Stunned at the degree of True's ethical breach, the chorus of Los Angeles museum and cultural leaders who had vocally defended the curator fell silent. Many now quietly questioned whether they had ever really known her. Some felt personally betrayed.

Within the Getty, True's departure and the hiring of MTO was like a cattle prod, shocking the institution into action. A day after True's resignation hit the papers, the museum announced that it had struck a deal with Italian authorities to return three contested antiquities. The most important was a 2,300-year-old vase painted by the Greek artist Asteas, one of the six pieces General Conforti had asked the Getty to return years earlier. The other two were a Greek epigraph, donated to the museum in the 1980s, and a bronze Etruscan candelabrum, the companion piece of the tripod True had seen in Medici's warehouse and given back to Italy ten years before. For the first time, the Getty struck a conciliatory chord, saying that it was giving the objects back "in the interests of settling the litigation and demonstrating the non-profit's interest in a productive relationship with Italy."

Desperate to find a win on the antiquities front, Getty officials tried to use the Aphrodite as leverage. Months earlier, the Getty had been quietly approached by Flavia Zisa, an emissary from the Sicilian Ministry of Culture. Zisa, a former Getty intern and occasional consultant to the museum's antiquities department, was now a professor of archaeology in Sicily and adviser to cultural officials there. She suggested that the Getty could get around its impasse with Rome and reclaim the high ground through a wrinkle in the Italian constitution that gave Sicily autonomous control over its own cultural exports. Zisa said this meant that Sicily also could strike its own cultural agreements. Would the Getty consider making a deal with Sicily concerning the Aphrodite?

The offer intrigued Munitz. He had no personal investment in the controversial piece, and as a student of literature, he had come to appreciate the metaphoric significance of the goddess. The Aphrodite was a totem, a symbol of who was right in the struggle between the Old World and the New World over antiquities. To Munitz, the Sicilian proposal represented another chance for redemption. He set up a meeting with Sicilian culture minister Alessandro Pagano in New York in December.

After the men exchanged formalities, Pagano wasted no time putting his offer on the table. "We're rich in culture. The Getty's rich in resources," he said. "Let's work together. The Aphrodite is the excuse to do so." Specifically, if the museum agreed to give the statue back to Sicily, the Sicilians would "retire" from True's criminal trial, in which they were named as a damaged party. Pagano also wanted the Getty's help with the conservation and marketing of Sicily's cultural heritage, which attracted few visitors. "Sicily is maybe the richest land" in artifacts, he said, "but there are museums that don't earn one Euro."

Pagano told Munitz that the Getty would not have to return the Aphrodite to Sicily. It would only have to turn over formal legal title to the statue. "Maybe you could send it back in one hundred years," Pagano joked.

Weeks later, Munitz sent a note to Pagano saying that the Getty was evaluating his "very intriguing ideas." But the talks grew cold. Erichsen and others feared that the Sicilians didn't have full authority to make the deal—Italian law wasn't clear on this point—and MTO had yet to study the legal case regarding the statue.

And by then, Munitz was doomed.

On October 30, 2005, John Biggs had announced the formation of a special board committee to oversee an internal investigation into Munitz's spending, as well as the Getty's acquisition of Greek and Roman antiquities. MTO would conduct the inquiry. Biggs stressed that the investigation was independent of Getty management and would go wherever the facts led. The signal was clear: the Getty board was backing away from its troubled CEO.

Olson personally took the lead in setting a new tone with the press. MTO would get to the bottom of things and make the results public, he promised. The days of stonewalling were over. Shedding some sunshine on the Getty would go a long way toward restoring its integrity.

MTO's first task was to investigate the Getty's "governance problems." The lawyers immediately began chewing up billable hours re-

searching Munitz's expense accounts and the legal exposure of the Getty board. They commandeered a windowless room a few floors below the CEO's office suite in the Getty administration building. It became known as the "Batcave," as it buzzed with lawyers and support staff carting in dozens of boxes filled with internal documents.

The lawyers identified thirty Getty computers, including those belonging to Munitz's staff and secretarial pool, that contained the most crucial information. With Biggs's approval, on a Saturday morning a security guard unlocked the door to Munitz's offices and allowed technicians to copy ten of his staff's hard drives. The data allowed the team to crosscheck the 230 trips Munitz had taken between January 1998 and July 2005, his use of grants and Getty staff, and the cache of transcribed voice-mail messages that detailed Munitz's every thought.

The team then fanned out to interview seventy-five people, sometimes about delicate matters. One of them was Nana Zhvitiashvili, a married curator from the State Russian Museum in St. Petersburg, with whom Munitz had nurtured an unusually close relationship. After the two met at a 2001 Salzburg Global Seminar, he steered a $200,000 grant to her museum and arranged to take her to a concert, a movie, and the Tate Modern in London, where she was putting together an exhibit. Munitz even offered to clear his schedule and act as her escort or otherwise "provide sustenance and comfort" during her time in London, even at 4 A.M., if she'd like.

Although the "chronicles of Nana" raised eyebrows, more problematic were Munitz's dealings with a twentysomething German intern named Iris Mickein. After the CEO addressed a group of interns about museum careers, Mickein made an appointment to discuss hers directly with Munitz. The intern showed up in a miniskirt and boots, which drew suspicious stares from secretaries and Munitz's top aide, Jill Murphy. The meeting sparked a keen interest in Mickein on the part of the CEO. After failing to secure her a one-year job with his friend billionaire art collector Eli Broad, Munitz put her on the Getty's payroll as "senior adviser to the president." He later arranged for a Getty-sponsored job for her at MoMA, facilitated by a $5,000 Getty

expenditure to fix her visa problems. When Mickein was through at MoMA, Munitz flew her around the country for tours of graduate programs and personal job counseling by friends such as Dallas art collector Raymond Nasher and Seattle Art Museum director Mimi Gates.

Even among friends inured to Munitz's manic mentoring of young women, the Mickein episode was excessive. For Murphy and his other senior staff, it was one of several surprises they'd discovered since fielding the initial questions from *Los Angeles Times* reporters. They realized that their charming, generous, effusive boss had been telling each of them different stories, dividing and conquering with the selective distribution of information.

The final break in faith came when Munitz learned that the *Times* was gearing up for a profile of Murphy. He decided it was time to cut her loose. "You need to be out by the fall," he told her. "You need to tell the paper you're leaving."

"I want two years of pay," she replied. "And I'm not saying anything publicly until we sign a deal."

Munitz agreed and asked his staff to draw up the paperwork, ignoring an order that he seek board approval before making any more contentious decisions. When Biggs confronted him about it, Munitz denied any knowledge of the deal. The lie fell apart when the human resources department confirmed that Munitz was behind the negotiations. Since Munitz technically had the authority to offer the deal, the board was forced to approve it. But the episode destroyed Munitz's last shred of credibility and goodwill with Biggs and turned his staff, particularly Murphy, against him.

The timing was lousy. At the request of MTO, Murphy sat down the Monday before Thanksgiving to answer questions about her boss. The session lasted five hours. They also met the next day, and the next. As Munitz's trusty protégée, Murphy had spent years "interpreting Barry" to those around him. She was exactly what the lawyers needed to pick through all the documents they had gathered.

After three days of grilling, they had one final question for Mur-

phy. When she formally left the Getty, would she consider becoming a paid consultant to their investigation?

She thought about it over Thanksgiving. Her last day on the Getty payroll was in January 2006. The very next day, she began working as a consultant for MTO.

WITH THE ITALIAN investigation and the revelation of a loan to True, Barbara Fleischman, the Getty's most generous living donor, faced her own reckoning. MTO began exploring how to remove her from the board. But Fleischman wasn't about to go quietly.

During a closed session with her board colleagues on November 10, 2005, she asked the attorneys to leave the room, prompting a murmur of protest before Munitz agreed to go along with her. When the door was closed, Fleischman stood up, clutching a prepared seven-page statement, and started to read.

She began by saying that her collecting practices and loan to True had been portrayed in a "distorted, untrue and malicious" manner. She then reviewed the events that had led up to the museum's acquisition of the Fleischman collection in 1996, which had been accomplished "in no small part because of the work of Marion True." After lavishing praise on the curator, Fleischman said that she had been delighted that her late husband had given True an "arm's-length commercial loan" at a prevailing interest rate to refinance her Páros house. "I thought it was a lovely and helpful gesture," she said, bristling at intimations by Erichsen and others within the Getty that it was a payoff. "It was neither hidden nor camouflaged because, quite simply, he was assisting a young friend in a straightforward and open manner." If True showed a lapse in judgment by not disclosing the loan, she continued, then the Getty staff was guilty of a "myriad of bad judgments" for bungling the response to the Italian investigation.

When Richard Martin wrote his now infamous 2001 memo about troubling documents in the Getty's files, Fleischman continued, why hadn't anyone immediately gotten to the bottom of it by meeting with Harold Williams, Arthur Houghton, John Walsh, or Debbie Grib-

bon? Why had Munitz dodged responsibility for the investigation, leaving the matter to Gribbon, Erichsen, and Murphy, all of whom had no experience in such matters and continued to make things worse? Why had Gribbon sat on her hands when Fleischman urged her to rally the support of the American museum establishment to fight back? And why had well-connected board members refused her call to seek a diplomatic solution by using their business and personal connections? The result of the Getty's serial bungling, she said, was to let the loyal Marion True take the fall for Walsh and the trust itself.

Fleischman then went on to contrast that treatment with the $3 million Gribbon had received upon her departure from the museum, even though her performance had not been "held in high esteem." Gribbon had committed a "serious breach of ethical behavior" — an apparent reference to her affair with former drawings curator George Goldner and the costly legal settlements with Goldner's successor, Nicholas Turner, to avoid an embarrassing trial. "Despite her disloyal behavior toward the Trust and ultimate treachery, what was her punishment? A golden parachute."

Now visibly angry and shaking, Fleischman said that she could understand Paolo Ferri's "despicable" political motivation in pursuing the illicit antiquities case, even the "contemptible" agenda of the *Los Angeles Times* reporters. But what she simply could not fathom was "the malice, the attempt to bend the truth and the injustice within the Trust itself."

She continued, "As trustees, we are only beginning to feel the depth of outrage and contempt throughout the world for the Getty's administration and governance in these matters. As a member of this board, I am deeply saddened to witness the dimming luster of a great institution."

Fleischman concluded with a bitter final swipe. "I must express that I now regret that Larry and I ever made the donation to the Getty Trust," she said, and took her seat.

21

TRUE BELIEVERS

A T 10 A.M. ON January 28, 2006, Barry Munitz flung open the doors of the newly renovated Getty Villa and allowed in the first visitors in eight years. "You're here at a very important moment," he said in an uninspired inaugural speech, looking awkwardly casual in a Getty baseball cap and varsity jacket.

It should have been a shining moment for the Getty. But Munitz and other Getty officials had all the gaiety of pallbearers. A global debate over cultural patrimony now focused on this sixty-four-acre plot of land off the Pacific Coast Highway. Staff were tired and beaten down by the year of turmoil and scandal that had dogged the institution. Rather than a celebration, the Getty Villa's public debut had become a cruel reminder of just how far the world's richest art institution had fallen.

Barbara Fleischman—whose name was memorialized in stone above the villa's new amphitheater—had resigned from the board just three days earlier. Munitz was clinging to his position amid the various investigations into his spending. The entire institution was rudderless.

Worse, the Getty's problems were spreading. Munitz's financial foibles had thrown a harsh spotlight on spending by nonprofit foun-

dations across the country, attracting the attention of the Senate Finance Committee. And foreign authorities were beginning to ask about the antiquities collections of museums and private collectors in New York, Chicago, Boston, Cleveland, Minneapolis, Toledo, Princeton, Richmond, and St. Louis. The Getty had always wanted to be the world's best-known museum. Now, in ways it had never imagined, it was getting its wish.

The visitors who thronged to the villa on the unusually cool morning seemed only vaguely aware of the Getty's internal strife. They were awestruck by the magnificently restored building they entered. J. Paul Getty's original museum had been transformed by the $275 million renovation, which cost more than fifteen times what the original structure had. The museum's awkward entrance—into an underground parking garage and then into the lobby via elevators—had been entirely reconceived. Visitors arriving from the Pacific Coast Highway now steered their vehicles up a lushly planted driveway of broad Roman flagstones and entered a new parking complex carved out of the canyon wall. There they donned laurel wreaths made of foam and approached the villa on foot, like Roman pilgrims, walking up a series of staircases that zigzagged up a massive outdoor façade of alternating layers of building materials—wood, stone, and cement. The idea was to give visitors the feeling of walking back in time, through the strata of an archaeological dig, to discover a site seemingly excavated from the hillside. Indeed, this was the defining metaphor of the entire redesign. The villa's architects used the horizontal layering motif as a recurring theme, one that underscored the Getty's professed respect for the world's ancient art and the villa's position as the only museum in the nation dedicated solely to classical antiquities.

At the top of the stairs, patrons found themselves standing on the rim of the new open-air Greek amphitheater. Of all the additions, the amphitheater was the most dramatic and the most difficult to complete. The Getty's lawyers had battled neighbors all the way up to the California Supreme Court for the right to build it. Once it was ap-

proved, work crews had to carve tons of dirt from the canyon wall to make room for the performance space dedicated to Lawrence and Barbara Fleischman.

The bowl of the Fleischman Theater emptied into a plaza leading to the villa itself, a re-creation of a first-century Roman country house painted in shades of ocher and red. Getty's original museum had never looked more beautiful. The columns of its gardens stood like soldiers dressed smartly in new coats, with a cream-over-cardinal color scheme. In contrast to the clinical white of the Getty Center, the villa's vibrant colors carried through the interior, forming a rich backdrop for the black Greek pottery and alabaster statuary positioned against the walls.

Then there was the light. The old villa had been dark and stuffy, with heavy drapes hung over the second-floor windows to keep the California sunshine from fading J. Paul Getty's collection of French furniture and paintings. Now, with the furniture and paintings moved to the Getty Center, the drapes removed, and new skylights punched through the roof, the marble statues in the upper galleries were bathed in natural light, just as they had been in ancient times.

All these touches reflected the impeccable taste of Marion True. Since the Getty had tightened its acquisition policy in 1995, she had spent much of her time conceiving of this transformation. It was True who had championed the idea of archaeological tribute, had fought for the theater, had chosen the colors, had unleashed the light. It was True who had met with prickly neighbors in their living rooms and represented the Getty at public hearings about the restoration. It was True who had insisted on redoing the entrance to a more historically accurate one, a change that had added substantially to the project's costs.

True also had conceived of the villa's unusual approach to displaying its ancient art. Instead of lumping the artifacts together by time period or culture, she assigned them to thematic rooms. Dominating the gods and goddesses room was the Aphrodite, her fingerless right arm extended as if pointing to her worshipers. Across the way in the

Trojan War room, a large glass case displayed the marble basin acquired from Maurice Tempelsman, adorned with the mythical scene of three sea nymphs carrying the weapons of Achilles. On the second floor, True had cleverly positioned things so that as the elevators opened, patrons were greeted by the riveting scene of the Getty's marble griffins tearing into the flesh of a hapless doe. Down the hall was the kouros, prominently displayed but with an awkward acknowledgment about its questionable authenticity. The golden funerary wreath was hung amid an array of other ancient jewelry. In the theater room were dozens of pieces from the Fleischman collection. And in the ultimate place of honor, the Getty Bronze occupied its own humidity-controlled room with a guard at the door.

True's hard work had paid off. But, as has always been the case at the Getty, visitors were more taken with the spectacle of the building than the antiquities True had risked her career and reputation to acquire. Since J. Paul Getty's death in 1976, the antiquities collection had quadrupled to more than 44,000 objects and now ranked among the best and biggest in the world. Much of it consisted of the study collection, accumulated for scholarly study by way of Jiri Frel's decadelong tax scheme. But among the few thousand antiquities worthy of display were pieces whose equivalents could be found in no other museum in the world. Indeed, three-quarters of the objects now on display had been acquired under True's direction. Most visitors were keenly aware that the woman of the day was absent, facing criminal charges in Rome, and that Italy was demanding the return of dozens of the celebrated items as stolen property.

Oddly, there was no public acknowledgment of those troubling facts. A video featuring True welcomed visitors, and True's high-pitched voice narrated much of the audio guide. The curator's staff, who had worked toward this day for more than a decade, wore T-shirts bearing a Latin motto inspired by Julius Caesar's famous boast "Veni, vidi, vici"—I came, I saw, I conquered. The Getty version was "Venimus, vidimus, retranstulimus"—We came, we saw, we moved back. In the current situation, it was unclear whether the reference

was to the Getty reoccupying its original home or to the fact that many of the objects on display would soon be returning to their countries of origin.

At what should have been the high point of her career, True had vanished. The bitter irony was not lost on her staff, many of whom silently honored her contribution with lapel pins that read TRUE BE-LIEVER.

ANOTHER PROMINENT GETTY official conspicuously absent from the Getty Villa reopening was the museum's new director, Michael Brand, an up-and-coming Australian whom Munitz had hired away from the Virginia Museum of Fine Arts. Now, just days after starting his job, Brand was on a plane to Rome. His mission: to kick-start negotiations with the Italians over their demands for many of the most glorious artifacts featured at the villa. Brand had seized on an invitation by Italian minister of culture Rocco Buttiglione to explore "new avenues" to break the deadlock.

Since Debbie Gribbon's disastrous trip to Rome in 2002, talks with the Culture Ministry had gone nowhere, leaving the Getty and its antiquities curator to struggle against Paolo Ferri in the crocodile jaws of the Italian criminal justice system. Brand concluded that the Getty had become too legalistic in its negotiations. This approach, focusing on technicalities and loopholes at the expense of the larger message, infuriated the Italians. Source countries were tired of being ripped off and belittled by museums in rich collecting countries that eagerly snapped up the fruits of illicit digs while deriding foreign officials as being stooges or corrupt. They wanted respect and control over their own cultural narratives, Brand saw. The fight over antiquities had become the perfect proxy war.

Before arriving at the Getty, Brand had had little or no experience with ancient Greek and Roman art. He had come to appreciate how looting devastated native artworks through his studies of Southeast Asian and Indian art. As director of Asian art at the National Museum of Australia, Brand had mounted a 1992 exhibit on the treasures of

Angkor Wat, the twelfth-century Khmer temple complex in Cambodia that had been ravaged by plunder. Yet this introduction had done little to prepare him for what was awaiting him at the Getty. The Greeks and Italians were hopping mad, and the Getty seemed to be doing its best to egg them on.

Brand got a glimpse of this during a get-acquainted trip to Brentwood shortly before he was to take over as museum director. His meetings included a background briefing about the antiquities problem from Peter Erichsen. As the Getty general counsel went down the list of suspect artifacts and foreign claims against them, Brand shuffled through a pile of background documents, then stopped.

He was looking at a letter dated November 14, 2005, from Lazaros Kolonas, the Greek director general of antiquities and cultural heritage. The Greek official wanted to know why no one at the Getty had responded to a letter sent six months earlier demanding the return of the funerary wreath and three other objects, including a marble relief purchased by J. Paul Getty himself in 1955. As Brand looked through the file, it was clear to him that as far back as the mid-1990s, the Greeks had furnished evidence suggesting that the pieces had been looted. The last they had heard from anyone at the Getty was in 1998, when True had promised to forward the request to museum lawyers. Since then, nothing—not a peep.

Whoa, thought Brand. Not even a courtesy reply to the Greek director of antiquities? No wonder he thinks we're stonewalling.

By the time Brand sent off a reply in December 2005 suggesting that he and Kolonas speak face-to-face after the New Year, rapprochement was even more remote. Between Kolonas's letter and Brand's reply, the *Los Angeles Times* and Nikolas Zirganos, a crack investigative reporter at the Athens newspaper *Eleftherotypia*, had written several stories about the funerary wreath and Greece's failed diplomatic attempts to secure its return. Greek cultural officials looked hapless compared to their Italian counterparts. Thoroughly embarrassed, the

Greeks had now abandoned their diplomacy and opened their own criminal investigation of the museum and its former curator.

In a late December reply to Brand, Kolonas claimed that Greece had been "deceived" by the Getty's smooth talk about protecting cultural heritage. "Indeed, Mr. Brand, what evidence do you have in order to persuade us that the Greek antiquities which we claim for years now, as well as dozens of others which presumably are kept in storerooms of the Getty Museum, are not products of clandestine activity in Greece?"

With two foreign courts now gearing up to take on the Getty, Brand decided that something had to change—something fundamental. And perhaps he was the perfect person to make that change. Unburdened by the sins of the Getty's past, the new museum director wanted to reopen the diplomatic and academic channels with foreign officials—to engage them as cultural colleagues, not courtroom foes.

His trip to Rome on the eve of the Getty Villa opening was the first test.

As THE WINDS whipped Rome on a cold, wet day in early January, Brand entered the Ministry of Culture building from a side entrance to avoid a clutch of reporters lying in wait at the front door. He was accompanied by a small contingent of Getty representatives, including Luis Li, an MTO partner assigned to look into the antiquities claims.

While Brand was there to set a new tone, Li was on hand to gather information. A former assistant U.S. attorney, Li had cut his teeth on prosecuting racketeering rings and white supremacists. Now the lead attorney for the firm's delicate antiquities probe, Li played the conciliator, with an easy smile and breezy, loquacious style. His team—which included several associates, paralegals, and Getty curators—had carefully vetted each of the objects being demanded by the Italians and Greeks—examining museum files, translating Italian court records, and interviewing Getty experts, including Marion True,

over two days in Rome. Li's task was to present to Getty trustees the most definitive report on the legal status of the objects and, once a decision had been made about what to return, help craft a deal.

Italy's Culture Ministry is housed in the old Collegio Romano, a sixteenth-century university where the Jesuit order was founded. Brand, Li, and the rest of the Getty team were ushered into the ministry's conference room—a large, two-story, dark-wood-paneled library with fluted wooden columns and a long, highly polished conference table in the middle. Waiting for the visitors was an array of Italian officials, many of whom had long memories of the Getty's missteps. Leading the group was Maurizio Fiorilli, a bespectacled senior government attorney with small blue eyes and the frazzled air of a mad genius. Even among the more demonstrative Italians, Fiorilli was known for launching into rambling, circuitous speeches and Chaplinesque pratfalls. But for all the snickering behind his back, Fiorilli commanded respect for his tireless defense of Italian cultural property.

True to his character, Fiorilli began the meeting with a long discourse on the criminal case, hinting at new indictments and expressing contempt for the Getty's fallen curator. "Marion True! The character of this woman!" he scoffed. Brand brushed aside the prosecutorial thrust, assuring his hosts that the Getty took Italy's patrimony claims seriously—seriously enough for him to miss the opening of the villa to attend this meeting. A cultural official then delivered a stone-faced soliloquy that portrayed the Getty as a rogue institution that had gorged on the fruits of looting ancient sites. The head of the Carabinieri art squad was deferential but made it clear that Italy still wanted the Getty Bronze.

Li pushed back gently, saying that his law firm had been hired to conduct an independent investigation of the patrimony claims. He was in Rome to get evidence from the Italians to further that investigation. After a break for lunch at La Fortuna, a favorite haunt of politicians and businessmen across from the Pantheon, the session ended with no new information exchanged. Brand and Li were then de-

livered to the culture minister himself, Buttiglione. A conservative Catholic whose campaign for European Union commissioner had been derailed by his opposition to abortion, Buttiglione was soft-spoken but equally self-righteous about the objects in question. As he puffed on a cigar, he sprinkled his comments with words such as "looted," "illegal," and "stolen," which set the jaws of the Getty's attorneys.

The Italians left their visitors to twist over the weekend before delivering any particulars. By then, Brand had departed, leaving Li in charge. On Monday, January 30, the Italians presented a three-hour, often chaotic slide show in a marble lecture hall, going over their evidence on each of the contested objects, which now numbered fifty-two. As the slide show continued into the next day, the Getty's lawyers saw scores of Polaroids seized from Giacomo Medici's warehouse. The images were clearly significant, some downright devastating. One showed the Getty's Apollo, now occupying the portico of the villa's basilica room, lying broken on a wooden packing crate, apparently fresh out of the ground. Getty vases were shown standing on someone's rug or kitchen table, or propped up against flocked wallpaper, presumably in a looter's house. For the first time, Getty representatives saw the Etruscan roof ornament that graced the cover of the Fleischman collection catalogue—broken, dirty, standing on a discarded pipe in some refuse yard, against the background of a broken chainlink fence. The worst pictures were of the griffins, lying dirty and broken on a crumpled Italian newspaper in the trunk of a car.

Besides the visceral impact of the photos, Li immediately recognized their legal import. He was impressed with archaeologist Daniela Rizzo, who made her presentation in measured, academic tones. "See that hole there?" she said, stopping at one slide of a piece of pottery now on display at the Getty Villa. "That was likely caused by a *spillo*," one of the iron rods looters used to probe for ancient tombs.

Li convinced the Italians to give him a CD containing their dossier on the objects, his major objective for the trip. But the Italians weren't done. As the second day wound down, Giuseppe Proietti, of

the Culture Ministry, insisted on issuing a joint press release saying that the ministry had presented "overwhelming evidence" that the Getty pieces were looted and that the museum was contrite.

"Signore Proietti, we're building a relationship here," Li pleaded.

"No," Proietti snapped, "we have to reach an agreement."

"Even in Italy you don't get married on the first date," Li replied.

Everyone laughed. They agreed to release a noncommittal statement calling the discussions "frank and productive."

It was going to be a rocky romance.

A WEEK LATER, the board of trustees gathered at the Getty Center over the weekend to hear MTO's report on Munitz. The report went into painstaking detail about Munitz's personal use of Getty funds. Even many of his allies on the board had been angered by his recent behavior, including his promise to give Jill Murphy a generous severance package without having secured the board's prior approval. By 9 P.M. Sunday, it was clear that those who wanted Munitz gone had the votes. The board felt that it had uncovered enough evidence against Munitz that he could be convinced to forgo the generous severance deal he'd lobbied for over the past eight years. The trustees voted to give Munitz until Thursday to decide his own fate: quit or be fired.

In the end, the ax fell before that deadline arrived. As he had with True, Biggs felt it was his duty to deliver the message in person. This time, the board chair summoned the CEO to his room in a modest hotel near the Getty Center. The Getty had started booking trustees there as a public relations precaution since the Munitz spending scandal had hit.

Waiting with Biggs was fellow trustee Jay Wintrob, CEO of AIG Retirement Services and one of Munitz's most ardent supporters. Wintrob had stood by Munitz as the *Los Angeles Times* stories had pounded away, but he had changed his mind about the CEO after reading the MTO report. When Munitz showed up, the three sat in Biggs's hotel room as the chairman went over MTO's findings.

"Barry, the board has voted unanimously to get your resignation," Biggs said at the end.

Munitz was visibly upset. Wintrob nudged him and said, "Barry, the report was such that they didn't feel they had any choice."

Finally, Munitz agreed to resign. The conversation wasn't long. Munitz knew it was fruitless to hang on any longer. After the meeting, he and his attorneys negotiated the terms of his departure from the Getty, promising to return $250,000 for any inappropriate expenses and waiving more than $2 million in severance pay guaranteed by his contract. In exchange, the Getty would not hold him responsible for any legal liability the trust faced in the California attorney general's investigation.

THE GETTY WAS not the only American museum making the pilgrimage to Rome. Met director Philippe de Montebello had long warned the Getty against capitulating to the "nationalistic" demands of Italy. But now, quietly, de Montebello had begun mounting his own rear-guard action to protect his museum from a similar fate.

Everything had begun to take its toll on de Montebello—shifting public opinion; the increasingly stern legal advice from the Met's general counsel; Ferri's growing interest in the museum and its former antiquities curator Dietrich von Bothmer. The final straw came from the *Los Angeles Times*, which in the fall of 2005 broke the news that the Italians had found confirmation of the illicit origins of the museum's famed Euphronios krater: Robert Hecht's handwritten memoir. It contained an account of how he had purchased the vase not from a Lebanese collector—the Met's thirty-year cover story—but from Giacomo Medici, whom Hecht described as having close ties to looters. Ferri was now threatening to do to the Met what he had already done to the Getty.

The Met had a strong self-interest in maintaining good relations with Italy, whose loans often helped the museum mount headline-grabbing blockbuster exhibitions. Indeed, in December 2005 the Met

was preparing for an exhibit on Antonello da Messina, Sicily's renowned Renaissance painter. It was possible only because of the cooperation of Sicilian cultural officials and the Foundation for Italian Art and Culture, a New York–based nonprofit whose board members included Rocco Buttiglione. As preparations for the exhibit were being finalized, de Montebello sent a letter to Buttiglione requesting a meeting to discuss Italy's claims to the Euphronios krater and Morgantina silvers.

De Montebello had long demanded "incontrovertible evidence" of the claims. But after his general counsel pointed out that such a standard didn't even apply in capital murder cases, he sheepishly retreated from that demand. After the Italians presented their evidence regarding the krater, the silvers, and four other vases, de Montebello told Proietti, "I think we've got a deal." In return, he pressed the Italians to make long-term loans to the Met of antiquities of similar value and significance to the ones they would lose. The two sides were hammering out the agreement in January 2006, just as Brand and Li were beginning to engage the officials in Rome.

The Met agreement grabbed international headlines. It was hailed as a watershed event that offered a model resolution for the growing tensions between Italy and American museums. Only de Montebello could have returned such precious objects to Italy and not been denounced by his peers. There was no small irony in the fact that the hardest of hardliners in the American museum community was now being hailed as a hero, while Marion True — who a decade earlier had been scorned for proposing this very approach — was facing a criminal trial.

Despite the public praise, de Montebello privately regarded the deal as a betrayal of his curators and a black mark on his reputation. He flew back to the United States, where he put the finishing touches on the agreement via conference call while attending the Association of Art Museum Directors' midwinter meeting in West Palm Beach, Florida. After hanging up the phone, he went to eat alone at the Marriott. When an East Coast museum director came over to say hello, a

gloomy de Montebello told him about the deal. "I know you're from a different generation," the Met boss said, "but I feel like I've let down my curators."

"Philippe, you've done a good thing for us," the other director said. "We needed to lance this boil."

When de Montebello walked into a conference room the next day, he received a standing ovation from his fellow museum directors. They cheered again after he outlined the agreement and explained his reasons for making it.

On February 21, de Montebello flew back to Rome, where he hoped to sign the deal with Italian authorities and then quietly slip out of town. Before he could leave, however, the Italians had arranged for a photo opportunity to record the moment for posterity. The Met acknowledged the agreement with a perfunctory one-page press release. In a *New York Times* interview, de Montebello was unrepentant, saying that he had been forced to make the deal in order to rid the Met of "irritants" and "vexing issues." He accused the Italians of "shabby" conduct for leaking the evidence about the Euphronios krater to the press, conveniently glossing over how the Met had ignored Italy's more subtle requests for years. He expressed revulsion at the plunder of cultural monuments while at the same time crediting the black market for preserving many of the world's greatest art objects.

In a speech before the National Press Club in Washington, D.C., two months later, de Montebello was even more strident. He heaped scorn on a few archaeological extremists who, he said, seemed to have captivated the media. He blamed the influx of looted antiquities in America on conniving dealers, while maintaining that museum curators — many of them with Ph.D.'s and archaeological experience themselves — had simply been duped. "Most staff at museums around the world acquiring works with doubtful provenance displayed not cupidity, if you will, but rather guilelessness in the face of very clever imposture and deception."

He also attacked those who were advocating the adoption of poli-

cies forbidding museums to buy antiquities that had appeared on the market without provenance after 1970. "That is not the high moral ground. That is a capitulation to a political agenda and a betrayal of a museum's basic mission and purpose, in this case the rescue and the preservation of objects of great aesthetic merit and intrinsic cultural significance," he said. "To simply and deliberately condemn innumerable worthy objects . . . to the trash heap or oblivion, through redirecting the market to a true black market, to buyers less committed to openness, conservation, scholarship and certainly access—is wrong."

BACK IN LOS ANGELES, Li's antiquities team continued poring over the Italians' photographic evidence, which appeared to support their demands for the return of twenty-one objects, including the griffins and the Apollo. (Li's team eventually found a twenty-second item that the Italians had missed.) The rest of the items on their list were "wobblers" or, as in the case of the Getty Bronze, not supported by the evidence.

Then there was the Aphrodite. The allegations in the Italians' dossier went back to Silvio Raffiotta's initial investigation and the rumors of a large statue having been found in Morgantina in 1979. There was also the more recent limestone test, which pointed to central Sicily as the source of the stone. The evidence amounted to a compelling circumstantial case, but not airtight proof of Italy's claim.

Digging through the Getty's files on the statue, Li's team found more pieces to the puzzle: the angry exchange of letters between senior Getty officials Luis Monreal and John Walsh; Renzo Canavesi's 1996 letter offering fragments and new information about the statue to the Getty, as well as True's ambivalent response. When Li contacted Malcolm Bell, the archaeologist reiterated his skepticism about the Morgantina provenance, but he acknowledged that the statue likely came from a place nearby, a conclusion that other scholars shared.

Canavesi was the one person who could answer the Getty's questions about the statue, yet no one at the Getty had ever questioned

him. MTO hired the corporate investigative agency Kroll, which in turn hired a Swiss private detective to conduct a background check on Canavesi. Canavesi's paternal relatives had never been wealthy enough to afford such an important antiquity, the detective found, and although his mother's family had been rich, the fortune had vanished by the time Renzo was born. Could his father, a poor watchmaker, and his mother, a homemaker, really have bought a larger-than-life statue on the eve of World War II? It was highly unlikely, the detective concluded.

In April 2006, Canavesi agreed to tell his story to the investigators at his attorney's office in Lugano. After serving in the Swiss army during World War II, he said, he had been a policeman for ten years. He quit to start his own currency exchange, which later grew into a shopping mall.

He admitted to one brush with the law—being stopped by police when his friend, reputed antiquities smuggler Orazio di Simone, was in the car with him. Di Simone was the Sicilian who Italian authorities had repeatedly been told had smuggled the Aphrodite out of Italy. MTO considered contacting di Simone but decided against it after they were warned by Italian law enforcement sources that he had ties to organized crime.

As for the Aphrodite, Canavesi said that his father had bought the statue in the 1930s in Paris, where he was working in a watch factory. When his family returned to the Lugano region, his father kept the statue unassembled in his home. Canavesi did the same after his father gave him the statue in 1960, keeping it hidden away in boxes in the storage area of his shopping mall. Neither his brother nor his employees knew about it. He didn't think about selling it until 1986, when he met Christo Michaelides, Robin Symes's partner, at a Geneva coin auction. Canavesi said that he went home, pulled the statue out of its boxes, and assembled it with the help of a friend. Michaelides brought Symes to see the statue, and the dealers offered to buy it for $400,000, a transaction recorded on the hand-printed receipt from his money exchange that the Italians had in their dossier.

The whole story sounded absurd. If Canavesi's father had purchased the statue in Paris, how had he hauled it back to Switzerland and kept it in his family home without anyone else in the family knowing? And why would Canavesi, a self-professed lover of ancient art, keep such a magnificent antiquity packed away in a shopping mall basement?

As the investigators were about to leave, Canavesi said that there was one more thing. He pulled out some twenty photos and laid them out for the investigators to see. They had been taken in the early 1980s and showed the statue on the floor in fragments, surrounded by dirt.

The photos undermined Canavesi's already implausible story. They might as well have come from Medici's warehouse. Their visceral power came through even in the dry language the Kroll investigators used to describe them. Now, nearly ten years after Marion True had passed up the opportunity to see the photos, the Getty had prima facie evidence that the Aphrodite had been looted.

After receiving the report of Li's investigation, Brand was convinced that the statue would have to be returned. But he realized that doing so would be a delicate matter. Not only would the Getty trustees be reluctant to part with such a huge asset, but the Getty also had an immense emotional attachment to the Aphrodite. Like a grief counselor, Brand slowly started to prepare people at the Getty to accept the idea that they might have to let her go.

The process began at a mid-May 2006 board meeting where Li laid out the initial findings of the MTO investigation. The report filled several black binders and weighed more than twenty-five pounds. Touching on the Aphrodite, Li mentioned problems with Canavesi's provenance story, discussed his photos, and suggested that "dangerous people" had been involved. Brand tried to get a sense of board members' feelings about a general strategy for negotiating with Italy. What would be the board's conditions for returning the Aphrodite? What information did trustees need to make them feel comfortable with the possibility of giving it back?

Brand's probing hit a nerve. Two trustees pushed back, saying that they wanted the staff to look into the matter further before even talking about such a drastic step. Although the investigation had punched holes in Canavesi's story, Brand still couldn't tell them with any certainty where the statue had come from.

For other board members, the question was not if but when to play the Aphrodite as a trump card with the Italians. Why lay it on the table unless the Getty knew the endgame?

A MONTH AFTER Brand and Li visited Rome, one of Greece's top government prosecutors went to Italy to strategize with Ferri. The two countries shared the same goal—the return of looted art and the end of predatory collecting practices. Greece had noted Ferri's success at leveraging cooperation while holding out the threat of criminal prosecution. If it had not been for the criminal case against True, the Greeks recognized, the Met would never have agreed to a deal.

In April, Greek authorities borrowed a page from Ferri's playbook and swooped down on True's Páros home, seizing seventeen unregistered antiquities, mostly ancient architectural scraps that were common in most Greek households. Agents nevertheless were inflamed by the find and took particular umbrage when they discovered a framed poster of Alexander the Great next to True's toilet.

The raid was mostly for effect. Greece had a new culture minister—his predecessor's party had lost the national elections—who had already invited Brand and Li to Athens in May for discussions about the funerary wreath and three other contested objects. This raised the stakes for those talks.

Despite the Greeks' initial use of strong-arm tactics, they took a far more academic approach to their negotiations. When the two sides met in May, instead of hammering Getty officials with suspicion and innuendo, the director of the National Archaeological Museum spoke to them about the significance of art in ancient Greece. Another senior cultural official detailed the history and craftsmanship of ancient funerary wreaths, down to the minutely coiled twigs and

shimmering gold leaves. The winding of the thread on the Getty's wreath, he noted, was consistent with workshops in Macedonia. The measured approach particularly appealed to Brand, who was desperately looking for some way to expand repatriation discussions beyond legalisms.

Following the meeting, the Getty quickly agreed to return a fourth-century b.c. Hellenistic tombstone and the fifth-century b.c. marble relief that J. Paul Getty had purchased in 1955. But Brand asked for more information on the other two objects, a marble statue and the golden wreath, which the Getty had bought for a total of $4.45 million. Although not as iconic as the Aphrodite, the wreath was one of a kind and had been featured on the cover of the museum's antiquities masterpieces book. It had also been one of True's favorites. Greek officials would not be put off and made it known that their decadelong investigation of the funerary wreath would soon lead to criminal charges being filed against True.

The Greeks sent the Getty color photographs of the wreath — images authorities had seized from one of its alleged smugglers. The photos matched several black-and-white photographs that True had long ago received from Christoph Leon, the wreath's dealer. Li's team also found True's written exchange with Leon, in which she concluded that the object was "too dangerous for us to be involved with" shortly before the Getty bought it.

The museum soon announced that it was sending back both the statue and the wreath.

For years, the Getty had been frozen, unwilling to return objects that were clearly looted for fear of doing damage to True's legal situation. Now, with the new leadership, that had changed. The decision to return the wreath was a tacit admission that it was illicit, yet the Getty said nothing to defend its former curator when announcing the decision. Days later, a Greek prosecutor charged True with trafficking the golden wreath. She would now face trial in two countries.

True had largely been silent since her departure from the Getty, but the return of the wreath and the Greek prosecutor's charges drove

her over the edge. In a bitter letter to three senior Getty officials, she tore into her former colleagues. "Once again you have chosen to announce the return of objects that are directly related to criminal charges filed against me by a foreign government . . . without a word of support for me, without any explanation of my role in the institution, and without reference to my innocence." The Getty's "calculated silence," she continued, "has been acknowledged universally, especially in the archaeological countries, as a tacit acceptance of my guilt." The Getty had made her the scapegoat for more senior officials—she never mentioned Gribbon, Walsh, or Williams by name —who had been "fully aware of the risks" of buying the suspect antiquities.

AT FIRST BLUSH, a similar regime change in Italy seemed to be just as lucky for the Getty. When Olson, Li, and Brand returned to Rome with the Getty's initial offer in June, the conservative culture minister Buttiglione had been replaced after national elections by Francesco Rutelli, the former mayor of Rome and a center-left politician with Clintonesque charisma.

Tall, with square features, neatly cut gray hair, and twinkling blue eyes, Rutelli made women swoon when he walked into a room. He was the great-grandson of the famous Italian artist Mario Rutelli, who had sculpted the winged victory on the Piazza Venezia monument to Italian independence. As mayor of Rome, Rutelli had overseen the renovation and construction of new museums for the 2000 Jubilee celebration and showed an appreciation for the economic benefits of cultural tourism.

In a warm-up meeting with the Getty visitors, the new minister turned on the charm. He told them that once, while on vacation in the United States, he had driven two hundred miles out of his way to visit the Getty. Then he admitted Italy's responsibility for its share in the looted antiquities equation. "We Italians have a lot of responsibility in this. This is not only your problem. We should have done a better job. But we must resolve this."

The Getty contingent assured Rutelli that it understood Italy's position. "We got the message," one member said. "The whole museum world got the message."

From there, the sides plunged into two days of tense negotiations. The talks reached a boiling point when, on June 18, the *Los Angeles Times* revealed that an internal Getty assessment had concluded that the museum had purchased 350 antiquities valued at more than $100 million from suspect dealers—far more than it had admitted publicly. Olson and Li tried to explain that the study was for accounting purposes only, but the Italians grew surly. They demanded the Getty's secret list and threatened to add dozens more antiquities to their current list of fifty-two contested objects. But both sides simmered down enough to sit through MTO's presentation of its findings. The Getty agreed in principle to return twenty-four antiquities, with the rest—including the Getty Bronze and the Aphrodite—held over for further discussion. In a joint statement, the Getty and Italy's Culture Ministry announced a breakthrough deal in which the museum would return "a number of very significant" pieces. For its part, Italy promised to loan the Getty objects of "comparable visual beauty and historical importance."

Within hours, however, the deal had come undone. When a jet-lagged Li finally arrived home, he was confronted with an Associated Press report in which Fiorilli, who had suddenly excused himself from the final negotiating session, declared that there was no agreement and the two sides were far apart. Fiorilli was scuttling the deal in part to object to the Getty's legalistic approach to the negotiations, which came across to the Italians as being more interested in protecting the assets of the trust than in acknowledging the patrimony claims. Fiorilli had become convinced that the MTO attorneys were being paid a percentage for every Getty antiquity they saved. He began privately to deride Olson and Li as "carpet sellers" and to complain bitterly that the Getty was bringing a "commercial view" to a cultural issue. "The problem is always this," he said, "money, money, money."

• • •

THE ITALIANS' REGARD for the Getty team fell even lower after the Culture Ministry struck a quick deal with Boston's Museum of Fine Arts for the return of thirteen objects the museum had bought between the early 1970s and the late 1990s for $834,000. The MFA had agreed to give the items back after just five months of quiet talks with the Italians, with no bickering over one-to-one loans or demands for legal proof of the objects having been looted.

A confession was not a condition of the deal. Like the Met, the MFA now tacitly acknowledged that the objects had been looted but claimed that it had all been a big mistake. "When we acquired these objects, we did it in good faith," said Malcolm Rogers, the museum's director. "We in Boston are committed, alongside the Italian government, to seeing the end of illicit excavations and the illicit trade in antiquities." What he did not say was that Italy had gathered evidence that the museum possessed four dozen more objects acquired from Hecht, Medici, and other dealers implicated in the looting investigation. The MFA had long been one of the principal players in the American antiquities trade. After all, the museum's former antiquities curator, Cornelius Vermeule, had been one of Hecht's closest friends and longtime customers, as well as a mentor of True and a close colleague of von Bothmer at the Met. Given the museum's legal exposure, it was getting off easy with the swift return of just thirteen items.

Rutelli and his staff crowed about the deal during a September press conference, held in one of the Culture Ministry's ornate meeting halls, where Carabinieri in dress uniforms guarded the returned objects. They included a second-century white marble statue of Sabina, wife of the Roman emperor Hadrian. In hailing the MFA's spirit of cooperation, the Italians were drawing a sharp contrast to the Met and the Getty. Unlike the Met, the MFA did not demand loans in exchange for all the returned objects and delivered them as soon as the deal was struck. And unlike the Getty, it did not resist.

"We're talking about true collaboration," Rogers said to underscore the point. "Not an eye-for-an-eye and tooth-for-a-tooth."

Times had certainly changed. After decades of intransigence, America's two leading museums were now trying to one-up each other in the deals they had struck with Italy. Meanwhile, the Getty, with the most at stake, was struggling to find common ground with Italy.

In october, olson, Li, and Brand tried one more time to nail down a deal. Flying to Rome again, the Getty team expanded the trust's offer from twenty-four to twenty-six objects and then played its trump card—the Aphrodite. Brand offered to share title to the goddess if the Italians would collaborate on scientific tests over the next four years to determine the statue's true origins. If, at the end of that period, the tests were inconclusive, the matter would be put to an arbitrator to decide.

The offer represented the first time the Getty acknowledged that it was willing to give up the goddess, but the jaded Italians were not impressed. Fiorilli's team rejected the Aphrodite deal, even as it agreed to memorialize the understanding about the other twenty-six objects. Translators labored for hours over versions of the agreement in English and Italian, and Olson and Fiorilli signed each of the ten pages. But once again, the agreement fell apart. Waiting in the British Airways lounge in London, Olson received a call from Rutelli's political attaché, who said that his boss had become upset while reviewing certain portions of the agreement.

"You're not going to back out of this agreement, are you?" Olson said. "You're going to live by it, aren't you?"

The Rutelli aide hedged. Olson suspected that the agreement created a political problem for Rutelli because it failed to include a clear return of either the Aphrodite or the Getty Bronze.

While in rome, Li had arranged for a meeting with True and her attorneys. Since True had been forced to resign, relations between the two parties had been nearly nil. The slow-motion criminal procedure was taking its toll on the curator. On her sole appearance at the courthouse, she had been mobbed by gawkers and paparazzi. The next day,

the dramatic photos appeared in newspapers around the world, show-
ing True in her oversize sunglasses, doing the "perp walk" to court
while being shielded from the cameras with her purse. The Getty was
still paying her legal bills but had otherwise distanced itself from her
defense, as the return of the funerary wreath to Greece had painfully
demonstrated. Yet the fate of the curator and her former museum
were still inextricably linked by Italy's case against True.

Li advised True that the Getty was getting close to reaching an
agreement with Italy. It would involve the return of many of the ob-
jects involved in her criminal trial. He said the return might provide
leverage that otherwise would not exist for True and her lawyers. Per-
haps the two parties should coordinate their efforts to give the return
the maximum possible impact on her case. Without saying it outright,
Li was suggesting that True should cut her losses and see if she could
obtain some leniency by admitting her actions.

True's lawyers politely declined. Backed into a corner, True had
become adamant about giving no ground in her legal case. In public
statements as curator, she had often acknowledged that American mu-
seums had routinely bought objects they had every reason to believe
had been looted. But making a similar admission now about herself,
after everything that had happened, proved more difficult for her.

Ferri had repeatedly said that he'd consider wrapping up the trial
quickly if True would give him a statement acknowledging her role in
the black market. Her most recent effort had failed to satisfy him. In a
written statement dated October 17, True had gone farther than she
had in her 2001 deposition, acknowledging more intimate knowledge
of the risky antiquities market even before she became curator: "I was
aware of the corruption that has pervaded the antiquities market for
centuries and while Curator, I openly and frankly acknowledged the
problems."

Yet she also made clear that all of her recommended acquisitions
had to be reviewed by the chief curator, the museum director, the reg-
istrar, the in-house counsel, and the CEO before they were ultimately
approved by the board of trustees. Everyone at the Getty was aware of

the problems in the antiquities market, she said. "It was, in fact, clear to all that . . . the antiquities market was . . . crowded with a number of objects of dubious origin and provenance and sometimes of dubious authenticity," True wrote. "Whenever objects of unknown provenance were proposed for acquisition, the Getty administration and I recognized the possibility that claims relating to such objects might subsequently arise."

Regarding the Aphrodite, she wrote, "There was no question that the piece originally came from South Italy or Sicily, but exactly when and from where was always a question." Trying to explain her decision back in 1996 not to meet with the statue's former owner, Renzo Canavesi, she said simply, "The difficulty of confirming unsolicited allegations and rumors can be time-consuming, expensive and inconclusive."

For Ferri, the statement left a wide gulf between the curator and culpability. While condemning "unscrupulous dealers," True continued to defend the Getty's acquisition policy and portray herself as the champion of returning artifacts to Italy. Nowhere did she acknowledge making a single mistake.

Ferri was disappointed. True was still not willing to be honest.

LIKE DISBELIEVING WITNESSES needing to revisit a corpse, Olson, Li, and Brand returned one more time to Rome in November. The city was abuzz with the impending wedding of Tom Cruise and Katie Holmes in nearby Bracciano. The Getty team came fortified with a new antiquities acquisition policy, which committed the museum to purchasing objects only if they had been legally exported before November 17, 1970, the date of the UNESCO Convention. Lost in the maelstrom of breaking news about the negotiations, the policy represented the most progressive collecting policy of any leading American museum.

Ushered into Rutelli's office, the Getty team found the culture minister bidding farewell to the world-famous Japanese architect Arata Isozaki, whose controversial new loggia was under construction

at the Uffizi in Florence. Charming as usual, Rutelli led them to an arrangement of couch and chairs at one end of the room—a beautifully appointed space that featured lighted alcoves reaching up to the twenty-foot ceiling.

Waiting for them were Fiorilli, Proietti, and the head of the Carabinieri. Everyone got down to business. Brand put on the table his best deal: no Getty Bronze, but the twenty-six objects agreed to earlier and full title to the Aphrodite. All he asked was that the Getty be allowed to hold on to the statue for a year to conduct additional tests —enough time to help his colleagues in the museum community feel comfortable with the decision to give up the icon.

Not good enough, said the Italians. They wanted all fifty-two objects in their dossier, including the Getty Bronze, about which the Italians had suddenly grown adamant. The shift in attitude seemed to coincide with increasing pressure from the residents of Fano, the sentimental hometown of the Lysippus statue and a stronghold of Rutelli's center-left party. Local schoolchildren had begun sending postcards by the hundreds to the Getty pleading for the statue, and area politicians were pressuring Rutelli not to back down.

The scene in Rutelli's office lapsed into the surreal when he went to his desk to take a phone call. "Maestro!" he exclaimed. It was director Franco Zeffirelli, who was staging a production of *Aida* at La Scala. Meanwhile, Fiorilli launched into a rant against Marion True and the Fleischmans. With hope slipping away, Li nearly shouted to interrupt him.

"Maurizio, are you saying that if we give you twenty-six items and the Aphrodite but keep the bronze, there's no deal?"

Fiorilli kept talking.

"Maurizio . . . the Aphrodite. You can have her. She's yours."

Fiorilli seemed unfazed. Li then turned to Proietti and said, "Are you saying that if we want to give you the twenty-six objects without the bronze, you won't take them?"

Proietti answered quietly, "Yes."

"Then there's nothing left to talk about," Olson said.

Li, Brand, and Olson stood up to leave. They extended the Getty's wishes to continue the conversation but said there wasn't much more they could do. Rutelli, now off the phone, came over to smooth things over, but the Getty team walked to the door.

Back at the hotel, Brand and Li sat at a small table in the lobby, ordered Scotch, and, as Hollywood celebrities drifted in and out on their way to the TomKat nuptials, spent hours writing a lengthy letter to Rutelli. This time, they weren't going to keep quiet while the Italians beat them up in what had become a struggle for public opinion. This was a unilateral statement that would be released to the press.

In it, Brand expressed his sadness at the impasse but gave the Getty's justifications for walking away. The Culture Ministry's demands for the Getty Bronze were "unfounded, late in coming and—with all due respect—unreasonable."

As for the Aphrodite, the museum would press ahead with studies of its origins. "If the studies demonstrate that the statue should be transferred to Italy," Brand wrote, "we will transfer it."

A BRIGHT LINE

IN EARLY 2007, when American museum directors met for their winter meeting, topping the agenda was the burgeoning antiquities scandal. The meeting was noteworthy for who was missing. Philippe de Montebello, the dean of American museum directors, was having double knee-replacement surgery. The symbolism was rich, some noted. For in his absence, de Montebello's hard-line position was having its legs taken out by the younger generation of museum directors, who felt reform was overdue. It was the first time in memory such views had been aired so openly.

The discussion was remarkable not just for its candor but for the fact that it was taking place at all. The Association of Art Museum Directors seemingly had settled the antiquities matter three years earlier with the new acquisition guidelines favored by de Montebello, which recommended that antiquities have an ownership history going back just ten years. Now the Getty's decision to break ranks and adopt 1970 as a "bright-line" cut-off date reopened the debate.

Michael Brand was almost jocular in sketching for his colleagues the preliminary findings of the Getty's internal investigation, particularly when it came to the Aphrodite. "The idea that this was on a don-

key cart from Sicily to Paris is highly improbable," Brand said wryly, poking fun at the Canavesi story. There was no feigning ignorance now about the statue's origins. Weeks earlier, the *Los Angeles Times* had published the results of a months-long investigation of the goddess. The story detailed the explicit warnings the Getty had received about the statue before buying it—from archaeologists, Italian officials, even the director of the Getty Conservation Institute, all of whom had said the statue was almost certainly looted. The article also took apart the cover story of the statue's former owner, Canavesi, revealing that his relatives had never heard of the seven-and-a-half-foot, one-ton statue, which had supposedly been sitting in their basement for nearly fifty years. Finally, the article cited two Sicilians with ties to the illicit trade who claimed to have seen parts of the statue not far from Morgantina in 1979, when it was rumored to have been illegally excavated there.

The Getty's stance had clearly emboldened other museums. Susan Taylor, head of the Princeton University Art Museum, told the audience that her museum was moving toward a bright-line policy, too. She was scheduled to fly to Rome in three days for her own talks about three artifacts in Princeton's collection that were implicated in the Medici files.

The third speaker, Timothy Rub of the Cleveland Museum of Art, addressed speculation that the Italians would be coming after the museum's statue of Apollo, thought to have been created by Praxiteles, one of ancient Greece's greatest sculptors. He made it clear that he saw the same kind of policy changes coming at the Cleveland, and expressed his doubts about the future acquisition of antiquities.

Sensing an opportunity, Max Anderson stood up in the audience when the panelists were done. Anderson was new at the Indianapolis Museum of Art but a veteran of the cultural patrimony debate, having served as assistant curator to von Bothmer at the Met and briefly adviser to the Fleischmans as they built their ill-fated collection. Having unsuccessfully pushed for bright-line reform in the past, he was now leading the fight again. "I appreciate the candor of my colleagues, and

I think the time has come to draw a bright line," said Anderson. "Now's the time to do it. We should reopen the guidelines."

The challenge triggered a lively debate. James Cuno of the Art Institute of Chicago jumped up. A member of the old guard and an outspoken collecting hawk, he was spoiling for a fight. No bright-line policy in America was going to stop the looting in Italy, he argued. The Italians had every right to make their patrimony laws, but they and other source countries had made archaeology the handmaiden of nationalism. Antiquities were best served by museums, not politics.

John R. Lane, director of the Dallas Museum of Art, made the collector's case more brusquely, and perhaps more honestly. "Maybe I'm out of step, but I'm an old museum guy, and I want to buy what I want to buy," he said. Given the recent headlines, the idea seemed so hopelessly out of sync that some people chuckled under their breath.

Peter Morrin, director of the Speed Art Museum in Louisville, weighed in next. You can make all the philosophical arguments you want about the value of universal museums, but you can't ignore the courts or public opinion, he said. The conviction of Frederick Schultz, the trial of Marion True, and the campaign by the Italians had changed everything.

The most telling sign that the times had changed came from Anne d'Harnoncourt, the director of the Philadelphia Museum of Art. She had stood solidly behind de Montebello in the past but now rose to call the ten-year rule "weaselly." She quickly regretted using the word, but it was too late.

The young reformers were clearly with the majority. It was only a matter of time before the association would jettison its ten-year rule and adopt the 1970 cut-off date first established by the UNESCO Convention some three decades earlier.

As breezy as Brand had been about the Aphrodite's origins in front of his fellow museum directors, one final task remained for him to convince the Getty board of trustees to return the statue that had come to symbolize the museum's antiquities woes.

In April 2007, Jerry Podany, chief of antiquities conservation at the Getty Museum, found himself on an airplane to perform what, in his line of work, was tantamount to identifying the mortal remains of a loved one. Of all the assignments he'd had over the years—appraising artifacts in Swiss bank vaults, sizing up statues in warehouses, eyeing vase fragments in dealers' display cases, examining microscopic fossils to determine a statue's authenticity—this would probably be the easiest. Yet it also had to be one of the weightier.

Podany was heading to Lugano to meet with Renzo Canavesi and confirm that his photos were, indeed, of the Getty's Aphrodite. The decision had already been made to give the statue back, but Brand wanted Podany to take one more look, just to make sure Canavesi's photos were of the same piece now towering in the Getty Villa. Luis Li, already in Europe on a vacation, arranged to accompany the conservator. Li had his assignment, too. He hoped to talk Canavesi into giving up at least a few of his photos for safekeeping at the Getty.

The whole thing came off like something out of John le Carré. On April 27, Podany and Li were met by Canavesi's attorney at a nondescript building in central Lugano. They were led to another anonymous office building and up to a sterile room. Waiting there was Canavesi. After shaking hands with his guests, the former tobacco shop owner matter-of-factly led them to a table where twenty photos were lying face-down.

Podany thought that maybe Canavesi wanted payment of some kind. But soon the photos were flipped over, and Podany trained his expert eyes on specific details—a fold, a break, a uniquely shaped crack—that matched his memory of the statue he had meticulously conserved for the past two decades. There was no doubt it was the Aphrodite.

The photos were devastating: they showed the statue in dozens of pieces on the floor of what appeared to be a basement. In one, some thirty fragments of the goddess lay scattered in dirt on a brown tile floor. At the top of the photograph, pieces of varying sizes were lined

up in rows on a large, thick plastic sheet. Another photo showed the statue's marble face still encrusted with dirt. Like the Polaroids seized from Medici's warehouse, these photos all but screamed that the Aphrodite had been looted.

After twenty minutes, Podany excused himself. He took a very long walk along Lugano's steeply sloping streets, passing quaint shops, the city hall with its Spanish tile roof, and the modern offices of Credit Suisse and Banca Unione di Credito. He walked through the Piazza Dante Alighieri, passed the front door of the cathedral, and continued out into the harbor of Lake Lugano, a blue jewel framed by mountains in the background.

Podany ran through the photographs in his mind, digesting what he had seen. He thought about the Aphrodite as Marion True's signature piece and the cruel irony that someone who had campaigned to change the buying habits of reluctant American museums had become a symbol of curatorial greed. And he thought about how all of it might have been prevented if True had seen these photos before the Getty bought the goddess.

When he returned to California, Podany wrote a brief memo to Brand confirming that the photos were of the Aphrodite. "Had I seen these photographs earlier," he told Brand, "I don't think we would be down this path."

AFTER EIGHT MONTHS of stubborn silence, broken only by a salvo of op-ed pieces from both sides in the *Wall Street Journal*, the Getty and Italy finally ended their standoff.

The deadlock had appeared unbreakable. The Getty had drawn the line at returning the Getty Bronze, whose discovery by Italian fishermen in international waters muddied any moral case for its return. But Italy could not give up on the bronze without losing face. As an additional incentive to the Getty, the Culture Ministry had been slowly strangling the museum with a de facto cultural embargo. Loans of Italian art and any cooperation with Italian museums had slowly

ground to a halt. In July, Rutelli traveled to Fano, where the statue was still legendary among the village's hardscrabble fishermen. Thumbing for dramatic effect a list of dozens of other Getty objects that Italy would demand if the museum didn't restart talks, the culture minister threatened to make the embargo official on August 1. As Rutelli's threatened deadline approached, the museum showed no signs of budging on the bronze.

The breakthrough came thanks to Maurizio Fiorilli. The state attorney had secretly engineered a clever way to restart negotiations with everyone saving face. Seeing that Rutelli was in danger of appearing toothless, Fiorilli quietly drafted a new legal complaint asking a regional court for a new investigation into the bronze. A group of cultural activists from Fano filed the complaint under their own names, with the agreement that Fiorilli's role would remain secret. The ruse had the desired effect—the complaint led to a new criminal investigation, providing the Culture Ministry with a convenient way to back away from its immediate demands. Soon after, Rutelli sent a private fax to Brand. Given the pending judicial investigation, he explained, Italy had little choice but to withdraw its request for the Getty Bronze for the time being. It could always be reinstated later, of course, depending on what the court found.

With the bronze off the table, the deadlock was broken. After a flurry of faxes just hours before the August 1 deadline, a deal was announced: of the forty-six artifacts that Italy was now demanding, the Getty would return forty, including the Aphrodite. The objects had been purchased over thirty years for nearly $40 million, and their current value was many times that. The Getty would receive no compensation for the loss, but the Culture Ministry offered to loan the Getty objects comparable to those being returned. It was to be the beginning of a new era of cultural cooperation, both sides proclaimed.

After nearly ten years of denial, double talk, rationalizations, stonewalling, finger-pointing, handwringing, second-guessing, defiance, and, finally, resignation, the Getty's antiquities nightmare was over.

• • •

AT THE GETTY, it was as if a cloud had lifted. The Italian negotiations had left the Getty stuck in a limbo of perpetual crisis. Now the rebuilding could begin.

Months earlier, California attorney general Bill Lockyer had completed his investigation into Barry Munitz's excesses. It proved to be little more than a pro forma review confirming what had already been published in the newspapers. In the end, Lockyer concluded that his friend Munitz and the Getty board had misused the trust's resources for their own benefit. But the attorney general stopped short of imposing any penalties. Instead, his office appointed a monitor to make sure that the trust implemented a broad slate of reforms.

The Getty was already well on the road to reform. In the two years since Munitz had been forced out, virtually all of the trust's senior leadership had left, as well as many of Munitz's handpicked trustees. New faces were everywhere.

James Wood, the well-respected former director of the Art Institute of Chicago—and someone who had attended the Met's secret summit of museum directors in April 2002—was coaxed out of retirement to provide a steady hand as CEO.

Brand was filling vacancies in the museum's leadership with capable, qualified people. In the antiquities department, True's deputy, Karol Wight, was joined by Claire Lyons, an outspoken archaeologist from the Research Institute. With few antiquities available for purchase under the strict new policy, staff members could devote their energies to scholarship and collaborative efforts with foreign countries.

The cloud, however, had not lifted from Marion True. Friends said that she was depressed. She spent her time remodeling her kitchen in France and following the tortured legal proceedings in Italy.

Shortly after the Getty inked its agreement with Italy, Fiorilli dropped the Culture Ministry's civil claims against all but three of the artifacts cited as evidence against True in the criminal case. The criminal case continued to grind on, with a hearing every few months. Its

outcome was largely irrelevant. Ferri told the press that he had no interest in putting the platinum-haired curator in jail. His goal had been to change the behavior of American museums, and that battle had been won. Marion True had been collateral damage, a means to an end, Ferri admitted. He continued to offer a speedy conclusion to the criminal trial in exchange for some acknowledgment of her role in the illicit trade, a deal True's attorneys continued to reject.

The Greek criminal case reached a similarly uneventful conclusion. In November 2007, the court agreed to drop all charges after True's attorney argued that the statute of limitations had expired.

At the Getty Villa, True's ghost still haunted the galleries, her high-pitched voice echoing through the audio guide, talking about the significance of objects that were no longer there. In the fall of 2007, items began disappearing from the villa overnight, removed from display cases or taken down from walls to await the arrival of a plainclothes Carabinieri, who would escort them back to Italy. Among these items were the griffins sinking their teeth into the hapless doe, the arresting scene that had greeted visitors coming off the second-floor elevator; the large marble basin with traces of the original painting, a centerpiece of the Trojan War room; and the Tyche, a small statue of the goddess of fortune that Medici had once offered to True along with a bribe. An Etruscan roof ornament and vase from the Fleischman collection, mainstays of the Dionysus room and theater gallery, disappeared as well.

Pieces once trumpeted with press kits and public acclaim had been unceremoniously ushered out of the villa after hours, like disgraced family members. Their absence was marked only by small felt stickers, barely concealed holes in the walls, and conspicuously empty spaces.

Meanwhile, the Aphrodite remained on display, seemingly untouched. During negotiations with the Italians, the Getty had convened a panel of international experts—including archaeologist Malcolm Bell—to conduct the first thorough study of the iconic statue. A

surprising fact began to emerge: the subject likely wasn't the goddess of love after all, but Persephone, the goddess of fertility. The only sign of the monumental struggle over her destiny was a discreet phrase Getty officials added without fanfare to her nameplate: "On loan from Italy."

ITALY, MEANWHILE, CONTINUED to wring concessions from other American museums.

In October 2007, Princeton University agreed to send back eight objects. The following month, New York dealer Jerry Eisenberg —who had sold the Getty his entire stock in the mid-1970s to fill the new Malibu museum—also returned eight antiquities, valued at $510,000.

In January 2008, New York socialite Shelby White became the first and most prominent collector to fall, ending eighteen months of intense negotiations with the promise to return ten pieces, including another masterpiece vase by Euphronios that had been on loan to the Met, where White served as a board member. Later that year, she returned two more pieces to Greece. White's objects flew back to Italy on the same plane as the two marble busts that had been found with the Aphrodite's head in Morgantina and purchased by Maurice Tempelsman.

In November 2008, the Cleveland Museum of Art agreed to return fourteen antiquities to Italy, citing proof that they had been looted. The majestic bronze Apollo would be the subject of a joint investigation. Six months later, Hicham and Ali Aboutaam, Lebanese brothers who operated antiquities galleries in Geneva and New York, returned 251 antiquities to Italy. They were among the thousands of pieces the brothers kept in storage in a Geneva warehouse adjacent to that of Giacomo Medici, a former mentor.

The stream of returned objects told a compelling story about the extent of the trade in looted antiquities. Yet for all the contrition on the part of shamed museums, dealers, and collectors, every return was

accompanied by the claim that the buyer had purchased the object innocently, with no knowledge of its illicit origins. The truth about the antiquities trade was still being denied.

Most of these pieces joined a triumphant exhibition of prodigal artifacts on display at the Palazzo del Quirinale, the official residence of the president of Italy, located on the highest of Rome's seven hills. More than a million visitors came to see the exhibit, whose title, Nostoi: Returned Masterpieces, was a reference to the heroes of the Trojan War who had returned home after their long ordeal.

Rutelli hinted that it was just the beginning. "I expect that over the next few years, hundreds of other works stolen from our national patrimony and taken abroad will return to Italy," he told the Italian press, adding that hundreds of objects in England from the Robin Symes collection might soon follow. "Ours is not a nationalistic discourse. On the contrary: it is a universal one, because each national patrimony belongs to the world, and circulation cannot be left to illegal organizations."

From Rome, the exhibit traveled to Athens, where it was displayed with the Getty's golden wreath and other returned artifacts. After the exhibit ended, the Italian pieces were sent home for permanent display in the regional museums of Lazio, Campania, Apulia, Umbria, and Sicily—near where they were once wrenched out of underground tombs.

In December 2010, Getty conservators quietly disassembled the Aphrodite and packed it for return to Italy, where it arrived in early 2011. The statue will spend its remaining years alongside other prodigal treasures at a seventeenth-century Capuchin monastery that serves as a museum in Aidone, the town just outside the ruins of Morgantina.

The chase is finally over.

Epilogue: Beyond Ownership

A s in a Greek tragedy, the Getty sowed the seeds of its own disgrace. For years it built an enviable collection of antiquities by turning a blind eye to their origins. Along the way, museum officials came to believe their own rationalizations and ignored the stark prophecies of people such as Arthur Houghton, who in the early 1980s had warned that "curatorial avarice" would someday trigger an international investigation and leave a stain on the Getty's name. When the day of reckoning came more than twenty years later, the Getty responded with hubris, then became mired in indecision. Unable to choose between saving its curator and saving its collection, the Getty wavered—and lost both.

Yet the controversy has had its redemptive effect. The Getty was forced to do something it had long avoided: pull back the veil of lies and obfuscation, go beyond "optical due diligence," and confront the truth about its past. In doing so, the chastened museum helped usher in an era of cultural exchange. The Getty's redemption came at a high cost, however. The museum lost forty of its most prized ancient objects, leaving the collection significantly diminished. But soon after they were returned, a remarkable series of long-term loans began to arrive from Italy.

The first came in the summer of 2009: the Chimera of Arezzo, a striking bronze sculpture of the legendary fire-breathing monster that bears the head of a lion, the body of a goat, and the tail of a serpent. For centuries, the slaying of the Chimera has been an allegory for culture's triumph over human nature, the victory of right over might. Courtesy of the National Archaeological Museum of Florence, the renowned Etruscan masterpiece was accompanied by the detailed story of its discovery, archaeological context, and ownership history —something lost for nearly all the objects in the Getty's permanent collection. The Chimera was found in 1553 by workers in Arezzo, east of Florence. A cache of small bronze figures found with it indicated they had been part of an offering to Tinia, the king of the Etruscan gods. The famed Medici family owned the piece before it was given to the Uffizi Palace in 1718 and the National Archaeological Museum of Florence in 1870. This was the type of coveted information that would never be available for the Aphrodite, the true identity and purpose of which remain a mystery to this day.

The Chimera loan was the first fruit of broad collaboration agreements Italy struck with the Getty, the Metropolitan Museum of Art in New York, Boston's Museum of Fine Arts, the Cleveland Museum of Art, the Princeton University Art Museum, and other institutions that returned a token number of their looted treasures. The arrangements carried enormous benefits for both sides. Museums received crowd-drawing masterpieces of unimpeachable provenance. The Italians appeared magnanimous while showing off some of their most precious objects, many of which had been languishing in remote regional museums. Italian prosecutor Paolo Ferri retired soon after the Getty deal was struck, but similar deals are likely to emerge as his successors press their case with museums in Europe, Japan, and Australia to which looted objects have been traced.

The agreements also appear to be achieving a much broader goal. Italian authorities have reported a marked decline in looting from archaeological sites. American museums have all but stopped purchas-

ing recently looted Greek and Roman antiquities. Reforms made in the wake of the Getty scandal were consolidated by a changing of the guard in the American museum community. A generation of "grand acquisitors"—Thomas Hoving, Jiri Frel, Dietrich von Bothmer, and Cornelius Vermeule—passed away during the scandal, and the Met's Philippe de Montebello retired. They have been replaced by a younger cadre of more enlightened directors who, like Marion True, may have sinned in the past but eventually embraced reform. A similar evolution has begun in the antiquities market itself. The men who dominated the trade for decades—Robert Hecht, Giacomo Medici, Robin Symes, Gianfranco Becchina—were consumed by their legal battles, yielding to a younger generation of dealers who wrestled more openly with the ethics of the trade.

Whether these changes will take hold more broadly remains to be seen. Looting continues around the globe, and wealthy collectors in Asia, Russia, and the Middle East have quickly filled the void left by American museums in the antiquities market. Even in America, some museums appear not to have gotten the message. Even as the Getty scandal made international headlines, several other southern California museums were caught in a tax fraud scheme to accept donations of looted Southeast Asian artifacts. The machinations were jarringly similar to the one Frel had carried out at the Getty some two decades earlier.

Likewise, not all archaeologically rich countries have been as reasonable as Italy, which limited its demands to objects looted since the 1970 UNESCO Convention. In April 2010, Egyptian officials organized a conference of twenty-one countries to draw up a wish list of artifacts they wanted returned. Many of the sought-after pieces were taken generations ago under colonial rule or other ethically murky circumstances. Greece, meanwhile, revived its demands for the return of the Elgin Marbles from the British Museum. It was an old argument made fresh by the $200 million museum the Greek government opened at the base of the Acropolis in 2008. Some of these claims

carry moral weight, but just as often they are driven by emotion and nationalistic impulses. Ultimately, they do little to address the scourge of modern looting.

As for the Getty, it appears unable to shake its founder's curse. Just as the organization emerged from the dark period of crisis marked by the fall of Barry Munitz and the conflagration over its antiquities collection, unrest returned. In 2009, the greatest recession in modern times forced the Getty to lay off veteran staff and once again curb its ambitions. In January 2010, museum director Michael Brand was pushed out after clashing over money with Getty Trust CEO James Wood—a sign that the Getty's unusual structure remains a nagging source of instability. Wood died unexpectedly in June 2010, leaving the world's richest arts organization for a time with no chief executive, no museum director, and a newly appointed board chairman to chart its uncertain future. It remains an organization still struggling to live up to its vast potential.

Marion True, meanwhile, remained stuck in the purgatory of the Italian judicial system until October 2010, when the statute of limitations expired on her remaining criminal charges. After five years of trial, True was excused without a verdict, leaving unresolved the question of her guilt or innocence. In truth, True's punishment has already been meted out—the destruction of her career and reputation, the unraveling of decades of work, and the return of dozens of objects she risked everything to acquire. True, at once the greatest sinner and the greatest champion of reform, has been made to pay for the crimes of American museums.

Like a heroine in a Greek tragedy, it took True's downfall to achieve the goal that guided much of her career. Her undoing forged a peace between collectors and archaeologists, museums and source countries. The new era she called for at Rutgers in 1998 is now within sight. It is one in which museums and countries alike will look beyond questions of ownership and embrace, as True said, the "sharing of cultural properties, rather than their exploitation as commodities."

ACKNOWLEDGMENTS

NOTES

FURTHER READING

INDEX

Acknowledgments

This book would have been impossible without the help of numerous people.

First among them are our confidential sources, all of whom spoke with us at considerable personal risk because they believed the public had a right to know the truth.

We are grateful to the staff and leadership of the J. Paul Getty Trust, who cooperated with this project knowing it would not always put their institution in a favorable light. In particular, former museum director Michael Brand, Getty spokesman Ron Hartwig, and outside counsel Luis Li gave us ample time to make sure we got it right.

Beyond the Getty, Thomas and Nancy Hoving in New York City opened their home, their archives, and their formidable minds to us. Many of the scandals in this book were first uncovered by this duo some twenty years before we arrived, and their humor, energy, and endless generosity are deeply appreciated. Thomas Hoving remained a supporter until his death in December 2009. In Maryland, Arthur Houghton generously allowed us to spend days in his home reviewing his considerable archives, which proved to be an essential window into the early years at the Getty Museum.

In Italy, we are indebted to Livia Borghese for her translation,

friendship, and patience as she sat through hours of legal hearings on our behalf, broken only by Robert Hecht's occasional arias or Giacomo Medici's frothing rants. Her smile opened doors in Rome, guided us through an uneasy quiet in Sicily, and helped us navigate the catacombs of Cerveteri.

In Athens, we were lucky to find not just a dogged fellow investigator but a friend, Nikolas Zirganos. He, too, welcomed us into his home and shared his wisdom from years on the trail of Greece's stolen patrimony.

Countless others helped us in ways large and small during our various trips across Europe looking for answers, and we thank them.

At the *Los Angeles Times*, we are indebted to our editor, Vernon Loeb, who pushed us to keep chasing Aphrodite when we thought we were done, as well as Dean Baquet, Marc Duvoisin, and Doug Frantz, who saw the potential of this story and championed our pursuit of it through trying times for the newspaper. We also thank Robin Fields and Louise Roug, who with Jason wrote the original articles about Barry Munitz's spending that started a three-year run of stories about the Getty. All but Marc have moved on from the *Times* but remain valued colleagues.

Our indefatigable early readers helped us understand where the manuscript resonated and where it fell flat, where we had failed to pick up threads and where we had unnecessarily buried the reader under mountains of facts. They were Sandy Tolan, a journalism professor and author of the best-selling book *The Lemon Tree*; an expert on the law who asked not to be identified but was both rigorous and thoughtful; and the husband-and-wife team of Paul Schnitt and Virginia Ellis, former *Sacramento Bee* business writer and former *Los Angeles Times* Sacramento bureau chief, respectively. Attorney Jonathan Kirsch, an accomplished author, helped craft our collaboration agreement, which, mercifully, was never invoked.

Finally, we salute our agent, Jay Mandel, at William Morris Endeavor Entertainment, and the excellent team at our publisher, Houghton Mifflin Harcourt—editor in chief Andrea Schulz, who ex-

hibited unflagging patience and optimism, as well as Lindsey Smith, Lisa Glover, Christina Morgan, and legal adviser David Eber. Our copy editor, Barbara Jatkola, was both patient and thorough. Any shortcomings of this book fall entirely on the shoulders of the authors.

OF COURSE, NO book would have been possible without the critical support and inspiration offered by our loved ones.

Jason thanks his wife, Anahi, whose love sustained this project for years, and Nicolas, whose birth marked its halfway point. Jason also thanks his grandfather, Dr. William C. Felch Sr., the family's first writer and a constant source of inspiration; his parents Will, Ginny, Carol, and Sue, and his sister, Kristin, who never stopped asking for updates; and Alfonso and Maria Carrillo, who were generous in so many ways.

Ralph thanks his father, Carl J. Frammolino, who inspired his career in journalism; his brother, Carl L. Frammolino, who is his best friend and was chief cheerleader during difficult moments of writing; his sisters, Janice and Kathy; and Julia Stenzel, who patiently let the creative process take precedent over plans for traveling through India. Finally, Ralph thanks the two most important people in the world to him, the ones who never stopped believing the book would come out — his daughters, Allyson and Anna. If this makes you proud, girls, it was worth it.

Notes

This book is the culmination of five years of reporting. Its origin was a series of investigative stories in the *Los Angeles Times* between 2005 and 2007. The articles revealed that the J. Paul Getty Museum had bought looted Greek and Roman antiquities from the black market while holding itself out as a model of reform. The series was a finalist for the 2006 Pulitzer Prize for Investigative Reporting and provoked an international debate about the role of American museums in the illicit antiquities trade.

Given the limitations of newspapers, much of the important context for the Getty scandal was never explored in those articles. Three decades of evolving legal standards were blurred by hindsight, and several important questions remained unanswered. How much did museum officials know about the objects they were buying? How could such intelligent and sophisticated people follow a path that led to this scandal? And why didn't they heed the warnings? For those reasons, we continued our research between 2007 and 2010. The result is this account, which reconstructs the Getty scandal, tracing the crisis from its roots in the 1970s to its recent resolution.

American museums have a public mission, but in many ways they

are secretive institutions. They conduct their business in private, and even the most basic facts about each acquisition—where it came from and how much the buyer paid for it—are rarely revealed. As a result, the public has very little idea of how these institutions are run and what values guide them. This book pierces that secrecy and provides an unparalleled view inside one of America's leading museums.

The backbone of this account is a trove of thousands of pages of confidential Getty records provided by half a dozen key sources at various levels of the institution. They include a confidential institutional history of the Getty as narrated by two generations of its leaders; a complete list of art purchased by the museum from 1954 to 2004, with the price paid for each piece; the private correspondence and contemporaneous handwritten notes of several top Getty officials; museum files on the contested antiquities and suspect dealers; and records detailing several internal investigations conducted over the years by various teams of Getty lawyers. These records were provided by sources who risked their careers and reputations for the public's right to know the truth. This account would not have been possible without them.

We also tapped other archives, both public and personal. Court records in Rome provided a road map of the illicit trade, captured in hundreds of pages of sworn depositions of dealers, looters, and Getty staff; original Carabinieri case files detailed decades of looting investigations; and the 650-page sentencing document for Giacomo Medici laid out the results of the decadelong Italian investigation. The personal archives of former Getty acting antiquities curator Arthur Houghton and the late Thomas Hoving, director of the Metropolitan Museum of Art, were also particularly useful.

In time, the Getty itself opened up and gave us limited access to its institutional archives. Although most reportorial gems had been carefully excised by the Getty's lawyers, the archives nevertheless provided an essential context to understand the Getty's origins and evolution, a central subplot of the story.

But documents are like shards of an ancient vase—some dull, some beautiful, all lacking context. To bring these records together, we conducted thousands of hours of interviews with more than three hundred people in the United States and Europe. They included virtually every central player in the drama (with the few key exceptions noted below). Some sat for hours and bared their souls; others answered reluctantly and only when presented with uncomfortable facts. Many requested anonymity, citing the ongoing criminal investigations into the events we describe. Before using information from anonymous sources, we carefully considered their motives and reliability.

The Getty generously made key staff members available for interviews, in particular former museum director Michael Brand, spokesman Ron Hartwig, and outside legal counsel Luis Li of Munger, Tolles & Olson of Los Angeles. Italian authorities also were generous with their time and records, in particular prosecutor Paolo Ferri; Judge Guglielmo Muntoni; Culture Ministry officials Maurizio Fiorilli and Giuseppe Proietti; investigators Maurizio Pellegrini and Daniela Rizzo; and Carabinieri art squad members Maximiliano Quagliarella, Angelo Ragusa, and Salvatore Morando. Antiquities dealers Giacomo Medici, Gianfranco Becchina, Frieda Tchakos, Robin Symes, and, in particular, Robert Hecht shared what they could about their exploits over the years.

Three key people were not available for interviews: J. Paul Getty, who died in 1976; Jiri Frel, the Getty's first antiquities curator, who died in Paris just as we were knocking on his door in Rome; and Marion True, the Getty's antiquities curator for two decades and a central character in the scandal.

Over five years of reporting, True declined more than a dozen interview requests, including several made through her attorneys in the United States and Italy. Shortly before our deadline, she agreed to participate in a written exchange for fact-checking purposes. She terminated the arrangement when the authors submitted a second round of questions. Nevertheless, her brief responses to our initial round of

questions were helpful, and we thank her. Some of the gaps left by True's silence were bridged by the hundreds of pages of depositions and written statements she gave to Italian and Greek authorities; the single press interview she gave to a sympathetic writer for *The New Yorker*; her Getty correspondence and expense accounts; interviews with her friends and colleagues; and the lengthy investigations into her actions by the Getty, Italy, and Greece.

Throughout the book, direct quotes and internal thoughts are based on firsthand accounts or reconstructed from contemporaneous written documents. Otherwise, we paraphrased.

Before publication, the story's principal players were offered an opportunity to correct the record during verbal fact-checking sessions in which we detailed our conclusions. Some—including John Walsh and Debbie Gribbon—chose not to participate.

Where there were contradictions or diverging accounts, we have favored contemporaneous documents over fading memories. In most cases where a significant dispute persisted, a dissenting view is reflected in the notes that follow.

PAGE PROLOGUE

1 *more than one hundred:* Between 2005 and 2010, American museums returned a total of 102 objects to Italy and Greece: 20 to Italy from the Metropolitan Museum of Art, including the Euphronios krater and the Morgantina silvers; 13 to Italy from Boston's Museum of Fine Arts, including its iconic statue of Sabina; 43 to Italy and 4 to Greece from the J. Paul Getty Museum, including the Aphrodite and the gold funerary wreath; 8 to Italy from the Princeton University Art Museum; and 14 to Italy from the Cleveland Museum of Art. Hundreds more objects were returned during those years by European and Japanese museums, antiquities dealers, and private collectors. *more than half a billion:* Italian authorities gave an insurance value of $700 million to fifty-six returned objects displayed in an exhibit titled Nostoi: Returned Masterpieces, which did not yet include the Aphrodite and Euphronios krater.

2 *an Egyptian papyrus:* The Abbott Papyrus at the British Museum.
 "In all Sicily": Marcus Tullius Cicero, *Against Verres*, 2.4.1, in *The Orations of Marcus Tullius Cicero*, translated by C. D. Yonge (George Bell & Sons, 1903). Accessed via Perseus Digital Library, http://www.perseus.tufts.edu/.

3 *"I saw successive"*: George Gordon Byron, *The Poetical Works of Byron*, Cambridge edition (Houghton Mifflin, 1975).
5 *"The Age of Piracy"*: Thomas Hoving, *Making the Mummies Dance: Inside the Metropolitan Museum of Art* (Simon & Schuster, 1993), 217.

1: THE LOST BRONZE

9 *In the predawn light:* The discovery of the bronze statue and its subsequent journey are based on the authors' 2006 interviews with Igli Rosati, the last surviving crew member of the *Ferrucio Ferri*; Sebastiano Cuva, a friend of the boat's deceased captain, Romeo Pirani, and others in Fano; Italian investigative files; Italian court documents from trials of the alleged smugglers; a 2006 investigative report on the bronze by the law firm Munger, Tolles & Olson; and Thomas Hoving's 1979 *20/20* report on the bronze (see chapter 4), a copy of which was provided by producer Peter Altschuler.

For details about the bronze, see Jiri Frel's monograph *The Getty Bronze* (Getty, 1978 and 1982) and Carol Mattusch's *The Victorious Youth* (Getty, 1997). Mattusch and other experts are uncertain of the Lysippus attribution. Heinz Herzer's restoration is based on interviews with Herzer and Artemis officials and on Getty conservation reports.

14 *Getty was a shrunken:* The description of and biographical details about J. Paul Getty are from interviews with Stephen Garrett and Burton Fredericksen and from several biographies of Getty, especially Russell Miller's *House of Getty* (Henry Holt, 1985) and Robert Lenzner's *The Great Getty: The Life and Loves of J. Paul Getty—Richest Man in the World* (Crown, 1985).

he bore a passing resemblance: Getty's friendship with Nixon became an issue when, in the midst of the Watergate hearings in September 1973, the billionaire suggested having Nixon officiate over the opening of the original Getty Museum. His adviser Norris Bramlett gently objected, noting, "Mr. Nixon is a very controversial person at this time. While I doubt that it actually will happen, it is possible that in four to six months he might be involved in impeachment proceedings." Getty Trust archives.

Adolf Hitler: The authors obtained, through a Freedom of Information Act request, a declassified memo on Getty from the commander of the U.S. Office of Naval Intelligence to FBI director J. Edgar Hoover dated August 26, 1942. It shows that the U.S. government considered Getty a "potential subversive," noting several links between him and the Axis powers. Just weeks after Germany invaded Poland in 1939, Getty traveled to Berlin and attended a speech by Hitler, commenting in his diaries that he found the führer's ideas "worthy of consideration." That same year, Getty spoke admiringly of the Italian dictator Benito Mussolini, writing in his diary that "Il Duce" was "the greatest son of Italy since Augustus" and had "done great things for Italy." In 1938, Getty purchased the Pierre Hotel in Manhattan and hired former employees of the Italian and German consulates to staff it. The hotel was known as a "hang-out for pro-Axis personalities and French collaborationists." In January 1941, Getty allegedly shipped a large amount of Mexican oil to Germany via Vladivostok. Later that year, Getty was re-

jected for a commission in the U.S. Navy because he was "suspected of being engaged in espionage." Despite those ties, the memo concludes, "It would appear, lacking other evidence, that Getty has been indiscreet in his choice of associates and naive in his interpretation of the political scene, rather than an avowed supporter of the Nazi or Fascist regimes."

15 *"The beauty one can find"*: J. Paul Getty, *As I See It* (Getty, 2003).
16 *Getty had begun collecting:* Getty's collecting is based on interviews with Garrett and Fredericksen and Getty's own accounts in *As I See It* and *Collector's Choice: The Chronicle of an Artistic Odyssey Through Europe* (W. H. Allen, 1955), a book Getty coauthored with Ethel Le Vane. See also the Getty Museum's 2009 exhibition catalogue *Collector's Choice: J. Paul Getty and His Antiquities.*
 "The habitual narcotics user": Getty, *As I See It.*
17 *"To me my works":* Le Vane and Getty, *Collector's Choice.*
 In a novella: J. Paul Getty, *A Journey from Corinth* (Privately printed, 1955). The original manuscript is in the Nethercutt Collection in Sylmar, California. According to a note in the Getty Research Institute archives, "The manuscript appears to have been prepared by a copy editor and later appears as a chapter in *Collector's Choice.*"
 Arriving at Sutton Place: Based on accounts of life at Sutton Place in Getty biographies.
 his hands shook: Based on reports of Getty's health at the time.
18 *Just as Getty was learning:* The Met's pursuit of the bronze and Getty's legal concerns are detailed in interviews with Thomas Hoving and confidential Met documents, including Dietrich von Bothmer's June 1973 acquisition report to the board of trustees; a memo from von Bothmer to Hoving dated January 1973; Hoving's June 1973 letter to Getty detailing the collector's legal concerns about the bronze; and correspondence between Hoving and Artemis officials. See also Hoving, *Making the Mummies Dance*, 366.
 some eight times: Saving Antiquities for Everyone (SAFE), podcast, February 20, 2006.
 the New York Times *began:* The series opened with an investigation by Nicholas Gage on February 18, 1973, and continued into early 1974.
19 *Hoving decided to propose:* Met documents and interviews with Hoving.
20 *a tax shelter:* This account is based on documents in the Getty Trust archives. Marion True described Getty's motives in her introduction to *The Getty Villa* (Getty, 2005): "Making the collection available to the public would bring with it certain tax benefits that appealed to the wealthy but thrifty collector." (See "admission" note below.)
21 *The small museum opened:* True, *Getty Villa;* interviews with Garrett and Fredericksen; Getty Trust archives.
 No admission was charged: At one point, Getty suggested charging admission but was advised against it by Bramlett. "While they would have no right to do so, people like Ralph Nader and Congressman [John] Patman could have a field day out of the J. Paul Getty Museum making an admission charge and I feel it would cause considerable ill-will and bad publicity towards you personally," Bramlett wrote Getty in a September 25, 1973, letter. "This is because you personally have been allowed under the tax law huge deductions in

computing taxable income because of your personal contributions to your Foundation. This means that the funds in the Museum are quasi-public funds because presumably the public at large has paid more taxes so that you could enjoy the tax saving. If the public must now pay to see the Museum, they could very well feel this is an imposition." Getty took Bramlett's advice and insisted that his museum be "free of all charges—be they admission or even for parking automobiles" (Getty, *As I See It*, 279). Admission to the museum is still free today, but it costs $15 to park in the garage.

22 *Garrett was skeptical:* Interviews with Garrett.
"It will be a re-creation": Interviews with Garrett.
the billionaire micromanaged: Interviews with Garrett; Getty Trust archives.

23 *the new Getty Museum:* Among the antiquities dealers who attended the opening were Robin Symes and Heinz Herzer. Getty never saw the museum that bore his name. After he left the United States in June 1951, he never returned, in part because of his fear of flying.

24 *beg and plead:* Interviews with Garrett and Fredericksen; Getty Trust archives.
the ninth codicil: According to Getty's will, press accounts, and copies of the Getty's federal tax forms, especially for 1977, Getty's gift amounted to sixty-four acres of property in Pacific Palisades (although the location is always referred to as Malibu, which is just a few blocks away) worth $3.1 million; the ranch house; Getty's $3.6 million art collection; $17 million in cash; and four million shares of Getty Oil stock worth $662 million. The will's twenty-first codicil—added by Getty shortly before his death, with Bramlett as the only witness—took control of the museum's share of the estate out of his family's hands and gave it to the museum's six-member board of trustees.

25 *to avoid paying California taxes:* According to records in the Getty Trust archives and an interview with former *Los Angeles Times* art critic William Wilson, the Getty frequently lent new acquisitions to out-of-state museums to avoid paying California's sales and use tax on foreign works of art.

2: A Perfect Scheme

26 *Among those:* Biographical details about Jiri Frel are from the Getty Trust archives and interviews with Stephen Garrett, Burton Fredericksen, Thomas Hoving, George Goldner, Selma Holo (director of the International Museum Institute and USC Fisher Museum of Art), Bruce McNall, William Wilson, Jerry Eisenberg, and Frel's ex-wife, Faya Causey.

27 *once revealed:* Declassified FBI documents. Frel said that he had tried to join the Communist Party as a career move but was rejected because of his "independent political philosophy." He added that the Communist regime had permitted him to travel extensively for academic reasons but had made him fill out lengthy forms listing the names of his contacts and information about them—information that he suspected was reviewed by the Czechoslovak intelligence service.

29 *"fucking American morons":* This quote and the preceding descriptions of Harold Berg are from interviews with Thomas Hoving.

in Wiener's name: Interview with Malcolm Wiener.

30 *twenty-five-year-old coin dealer:* Biographical details about McNall are from public records; interviews with McNall, Hoving, Arthur Houghton, and Robert Hecht; and McNall's autobiography, *Fun While It Lasted: My Rise and Fall in the Land of Fame and Fortune* (Hyperion, 2003). McNall is known for his boyish enthusiasm and ever-changing stories about himself. A dropout from a Ph.D. program in classics at UCLA, he told people he had attended Oxford. In truth, he had just driven through the university. He told Hecht that he had once worked with a local plastic surgeon helping perform face-lifts. According to a former colleague, McNall also claimed to have been a surgeon in a burn unit before an especially sad case of a burned girl prompted him to turn to coins. When the colleague pointed out that McNall was far too young to have graduated from medical school, the dealer claimed that he had been in an accelerated program. "It was easy," he quipped. McNall, who later acquired a controlling interest in the Los Angeles Kings hockey team, was convicted in December 1996 of defrauding his own franchise, a securities firm, and six banks of $236 million. He was sentenced to seventy months in prison and ordered to pay $5 million in restitution to the banks. He was released from prison for good behavior in 2001 after serving nearly five years.

McNall's supplier: Biographical details about Hecht are from interviews with Hecht, McNall, Hoving, and Giacomo Medici; Marion True, deposition before Paolo Ferri and Guglielmo Muntoni, Los Angeles, June 20–21, 2001 (hereafter "True's 2001 deposition"); Frieda Tchakos, deposition before Paolo Ferri, Limassol, Cyprus, February 19, 2002 (hereafter "Tchakos's 2002 deposition"); Robin Symes, deposition before Paolo Ferri, Rome, March 28, 2003 (hereafter "Symes's 2003 deposition"); and Hecht's unpublished memoir, which was seized by Italian authorities.

32 *to back up values:* In the authors' interview with Jerry Eisenberg, he said, "I did a few appraisals but never took any commission from Frel. I remember he wanted to get as much as he could. I wouldn't put my signature on it unless I could defend it."

33 *The value of the gifts:* According to Hecht's memoir, in which he recounts discussing the dollar amounts with Weintraub: "Later, Sy remarked to me that he only purchased antiquities to make donations and that it was not worth his trouble if he could not multiply his cost by 5× for the donation." *the donation scheme:* Interviews with McNall; Arthur Houghton's contemporaneous notes (hereafter "Houghton's notes"); confidential Getty records of its internal investigation into the donation scheme. All the donors, with the appraised values of their donations, are listed in the trust's tax returns. Most donated objects were published in the *J. Paul Getty Museum Journal*, the museum's annual catalogue of acquisitions. Actual values paid for the objects come from internal Getty records or Houghton's notes. Jane Cody, McNall's former wife, said that she knew nothing about $293,000 worth of antiquities listed as gifts in her name. Faya Causey would not comment on donations from her and her family. Sy Weintraub died in 2000. Gordon McLendon died in 1986. In an e-mail to the authors, attorney Ken Ziffren said, "My partner, Skip Brittenham, and I recall that Bruce McNall, then a client of

our firm, asked if we would purchase some Greek art and donate it to the Getty Museum. We agreed to do so and believe we ultimately purchased the art and donated it on the basis of the actual cash purchase price each of us paid for the art. We became aware sometime later that other individuals may have donated art on the basis of large appraisals of fair market value. Neither of us recall any contact with Mr. Frel." In a subsequent e-mail, Ziffren corrected that statement, saying that a review of his records showed that neither he nor Brittenham had actually purchased any objects or claimed any tax deductions. Ziffren and Brittenham refused to elaborate, citing attorney-client privilege. Lily Tomlin, contacted through a representative, declined to comment. William Herbert Hunt, speaking on his brother Nelson Bunker's behalf, said that they had done business with McNall and met Frel but that he did not specifically recall buying any objects on display at the Getty. In the authors' interview with Alan Salke, he confirmed that the government took him to court over the appraised value supplied by Frel for his donation to the Getty. Salke said that he ended up settling for a value of $75,000 and paid $35,000 in back taxes. Richard Sandler, an attorney for the Milkens, said that Lowell never donated anything to the Getty. Michael did, Sandler said, but only after he had an independent appraiser set the value for tax purposes, which the IRS did not contest. The authors could not reach Stanley Silverman for comment.

36 *He built a swimming pool:* Interviews with McNall and Eisenberg.

a shiny BMW: Interview with Goldner. Vasek Polak died in 1997.

one of the largest: Tax fraud has been a recurring problem in American museums, but few cases have been as systematic as the Getty's decadelong scheme. In 1982, two undercover IRS agents made donations of overvalued Egyptian artifacts to the Los Angeles County Museum of Art. LACMA officials accepted the objects with inflated values and signed backdated donation forms for the agents. LACMA officials later said that this was "an honest mistake" and promised to change their procedures. But in 2008, LACMA was among several southern California museums raided by federal agents investigating a tax fraud scheme involving the donation of inflated Southeast Asian artifacts. To date, no museum official has been charged with a crime. The Smithsonian Institution also has been accused of repeat offenses. In 1983, the IRS found that gems donated to the Smithsonian had been appraised at five times their true value. The museum pledged to tighten its procedures. In 1997, a New Jersey businessman donated four Stradivarius instruments with a claimed value of $55 million to the National Museum of American History, making it one of the largest gifts ever to a Smithsonian museum. Records later provided to Congress showed that museum officials had valued the instruments for insurance purposes at just $5 million. The donor was later convicted of an unrelated tax fraud.

More than a hundred: These figures and the broader tax fraud were first exposed by Thomas Hoving and Geraldine Norman, "Huge Tax Fraud Uncovered at Getty Museum," *Times* (London), February 13, 1987. The authors independently confirmed the donation amounts with Getty tax records and confidential Getty records of its internal investigation.

Others viewed the donations: Interviews with Eisenberg and Fredericksen; Houghton's notes.

3: Too Moral

38 *the Getty would be required:* As a private operating foundation, the Getty is obligated to spend 4.25 percent of its endowment every year on activities that benefit the public. With $1.2 billion in assets in 1981, that amounted to $51 million in required spending.

40 *Williams laid out:* This account of the Getty Trust's conception is drawn largely from interviews with Harold Williams and from the trust's archives, which include the original proposal from Otto Wittmann and other key documents. The Getty's unusual structure—having a museum director who reported to the CEO of the trust—would prove to be a fateful choice, as successive generations clashed over their respective roles.

41 *Arthur Houghton III:* Biographical details about Houghton are from Houghton's résumé, public records, and interviews with former Getty officials. Given his unusual background, many suspected that Houghton had been— or perhaps still was—an employee of the CIA. Houghton did little to dispel the rumor, and the story grew into a tall tale about the agency having dispatched Houghton to the Getty to keep an eye on Frel, a suspected Communist spy. Neither was true. Houghton had worked briefly in the State Department's bureau of intelligence and had close friends at the CIA, but he was never a spy.

He began collecting: Much of this chapter is taken from confidential Getty records and hundreds of pages of detailed notes that Houghton kept of his activities in the Getty's antiquities department. Thanks to his State Department training, Houghton's remarkable diary of his daily life often recounts verbatim conversations and detailed descriptions of meetings and events. Confidential Getty records, including attorney Bruce Bevan's investigation of Houghton's allegations against Frel, and interviews with several former Getty officials, including Williams and John Walsh, confirmed and expanded on these events.

42 *young German secretary:* When asked about Houghton's account, Renate Dolin told the authors that she was unaware of the donation scheme. "Whatever I typed was dictated to me. He [Frel] would give me papers to type and dictate letters to me, and I would just type it. I was really not knowledgeable about what it meant."

44 *Marit Jentoft-Nilsen:* Jentoft-Nilsen died in January 2005, before the authors had an opportunity to contact her. A member of her family provided the authors with hundreds of pages of her personal records from her time at the Getty that verify much of Houghton's account and add new details.

45 *courtesy of a major dealer:* The dealer was Robin Symes, according to Houghton's notes.

"massive cash payments": According to Houghton's notes, Mayo told Houghton about the payments over dinner on June 24, 1983. Attorney Bruce Bevan also described the alleged payments in a confidential memo to Harold Williams dated May 1984: "She told Houghton that she had seen or knew of massive cash payments by Summa [Gallery] to Frel and that Bruce McNall of Summa was a guarantor of the note on Frel's house. Ms. Mayo has refused to discuss the matter with me." In the authors' interview with Mayo, who later became antiquities curator at the Virginia Museum of Fine Arts, she

denied acting as a conduit for payments to Frel and recalled confronting Houghton about the story.

The dealers hosted: The description of the reception at the Kimbell is from interviews with McNall, a former Getty official, and other participants, as well as Houghton's notes.

46 *a collection of ancient amber:* The actual and claimed values of the McLendon donation are detailed in Houghton's correspondence with McNall over the IRS investigation, interviews with McNall and a former Getty official, and Houghton's notes, which include this passage: "McNall said that the McLendon IRS settlement involved McLendon's acceptance of IRS' judgment that the material he had bought had been vastly over-valued, was worth only $1.5 million rather than the very high figure he had placed on it (McNall said 'over $20 million'), and that he had had to return $2.1 million to IRS. McLendon had then demanded reimbursement from McNall, with threat of going to IRS with the full story if McNall did not pay. McNall said he [Frel] thinks he has not been implicated now, although he [Frel] had arranged the transfer of the McLendon material to the Getty Museum, falsifying the appraisals as having been given by Fritz Bürki."

his legal memo in hand: Based on a copy of the June 1983 legal memo and interviews with a former Getty official. Houghton's personal attorney was his half brother Peter P. Gates.

47 *several other Getty donors:* This account, contained in Houghton's notes and subsequent documents from an internal investigation, was later confirmed by a senior IRS investigator interviewed by the authors. The IRS investigation never resulted in charges because Frel left the country before the full scope of the scheme came to light, and proving intent would have been difficult, the investigator said.

48 *"You have no idea":* Frel's comment would prove prescient when, in 2008, IRS and other federal officials raided four southern California museums while investigating a similar donation scheme, this one involving looted Southeast Asian antiquities. At least one of the players in the 2008 scheme was also involved in Frel's donation scheme at the Getty. The scope of the problem became clear when the *Los Angeles Times* did an analysis of IRS art donation records. American art donors claim nearly $1 billion in tax write-offs every year, the records show. Over the past twenty years, the IRS has checked only a handful of these donations, but more than half were found to have been appraised at nearly double their actual value.

50 *"Jiri's wife smuggled it":* Houghton's notes cite a December 1983 conversation with Faya Causey about the Egyptian head: "I asked if she had Customs invoice for it; she said no, she had not reported it to Customs, simply walked it in." Houghton's notes also say that he later told Frel that he would not present the piece for acquisition because of the facts that "it had no Customs clearance, that it was an object which could not be presented—and that if it were bought it would have illegally entered the museum, making both him and the museum vulnerable to a charge of willful felony." Causey, now at the National Gallery of Art, denied the account. "It's not true," she said. "I didn't carry stuff in, not with two kids."

at each other's throats: Jentoft-Nilsen's personal records and interviews with a family member and a former Getty official.

The question of his personal gain: Getty officials did not acknowledge the reasons for Frel's departure until four years later, in 1987, when Thomas Hoving and Geraldine Norman exposed the tax fraud scheme in their article "Huge Tax Fraud Uncovered at Getty Museum." Even then, Getty officials insisted that Frel had been allowed to stay on the Getty payroll because no evidence had appeared to suggest that he had benefited personally from his activities. This was not true. In addition to the reports of "massive cash payments," several reports had emerged that Frel was accepting "commissions" from antiquities dealers while on the Getty payroll. For example, in 1984 Williams was told that Frel had requested a $500,000 kickback in exchange for convincing the Getty to buy a number of Roman bronzes. In February 1985, Houghton informed Walsh in a memo that Frel had received a $10,000 commission for assisting in the sale of a $200,000 statue of Venus to Fred Richmond, a former New York congressman who had lost his seat after pleading guilty to tax evasion and marijuana possession in 1982. (Richmond served nine months in prison.) The Venus was jointly owned by Robert Hecht, Jonathan Rosen, and Hydra Gallery, the Swiss front company for Giacomo Medici, who ultimately paid Frel, according to Houghton's memo to Walsh. "This has been going on for years," the memo concluded.

51 *He had begun:* Confirmed in interviews with Williams.
 the fate of Getty Oil: See Thomas Petzinger Jr., *Oil and Honor: The Texaco-Pennzoil Wars* (Putnam, 1987).

52 *They confronted him:* Houghton's notes give the date of the meeting and Frel's subsequent account of it to Houghton. See also Hoving and Norman, "Huge Tax Fraud Uncovered at Getty Museum."
 Bevan's investigation yielded: Bevan recounted his investigation in a detailed confidential memo to Williams dated May 10, 1984.

54 *a cunning gamesman:* Petzinger, *Oil and Honor.*
 It was projected: The costs of the Getty Center escalated precipitously over the years. In 1983, when the trust first announced plans for the construction project, it was projected to cost just $100 million and expected to be completed by 1987. A Getty press release from 1991 estimated the cost at $390 million. By the time of its opening in 1997, the cost of the Getty Center had exceeded $1 billion. The Getty Villa renovation project was beset by similar delays and cost overruns.

56 *The issue was sensitive:* Williams has denied any wrongdoing, saying that there was no need to notify the board or the IRS. "It was a phony transaction that had to be undone," he told the authors.

4: Worth the Price

57 *Sitting in the Getty's:* Details about the kouros are from Houghton's notes, confidential acquisition reports provided to the Getty board, scientific analysis from Getty conservation reports, and interviews with Jerry Podany.
 only a dozen: See Gisela Richter's landmark study, *Kouroi: Archaic Greek Youths; A Study of the Development of the Kouros Type in Greek Sculpture* (Phaidon, 1970).

58 *the trustees gathered:* Thomas Hoving, *False Impressions: The Hunt for Big-Time Art Fakes* (Simon & Schuster, 1996), 279–310.

Zeri's denunciation: The lengthy internal debate over the legal status and authenticity of the kouros is taken from various confidential Getty records, including Bruce Bevan's legal memo to Getty general counsel Barbara Capodieci in July 1984; Houghton's notes; and interviews with Thomas Hoving, John Walsh, Harold Williams, Burton Fredericksen, and other former Getty officials.

59 *were being denounced:* Houghton's notes show that he privately obtained a copy of a memo from the 1982 annual meeting of the Archaeological Institute of America's Committee on Professional Responsibilities, in which the Getty's collecting policies were denounced.

a series of memos: They include memos on November 9, 1983, regarding criticism from the archaeological community of the Getty's acquisition policy, which Houghton said "need not be given overdue weight in determining what we acquire"; on November 23, 1983, regarding the kouros; on November 29, 1983, regarding the potential fallout from acquiring the kouros; on January 20, 1984, regarding the possibility of collecting antiquities from the Near East, in which Houghton noted, "clandestine excavations will continue, new objects of both greater and lesser importance will appear on the market, and the likelihood of any single new buyer substantially affecting this process will probably not be high"; on April 3, 1984, regarding the National Stolen Property Act, in which Houghton informed Walsh that U.S. Customs Service officials would enforce the 1977 *McClain* decision making illegally exported objects stolen property under U.S. law (see next note); on May 24, 1984, regarding the provenance policy of other American museums, in which Houghton notes that other museums were concerned that they not be "seen to encourage" looting while at the same time not be "so restrictive as to preclude the acquisition of objects important to their collections"; and on September 27, 1984, a lengthy confidential discussion titled "Ethics and the Acquisition of Antiquities." The last memo is perhaps the best articulation of a view that guided American museums for decades and ultimately led to the international scandal. Ironically, Houghton at the time was a member of the State Department's Cultural Property Advisory Committee, whose task was to consider requests from foreign governments for U.S. restrictions on the importation of antiquities.

61 *a 1977 case: United States v. McClain* established an important legal precedent: dealing in objects taken from a country with a clearly established ownership law would be considered the equivalent of trafficking in stolen property under the National Stolen Property Act. In this case, the U.S. Court of Appeals for the Fifth Circuit upheld the conviction of American art dealers who knowingly sold Mexican antiquities protected under Mexico's cultural property law, which declared undiscovered antiquities the property of the state. The appellate decision was legally binding only in the Fifth Circuit but suggested that other courts might consider the practice of buying illegally excavated or exported antiquities a violation of the National Stolen Property Act. Not until the conviction of Manhattan art dealer Frederick Schultz in 2002 (*United States v. Schultz*) did the "McClain doctrine" formally take root in New York, the heart of the American antiquities trade.

"The reality is": This stark assessment, which Houghton's notes show was widely discussed inside the Getty from as early as April 1984, is one of several indications that American museum officials were well aware that they were buying recently looted objects, a charge they vehemently deny to this day.

62 *a geochemist:* Stanley Margolis, a professor of geology at the University of California, Davis, described his process and results in "Authenticating Ancient Marble Sculpture," *Scientific American*, June 1989, as well as in internal Getty technical reports.

One expert on classical: Professor Evelyn Harrison cautioned the young museum against hubris: "At this stage of the development of the Getty collection of classical sculpture, I wonder whether the loss of a spectacular acquisition to a European competitor (assuming that the kouros is authentic and truly beautiful) would do the reputation of the museum as much harm as would be done by the addition of another piece which is either of morally dubious provenance, like the 'Getty Bronze' or of questionable authenticity . . . There are so many fine and important pieces in the collection that it seems too bad to let them be overshadowed in this fashion." Her prescient advice was ignored.

63 *"They read the technical":* Cornelius Vermeule's phone conversation with John Walsh is described in Walsh's confidential memo to file dated August 9, 1984.

Walsh then contacted: Walsh's conversation with von Bothmer is described in Walsh's confidential note to file dated August 15, 1984: "He has talked with Becchina, who assured him that 'you can exclude Greece' as its place of origin, meaning modern Greece, and that he should 'pay no attention to the documentation, since it will not help you.' Von Bothmer takes this to indicate Magna Graccia, specifically Sicily." Also, Houghton's memo to Walsh dated March 5, 1986, makes clear that Getty officials knew that Gianfranco Becchina trafficked in looted art and notes that von Bothmer "has spoken many times to others about his conviction that the kouros was excavated recently, at Mozia, an island off Sicily's western coast."

64 *learned about the interview:* Houghton's notes describe True's role and detail the Getty's hurried efforts to find a translation of Zeri's remarks.

In talks with the Getty: The Tempelsman negotiations are based on Houghton's notes and his October 10, 1984, report to Walsh.

65 *an Italian middleman:* Biographical details about Giacomo Medici are from Italian court records and interviews with Medici, Robert Hecht, Frieda Tchakos, and former Getty officials.

66 *Inside the Getty:* Interviews with two former Getty officials.

Houghton had once made: Houghton's notes show that he visited Medici's Geneva warehouse in February 1984. During the visit, Medici and an associate also said they "used English sales to give good provenance to material they wanted to sell later." Medici explained to Houghton that he would have someone else put one of his objects up for auction, then buy it himself. In this way, objects were "washed through Sothebys [*sic*]."

Houghton detailed his discovery: Houghton's memo to Gribbon dated October 24, 1985.

67 *made a surprising announcement:* Walsh's July 1, 1985, memo to museum staff. He also copied the staff of the Getty Trust.

Gianfranco Becchina: Anti-Mafia law enforcement authorities in Sicily allege that Becchina has ties to the Sicilian Mafia. Specifically, one Mafia turncoat described Becchina as what is known in the Cosa Nostra as *"a disposizione"* —a friend of the family, someone who could be tapped by the Mafia for a favor if the need arose. Becchina's neighbor in Castelvetrano, Ciccio Messina Denaro, was made a member of the "Super Cosa," a council of the three most powerful Mafia families, soon after Frel's arrival. The Denaro family owned several sand quarries. One of Becchina's businesses in Castelvetrano was a cement company. His business partner in that venture would later be convicted of Mafia-related crimes. Becchina denies any ties to organized crime.

68 *He sent a memo:* Houghton's March 5, 1986, memo to Walsh, titled "Kouros: Public Guidance: Questions of Provenance." Houghton also noted that Becchina was "believed to work extensively with Italian sources" and that von Bothmer was convinced that the kouros had been "excavated recently, at Mozia, an island off Sicily's western coast."

69 *"The kouros documents":* Houghton's notes from March 5, 1986.
In March 1986: Interviews with Hoving; Hoving, *False Impressions,* 279–80.

70 *"Frel told me":* Houghton's notes of the March 17, 1986, meeting with Gribbon, Walsh, and True. According to Houghton's notes, Walsh and True both thought it better not to investigate the suspect kouros documents: "JW said he believed the kouros was a recent discovery. It may have been found in S. Italy, delivered from Italians through Becchina to us. He did not want to pursue the matter of the letters—it was better not to know whether the signatures were authentic. MT made strong recommendation that the Museum should not know that the letters were forged. We should not confirm it. I disagreed."

71 *a carefully orchestrated plan:* Houghton's notes, his resignation letter, and interviews with former Getty officials. Among those Walsh consulted after reading Houghton's resignation letter was Harry Stang, an attorney at Musick, Peeler, the Getty's law firm. Years later, Stang would represent True after she was indicted by the Italians.

5: AN AWKWARD DEBUT

74 *Marion True had come:* Biographical details about True are from her résumé; her high school yearbook; and interviews with friends, a high school classmate, town officials, and former professors and colleagues, including Stanley Moss and John Herrmann. Details about her marriage to the cardiologist come from public records and an interview with her stepdaughter Fiona McCaughan. The account of True's early years at the Getty is based on interviews with former Getty staff and True's annual performance evaluations, in which she described her work. True provided details about her career in Marion True, written statement submitted to Paolo Ferri, Rome, October 17, 2006 (hereafter "True's October 17, 2006, statement to Ferri").

76 *a growing taste for extravagance:* Interview with McCaughan.
cleaned $50,000 out: According to McCaughan, citing conversations with her

father, who is now dead. In a written reply to the authors, True denied the story: "I did not leave with $50,000 nor did I claim I had the right to $50,000. We never had $50,000, but $35,000 from the sale of our previous residence. I took enough money to buy a car ($5000 for a Honda CVCC) and $750 to pay the deposit on a studio apartment in Cambridge. The divorce, for which I filed, was a no-fault divorce and I asked for nothing — no alimony, no property or anything else."

77 *She refused to return:* Interview with a London dealer and an American curator knowledgeable about the arrangement, which True confirmed in her written reply to the authors: "Ingrid McAlpine could not demand the return of the money, because there were no grounds and I was not fired. After 4 months, I had found another position with Stanley Moss and resigned."
 Frel believed: Interview with Faya Causey.

78 *she left the controversial Straw:* In her written reply to the authors, True said, "I had no position in Steven Straw and Co., but was paid on an hourly basis for research done on 19th [century] American and European paintings (not my field) and thus did not consider it a part of my 'professional' experience as a specialist in antiquities."
 largely by default: Account of True's selection based on interviews with Delivorrias, Houghton, Goldner, and a close friend of True's at the time.

79 *True never did tell:* In her reply to the authors, True wrote, "When A. Houghton suggested that I report the dispute with [the] McAlpines as part of my background, I did not understand the need. There was no dispute to report — I had left of my own free will — and no lawsuit was ever filed. Also, to my knowledge, the Getty Museum never did business with the McAlpines."
 Houghton placed a call: Houghton recounted the call in a letter to a former colleague still employed at the Getty.

80 *True reluctantly picked up:* True's kouros investigation is detailed in her December 1986 report to Bruce Bevan.
 only one other person: In 1990, further evidence came to light that the kouros was a fake. Jeffrey Spier, an American archaeologist and occasional antiquities dealer, told True that he had been shown the torso of a smaller kouros that was an obvious fake and bore a striking resemblance to the Getty's. The Italian seller told Spier it was the Getty kouros's "younger brother" and had been made by the same forger. Through further research with market sources, Spier learned that both statues had been carved by Fernando Onore, one of Rome's most renowned restorers and copyists, from the same large block of weathered marble taken from the ancient city of Selinunte, Sicily. When Onore was finished, others created the fake patina by rubbing the surface with lead, then "cooking" it in a bath of muriatic acid to crystallize the surface before giving it a final soak in sulfuric acid. It was then polished with chestnut leaves, which stained the surface a brownish color. The large kouros was reportedly given to a middleman in Calabria, who sold it to Gianfranco Becchina for 200 million lire (about $100,000). It is not clear whether Becchina was aware of its origins. The smaller kouros received a different patina. It was rubbed with vinegar and buried in the ground for more than a year. The result was less convincing. Several major dealers in Switzerland had refused to buy it, despite a rapidly falling price. It was being

offered to Spier because it was "burned" on the market. When True heard Spier's story, she was intrigued. The Getty purchased the torso of the small kouros, paying $25,000 plus a $75,000 "finder's fee" to the dealer. Its similarities to the larger kouros led True to doubt the authenticity of the Getty's statue even more. She confided to Spier and others that she now thought the Getty's statue was "almost certainly a fake." When True showed the smaller kouros to Becchina, the dealer became furious, claiming that Giacomo Medici had had it made to discredit the Getty's statue. True's own investigation confirmed Becchina's suspicion: Medici had ordered the forgery made. When True confronted Medici about the small kouros, the dealer laughed and offered to donate its missing pieces—two legs and the head—to the Getty. The pieces had not received the botched acid wash and were a floury white—almost a perfect match to the larger kouros. If, as it appears, the larger kouros was an elaborate ruse orchestrated by Medici to undermine his rival Becchina, the scheme worked. The Getty never did business with Becchina again, and Medici became the museum's principal source of antiquities. The authors were unable to locate Onore, and Becchina refused to comment.

6: THE WINDBLOWN GODDESS

84 *she paid a visit:* The story of the Aphrodite in Battersea and its arrival at the Getty were detailed in an interview with antiquities conservator Jerry Podany and in his conservation report. Its subsequent acquisition, as well as technical details about the statue, are contained in the museum's files and in confidential Getty records of the subsequent internal investigation. The files include True's acquisition proposal, one of the few expert views rendered on the statue.

Symes was a fair: In a March 20, 2001, deposition for an unrelated lawsuit against Symes, Christo's sister Despina Papadimitriou described how the couple worked. "My brother had a good eye for beautiful objects. He had enormous drive, energy and vision and usually took the initiative in acquiring objects and undertaking business risk. He also had my family's strong financial background and was accustomed to considerable wealth . . . Robin also had a good eye but was more conservative. His strongpoint was an ability to sell works of art to clients at a high price and to keep those clients happy."

Their London house: The two separate houses at 1/3 Seymour Walk had been joined into one. Symes and Michaelides shared the residence for more than twenty years.

88 *"Not to worry":* Interview with Nicolaos Yalouris, a former friend and colleague of True's, who said that the curator had been corrupted by the antiquities market.

Love had often warned: Interview with Iris Love. True denied this account through her attorneys.

The Getty's existing: The Getty's 1980 acquisition policy applied to all acqui-

sitions, not just antiquities, and included the following strict conditions: "No object will be approved for acquisition if it is suspected of being illegally exported from its country of origin or imported into the United States; no object will be approved for acquisition without assurance that valid and legal title can be transferred to the Museum; The J. Paul Getty Museum will abide by all United States and international law concerning transfer of ownership and transportation across boundaries; every effort will be made by the Museum to inquire into the provenance of the acquisition."

Walsh disagreed with: John Walsh, deposition before Daniel Goodman and Guglielmo Muntoni, New York, September 21, 2004 (hereafter "Walsh's 2004 deposition"); interview with Walsh; Walsh's confidential policy proposal to Harold Williams, November 5, 1987.

89 *Walsh proposed a solution:* Walsh's proposal and the internal debate over it in September 1987 are captured in the draft policy and copies of Walsh's handwritten notes. In an interview, Walsh confirmed to the authors the authenticity of the notes and elaborated on them. He and Williams still insist that the conversation—including statements such as "We know it's stolen" and "Symes is a fence"—were hypothetical and not direct references to the Aphrodite, which was being considered for acquisition at the time. True gave a different account, saying that the Aphrodite was seen internally as a "test case" for the new policy. Marion True, statement before Paolo Ferri, Rome, October 28, 2006 (hereafter "True's October 28, 2006, statement before Ferri").

Could the Getty: While at the Securities and Exchange Commission, Williams had played a central role in advocating for the Foreign Corrupt Practices Act and knew the museum might be held criminally liable for any bribes paid at any point in an object's path to the Getty.

91 *Luis Monreal . . . exploded:* Interviews with Luis Monreal. In a 2007 statement to the authors, Walsh said, "I believe we performed every test that the museum's conservators . . . thought might possibly be informative." In his own 2007 statement to the authors, Williams said that Monreal often sent "alarmist notes" and that Walsh's response in regard to the Aphrodite was "appropriate."

94 *If it contained pollen:* Some experts today debate whether palynology, the study of pollen, was sufficiently advanced at the time to make such a determination. Twenty years later, when the Getty finally tested the pollen and soil, experts were able to determine that they were consistent with samples from Sicily.

95 *one very upset antiquities dealer:* Hoving's conversation with the dealer was off the record. Hoving, who died in 2009, never broke his commitment to the dealer, refusing to provide the dealer's name to Italian authorities.

A top Sicilian smuggler: Orazio di Simone, according to Hoving. Di Simone's name would emerge again years later as a "friend" of the man who sold Symes the statue. When questioned by Italian authorities in a separate legal case, di Simone offered to lead them to the missing fragments of the Aphrodite, including her nose. In an interview in Rome with his attorney present, di Simone acknowledged knowing Renzo Canavesi, a "fellow coin collector," but denied being a smuggler or having any involvement in the Aphro-

dite. "What I know I've learned from the papers," he said. "There's nothing worse than a rumor that gets out and goes all around the world and stays on you as a mark forever."

96 *Hoving hung up:* Interviews with Hoving; Hoving's personal files.

7: THE CULT OF PERSEPHONE

97 *city-state of Morgantina:* The description of Morgantina is based on a visit to the site and interviews with Malcolm Bell, the director of the site's American archaeological team. The history of ancient Sicily is from M. I. Finley, Denis Mack Smith, and Christopher Duggan, *A History of Sicily*, vol. 1 (Viking, 1987). Sources as old as the Homeric "Hymn to Persephone" and Ovid's *Metamorphoses* mention Lake Pergusa as the site of Persephone's abduction. It was along its shaded banks, the Homeric hymn recounts, that Persephone plucked a "cosmic flower" and out popped Hades, her uncle and the god of the underworld.

99 *Giuseppe Mascara:* The authors tried to contact Mascara in both Sicily and Milan, where he moved after reportedly receiving death threats for cooperating with authorities. He would not comment. In the authors' interviews with Bell, he recalled crossing paths with Mascara several times in the early 1980s.

Looking at the photos: Despite mounting scientific evidence linking the Aphrodite to the Morgantina region, Bell has long been skeptical of the idea, more because of the absence of concrete evidence than his having any evidence to the contrary. Some experts suspect that Bell's reluctance to accept Morgantina as the source has its roots in his theory of the city's economic decline in the late fourth century B.C., something that would be hard to square with the statue having been created at that time.

100 *"I would therefore":* During the Aphrodite controversy and for years after, True and other Getty officials would distort Bell's conclusion, saying that he had completely ruled out Morgantina as a possible place of origin for the statue.

Graziella Fiorentini: Fiorentini did not respond to several requests for an interview. Her account is taken from her complaint to Italian authorities; her cables to True; her interview with Patricia Corbett, a reporter for *Connoisseur*; and Italian investigative documents. Thomas Hoving, Corbett's editor at the time, provided her handwritten notes to the authors.

101 *True tried calling:* True's account of these events is contained in her October 28, 2006, statement before Ferri and in confidential Getty records relating to the subsequent review of the acquisition.

the precise timing: Years later, Getty officials and the Getty's outside counsel, Munger, Tolles & Olson, would not say which came first—the Mailgram or Williams's signature.

102 *the Carabinieri's art squad:* Information about the art squad's early years is from interviews with General Roberto Conforti and other Italian officials.

103 *Raffiotta launched an investigation:* Based on interviews with Silvio Raffiotta and Fausto Guarnieri, who became the lead investigator of Mascara and the Aphrodite and worked closely with Raffiotta.

104 *Orazio di Simone:* The art squad has a lengthy file on di Simone, who was arrested several times in the 1980s and 1990s for his alleged involvement in antiquities smuggling. He was charged but never convicted for his role in the Aphrodite case. In the authors' interview with him in Rome, di Simone described himself as a coin collector and denied being a smuggler or having ties to the Sicilian Mafia, as some have alleged. At the time of the interview, he was under investigation again for his alleged role in another antiquities smuggling operation.

The three marble: Guarnieri's sources told him that the shepherds, the Campanella brothers, had gone to the hillside of the San Francesco Bisconti district of Morgantina after a big storm looking for coins and saw the top of a marble head poking out of the ground. That night, they returned to the site and put up a small tent to hide the light of their lamps and protect the hole they were digging from the rain. They found two marble heads and a number of matching feet and hands. A few days later, they found a third head nearby. It had a broken nose and was of a slightly different style—a description that matches the head of the Aphrodite. The Campanellas reportedly sold the three heads to middlemen in nearby Piazza Armerina for 200,000 lire (about $1,000). The middlemen allegedly sold them to di Simone. When approached by one of the authors at his farm, one of the Campanella brothers denied having ever seen the Aphrodite. "Here, if you talk, they shut your mouth and cut your throat," the aging shepherd said. His wife added, "Here, you see something and you didn't see anything, you hear something and you didn't hear anything. If you want to live happy, you don't know anything."

105 *one of Connoisseur's best researchers:* Patricia Corbett.

106 *the feud between:* Luis Monreal's exchange with John Walsh is based on interviews with Monreal and a description of the letters by two sources who wish to remain anonymous.

107 *just beginning his investigation:* The description of Guarnieri's investigation is based on Italian court records and interviews with Guarnieri and Raffiotta. The details were confirmed and expanded on in an October 3, 1989, report by the Sicilian journalist Enzo Basso in *Il Venerdì di Repubblica.* Basso did not name his source at the time but later confirmed that Mascara had given him details of the statue's discovery. Mascara was also one of Guarnieri's sources.

108 *an anonymous tip:* Some have speculated that the source of the tip was Robert Hecht, who was living in Paris at the time and likely would have known about the Aphrodite's discovery. Hecht was known to drop a dime on competitors when he was cut out of a deal. He would not comment on this speculation.

Nicolo Nicoletti: Nicoletti and di Simone were named in the subsequent criminal complaint filed by Raffiotta but were never convicted.

8: THE APTLY NAMED DR. TRUE

114 *Heilmeyer's radical thoughts:* Interviews with Wolf-Dieter Heilmeyer.
115 *"Well, this is":* Interview with Heilmeyer.
116 *"Holy doodle":* This comes from True's deposition in the lawsuit filed by the government of Cyprus and the Greek Orthodox Church against art

dealer Peg Goldberg regarding the mosaic. Marion True, deposition before Thomas Kline and Joe Emerson of Baker & Daniels, Los Angeles, April 25, 1989.

Karageorgis had started out: Houghton's notes detail the delicate negotiations with Cyprus over the idol. Houghton learned that the Getty had purchased it in 1983 for $480,000. A little digging revealed that the provenance information submitted by Jiri Frel had been invented. The object had likely been illegally exported from France (not Switzerland) and smuggled into the United States. The Getty also had likely paid nearly $300,000 too much for it. Although all this was troubling, Houghton's real concern was, once again, the optics. "Cyprus would seem to have no evidentiary basis for a claim that might compel the Museum to return the idol," he advised attorney Bruce Bevan, "but . . . publicity about it could become very negative, particularly if it follows some vigorous public discussion about provenance issues with other material, such as the kouros."

had been illegally removed: For a detailed account of the case, see Dan Hofstadter, *Goldberg's Angels* (Farrar, Straus & Giroux, 1994).

117 *"We as an institution":* When Goldberg's attorney asked her to clarify what she meant, True went further: "Well, obviously we are a museum that is in its acquiring phase, and we buy art on a continuing basis. At the same time it is our feeling that we should do this in as ethical a manner as possible, and that means that in making acquisitions we also want to respect the laws of the art-rich nations . . . and it would be I think really against our interests, against the interests of the institution that I represent, and my personal interest as a scholar to buy objects that were really—in a way that was counter to the interests of those countries." True carefully avoided any mention of the Getty's recent dispute with Cyprus over the museum's own incautious purchase of the looted idol. Instead, she portrayed the upcoming conference on Cyprus as a happy coincidence rather than part of the settlement of the nation's claim to the idol.

118 *"All the red flags":* Testimony of Gary Vikan, an expert in Byzantine art and at the time curator of medieval art at the Walters Art Museum in Baltimore. He is now the museum's director.

True organized: A month after the conference, Italy's minister of culture Francesco Sisinni contacted John Walsh about the Getty Bronze. Italy had not forgotten the old sleight. The Getty was ethically and legally obliged to return the bronze, Sisinni wrote, which Italy claimed had been exported illegally from the country. Walsh responded, "The statue has a tenuous relationship to Italian patrimony . . . To our knowledge no new facts have come to light that might affect our view of the status of the statue." Despite Walsh's bravado, the Getty hired Italian attorneys to review their legal standing in the case.

Meeting with Italian officials: Interview with Adriano La Regina, Rome's superintendent of antiquities. It was during a coffee break at this conference, True would later testify, that she was approached by an acquaintance named Giacomo Medici. Medici introduced his daughter, who was interested in archaeology and had applied to True's alma mater, New York University. True agreed to have dinner with the Medicis that night.

The Lex Sacra: Adapted from Margaret M. Miles, *Art as Plunder: The Ancient Origins of Debate About Cultural Property* (Cambridge University Press, 2008); internal Getty documents; and interviews with archaeological authorities at Selinunte, who to this day recall True's gesture.

119 *In March 1992.* This account is drawn from confidential Getty records; Greek, German, and Interpol law enforcement records; and interviews with senior members of the Greek art squad. Nikolas Zirganos, a Greek investigative reporter, uncovered much of the Greek side of the story and provided unmatched assistance to the authors. The description of the wreath and its artistic parallels is drawn from True's acquisition proposal and interviews with Jerry Podany, who accompanied True on her visit to the Zurich bank vault. True's thoughts are drawn from her account of the ordeal in her October 28, 2006, statement before Ferri. Subsequent criminal charges against True were eventually dropped because the statute of limitations expired during her Greek trial.

120 *On a business trip:* Interview with Frieda Tchakos.
Christoph Leon: Leon was a fallen archaeologist who had trained at the German archaeological school near Olympia, Greece. While there, Leon struck his colleagues as a clever young man and a promising archaeologist, someone who had the brains and the skill to make important advances in the field. But the young Austrian spent much of his time talking about fast cars and the fine restaurants he hoped to enjoy—luxuries the archaeological service would never offer. After receiving his degree, Leon drifted into the antiquities market, serving as an adviser to one of the biggest antiquities collector-dealers of the day, Elie Borowski. His former colleagues saw the move as a betrayal.

9: THE FLEISCHMAN COLLECTION

124 *whose friendship with the couple:* In sworn statements and court documents, both True and Barbara Fleischman claimed to have met in 1991. In fact, they met several years earlier, around 1986 (see chapter 17, note 6). Italian prosecutor Paolo Ferri believes that True and Fleischman attempted to obscure their earlier relationship to mask True's influence on the Fleischman collection.
the pieces were displayed: This description is derived from photos in the 1994 Getty exhibit catalogue and from people who visited the Fleischmans' apartment.
came from modest origins: The Fleischmans' background is drawn from interviews and Barbara Fleischman's self-published book, *No Substitute for Quality* (Greenwich Publishing Group, 1995), written for her husband's seventieth birthday in 1996.

125 *Overweight, outgoing, and at times pushy:* This description is from an interview with someone close to the Fleischmans.
Art, he preached: Oral history interview with Lawrence A. Fleischman, February 28 to March 9, 1970, Archives of American Art, Smithsonian Institution.

126 *His buying power:* Interview with Max Anderson, former assistant antiquities curator at the Metropolitan Museum of Art.

127 *"Larry Fleischman has bought":* J. Michael Padgett's handwritten letter to Karen Manchester.
"Everything comes": Interview with someone close to the Fleischmans.
The Fleischmans' relationship: Barbara Fleischman, deposition before Paolo Ferri and Guglielmo Muntoni, New York, September 20, 2004 (hereafter "Fleischman's 2004 deposition"). True described her relationship with the Fleischmans in her October 17 and 28, 2006, statements to Ferri. She noted her stays with them in her expense accounts, where she sought reimbursement for hospitality gifts, usually meals or flowers, purchased for them. In Walsh's 2004 deposition, he said that he encouraged the relationship.
a bidding war: Interview with George Goldner, former Getty drawings curator, who acted as an informal go-between during the negotiations.

128 *"surgical strike":* Interview with someone close to the Fleischmans.
True urged her bosses: Confidential Getty documents prepared for the $5.5 million purchase from Fleischman.
"I think it is": True's January 1992 memo to John Walsh.

129 *She offered the Getty:* Fleischman's 2004 deposition and her statement to the Getty board shortly before resigning (see chapter 20).

130 *Fleischman was stunned:* Ibid.
"I can't afford": Fleischman's 2004 deposition.
"I have a wonderful": Interview with John Herrmann.
the MFA pulled out: Ibid.
On opening night: Details of the Fleischman exhibit are from Fleischman, *No Substitute for Quality*, and Getty records in the Getty Trust archives.
nearly two hundred objects: Fleischman, *No Substitute for Quality*, 124.

132 *Suddenly, one boy:* Audio recording of Fleischman's lecture at the Getty.
were well aware: Based on an interview with a former official. Barbara Fleischman has denied being courted by the Getty for donations of money or antiquities.

133 *The tension had become:* Interviews with two former members of the Getty conservation staff.
invited Harold Williams: Ibid.

10: A HOME IN THE GREEK ISLANDS

135 *True had always longed:* The account of how True learned about the Páros house and her arrangements for a loan to buy it is based on True's October 17 and 28, 2006, statements to Ferri; interviews with Dimitri Papadimitriou, the nephew of Christo Michaelides; and Hugh Eakin, "Treasure Hunt," A Reporter at Large, *The New Yorker*, December 17, 2007.
a passport into: Descriptions of Greek society are based on interviews with Benaki director Angelos Delivorrias and Museum of Cycladic Art director Nicholas Stampolidis; reporting by Greek investigative journalist Nikolas Zirganos; and True's October 17 and 28, 2006, statements to Ferri.

136 *The Goulandrises bought freely:* Interview with Stampolidis.

137 *becoming chummy with collectors:* Interview with Selma Holo. A protégée of Jiri Frel, Holo said that True's predecessor taught her always to remember that collectors and dealers are not friends but lavish praise and favors on curators to advance their own financial interests.
"*I have to say*": Eakin, "Treasure Hunt."
The small villa: Greek land and sale documents.
on her curator's salary: Interview with George Goldner.
He advised against it: Eakin, "Treasure Hunt."

138 *He had wealth:* Christo's sister Despina married into the Papadimitriou family. Her shipping magnate husband and their son Dimitri used shell companies for both business and personal finances, according to testimony offered in a 2001 lawsuit filed against Symes by Christo's family after Christo's death. The family had forty offshore companies, some of which were controlled by Christo. "Never was Christo involved in the Papadimitrious' shipping, but, of course, the various 'Swiss' family offshore Panamanian companies controlled by Christo were used both by Christo for business and personal transactions," Despina testified in a March 21, 2001, deposition for the trial.
"*There is a lawyer*": Ibid.
a four-year loan: Transaction documents supplied by Harry Stang, True's Los Angeles attorney.
Michaelides later told: Interview with Dimitri Papadimitriou. In 2005, Michaelides' nephew recalled a conversation with his uncle in which Christo admitted being the source of the funds. Papadimitriou said that he also saw papers showing the $400,000 transaction. Later, through his London spokesman, Papadimitriou elaborated, saying that "any loan would have to come from family funds" and stressed that neither he nor his parents were involved in the loan.
"*I want someone*": The account of Papadopoulos's recruitment, work at the Getty, and specific conversations with True about the acquisition of the Fleischman collection is based on interviews with a former Getty official.

139 "*Can you look*": Interview with a former Getty official.
The initials: Footnote by Papadopoulos in the Italian Ministry of Culture's publication of the Francavilla Marittima material.

140 *Italian newspapers carried:* Interview with a former Getty official.
just another passing fad: Interviews with two former Getty officials.

141 "*Do you know*": Interviews with Goldner.

142 *more than 40,000-piece collection:* "New Mission for Getty Villa in Malibu Defined, Preliminary Master Plan Approved by Trustees, Modifications to Antiquities Acquisitions Policy," Getty press release, November 20, 1995. (Release put the collection at 30,000 objects, but officials say it was closer to 44,000.)
The announcement of: Ibid.

143 *The reaction to:* Interviews with officials at the Met, Boston's MFA, and Ricardo Elia at Boston University.
Fleischman would later claim: Interviews with Barbara Fleischman; Fleischman, *No Substitute for Quality;* Fleischman's 2004 deposition.

144 *True would be undermining:* In an interview, Heilmeyer, director of antiquities at the Berlin Museums, said that he also warned True against acquiring the

Fleischman collection. "I said I would never get that collection, not even as a donation. I would never take it because there was a lot of looted material in there."

Walsh and True flew: Walsh's 2004 deposition; True's 2001 deposition.

145 *With her hands shaking:* Interview with a former Getty official.

Papadopoulos began looking: He became professor of classical archaeology, history, and culture at UCLA's Cotsen Institute of Archaeology.

Robin Symes was livid: Interviews with Fleischman and two former Getty officials.

146 *Larry brought up:* This account of the conversation and the terms of True's loan is based on interviews with Fleischman; the Munger, Tolles & Olson investigation of the loan; and True in Eakin, "Treasure Hunt"; and Fleischman's statement to the Getty board shortly before resigning (see chapter 20).

She had agreed: In interviews in 2006, Fleischman claimed that True had made payments of $3,000 a month religiously since 1996, but she would not provide documentation of the payments. Getty officials said that they had seen no evidence of the payments. Shortly before publication, the authors asked True through her attorney to provide proof of ongoing payments. She declined.

11: Conforti's Men

147 *Just months before:* This account is based on interviews with art squad members, the case file, and interviews with Silvio Raffiotta and Paolo Ferri.

148 *had tried to take:* Interview with Raffiotta.

In more recent years: Visit to the Swiss Customs Museum in Cantine di Gandria.

149 *Tabaccheria Canavesi:* Visit to the shop, which has retained its name but is now owned by a relative.

General Roberto Conforti: General Roberto Conforti's background is based on interviews with Conforti, other members of the art squad, and senior Italian cultural officials. See also Peter Watson and Cecilia Todeschini, *The Medici Conspiracy: The Illicit Journey of Looted Antiquities* (PublicAffairs, 2006).

151 *an investigation of Pasquale Camera:* This account is based on Italian court records; interviews with Ferri and other Italian investigators; and Watson and Todeschini, *Medici Conspiracy.*

an organizational chart: The authors obtained a copy of the chart from Italian court records.

the Swiss holding company: Information about Edition Services and the description of it as a glorified mail drop are from a visit to the Geneva office and an interview with Albert Jacques. According to depositions given in the Greek lawsuit filed against Robin Symes by Christo Michaelides' family, Jacques was also involved in helping Symes set up his company, RS Ltd., in 1977.

152 *raided Medici's premises:* The description of the raid is based on interviews with participants; Italian court records; a visit to Geneva Free Ports; and photos

of the raid from Andrew L. Slayman, "Geneva Seizure," *Archaeology*, September 18, 1998, available at http://www.archaeology.org/online/features/geneva/index.html.

153 *True testified under oath:* Marion True, deposition before Richard Robinson, October 4, 1995, Los Angeles. A copy of this deposition is in Italian court records. In her March 15, 2005, testimony before Paolo Ferri and Guglielmo Muntoni (Los Angeles; hereafter "True's 2005 testimony"), True gave a more accurate account that is supported by interviews with Robert Hecht and confidential Getty records.

True had written to Medici: When Italian authorities raided Medici's warehouse, they found several letters from True to Medici, including one in which she discussed the tripod.

154 *The Italians' request:* Interview with Rosario Alaimo, professor of geochemistry at the University of Palermo.

she handed him a baggie: Interview with a former Getty official.

155 *sent a letter to Getty CEO:* The contents of the letter and the two photographs sent with it were described by a senior Getty official and a second person familiar with their contents. True described the letter and her reaction to it in her October 17, 2006, statement to Ferri.

156 *More than a year later:* This account is based on a copy of True's remarks and interviews with those who attended the meeting, including Italian government archaeologist Daniela Rizzo (no relation to Maria Antonietta Rizzo) and Wolf-Dieter Heilmeyer.

12: THE GETTY'S LATEST TREASURE

159 *Richard Meier's modernist creation:* Although a few critics noted the aloofness of the Getty Center's setting, most gushed praise. A writer in the December 7, 1997, *San Francisco Examiner* pronounced Meier's work to be "as brilliant and satisfying an executed architectural conception as any of us are ever likely to experience at such a colossal scale in our lifetime."

The trust's seven: The programs were the Getty Museum, Research Institute, Conservation Institute, Leadership Institute, Grant Program, Education Institute for the Arts, and Information Institute.

160 *the Getty Museum's art collection:* The bulk of the antiquities collection was left in storage during the remodeling of the original Getty Museum in Malibu. On display, however, was a small exhibit of the Getty's best antiquities, titled, ironically enough, Beyond Beauty: Antiquities as Evidence. Among the objects highlighted was the Aphrodite. "Beyond its beauty every ancient artifact preserves additional information that has often been undervalued or overlooked . . . This exhibition explores the variety of cultural, historical and technological evidence embedded within ancient works of art, and the important role that evidence plays in understanding and preserving such objects."

More than seven hundred: After wildfires, an earthquake, the Rodney King beating by police, a riot, and the O. J. Simpson trial, the opening of the Getty Center was a source of relief for the city of Los Angeles. The *Los An-*

geles Times dedicated its Sunday magazine to the event, and local glitterati scrambled for tickets to the eighteen invitation-only preview events, including several black-tie dinners.

the Getty's incoming CEO: Details are from a videotape of the Getty Center opening found in the Getty Trust archives.

His goal was: While reluctantly funding Meier's cultural acropolis, trustees privately fretted that its scale, location, and cost reinforced the Getty's image as too elitist. Board members Ramon Cortines, the Latino superintendent of Los Angeles city schools, and Blenda Wilson, the black president of California State University, Northridge, often complained that the Getty was off-putting to minorities because it "radiated wealth." Board chairman Robert Erburu worried openly about that image, often recalling a conversation he'd had about the new Getty Center with his Latino maid. "People like us don't belong there," she'd told him. Interview with a high-ranking Getty official.

161 *Munitz had grown up:* Munitz's personal history is from interviews with Munitz and published accounts, including "The CEO of Higher Learning," a *Los Angeles Times Magazine* profile that ran in January 1997 and is believed to have impressed Erburu. Erburu declined repeated requests for an interview.

He left his third wife: Vicky Ward, "The Getty's Blue Period," *Vanity Fair,* March 2006.

had enraged environmentalists: Munitz's tenure at MAXXAM during the tree-cutting controversy dogged him when he moved to California. At one Cal State board meeting, environmentalists showed up dressed as trees and lay down in protest. Munitz responded by opening his address with "Ladies, gentlemen and trees . . ."

162 *Others lauded:* Indeed, a year before his appointment, Munitz was in such high regard that the *Orange County Register* started a review of his five-year tenure at Cal State this way: "Barry Munitz does not walk on water. But to his legion of supporters up and down the state, that's about the only thing that the head of the 22-campus California State University system cannot do."

He privately badmouthed: The design flaws became painfully obvious when more than 800,000 people swamped the Getty Center during the first five months. There wasn't enough room in the underground parking garage, and the dearth of toilets was highlighted in a *New York Times* article on April 2, 1998, which began, "Here is a tip on how to enjoy the hottest new cultural attraction in Los Angeles: use the restrooms at the tram entrance before heading up to the Getty Museum." This discussion is also based on interviews with former Getty officials.

163 *the neighbors filed:* The seeds of the lawsuit were planted in July 1997, when Getty staffers had a private after-hours party at the villa to mark its closing for renovations. Neighbors were awakened by the noise reverberating up the canyon walls from the crowd, two bands, and the staffers splashing in the villa's reflecting pool. In February 2003, the California Supreme Court let an appellate court decision stand in favor of the Getty. But the lawsuit delayed new construction at the villa by at least three years, nearly doubling the price.

friends and colleagues noticed: True's change of character is from interviews with several of her former colleagues and friends.

True stopped speaking: Interviews with George Goldner.

She used the trust's wealth: The description of True's use of Getty funds is based on several years of her Getty expense accounts.

164 *True signed a resolution:* Reformers in the European art world, who had earlier called for loans of antiquities, considered True's vocal support at Rutgers to be of major significance. Interview with Wolf-Dieter Heilmeyer.

Six months later: A record of the April 1999 panel discussion—which included True; writer and social critic Christopher Hitchens; attorney Patty Gerstenblith; art collector Shelby White; and Michael Daley, director of the art advocacy group ArtWatch International—can be found at http://www .najp.org/events/whoowns/EV1(g)%20Antiquities.pdf.

165 *The appeal rallied:* Those lining up in favor of Steinhardt included the American Association of Museums, the Association of Art Museum Directors, the Association of Science Museum Directors, and the American Association for State and Local History. Those against it were the Archaeological Institute of America, the American Anthropological Association, the U.S. National Committee of the International Council on Monuments and Sites, the Society for American Archaeology, the American Philological Association, and the Society for Historical Archaeology.

"the most serious threat": From the amicus curiae briefs filed by the museum groups in favor of Steinhardt's appeal.

166 *fourth-century B.C. bronze:* The story of the Saarbrücken bronze, as it came to be known, is based on confidential Getty records, including a copy of the correspondence between "Jack Wynn" and Marion True; interviews with former Getty officials; international law enforcement documents, including an Interpol account of the FBI's interview with True; interviews with Greek investigators; and the reporting and assistance of Greek journalist Nikolas Zirganos. Jack Wynn could not be located, and it is not clear whether this name is an alias, as in the case of "Dr. Victor Preis" and the funerary wreath. Christoph Leon declined to comment in detail on the Saarbrücken case, but in the authors' brief interview with him, he said of True, "She was never interested in buying this piece. She expressly said that, and her visiting was only [for] the archaeological interest . . . I don't want to elaborate on this. She did not see it in my home."

the Greek art squad had been: As described by a former art squad chief, the Greeks began working with German police and uncovered a smuggling network that allowed dealers in Munich to "shop" for looted antiquities from a catalogue of photos. The pieces were then smuggled into Germany by second-generation Greek Germans in fruit trucks or ships' cargo holds.

167 *"Tomorrow one of our officers":* July 1998 art squad report to the public prosecutor in Athens. True denied ever making an offer for the statue.

"previously come to the attention": Interpol communiqué from Washington, D.C., office to Los Angeles office, August 1990. Leon declined the authors' requests to discuss the allegations.

168 *True admitted:* Report from Interpol U.S. to Interpol Germany and Interpol Greece reporting on the oral examinations of True, Christine Steiner, and

John Papadopoulos by an FBI agent based in Los Angeles, November 23, 1998.

13: Follow the Polaroids

169 *Raffiotta had been pursuing:* Interview with Silvio Raffiotta.

170 *Ferri had jumped:* This description of Ferri's background and interest in antiquities is based on interviews with Ferri.

171 *the venerable auction house:* The report was based on hundreds of pages of internal documents leaked by a disgruntled former Sotheby's employee to Watson. The documentary coincided with the release of Watson's book *Sotheby's: The Inside Story* (Random House, 1998).
the Villa Giulia: The museum is housed in a sprawling villa designed in part by Michelangelo and built in the 1550s as a summer getaway for Pope Julius III. The pope scandalized the church by awarding cardinal status to his adopted teenage nephew, who was reportedly also his gay lover.

172 *"Stop!" Pellegrini cried:* This account is based on interviews with Daniela Rizzo and Maurizio Pellegrini. Watson (*Sotheby's*, 355) has the date of sale as December 8, 1994, not November 12.
Ferri looked up: Based on interviews with Ferri, Pellegrini, and Rizzo.

176 *As Rizzo and Pellegrini:* This process took place over several years, with Rizzo and Pellegrini submitting a full report to Ferri in the summer of 1999— months after Ferri's confrontation with True at the Villa Giulia described later in this chapter.
labeled "Trip to LA": In April 1987, Hecht, Medici, and Medici's son traveled to the Getty. Medici had with him twenty ancient plates that True had seen in his Geneva warehouse. True showed the plates to museum director John Walsh, who turned them down. Medici was so irate that he refused to sell the Getty the fragments that matched one of its vases. An internal review found that True wrote an apologetic letter, adding a line she would come to regret: "Slowly, we will work on John and try to persuade him to change his mind."

177 *As she had with:* True had returned the tripod in November 1996.
She was signing paperwork: This confrontation is based on True's 2005 testimony, as well as interviews with the Carabinieri and Ferri.

14: A Wolf in Sheep's Clothing

179 *True and the Getty were suggesting:* In the press release announcing the return of the Onesimos, True is quoted as saying, "Our antiquities collecting policy calls for our prompt return of objects to their country of origin should information come to light that convinces us that this is the appropriate action to take. While no claim had been made for these objects prior to our initiating the return, we felt that in each instance there was sufficient cause to remove the objects from the collection and return them to their country of origin."
like waving a red cape: Interviews with John Herrmann and George Goldner.
"She's wandering all over": Interview with a former senior Getty official.

180 *Philippe de Montebello:* Biographical details of de Montebello are from various
sources, including an interview with a Met curatorial official and the Met
Web site.
naked nationalism: Based on statements by de Montebello in various newspa-
per articles, as well as his National Press Club speech in 2006 (see chap-
ter 21).

181 *The Met's acquisition policy:* Archaeologists claimed that the Met's policy was a
farce, since most looted objects could be "cooled off" in a Swiss warehouse
for a decade or more and beauty or cultural significance was highly subjec-
tive.
"some of the finest": Celestine Bohlen, "Archaeologist Vindicated in Hunch
on Antique Silver Hoard," *International Herald Tribune,* February 3, 2006.

182 *Investigators found:* Law enforcement records and Italian court documents
show that Interpol authorities in Beirut were unable to find the Lebanese
dealer. Ashton Hawkins claimed that the silvers were imported into the
United States before the Met purchased them, but records show that Cus-
toms Service officials found they had been imported on behalf of the mu-
seum by Robert Hecht. Italian court records describe Hawkins's statements
to U.S. law enforcement about the importation as "incoherent" and "contra-
dictory."

183 *In October 1999:* The request and supporting statistics are from *Report of the
Cultural Property Advisory Committee on the Request from the Government of the
Republic of Italy Recommending U.S. Import Restrictions on Certain Categories of
Archaeological Material,* submitted to the U.S. State Department on Febru-
ary 7, 2000. Italy's request for import restrictions was ultimately approved
in 2001, renewed in 2006, and under review for a second renewal in Au-
gust 2010. The Cultural Property Advisory Committee's report was released
in March 2004 under a Freedom of Information Act request by Peter K.
Tompa, counsel for the International Association of Professional Numisma-
tists.
On October 12: Transcript of October 12, 1999, Cultural Property Advisory
Committee hearing. The description of events are from inverviews with var-
ious participants and the authors' visit to the meeting room.

185 *The curator went even further:* Often overlooked, True's letter to the commit-
tee was astonishingly forthcoming about the moral blindness of antiquities
curators, including herself. A copy of True's October 12, 1999, letter was
provided by the Cultural Property Advisory Committee.

187 *Munitz had facetiously suggested:* Although Munitz has denied using the Star-
bucks line on staffers, he did once facetiously suggest in front of trustees that
a top financial officer in charge of the Getty renovation might soon be
"wearing a Starbucks hat" if the project didn't come in on time. Interviews
with two former Getty officials.

188 *He filed a defamation:* In his suit, Turner claimed he was wrongfully termi-
nated following an affair with his secretary. The secretary allegedly told him
"that 'everyone in the Museum had affairs,' including Goldner and Gribbon,
and that no disciplinary action was ever taken," according to the suit. Two
former Getty officials confirmed the Gribbon-Goldner relationship, and
Goldner said in an e-mail, "I don't deny it." Debbie Gribbon declined to
comment.

190 *True dismissed fears:* A copy of True's remarks was provided by the Getty Trust.

15: Troublesome Documents

195 *On October* 17: Details of the Getty's internal investigation are from confidential Getty records and interviews with several former senior Getty officials.

acquisition of a painting: Martin was working at the Manhattan boutique law firm Werbel & Carnelutti when he was first hired by the Getty to defend its acquisition of Rubens's "The Death of Samson." The Italians had opposed the Getty's export of the painting until their experts determined it was a knockoff worth a fraction of the $3 million down payment the Getty had paid. Barry Munitz knew Martin through Martin's wife, Jill, who had represented him during the Texas savings and loan lawsuit. Interviews with a former high-ranking Getty official.

197 *a VIP escort:* Eakin, *"Treasure Hunt."*

the greetings were warm: Interviews with Paolo Ferri and a second participant in the meetings.

199 *"We have a problem":* Gribbon's conversation with Murphy is based on interviews with a former senior Getty official.

201 *a "great advantage":* Two sources say that this was the first and last time the question of True's representation was formally weighed, despite damning information that surfaced later, such as True's undisclosed loans from Christo Michaelides and the Fleischmans.

no legal consequences: Ferri has stated on several occasions that the Getty's attorneys acted improperly by verbally promising to provide all relevant documents but then withholding the most damaging ones. "It seems to me there was a legal and moral obligation to give everything possible related to this conspiracy, and hiding material to me is truly reprehensible," Ferri said during True's 2005 testimony. Richard Martin, Francesco Isolabella, and Peter Erichsen have all refuted this claim. "What the museum gave is exactly what I offered verbally in the first meeting," Isolabella said in the same 2005 hearing. In an interview with the authors, Martin said, "We provided him with everything he asked for. I didn't mislead him, and I didn't misrepresent anything." In a written statement to the authors dated July 30, 2008, Erichsen said, "The Getty was at all times in good faith compliance with its agreement with the Italian prosecutor."

202 *The curator was polite:* Penny Cobey's interview with True and concerns about the Aphrodite are recounted in Cobey's confidential memo to Martin on the Aphrodite acquisition, dated March 4, 2001.

there was no proof: During the controversy over the Aphrodite, True suggested that it could have been made in Italy but exported in antiquity to Libya, also the site of ancient Greek colonies, and where it was found centuries later.

"to keep the Carabinieri": Cobey's memo on the Aphrodite acquisition.

204 *Canavesi's trial lasted:* Copy of trial transcript.

In Christine Steiner's records: Handwritten notes in Getty files.

16: Mountains and Molehills

207 *early dealings with Jiri Frel:* Hecht's memoir mentions True only once, when the middleman proposed selling the Getty a red-figured psykter (a jar for cooling wine), looted from near Cerveteri, for $700,000. At first True was enthusiastic about the potential acquisition, Hecht writes, but when he flew to California with the object, the curator changed her mind, claiming that she had heard it was a fake. Apparently, True had picked up a rumor that a rival dealer had put out into the market.

 He lingered on: Hecht's memoir describes the moment he first saw the stellar antiquity: "GM [Giacomo Medici] was loyal + one morning in Dec. 1971 he appeared at our apt in Villa Pepoli shortly after breakfast with polaroids of a kr. signed by Euphr. I could not believe my eyes."

208 *It was the whiteness:* The account of Ferri's visit to the Getty Center and True's deposition is based on interviews with Ferri; two former Getty officials; and True's 2001 deposition.

210 *Over the course:* This account is based on the transcript of True's two-day deposition.

214 *had produced no more leads:* Interview with Paolo Ferri.

 her disclosure about von Bothmer: Interviews with two former Getty officials.

216 *Board members also:* Interviews with two former Getty officials.

218 *"radioactive":* Notes from the Getty's internal review and interviews with a former Getty official.

219 *it was important that the Getty:* After years of internal fretting about the legality of their actions in the antiquities trade, both True and Walsh would deny under oath that they were aware that the Getty was buying looted art. True's 2001 deposition; Walsh's 2004 deposition.

 In March 2002: The story of the Poseidon is based on interviews with two former Getty officials, contemporaneous notes from a participant in the talks, internal Getty records, and information supplied by Getty antiquities curator Karol Wight.

220 *With Erichsen's approval:* In his July 30, 2008, written statement, Erichsen said, "I have no recollection of 'approving' the loan . . . nor do I recall any controversy about the loan . . . My position throughout was that the evidence should be weighed as dispassionately as possible under the circumstances."

221 *the family filed suit:* Court documents from Symes's London trial show that Michaelides' family believed that his personal effects included "six watches, several of them Cartier from the 1920s and one Rolex, [and] one pair of cufflinks by Cartier inlaid with sapphires and baguette diamonds."

 Michaelides' poor aunt: In her 2001 deposition for her family's lawsuit against Robin Symes, Despina Papadimitriou described the financial condition of the aunt: "Her husband had died when she was pretty young, in her early 30s, and she was not well off. My father supported her for all his life. It is inconceivable that Christo would have asked her for even small loans." The lawsuit drove Symes into bankruptcy on March 27, 2003.

223 *Erichsen was satisfied:* In his July 30, 2008, written statement, Erichsen said that True was interviewed about the loan in Gribbon's office and "flatly and without elaboration denied the loan's existence." Given the earlier warning

she had received from Walsh, Erichsen added, "Dr. True could not have failed to understand the significance which the Getty would attach to the matter. If Dr. Gribbon or I did not ask follow-up questions, our failure to do so pales in comparison to Dr. True's disingenuousness in answering the basic question so misleadingly."

17: ROGUE MUSEUMS

224 *an international arrest warrant:* Interview with Paolo Ferri. Apparently, Frieda Tchakos thought that Cyprus wouldn't honor the warrant.

an unrelated looting case: The Carabinieri had traced a looted white marble statue of Artemis to Tchakos's gallery in Zurich. When the dealer balked at cooperating with the Italians, Ferri issued an arrest warrant and sought extradition—a move that finally shook the statue loose. Although Ferri dropped the extradition request, he refused to drop the arrest warrant unless Tchakos provided information about the illicit antiquities market.

"I won't pull": Interview with Ferri.

coolly answering questions: Tchakos's 2002 deposition.

226 *The strange thing:* In an e-mail to the authors, Barbara Fleischman disagreed with Tchakos's characterization, saying that her husband had bought several Cycladic pieces.

But Ferri believed: True and Fleischman have both adamantly denied that the collection was a front for the Getty. Both have said that they were introduced in the early 1990s. In his 2004 deposition, John Walsh testified that he had introduced True to the couple at a Getty symposium in 1991, by which time the Fleischmans had already acquired most of their collection. All three accounts are incorrect. The authors learned that True first met the couple at least five years earlier, in the mid-1980s, in the midst of their most active collecting. The Fleischmans' daughter, Martha Fleischman, president of the Kennedy Galleries in Manhattan, confirmed the earlier date in an e-mail to the authors: "I discussed this with my mother who looked at her book and realized that 1991 was actually the year that Marion True had asked to do an exhibition of their collection. My mother said that this date had just stuck in her mind, but that the first meeting must have been around 1986 or so."

"I believe that": Symes's 2003 deposition.

227 *In an interview:* Hugh Eakin, "Looted Antiquities?" *ARTnews*, October 2002.

228 *"If an American conspired":* Judge Jed S. Rakoff's 2002 ruling in *United States v. Schultz*.

229 *The Met director was shaken:* In the authors' interview with Met spokesman Harold Holzer, who accompanied de Montebello to the *New York Times* meeting, Holzer said that the director was "surprised" at both the ardor and the nationalistic views of board members, some of whom were or had been foreign correspondents. De Montebello, who retired in 2008, declined to be interviewed for this book.

A subsequent editorial: "Return the Parthenon Marbles," editorial, *New York Times*, February 2, 2002.

an interview with Dietrich von Bothmer: The content of Ferri's rogatory is from Ferri's e-mail to the authors. Ferri considered von Bothmer to be the "godfather," or hub, of the looted antiquities trade in America. Prior to von Bothmer's death in October 2009, his representatives declined interview requests, citing his failing health.

230 *it was no longer:* Insiders credit Met general counsel Sharon Cott with bringing de Montebello to the conclusion that his demands were extreme and the Met had to give back suspect objects or face the fate of the Getty. Cott declined the authors' request for a comment.

 de Montebello sent invitations: This account of the meeting is from interviews with two participants, a copy of de Montebello's invitation letter, and other written materials presented at the meeting. On hand for the discussion were James Wood of the Art Institute of Chicago and his outside counsel, Thad Stauber; Katharine Lee Reid of the Cleveland Museum of Art and her outside attorney, Josh Knerly; and Debbie Gribbon and Penny Cobey.

231 *"I'm here to propose":* The descriptions of the meeting and the "off-the-record chat" afterward are based on accounts provided by Italian participants in both conversations, a member of the Getty team, and Peter Erichsen's November 1, 2002, timeline of events related to the Italian case, which summarizes the meetings. The timeline was part of Erichsen's November 5, 2002, briefing paper to the Getty board's executive committee (see chapter 18). In his July 30, 2008, written statement, Erichsen described the meeting as "entirely businesslike." He said that the side meeting did not include a "settlement offer" and "was intended to be a way of cooperating with the Italian authorities to develop evidence relating to the provenance of objects; this we repeatedly and politely did."

232 *If the Getty was willing:* Erichsen's November 5, 2002, briefing paper to the Getty board's executive committee.

233 *Erichsen summarized:* An October 9, 2002, draft of Erichsen's memo to Munitz titled "The Carabinieri's Submissions as to Six Objects in the Getty's Collection." In the draft memo, Erichsen said that the Carabinieri had "for the first time explicitly stated that a 'good faith gesture' involving the return of three to five objects might lead to a favorable resolution of the investigation of Marion True." He said that the Italian evidence was in many cases "arresting" but did "not compel a decision to return." He noted, however, that "any decision we make must be considered against the background of a decade of policy pronouncements by Getty curators of their unwillingness to retain objects convincingly claimed by Italy as cultural patrimony."

18: THE REIGN OF MUNITZ

234 *had plummeted $2 billion:* From $5.8 billion in 2000 to $3.8 billion in September 2002.

235 *Munitz's own profligate use:* Details about Munitz's use of Getty resources are based on internal Getty records and were first published in a *Los Angeles Times* investigation of Munitz in June 2005. The information was later verified by an internal Getty investigation and by investigators for the California

attorney general, who in October 2006 found that Munitz had violated laws against using charitable resources for personal gain.

an absentee CEO: On various occasions, Munitz has defended his actions, saying that the Getty board knew about and approved all his trips and expenses, and in fact granted him several perks in his contract, including first-class travel with his wife. He has said that the board encouraged his extensive time away from the office to develop outside institutional and fundraising support. As for personal use of Getty staff, Munitz has said that he initially tracked and paid taxes for services as added income, but when the Getty switched accounting systems, he stopped tracking them. Working from home, he has said, allowed him time to reflect and be more productive.

237 *she had to run:* Indeed, the quirky Getty administrative structure removed the museum director from dealing directly with the trustees, unlike at the Met and other major museums, where the director called the shots. Museum world insiders considered the reporting structure at the Getty a major drawback of the director's job.

238 *True called Fleischman:* Interviews with Barbara Fleischman. True's desire to talk to Munitz was awkward because she didn't report directly to the CEO, but to her institutional adversary, Debbie Gribbon. At the urging of board members, Munitz eventually changed the line of authority so that True reported directly to him about the villa reconstruction.

239 *"I want you to know":* As recounted in Munitz's letter to David Gardner dated October 15, 2002, and in interviews with Gardner.

240 *He spent hours:* Ibid. In an interview by the authors, one Getty official described Munitz as being obsessed with the letter.

The Italian investigation: This account of the November 2002 conference call and January 2003 board briefing is based on interviews with participants, various drafts of briefing papers presented to the board, and notes taken by a participant during the conference call. In his written statement to the authors, Erichsen said, "I made an effort at all times to provide the Board with as full a description of the Italian controversy as I could." Each of his dozen major briefings "was discussed in advance and in detail with Dr. Munitz and, frequently, board leadership."

242 *All the references:* The executive committee was resigned to the fact that the briefing document, no matter how carefully guarded, would eventually be leaked or could be discoverable in court proceedings. According to one former Getty official with knowledge of the conference call, Kaplan also removed anything that seemed to point the finger at Gribbon from the document.

The precautions worked: In an interview by the authors, a member of Munitz's management team claimed that they first alerted the board about "troubling" documents in March 2001 and provided updates at every regular meeting. The authors found no documents to support this assertion.

Erichsen's presentation dwelt: Copies of Erichsen's November 2002 briefing papers and interviews with two former Getty officials. Board members, John Biggs in particular, wondered whether True would strike a plea bargain in which she turned against Gribbon, John Walsh, Harold Williams, and the trustees. "What are we going to do when we get the call she's sitting on a beach in Brazil and they [the Italians] are now turning their attention to the

people higher up the chain?" one source quoted Biggs as saying. Interview with a former Getty official and Biggs, who confirmed his concern.

243 *not just a Getty issue:* The Italians made no secret that their legal strike against True was the first volley in a "coast to coast" campaign to "systematically scour . . . every major collection of Etruscan, Greek and Roman antiquities in the United States" and recover those that had been looted. Their targets included the Met, the Saint Louis Art Museum, the Cleveland Museum of Art, the Tampa Museum of Art, the Toledo Museum of Art, and the Princeton University Art Museum. Eakin, "Looted Antiquities?"

244 *"It's just like Nuremberg":* Interview with a Getty official who attended the meeting.
The board was reluctant: As one former Getty official told the authors, board members were worried about taking a public stand only to have emerging facts about True undercut them.
"I agree . . . completely": From a copy of Erichsen's transcribed voice-mail messages. Kaplan declined the authors' requests for an interview.

246 *Gardner was stunned:* This account of Gardner's conversations with Munitz and other board members is based on interviews with Gardner and two former Getty officials.
He set up a meeting: This account is based on interviews with two former Getty officials.

247 *Gardner, meanwhile, was lobbying:* Munitz's letter to Gardner, January 2004; interviews with Gardner.
The payoff came: This account is based on interviews with Gardner and one other participant in the closed-session meeting.

249 *turning the screws:* This account of Munitz's barrage of criticism and the April 2004 board meeting is based on interviews with two former Getty officials and copies of Munitz's "performance review" for Gribbon.

250 *he flogged the tearful:* This account is based on Munitz's nine-page follow-up letter to Gribbon and interviews with two former Getty officials.
She was sanguine: Interview with a former high-ranking Getty official.

251 *Then, on September 21:* The account of this episode is based on interviews with Biggs and two former Getty officials. Gribbon, most recently interim director of the Cleveland Museum of Art, declined comment.

19: The April Fools' Day Indictment

253 *"They are trying":* A claim the middleman made in interviews with reporters. The description of Giacomo Medici is based on the authors' observations.
five months to write: A telling fact about the complexities of the case, since the usual amount of time allowed for judicial decisions is three months.
He sentenced Medici: The sentence was held in abeyance pending Medici's appeal. The fine was paid in part by the seizure of the dealer's rambling and garishly colored villa in Santa Marinella. In July 2009, an Italian appellate court upheld Medici's sentence, but he appealed to the supreme court. Because he is now over seventy, he is exempt from having to serve any prison time.

254 *who had successfully defended:* Coppi led a defense team that eventually won

acquittal of the seven-time prime minister on charges that he had close associations with the Mafia and had ordered the murder of an investigative journalist who was on the verge of exposing those connections. The case is considered one of the most important post–World War II political trials in Italy.

"Did Marion True": Fleischman's 2004 deposition.

255 *"a little black book":* Ferri had taken copies of the book, which he returned to Fleischman's lawyers. He never used the information in the trial.

During the next day's: Walsh's 2004 deposition.

the deposition of Karol Wight: Karol Wight, deposition before Paolo Ferri and Guglielmo Muntoni, Los Angeles, September 23, 2004.

256 *During a break:* In interviews, Ferri said that he took umbrage when Martin reportedly accused the prosecutor of being ignorant of Italian legal procedures.

Erichsen advised: Erichsen's July 30, 2008, written statement; interviews with two Getty officials who attended the meeting.

Muntoni's steely contrariness: During the trip to America, Muntoni had refused to dine with Ferri and others in the Italian contingent until the last night, when the final deposition was finished. Even then he remained inscrutable.

257 *On a Sunday afternoon:* This scene is drawn from interviews with Ferri.

a certain Greek vase: The Getty catalogue of the Fleischman collection noted that the piece had been in a 1988 catalogue for Atlantis Antiquities, a gallery partly owned by Hecht. Through her daughter, Barbara Fleischman told the authors the invoice for the vase was dated and paid in 1988.

Fleischman claimed: Ferri didn't know it at the time, but True and the Fleischmans had actually met two years before the Greek vase was purchased. See chapter 17, note 6.

how could Larry Fleischman: Barbara Fleischman and her daughter, Martha Fleischman, declined to be interviewed on this and other important points of Ferri's theory.

258 *Hecht volunteered spontaneously:* In an interview for this book, Muntoni said that he still wonders why Hecht made the remark. "In this way, he was destroying the cover story which defended Marion True . . . He just volunteered it." Although True and Martha Fleischman declined to be interviewed for this book, both have publicly refuted Ferri's assertion that the collection was a "front" intended to launder looted pieces for the Getty. After the *Art Newspaper* printed the allegation in April 2008 as part of its report on a court proceeding, True sent a strongly worded letter to the editor saying, "Your article repeats utterly false accusations without analysis or providing an opportunity for a response. Doing so is unfair not only to me, but to two collectors who were dedicated for decades to the support and strengthening of museums not only in America but in England and Italy as well." Martha Fleischman wrote, "The image of my mother, in cahoots with Dr Marion True, conspiring to muddy the waters of provenance, would suggest a hilarious screenplay if this trial were not so vicious in tactics and destructive in effect." Both letters appeared in the May 2008 issue of the *Art Newspaper* and are available at http://www.theartnewspaper.com/articles/Letters-to-the-editor%20/8470.

In a final bid: This account is based on True's 2005 testimony and interviews with Ferri and Muntoni.

259 *"Probably nothing":* True wrote to the authors, "I did not propose returning them as the provenance provided by Medici was contradicted by the opinion of Janos Szilagy. Szilagy was considered a more reliable expert. Many dealers claim knowledge of provenance without evidence."

"I'm sorry": Muntoni, who started out unconvinced that True was part of a conspiracy, later pointed to this moment as decisive. Even then, he regarded the curator as a good person who may have wanted to change things but was trapped in a job that was dependent on acquiring looted antiquities. Interview with Muntoni.

20: LIFESTYLES OF THE RICH AND FAMOUS

261 *a series of investigative stories:* The stories on Munitz were reported and written by Jason Felch, Robin Fields, and Louise Roug. Stories about the antiquities scandal were reported and written by Jason Felch and Ralph Frammolino. The account of internal Getty reaction to the series is based on interviews with former Getty officials.

262 *recently tried to recruit:* Months before, Olson had turned down a Getty board appointment after the trustees failed to heed his recommendation to form an internal committee to investigate the allegations about Munitz coming out in the *Los Angeles Times.* Interview with someone with knowledge of the discussions.

263 *"You're in trouble here".* This account is based on interviews with two former Getty officials and Biggs. The former Getty officials also told the authors that Olson warned Bryson that she or other board members could go to jail—a statement Olson declined to discuss with the authors because of attorney-client privilege. Bryson, who stepped down as board chair in 2010, did not respond to repeated requests for an interview. Getty records show that MTO immediately began investigating the liability of trustees and the criminal liability the Getty faced under federal law prohibiting the receipt of public goods.

As if to underscore: In California, the attorney general is responsible for regulating charitable trusts that are registered in the state and can take legal action if the assets—considered public because they are tax-exempt—are used for personal gain.

264 *hired a crisis management firm:* The Getty hired Sitrick and Company, a Los Angeles–based firm specializing in "crisis communications." One of the first things Sitrick suggested was that Munitz announce an investigation into the leak of the documents, thus shutting down the *Times'* sources. Getty officials decided against this tactic. Sitrick also urged the Getty to engage the newspaper, but Munitz refused. The Getty ended up paying Sitrick $750,000 for largely unheeded advice, according to a Sitrick executive, a former Getty official, and Getty records.

Munitz called True: These accounts of the meeting between Munitz and True and of Munitz's conversation with Fleischman are based on interviews with a former Getty official and someone familiar with the subsequent MTO in-

vestigation into the loan. Munitz wasn't the only one who was worried about the loan. Erichsen also was reportedly upset by True's refusal to name the lenders and repeatedly called her to demand their identities. Interview with a former Getty official.

True said that Gribbon: An alternative account from Barbara Fleischman had Debbie Gribbon and Peter Erichsen approaching True informally at a cocktail party to ask casually about the loan.

Racing home to change: This account is based on an interview with someone familiar with the episode, which was part of the later investigation into True's loan.

265 *The curator appeared:* Details of this discussion come from Biggs and a former Getty official familiar with the conversation. The former Getty official also claimed that Olson advised the Getty to fire True if she had not disclosed the loan and was upset to hear later that Biggs had allowed her to "retire."

267 *For the first time: Los Angeles Times,* October 4 and November 11, 2005.

Flavia Zisa: A close friend of True's, Zisa happened to show up to talk to the Getty the day True was told she had to resign or be fired. Zisa found out what had happened when she went to True's Santa Monica condo and found the distraught curator in tears.

in New York: The occasion that brought the men together was the opening of a Met exhibit on Antonello da Messina, Sicily's most famous Renaissance painter. Also in attendance at the meeting was Luis Li, the MTO attorney who was in charge of the firm's investigation into Italian claims against Getty antiquities. This account of the meeting between Munitz and Pagano is based on Getty documents and interviews with Alessandro Pagano, Flavia Zisa, and a former Getty official.

268 *But the talks grew cold:* The Sicilians wanted Munitz to take quick action because Pagano was facing reelection in two months. Pagano won the election, but Munitz was ousted, and the talks formally died. Interviews and e-mail exchanges with Luis Li, Getty spokesman Ron Hartwig, and Flavia Zisa.

Erichsen and others feared: Interviews with Li and Hartwig.

board was backing away: "This puts the board chair and vice chair in the driver's seat, looking at policy issues independent of the management of the Getty," board member Ramon Cortines told the authors.

269 *delicate matters:* Munitz's spending related to Nana Zhvitiashvili and Iris Mickein raised eyebrows among members of the board, but the authors found no evidence that the relationships were sexual. Rather, people close to Munitz said that he had a penchant for mentoring talented young women, lavishing them with attention and support in an almost fatherly way, much as he had with his chief of staff, Jill Murphy.

Munitz even offered: Copies of Munitz's correspondence with Zhvitiashvili.

The intern showed up: Interview with a former high-ranking Getty official.

He later arranged: Munitz's memo to John Elderfield, MoMA's chief curator of painting and sculpture, dated February 24, 2003.

270 *The final break:* This account of Munitz's conversation with Murphy is based on an interview with a former Getty official.

271 *Fleischman wasn't about:* The account of Fleischman's speech to the board is

based on a copy of her seven-page statement and interviews with two former high-ranking Getty officials who attended the board meeting.

2 1: TRUE BELIEVERS

273 *the Getty Villa's public debut:* The morning of the opening, the *Los Angeles Times* ran an article with the headline "Getty Official in Italy for Talks on Contested Art; As the museum opening nears, its director begins a 'dialogue' on rights to antiquities. Ex-curator is accused of conspiring to receive looted items."

275 *All these touches:* "Marion True was the driving force behind the villa. It became her, as far as I could tell . . . It was her main dream and total commitment to make the villa a reality, so she was the force that kept moving the ball forward—the planning, the design, the programmatic concepts." Interview with a former high-ranking Getty official.

276 *the few thousand antiquities:* Even with the extra room, the Getty Villa could display only about half of the twenty-five hundred antiquities considered to be of museum quality.

277 *the perfect proxy:* Ferri said that his legal case wasn't about retrieving priceless art objects for Italy, where museum warehouses are stuffed with superior pieces. "That's not the battle we are conducting," he told the authors. "We are conducting another battle. We are saying to the museums . . . stop acquiring, and that means stop looting." He also said that he intended the Aphrodite to be a "symbol" of the battle and had added it to the Getty demand list at the last minute "to make a bang."

279 *Li had cut his teeth:* Li's most noteworthy case was the successful prosecution of former Los Angeles Rams cornerback Darryl Henley, who in 1997 was sentenced to forty-one years in prison for drug-related offenses and plotting the murder of a witness and federal judge in his drug trial.

280 *Brand, Li, and the rest:* This account of the Getty's negotiations with the Italians is based on interviews with Luis Li, Michael Brand, Maurizio Fiorilli, Giuseppe Proietti, Rocco Buttiglione, Daniela Rizzo, and others.

282 *A week later:* This account is based on Getty records and interviews with John Biggs and other board members present at the meeting.
In the end: This account is based on interviews with Biggs and a former Getty official. Munitz had already seen the writing on the wall. Weeks before his firing, he had met for lunch with California attorney general Bill Lockyer to say that he would be stepping down and to mull over his professional options. Lockyer, whose office was still investigating Munitz, later denied that his private talk with Munitz was improper or changed the outcome of his inquiry, which concluded that Munitz and the Getty board had misused trust money but imposed no sanctions.

284 *"incontrovertible evidence":* Several knowledgeable insiders credit Met general counsel Sharon Cott with nudging de Montebello toward the realization that the Italians didn't have to meet such a high standard. De Montebello declined to be interviewed for this book.
de Montebello privately regarded: This account is based on an interview with

the East Coast museum director in whom de Montebello confided at the West Palm Beach meeting.

285 *In a speech before:* Transcript of de Montebello's speech at the National Press Club, Washington, D.C., April 17, 2006.

287 *It was highly unlikely:* Interview with the Swiss private detective and internal Getty records.

had ties to organized crime: Orazio di Simone denied this in the authors' interview with him in Rome.

288 *"dangerous people":* Interview with a former Getty official who attended the meeting.

289 *Two trustees pushed back:* Former and current Getty officials identified the trustees as Jay Wintrob and Peter J. Taylor, managing director for the Los Angeles branch of Lehman Brothers.

Greece had a new: This account is based on interviews with Brand and Li.

291 *In a bitter letter:* True sent the letter, a copy of which was obtained by the authors, on December 18, 2006. It was addressed to Deborah Marrow, interim CEO of the Getty Trust after Munitz's resignation; Michael Brand; and Ron Hartwig.

the new minister turned: Interviews with Francesco Rutelli, Brand, Li, Hartwig, and Filippo Sensi, former official with the Italian Ministry of Culture.

292 *Within hours:* This account is based on interviews with Li, Hartwig, Fiorilli, Rutelli, and Sensi. MTO attorneys deny taking a "commercial" view of the negotiations, as Fiorilli suggested. Getty records show that they were paid hourly for their work.

293 *"When we acquired":* Interview with Malcolm Rogers at the return ceremony in Rome.

294 *Flying to Rome:* This account of the negotiations is based on interviews with Li, Hartwig, Brand, Fiorilli, and Sensi.

295 *In a written statement:* True's October 17, 2006, statement to Ferri.

296 *Ushered into:* This account is based on interviews with Li, Hartwig, Brand, Fiorilli, Rutelli, and Sensi.

22: A Bright Line

299 *In early 2007:* This account is based on interviews with Michael Brand, Max Anderson, and another museum director present at the meeting.

302 *Podany was heading:* This account of Podany's visit to see Canavesi's photos is based on interviews with Podany and another person present at the meeting.

304 *Thumbing for dramatic effect:* Interview with Filippo Sensi. Francesco Rutelli made the threat twice, in Rome and in Fano, where the Getty Bronze was first brought onto land.

It could always be: Interview with Maurizio Fiorilli and confirmed by Rutelli. Fiorilli later denied that he had engineered the court complaint.

305 *Fiorilli dropped:* Interview with Ron Hartwig.

307 *a former mentor:* In the authors' interview with Hicham Aboutaam, he recalled visiting Medici's warehouse as a child.

308 *"I expect that"*: "Italy's Rutelli Expects to Reclaim 'Hundreds of Other Works'; Shelby White's Returns to Be Exhibited," *ArtsJournal*, March 27, 2008, http://www.artsjournal.com/culturegrrl/2008/03/rutelli_expects_to_reclaim_hun.html.

"Ours is not": From Rutelli's remarks at Nostoi opening, quoted in "Rutelli Deploys Universal Museum-ists' Own Rhetoric Against Them," http://www.artsjournal.com/culturegrrl/2007/12/rutelli_deploys_universal_muse.html.

PHOTO CREDITS

Further Reading

For more academic treatments of the legal and ethical aspects of cultural property debate, see the following sources:

Appiah, Kwame Anthony. *Cosmopolitanism: Ethics in a World of Strangers*. W. W. Norton, 2006.

Bator, Paul. "An Essay on the International Trade in Art." *Stanford Law Review* 34 (1982): 275.

Coggins, Clemency. "Illicit Traffic of Pre-Colombian Antiquities." *Art Journal* 29 (1969): 94.

Cuno, James. *Who Owns Antiquity? Museums and the Battle over Our Ancient Heritage*. Princeton University Press, 2008.

———, ed. *Whose Culture? The Promise of Museums and the Debate over Antiquities*. Princeton University Press, 2009.

Fitz Gibbon, Kate, ed. *Who Owns the Past?* Rutgers University Press, 2005.

Merryman, John Henry. "Cultural Property Internationalism." *International Journal of Cultural Property* 12 (2005): 11.

———. "A Licit International Trade in Cultural Objects." *International Journal of Cultural Property* 4 (1995): 13.

———. "Two Ways of Thinking About Cultural Property." *American Journal of International Law* 80 (1986): 831.

Prott, Lyndel V. "The International Movement of Cultural Objects." *International Journal of Cultural Property* 12 (2005): 225.

Renfrew, Collin. *Loot, Legitimacy and Ownership: The Ethical Crisis in Archaeology*. Duckworth, 2000.

For more journalistic accounts of the antiquities trade, see the following sources:

Atwood, Roger. *Stealing History: Tomb Raiders, Smugglers, and the Looting of the Ancient World*. St. Martin's, 2004.

Chamberlin, Russell. *Loot!* Facts on File, 1983.

Meyer, Karl. *The Plundered Past*. Atheneum, 1973.

Network. Documentary. Directed by Andreas Apostolidis. Research by Nikolas Zirganos and Rea Apostolides. 2006.

Silver, Vernon. *The Lost Chalice: An Epic Hunt for a Priceless Masterpiece*. William Morrow, 2009.

Watson, Peter, and Cecilia Todeschini. *The Medici Conspiracy: The Illicit Journey of Looted Antiquities*. PublicAffairs, 2006.

Waxman, Sharon. *Loot: The Battle over the Stolen Treasures of the Ancient World*. Times Books, 2008.

Index